Color and Its Reproduction

Second Edition

Color and Its Reproduction

Second Edition

by
Gary G. Field

GATF*Press*
PITTSBURGH

GATF*Press*
Graphic Arts Technical Foundation
200 Deer Run Road
Sewickley, PA 15143-2328
Phone: 412/741-6860
Fax: 412/741-2311
Email: info@gatf.lm.com
Internet: http://www.gatf.lm.com

Orders to:
GATF Orders
P.O. Box 1020
Sewickley, PA 15143-1020
Phone (U.S. and Canada): 800/662-3916
Phone (all other countries): 412/741-5733
Fax: 412/741-0609
Email: gatforders@abdintl.com

Contents

Publisher's Foreword

In 1988 the Graphic Arts Technical Foundation first published *Color and Its Reproduction* as its core text on color for the printing industries. The book has performed as a perennial bestseller ever since.

GATF*Press* is proud to continue its long and successful partnership with Professor Gary G. Field of California Polytechnic State University and to publish *Color and Its Reproduction, Second Edition*. It is completely revised and updated, offering much new material. We believe it will continue as the text of choice among printing and design professionals—and especially in university classrooms.

We realize, however, that color is a moving target. Please contact us with your comments on the text and suggestions for future editions.

Peter Oresick
Director
GATF*Press*

Preface

The primary objective of this book is to establish a basis for the reader to make informed judgements about color reproduction quality. This basis is built upon a review of essential research studies and a detailed coverage of the practical aspects of photomechanical color reproduction. The text also covers the fundamental concepts of color science and engineering that are of importance to the printing and related industries.

Color and Its Reproduction is primarily directed to those involved in the production of printed color reproductions; notably, skilled prepress and printing personnel, quality analysts, and production managers. Technically-inclined designers, print buyers, sales representatives, and general managers will find much of interest within this text. It provides individual readers with a deeper understanding of their own particular field of expertise, together with an appreciation of the interrelated nature of all stages in the color reproduction process. Color and imaging scientists, and those who teach or study color reproduction at colleges and universities, will also benefit from this book. An extensive set of references is provided for scholars and researchers who wish to consult original sources or to read more detailed expositions of individual aspects of color reproduction.

Much has happened in the years since the first edition of this book was published in 1988. Quite apart from the obvious advances in technology, a number of other books on facets of color reproduction and quality control have been published during this period. This updated edition, therefore, has been restructured to reflect these developments: about 40 percent of the text is new, and it now places greater emphasis on color and color reproduction concepts, and less

on the routine quality control issues that were part of the first edition.

The first three chapters lay the historical and theoretical foundation of the color reproduction process. The review of color fundamentals is then rounded out by two chapters on color perception and one on color measurement.

Color reproduction practices are covered in the two chapters on the ink-paper-press system and the chapters on color originals and color separation. Two critical chapters on color systems analysis and color reproduction objectives define what constitutes color reproduction excellence and explain how all production elements must be linked if this goal is to be achieved. The final chapters explore the particular color requirements of individual printing markets, and describe the use of color proofs and color communication techniques to help achieve customer objectives.

I have received many positive reviews of this book's first edition from industry, science and education. I am grateful for these comments, and acknowledge the care exercised by the reviewers of the initial manuscript for helping to establish *Color and Its Reproduction* as an authoritative reference. My appreciation is also extended to those who have made suggestions about the content of this edition, and to the individuals and organizations who kindly granted permission to reproduce certain illustrations.

I express my particular thanks to Rosemary Wagner who expertly restructured the data files and entered the updated material for this edition. Erika Kendra and Thomas M. Destree at GATF edited the text and provided the project management expertise required to ensure timely publication. Finally, I am always grateful for the support, encouragement and patience of my wife, Mary Ann Ashcroft, who helped make it possible for me to complete this revision.

Gary G. Field
San Luis Obispo, California
September 1997

1 History of Color Reproduction

Introduction

An initial review of the significant advances in the complex and interesting process of color reproduction will help to establish a foundation upon which to build a detailed study of the relevant technologies and materials. Printed color reproduction developments will be emphasized over those occurring in photography and television.

An understanding of earlier technologies and problems is of benefit to the researcher who seeks new ways to improve the color reproduction process. Many older methods, although inefficient by today's standards, could produce reproductions of exceptional fidelity. A historical appreciation can also inspire practitioners to experiment with current processes for ways to exceed the imaging excellence of the past. It is, furthermore, proper to mark the contributions of scientists, technologists, and companies to the science and art of color reproduction. Consult the books by Sipley (1951), Burch (1983), and Coote (1993) that are listed in the References section for more detail. Back issues of the *Penrose Annual* (first published in 1895) contain excellent examples of fine color printing and numerous articles that describe how this process has evloved over the years.

Definition of Color Reproduction

Color reproduction is a process of producing a color image from some form of original scene or object. Generally speaking, the process includes making photographic color transparencies and prints, television images, computer monitor displays, and printed reproductions. Optics, electronics, photosensitive materials, and the physical transfer of a colorant to a substrate are key elements in the broad process of color reproduction in the printing industry.

The process of **photomechanical color reproduction** specifically concerns the printing industry, and generally involves making reproductions from existing photographs or artwork. The indirect version of this process includes the production of intermediate images (such as films and plates) prior to the physical transfer of colorants to substrates. The direct version includes those processes that generate images directly onto a substrate from digital data without benefit of intermediate films or plates.

Four-color process printing encompasses the photomechanical color reproduction process, and also includes the generation of flat color tones with halftone tint combinations of process colors. The **process colors** are yellow, magenta, cyan, and black. The term **process-color printing** has come to mean the same as four-color process printing because three-color process printing is rarely used today.

The production of an original series of artistic prints from, for example, hand-drawn lithographic stones is not color reproduction. Similarly, the mass production of such products as flat color labels or packages is not color reproduction. Both processes, however, have made contributions to process-color printing and will be discussed in the appropriate sections of this book.

Color Photography History

The first-known color reproduction was demonstrated by the Scottish physicist Professor James Clerk Maxwell. Maxwell's associate, Thomas Sutton, photographed a scene three times, once through a red filter, once through a green filter, and once through a blue filter. These black-and-white negatives were in turn contacted to produce positives that were each mounted as lantern slides. Each slide was placed in a different projector and the three images focused together, in register, onto a screen. Red, green, and blue filters were placed over the lens of the respective projectors that contained the red, green, and blue positive images of the scene.

Maxwell first published details of how to make a trichromatic reproduction in the *Transactions of the Royal Society of Edinburgh* during 1855. A demonstration of this technique was made on May 17, 1861, at the Royal Institution of Great Britain in London. The demonstration was part of a presentation on Thomas Young's theory of primary colors and color vision, rather than on color photography.

It was the fortunate combination of ultraviolet reflection from red areas of the original and the transmission characteristics of the liquid color filters that enabled Maxwell to produce a reasonable reproduction despite the restricted (blue and ultraviolet) color sensitivity of the emulsions being used. The subsequent development of full-color sensitive materials firmly established Maxwell's color separation principle as the basis of all successful color reproduction systems.

A process developed in 1891 by Professor Gabriel Lippmann of Paris was subsequently marketed during 1893 by the brothers Auguste and Louis Lumière of Lyon as the first commercial color photography method. The Lippmann process was based upon the principle of spectral interference between layers of ultra-fine silver grains within an emulsion. In practice, the Lippmann process enjoyed limited success because the severe practical difficulties relative to exposing and viewing the image more than outweighed the spectral purity of the resulting photograph.

The first tri-color single-film image for color photography was patented by French scientist Louis Ducos du Hauron in 1868. In his system, the image on a black-and-white panchromatic emulsion was broken up by a series of red, green, and blue transparent dots or lines that formed a screen in front of the emulsion. The dots and lines were so small that they could not be resolved by the eye. After exposure, the film was reversal-processed to yield a positive image behind the red, green, and blue mosaic. This additive-color transparency principle eventually found commercial application with such processes as the Lumière Autochrome process of 1907 (a random pattern of red, green, and blue grains), the Finlay plate of 1908 (a ruled red, green, and blue screen), and the Dufay process (printed red, green, and blue screen) of 1935.

The additive-color transparency was reintroduced in 1983 by Polaroid Corporation with their 35-mm Polachrome slide process. Polachrome has a screen of 1,000 red, 1,000 green, and 1,000 blue lines per inch (about 40 lines per millimeter) across the image area, and a minimum density of about 0.70; consequently, image quality is limited by comparison with subtractive systems.

It was also Ducos du Hauron who pioneered development of the subtractive color system. The first book on color photography, entitled *Les Couleurs en Photographie: Solution du Probleme,* was authored by him in 1869. He suggested mak-

ing separation negatives through red, green, and blue filters, then making positive transparencies from each, and dyeing them with colors that absorb each respective primary (i.e., cyan, magenta, and yellow).

The principles of the subtractive color photography process were also developed, completely independently of the work of Ducos du Hauron, by Charles Cros, who had submitted a sealed report of his theories to the Academie des Sciences in 1867. Cros has subsequently been credited as being the first to suggest the dye imbibition process, in which a dye is transferred from an image carrier to a substrate. The papers of Ducos du Hauron and Cros were both first read at the same 1869 meeting of the Société Francais de Photographie.

The two subtractive systems that initially received widespread popularity were the Autotype Carbro process (1925) and the imbibition methods first applied in 1925 by Jos Pé. The commercially successful imbibition methods include the Technicolor Process Number Four (1932) and the Eastman Kodak Dye Transfer Process (1945). The first full-color Technicolor motion pictures were *The Flowers and the Trees* (a Walt Disney cartoon of 1932), *La Cucuracha* (a live-action two-reel short film of 1934) and *Becky Sharp* (a full-length feature of 1935).

The subtractive methods described were difficult to use because they required the accurate registration of the colored positives (carbro) or the accurate registration of images from dyed positive matrices (imbibition processes). The solution was a three-emulsion film, each layer made sensitive to a different color (red, green, or blue) and then dyed a different color (cyan, magenta, or yellow) in processing. The first successful film of this type was Kodachrome, introduced by Eastman Kodak Company in 1935. This film used a complex processing cycle that involved processing each emulsion separately (although on a common support). The I.G. (Interessen Gemeinschaft, now Agfa-Gevaert) Agfacolor process of 1936 used color couplers within the emulsion, which made possible a much simpler processing procedure. These films were both reversal materials; the first color negative material was Kodacolor, introduced by Eastman Kodak Company in 1942. Another milestone development in color photography was the Polaroid Corporation Polacolor peel-apart "instant" system of 1963, and the single-sheet version of 1972.

Electronic still cameras use a photosensitive array to record image detail as a series of electrical signals. These arrays are known as charge-coupled devices (CCDs) and are available in either linear or area configurations. Electronic cameras rely upon three-filter methods to produce the red, green, and blue color records. One such method employs a filtered area-array CCD; i.e., the individual photosensitive elements within the array are covered by red, green, or blue filters. Another method uses three separate CCDs and a beam-splitting filtration system. The red, green, and blue records are used to generate a color monitor display, or to produce tangible reflective or transparent subtractive images.

The Kodak Photo CD system of 1990, developed by the Eastman Kodak Company and Philips N.V., is a method of recording picture information from conventional 35-mm color negatives or transparencies onto a compact disc. The image record, which is now in digital form, may be displayed on a computer monitor or television screen, used to generate a color print, or used to produce such other types of image output as color separations for the printing process. Developments in electronic photography and imaging have eroded many of the distinctions between photography and the prepress activity of color separation.

Color Television History

Early experiments with color television resulted in the development of the successive frame method, where a rotating red-, green-, and blue-filter wheel was placed over the lens of the television camera. This produced successive red, green and blue color separation images. A similar filter wheel in the receiver was rotated in synchronization with the frames. The result was a full-color television picture. This Columbia Broadcasting System method was standardized in 1950 by the Federal Communications Commission (FCC) for use in the United States. The system was not widely used, and subsequently the FCC set aside its 1950 decision and approved the National Television Systems Committee (NTSC) system in 1953.

The NTSC system, based on technology developed by the Radio Corporation of America (RCA), uses three receptor cameras and in the receiver three electron guns, a shadow mask, and a screen consisting of a mosaic of red, green, and blue phosphors. The NTSC system was followed by the German PAL system. Another refinement was the French

SECAM system, introduced in 1967. All three systems have many common features. The tube phosphors and shadow masks have developed from a series of red, green and blue dots to red, green, and blue strips, but otherwise the basic technology remains little changed. The European systems have a higher resolution image than the American system: 625 scan lines vs. 525 scan lines per image.

Color Monitors

Computer color monitors (sometimes called video display units, or VDUs) work on the same principle as television picture tubes. A color monitor's resolution is, however, more than twice that of a comparable color television screen because the red, green, and blue phosphors are arranged in a finer mosaic.

The first printing industry application of color monitors to the task of color quality evaluation was the Hazeltine Corporation unit of 1970. The system was designed initially to preview color separation films, but was later modified to display color scanner output signals prior to making separations. Color monitors are now widely used in the printing and photofinishing industries for the routine evaluation of images prior to generating the appropriate output record.

Color Printing History

The first use of color in printing dates back to the fifteenth century. This use was generally restricted to solid colors for decorative purposes. It was not until the early eighteenth century, when Jacob Christoph Le Blon introduced what can be described as the first form of halftone three-color printing. Le Blon, who was influenced by the work of Isaac Newton, chose yellow, red, and blue inks as his primary colors. These inks were the forerunners of today's yellow, magenta, and cyan colors. The halftone effect was obtained by using the mezzotint technique to hand-engrave copper plates. The first specimen prints produced by this process were made in about 1704.

Le Blon, of French extraction, was born in Germany during 1667. His process was not a success in Europe, so he moved to London in 1719. It was in England where the three-color printing process became an artistic success, but for a variety of reasons, Le Blon was not financially successful. In 1722, he published details of his work in the publication entitled *Coloritto, or the Harmony of Colour in Painting*. In 1735, LeBlon moved to Paris, where he is believed to have used a black plate as a key for the colors.

Le Blon was the founder of process-color printing; the only major difference from modern techniques was that he had to engrave his plates by hand copying, whereas the copying and engraving are done today by photomechanical techniques.

The nineteenth century saw the successful commercial use of chromolithography (1819), wood-block color printing (1823), and stencil printing. Many other processes and variants were introduced during this century; while they are all examples of process-color printing, they generally do not fit the definition of color reproduction. They were all hand methods and could be best classified as original color prints rather than reproductions, although some were produced as copies of original paintings.

From about 1870 onwards, major developments were made that laid the foundation for today's color printing processes. In 1869, Ducos du Hauron made a crude three-color reproduction by lithography using a photomechanical process. No screen was used, and the tonal gradation relied upon the grain of the original subject, the photographic emulsion, and the lithographic stone. A major breakthrough for color reproduction came in 1873 when Professor Hermann W. Vogel of Germany developed improved color-sensitive photographic emulsions.

Vogel's improved sensitivity emulsions were soon being used by collotype printers to produce the first photomechanical color reproductions. Josef Albert of Munich, for example, made three-color reproductions during 1874.

A reproduction of the first U.S. commercial halftone color reproduction.

The original was produced by William Kurtz in New York for The Engraver and Printer *of Boston in 1893. It used single-line screens and employed three colors.*

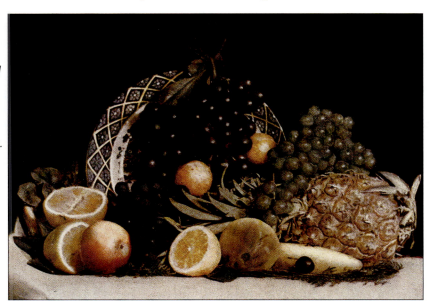

In 1881, Frederick E. Ives of Philadelphia patented the halftone screen, which allowed him to develop and exhibit the first example of trichromatic halftone color printing at the Novelties Exhibition in Philadelphia during 1885. Max Levy of Philadelphia successfully developed a precision manufacturing process for these screens during 1890.

The first commercial color photoengravings were produced during 1893. William Kurtz of New York and the Photo Chromatic Printing Co. of Belfast both deserve credit for this feat. Their processes were based upon the work of Ernst Vogel, the son of Herman Vogel.

Dr. E. Albert and H. Ulrich of Germany are credited with first using the four-color photomechanical process. A patent was issued in 1899 to Albert for undercolor removal and the use of the black printer. The four-color process initially proved to be more popular in the U.S. than in Europe, but today virtually all process-color printing is in four colors. The use of black helped to achieve neutrals as well as to increase the picture contrast.

Developments in Color Printing Technology

Printed color reproduction grew rapidly in popularity during the late nineteenth and early twentieth century until the great bulk of all pictorial reproduction was in color. The basic principles of photomechanical color reproduction remain the same today as they did in 1900, but there have been many important advances over the years that have led to improved quality and lower costs.

A major achievement in color reproduction was the development of photographic color-masking techniques. The first of these was patented by Dr. E. Albert in 1900. Over the years about 100 masking patents have been issued, most with the objective of correcting the unwanted color absorptions of the process inks, in particular, magenta and cyan. For a variety of reasons, these processes did not become popular until developmental and educational efforts by Alexander Murray of Eastman Kodak and Frank Preucil of the Lithographic Technical Foundation made masking very common in the United States. These techniques resulted in greatly reduced time and costs, as compared to the laborious hand retouching methods.

The original pigments used in printing inks were mainly inorganic pigments that had a restricted gamut, and, in some cases, poor transparency. The development of organic pigments increased the available color gamut while still

retaining reasonable permanence. The major developments were as follows:

- The azo colors for ink manufacture developed between 1899 and 1912. Most yellow pigments are of this class.
- The discovery of the tungstated and molybdated pigments in about 1914. Our best process magentas fall into this class.
- The discovery in 1928 of phthalocyanine pigments, which made possible the first really permanent brilliant cyan suitable for process-color printing.

A more recent advance in color reproduction was the development of the electronic color scanner. The first machines were developed in the late 1930s by Professor Arthur C. Hardy of the Massachusetts Institute of Technology together with F. L. Wurzburg, Jr. of the Interchemical Corporation, and by Alexander Murray and Richard C. Morse of the Eastman Kodak Company. The rotating drum principle Kodak scanner was further developed into the first commercial scanner — the Time-Springdale scanner of 1950.

A reproduction (left) of the first commercial scanned reproduction from the July 1949 issue of Fortune.

The Time-Springdale scanner was used to make the original color separations.

Courtesy Time Life Syndication

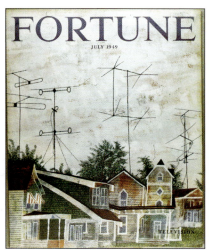

The first commercial color separations to be produced by a scanner were printed in the July 1949 issue of *Fortune* magazine. The first CCD-based flatbed scanner was introduced by Eikonix during 1982.

Unprecedented control of the color separation process was achieved when scanners were linked to large digital imaging systems. The 1979 Scitex Response 300 was the first of these systems to incorporate a color monitor, graphics workstation,

storage media, and powerful image retouching and layout software. The 1989 combination of the Apple Macintosh computer and Adobe Photoshop retouching software brought many of the large-scale imaging systems' features to desktop publishing.

Digital imaging technology also made it possible to make color separations without the restrictions of conventional halftone screens. The Agfa CristalRaster screening technology (introduced during 1993) formed a mezzotint-like, random pattern "stochastic" screen that produced moiré-free color reproductions. The absence of moiré problems made it practical to make reproductions with six, seven, or even more colors.

Other developments that led to greater use of process-color printing included the four-color press. The first recorded use of a four-color lithographic sheetfed press was by the Traung Label and Lithograph Company of San Francisco, California, during early 1932. This offset press was made by the Harris-Seybold-Potter Company of Cleveland, Ohio. Four-color web offset presses preceded sheetfed presses. In 1926 the Melbourne, Australia daily newspaper *The Argus* installed the German-built Vomag web offset machine that had four perfecting printing units. This press was used to print weekly color supplements and magazines. The Berlin, Germany, company of Messrs. Dr. Selle and Company was reported to have been printing four-color work by web offset in 1926.

The Cottrell Company reportedly made a four-color common-impression-cylinder rotary letterpress sheetfed machine about 1912, but the thick letterpress ink films made wet-on-wet process-color work impractical.

The first three-color intaglio prints were produced on a web machine at Siegburg in 1914. A common impression cylinder was used on this machine. Around the same time, a multiunit Goss intaglio press was installed at *The Chicago Tribune*. This machine had separate-unit type construction for each color. There are indications, however, that the first successful gravure process four-color work on a multicolor machine was not produced until the late 1920s or early 1930s, probably on a machine made by the Albert Company.

The printing industry has long been interested in the potential application of electrostatic imaging technology to color reproduction. There are two basic types of electrostatic imaging: dry toner, and the higher resolution, but more difficult to control, liquid toner systems.

Dry toner electrostatic imaging has its roots in the Xerography process that was invented by Chester F. Carlson during the late 1930s, and refined during the 1940s. The first commercial black-and-white Xerox machine was marketed during 1950. A color Xerox machine was introduced during the early 1970s.

Much of the liquid-toner electrostatic technology was developed in the 1950s by K. A. Metcalfe and R. J. Wright at the Research Laboratories of Australia, a division of the Department of Defence. A high-quality, commercial halftone color proofing process based upon this technology was marketed under the Remak name in the mid 1960s.

The first webfed electrostatic printing press was that developed by RCA in 1960 for the U.S. Army. This machine, and the 1962 Harris-Intertype Corporation version that followed, was designed to print maps in up to five colors.

In general, the early electrostatic imaging systems had difficulty in reproducing continuous-tone color images. During the 1980s, however, color copiers were introduced from a number of manufacturers that could produce acceptable color reproductions of pictorial images.

In 1993, commercial "direct digital" electrostatic processes were introduced. The presses could produce a color image directly from digital data without the need for the traditional intermediate films or plates. Indigo N.V. marketed a sheetfed press that used liquid ink technology, and Xeikon N.V. introduced its DCP-1 webfed press that used a dry toner imaging system.

Concluding Analysis

Maxwell's 1855 paper on primary colors still forms the theoretical basis for today's color reproduction methods. In fact, of the practical systems that were based upon Maxwell's theory, the photomechanical color reproduction process remained virtually unchanged from the late 19th century to the 1950s.

Electronic color scanning and digital image processing marked a turning point in the evolution of color reproduction processes. The unprecedented control of the color separation process that such technologies offered led to more consistent color quality at lower cost.

The use of color monitors brought an even greater degree of predictability to color reproduction. It was now possible to preview the image and to make adjustments, if needed, prior to generating the output image. Monitor images are not an

exact match to hard copy output, but the guidance afforded by these images is such that color reproductions are now more consistently closer to the limits of color quality excellence than ever before. A further improvement in quality requires the use of new materials and methods.

A practical alternative to Maxwell's tri-color separation method may now be at hand. The introduction of stochastic screening has freed the printing industry from reliance upon the four process colors that were dictated by the moiré considerations of conventional halftone screens. Color separations for different or extra colors may now be produced from digital image files through the use of appropriate software. A key consideration, however, is whether the extra color quality offered by six, seven, or higher color reproduction systems is sufficient to justify the extra costs.

2 Color Theory

Light and Color

A thorough treatment of color fundamentals, especially as they apply to Chapters 2, 4, 5, and 6, has been published by the Optical Society of America (OSA, 1953). This authoritative source is highly recommended to those seeking a more detailed treatment of color science essentials.

To understand the process of color reproduction, it is first necessary to gain an appreciation of the phenomenon of color. To do this, it is necessary to examine the nature of light, without which color would not exist.

Light is radiant energy that is visible to the normal human eye. For the purposes of this discussion it can be assumed that light travels in wave motion, with the color of light varying according to the length of the wave. The wavelengths can be measured and classified with other forms of energy on the electromagnetic or energy spectrum.

The scale ranges from the extremely short waves of gamma rays emitted by certain radioactive materials to the radio waves, the longest of which can be miles in length. Light, the visible spectrum, ranges from about 400 to 700 nm (billionths of a meter) in length. Below 400 nm are the ultraviolet rays, which are important when dealing with fluorescent materials. Some materials absorb ultraviolet radiation, which is invisi-

The visible spectrum.

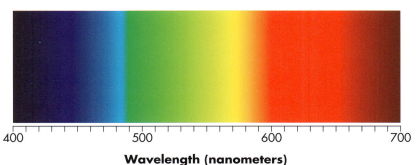

Wavelength (nanometers)

The electromagnetic spectrum.

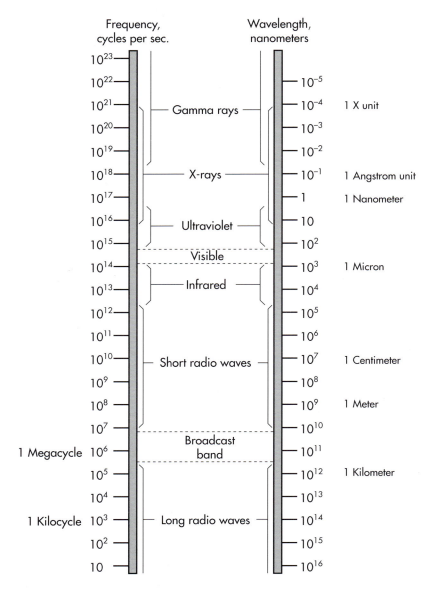

Frequency, cycles per sec.		Wavelength, nanometers	
10^{23}			
10^{22}		10^{-5}	
10^{21}	Gamma rays	10^{-4}	1 X unit
10^{20}		10^{-3}	
10^{19}		10^{-2}	
10^{18}	X-rays	10^{-1}	1 Angstrom unit
10^{17}		1	1 Nanometer
10^{16}	Ultraviolet	10	
10^{15}		10^{2}	
	Visible		
10^{14}		10^{3}	1 Micron
10^{13}	Infrared	10^{4}	
10^{12}		10^{5}	
10^{11}		10^{6}	
10^{10}	Short radio waves	10^{7}	1 Centimeter
10^{9}		10^{8}	
10^{8}		10^{9}	1 Meter
10^{7}		10^{10}	
1 Megacycle 10^{6}	Broadcast band	10^{11}	
10^{5}		10^{12}	1 Kilometer
10^{4}		10^{13}	
1 Kilocycle 10^{3}	Long radio waves	10^{14}	
10^{2}		10^{15}	
10		10^{16}	

ble, and emit radiation that is part of the visible spectrum. Above 700 nm are the infrared rays, which have significance in certain kinds of photography.

The visible spectrum occurs in nature as a rainbow. It can be duplicated in a laboratory or classroom by passing a narrow beam of white light through a glass prism. The spectrum appears to be divided into three broad bands of color—blue, green, and red—but in fact is made up of a large number of colors with infinitesimal variations between 400 and 700 nm.

Refraction of a beam of white light by a prism, forming a spectrum.

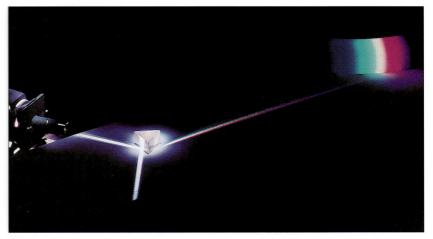

The colors in the spectrum are physically the purest colors possible. The splitting of white light into the visible spectrum, and the recombining of the spectrum to form white light, was first demonstrated and reported by the English scientist Sir Isaac Newton in 1704.

The reason that a spectrum can be formed by passing white light through a prism has to do with the refraction of light as it passes from one medium (air) to another (glass). The prism bends light of the shorter wavelengths more than light of the longer wavelengths, thus spreading the light out into the visible spectrum, as shown. Drops of rain act in a manner similar to that of a prism; when a narrow beam of sunlight breaks through the clouds to form a rainbow, the beams are refracted by moisture in the air.

If wavelengths between 400 and 700 nm are combined in nearly equal proportions, we experience the sensation of **white** light; however, the human eye is somewhat flexible on this point. We often accept the light from a tungsten lamp as white, while at other times, we accept the light from a cloudless blue sky as white. Clearly, the human eye is quite adaptable to different illuminants. For the purposes of graphic arts color reproduction, compromise white light has been defined, a specification needed to help minimize color perception and communication problems.

Additive Color Reproduction

When wavelengths of light are combined in unequal proportions, we perceive new colors. This is the foundation of the **additive-color reproduction process.** The primary colors of the process are red, green, and blue light. Secondary col-

*A double rainbow,
Phillip Island, Victoria.*

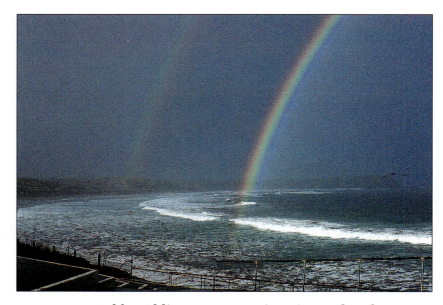

ors are created by adding any two primaries: red and green
combine to produce yellow; red and blue combine to produce
magenta; and blue and green combine to produce cyan. The
presence of all three colors will produce white, and the
absence of all three will result in black. Varying the intensity
of any or all of the three primaries will produce a continuous
shading of color between the limits. This is the principle of
color television, which can be readily observed by examining
the red, green, and blue mosaic on the screen with a magni-
fying glass.

A potential drawback of the practical additive-color repro-
duction systems is that they need high-intensity illumination
in order to produce whites and colors of acceptable lightness.
Television systems or computer color monitors do not have
the problem of low lightness values, because self-luminous
sources make up each element of the picture. The overall
luminosity of these elements may be adjusted by the controls
for contrast and/or brightness. Television, furthermore, is
usually viewed in a dimly lit room, therefore creating the
illusion of greater luminosity in light tones because of the
subsequent increase in apparent contrast.

Transparency photographs made by the additive process,
however, appear to be low contrast because: the red, green,
and blue filter mosaic absorbs two thirds of the light in the
whitest areas; there is a relatively low maximum density;
and there are practical restrictions on the intensity of the

Additive color combinations.

Red + Green = Yellow
R + G = RG

Red + Blue = Magenta
R + B = RB

Green + Blue = Cyan
G + B = GB

Red + Green + Blue = White
R + G + B = RGB

The principles of additive color reproduction.

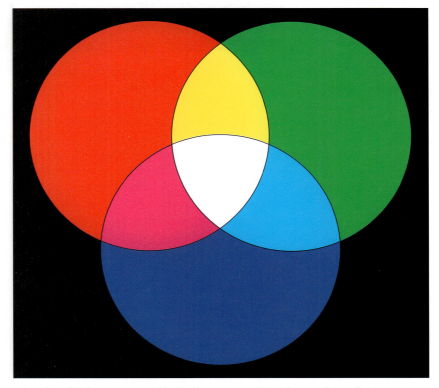

viewing light source. Satisfactory reflection color photographs and color printing cannot be produced by the additive process. Red, green, and blue rotating reflection disks are often used to illustrate the principles of additive-color reproduction, but it is necessary to illuminate the disk with an extremely intense light to achieve good results.

The red-, green-, and blue-filter mosaic of a color television screen.

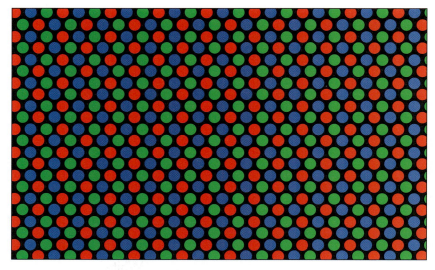

Subtractive Color Reproduction

The limitations of the additive process for reflective light viewing can be overcome with the **subtractive process.** The subtractive system starts with white (white paper illuminated by white light, for example) and subtracts red, green, and blue to achieve black. The additive system, by contrast, starts with darkness (a blank TV screen, for example) and adds red, green, and blue to achieve white.

The subtraction of red, green, and blue is achieved by using colorants that are their opposites. For red, this is a color made up of blue and green (i.e., minus red), called cyan. For green, this is a color made up of red and blue (i.e., minus green), called magenta. For blue, this is a color made up of green and red (i.e., minus blue), called yellow.

Colors are achieved by subtracting light away from the white paper (which reflects red, green, and blue). A combination of yellow (minus blue) and cyan (minus red) will, for example, result in green. The table on the facing page shows the possible combinations.

The secondary colors of red, green, and blue, and the tertiary black color, which are all created from overlaps of yellow, magenta, and cyan, also function as subtractive colors. A blue area, for example, subtracts red and green from white to leave blue.

The subtractive primaries of yellow, magenta, and cyan were chosen for reason of efficiency but, in theory, any number of colors may be used in a subtractive color reproduction system. In fact, the same reasoning applies to additive systems, but in practice the purity of the three additive pri-

Subtractive color combinations.

White + Yellow + Cyan = Green
RGB − B − R = G

White + Magenta + Cyan = Blue
RGB − G − R = B

White + Magenta + Yellow = Red
RGB − G − B = R

White + Yellow = Yellow
RGB − B = RG

White + Magenta = Magenta
RGB − G = RB

White + Cyan = Cyan
RGB − R = GB

White + Yellow + Magenta + Cyan = Black
RGB − B − G − R = 0

The principles of subtractive color reproduction.

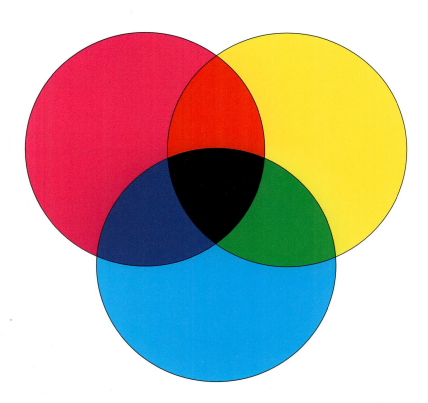

maries is such that there is little need to deviate from a red, green, and blue light system. Extra colors are sometimes used in color printing to partially compensate for the color gamut deficiencies of the primary subtractive colors.

Any color in between the limit (or gamut) colors may be obtained by varying the proportion of any or all of the colorants. The subtractive color principle is used for most modern color photography and all color printing processes. The illustration on the previous page depicts this technique.

The Color Fusion Process

Color fusion occurs when a combination of viewing distance and image color element size are such that the human eye perceives a single color instead of resolving the separate color elements which form the color. In the case of ink or pigment mixtures, the individual pigment particles are so small that they cannot be resolved by the human eye at any distance. In the case of a coarse-screen billboard poster, however, the observer may have to stand at a considerable distance before the fractional halftone areas cannot be resolved and the image appears to have a continuous-tone nature.

Both color television and printing make use of a regular pattern of image elements to create the range of colors in a reproduction. For color television, this consists of uniform-size elements of red, green, and blue that vary in intensity. At a proper viewing distance the eye does not resolve the individual elements and fuses the red, green, and blue areas to form a composite color.

In color printing, the process is somewhat more complex. For most color printing, the area covered by the yellow, magenta, and cyan ink varies, but the thickness of ink remains constant (gravure is the exception). Unlike television, these colors overlap each other, producing secondary colors of red, green, and blue. Where all three primaries overlap we have black, and where no ink is present we have the white paper. There are, therefore, as many as eight separate image elements — white, yellow, magenta, cyan, red, green, blue, and black. At a proper viewing distance the eye does not resolve the individual elements but instead fuses them to form a composite color sensation.

Distinctions between additive color, subtractive color, or color pigment mixtures are irrelevant from a color perception point of view. If surface reflections are controlled or neutralized, it is impossible to detect the method used to create the color once color fusion has occurred.

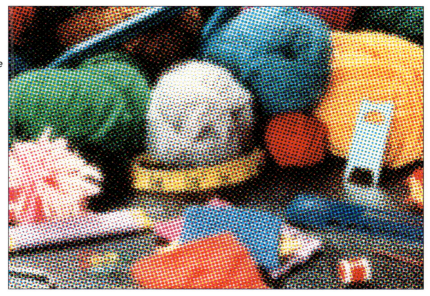

An enlarged section of a photomechanical color reproduction.

Color fusion of the halftone dot elements may be observed by gradually increasing the viewing distance.

How Color Printing, Photography, and Television Work

The objective in printing is to produce yellow, magenta, and cyan images that are negative records of the amount of blue, green, and red in the original. This is achieved by initially photographing the original, in turn, through blue, green and red filters. The subsequent image records or signals are adjusted as required prior to generating a halftone film image that is suitable for the chosen printing process. The films are then used to make the image carriers, which may be plates, cylinders, or stencils. Each plate is inked with its appropriate ink, which is transferred, in turn, to a white substrate. The more direct printing systems may eliminate the films, or even the plates, from the production process.

There are practical considerations that limit the thicknesses of yellow, magenta, and cyan inks that may be printed by most processes; consequently, a black printer is normally employed to compensate for the resulting loss of image contrast. The black printer is made by photographing the original sequentially through red, green, and blue filters, and then following procedures similar to the other colors. The illustration on the facing page shows the complete process in schematic form.

In conventional photography, color reproduction is achieved by using three emulsions coated onto a common base. Each emulsion is sensitive to a different color, and in processing, each is dyed a corresponding color. The top layer

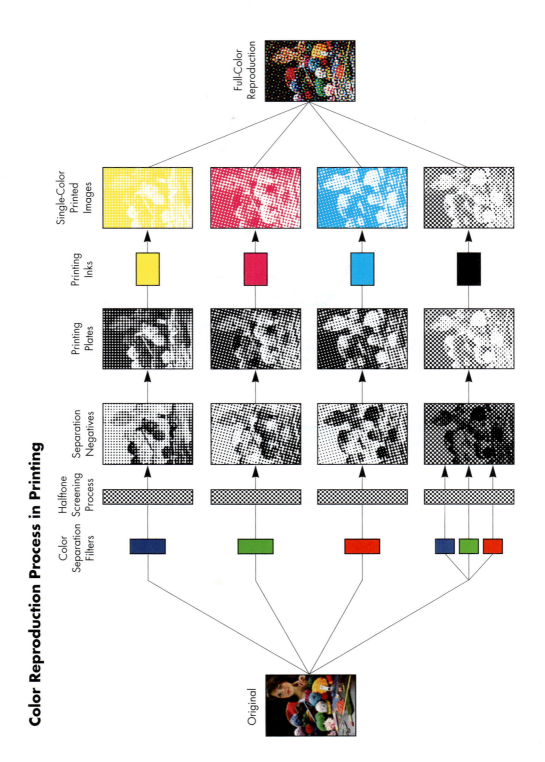

Color Reproduction Process in Printing

Full-Color Reproduction

Single-Color Printed Images

Printing Inks

Printing Plates

Separation Negatives

Halftone Screening Process

Color Separation Filters

Original

The principles of color reproduction in printing.

The processing of reversal color film.

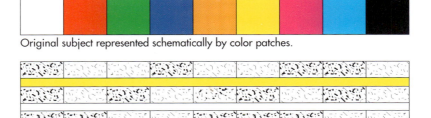

Original subject represented schematically by color patches.

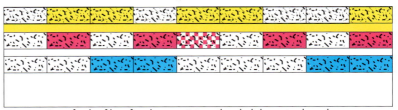

Cross section of color film after the silver halide grains exposed in the camera have been developed to produce negative silver images.

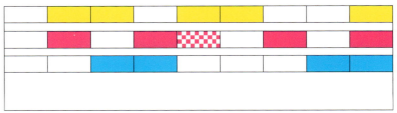

Cross section of color film after the remaining silver halide grains have been exposed to light and developed to produce positive silver and dye images.

Cross section of color film after both negative and positive silver images have been removed leaving only the positive dye images.

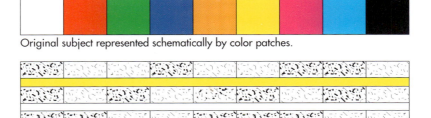

Dye images as they appear when the film is viewed by transmitted light.

is sensitive to blue light and is dyed yellow, the next layer is sensitive to green light and is dyed magenta, and the bottom layer is sensitive to red light and is dyed cyan. Actually, the second and third layers are also sensitive to blue light, but a yellow filter (which is removed during processing) between the first and second layers stops any blue light from affecting the middle and bottom layers. The foregoing description applies to negative and reversal processes for both reflective and transparent photographs.

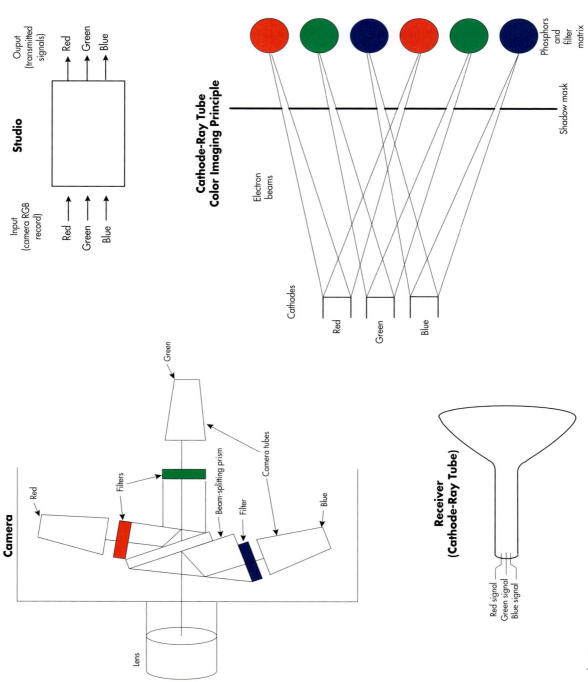

Color television operation.

Some of the electronic color photography processes for producing reflection prints are parallel to those used in the printing industry. The dye sublimation process, in particular, works by transferring images from thermally-activated colorant carriers, in sequence, onto a common base. The major differences are that the process is much slower than printing, the image is not screened, and dyes replace the inks.

Color television uses a special camera to record an image by scanning a scene very rapidly line by line. The light beam that passes through the lens of the camera is initially split into three by the use of prisms or dichroic mirrors, and then passes through red, green, or blue filters. The subsequent light beams are converted into electrical signals by photoconductive materials in the camera tubes. These signals are processed at the studio and then transmitted to the television receivers. The cathode ray tubes of the receivers each contain three cathodes, which emit a stream of electrons corresponding to the red, green, and blue signals that make up the image. The electrons strike the red, green, or blue phosphors on the inside face of the tube, causing them to glow; and, therefore, form an image. Each electron stream is aligned to strike only its respective phosphors.

Concluding Analysis

The methods of projecting three positive images in register through red, green, and blue filters (developed by Maxwell and others) are the only pure forms of additive color reproduction. Conventional color photography, with its layers of continuous-tone yellow, magenta, and cyan dye images, is a pure form of subtractive color reproduction. In the first case, a color is formed by the addition of infinitely variable red, green, and blue light intensities, and in the second case, by the subtraction of red, green, and blue light from white light via infinitely variable intensities of yellow, magenta, and cyan dye layers.

Color television and color printing are, respectively, additive and subtractive methods of color reproduction; however, both also rely upon the process of color fusion for successful results. The red, green, and blue television screen or color monitor elements, and the white, yellow, magenta, cyan, red, green, blue, and black fractional areas within a printed image must be viewed at a distance great enough that the eye cannot resolve the individual color elements, therefore

producing a continuous color sensation. The optimal viewing distance for color fusion to occur will depend upon the size of the individual color elements (i.e., halftone screen ruling in printing, or viewing screen dimensions in television) and the observer's visual acuity.

3 Color Systems

The Evolution of Systematic Color Reproduction

The first forty or fifty years of photomechanical color reproduction practice relied upon the skills of color craftsmen who chemically modified film or plate images until an approved result was achieved. The dominant production methods included the use of glass-based photographic emulsions and etched-copper photoengravings. Letterpress was the primary process-color printing method of that era.

The next thirty or so years, through to the 1960s, saw the systematic introductions of stable-based film emulsions, new color masking techniques, gray balance and other forms of feedback information charts, color separation scanners, and the rise and eventual dominance of the lithographic printing process. The educational and research efforts of (in particular) the Eastman Kodak Company and the Lithographic Technical Foundation (later GATF) were particularly important during this phase of development. The advances made in this period emphasized the application of measurement techniques, densitometry, color correction theory, color control on press, consistent photographic processing and the general skills of analysis and control. The primary color-systems focus of this era was upon the quantification of the link between the ink-paper-press subsystem and the color separation and plate subsystem. Significant manual retouching of selected image areas was still required in order to incorporate the reproduction requirements of particular originals into the color separations.

The 1967 publication of *Principles of Color Reproduction* by J. A. C. Yule was a key event in the evolution of photomechanical color reproduction theory and practice. This text presented a compilation of scientific studies covering the color-related aspects of ink and paper, together with those addressing color printing, color separation, color scanner

technology and graphic arts aspects of color measurement. Yule also included a number of end-of-chapter problems for refining the reader's color reproduction problem-solving skills. This consolidation of photomechanical color reproduction knowledge established, in retrospect, a solid foundation upon which to build understanding of optimum color reproduction and the color quality approval process. John Yule's book is still a standard reference in the field of photomechanical color reproduction.

The landmark 1971 Williamsburg conference of the Inter-Society Color Council explored "The Optimum Reproduction of Color" (Pearson, 1971). The theoretical relationships between the original scene or photograph and the subsequent reproduction were addressed from a color science point of view at this conference. The Graphic Arts Technical Foundation followed with a series of four Color Conferences (Field, 1973) during the period 1971–1972. These conferences examined the production aspects of photomechanical color reproduction and, importantly, included significant presentations on the creative aspects of color printing and the production aspects of the origination process. The concept of a systems engineering approach to color reproduction was developed during this time and presented to audiences who attended an extensive series of GATF color reproduction programs.

The systems approach to color reproduction concept was a new way of viewing the process that not only included the traditional feedback relationships between press and prepress, but also incorporated the optimum and creative requirements in the "set point" element of the control or systems engineering diagram. An expanded version of this concept (Field, 1974) emphasized the importance of modifying the color separations to reflect the requirements of the original.

An evaluation of the systems approach to color reproduction has been previously reported (Field, 1984) in a TAGA paper. This study concluded that color monitors were the most efficient method for establishing the optimum color reproduction aspects of set point calibration. Modern color separation systems now incorporate calibrated color monitors to help refine the initial mathematical transformation from original to reproduction. These technologies are covered more fully in the color management section of this chapter, and in Chapter 12.

Systems Engineering Principles and Applications

In order for a color reproduction to be successful, there must be control and balance between all stages in the cycle from the original scene to the final reproduction. This is probably most true in the printing processes because of the large number of imaging stages and the great variation possible with both different input originals and the variety of printing processes and materials that may be chosen.

In order to exercise control over a printed color reproduction, it is necessary to think of it as a system. A system can be defined as a group of interrelated elements forming a collective entity. A **control system** is an arrangement of elements connected or related in such a manner as to command, direct, or regulate itself or another system. A **closed-loop control system** is one in which the control action is somehow dependent upon the output. Finally, **feedback** is the property of a closed-loop system that permits the output to be compared with the input so that the appropriate control action may be initiated.

In such a control system, there is a process that is subject to a disturbing influence and to a restoring influence of a manipulated variable. The process sends information to the controller about its condition. The controller compares the signal of process condition against a desired standard or set point and makes proper adjustment to the manipulated variable in order to restore the process to its desired condition.

A control system.

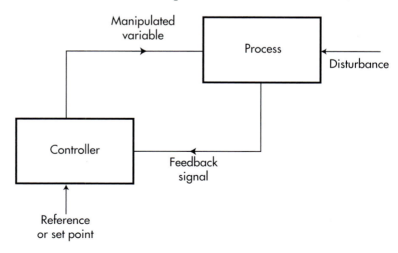

The general operation of a control system can be illustrated by reference to a heating and air conditioning system. The optimal temperature is represented by the set

point. The optimum may vary from person to person and also by time of day (temperatures may be set lower at night). As the temperature of the room (the process) rises or falls because of disturbing influences (e.g., people crowding into the room or a window left open), the thermostat (feedback signal) reports this change from the stable state to the master control system. The controller actuates the heating or cooling mechanism and pumps warmer or cooler air (the manipulated variable) into the room in an attempt to restore the previous conditions.

Color reproduction control system.

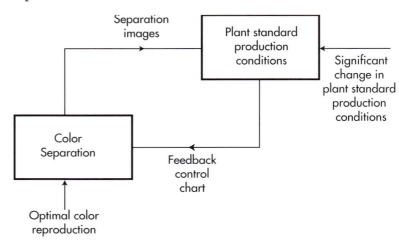

The illustration shows the interrelationship of elements necessary to achieve controlled results in a photomechanical color reproduction system. The process in this system is the combination of the paper, ink, plate (or, more generally, the image carrier), press, printing procedures, type of color original, and color scanner electro-optical response. A general objective is to keep this process constant, and, indeed, this is theoretically possible when a printer is engaged in printing the same kind of product week after week.

In practice, however, changes or disturbances occur in the process. These could be a change from a coated paper to an uncoated paper, a change in color sequence, a change from a sheetfed press to a webfed press, a change from a rotary drum to a flatbed scanner or many other similar shifts. Even if these changes do not happen for any given color reproduction system, it is common for a particular plant to produce a variety of color printing using different materials and processes, hence necessitating the establishment of several color reproduction systems. Of course, the presence of a new

system only occurs if the disturbance to the process has been significant. Changing from one brand of coated paper to another probably would not be significant.

The effect of a disturbance on the process is indicated by the feedback mechanism. The feedback for press-related disturbances is a printed sheet, which is more useful if it is in the form of a color chart that displays the gamut of the system. The feedback signal that characterizes a color scanner's response to a particular make and type of color original is generated from a standard test image.

Feedback control is interpreted by the controller and used as a guide to manipulate a variable that, when fed into the process, compensates for the effect of the disturbance. The manipulated variable will also incorporate the changes required for the set point refinements. The set point will shift according to concepts of optimality.

The production of the color reproduction system's manipulated variable (color separation images) may, for example, commence with a scanner or system operator first assessing a printed color chart and then comparing it against the previous standard printing in order to detect any significant deviation in appearance. If the color chart appears darker than the previous standard, the scanner or system operator will then manipulate the various controls to produce a set of color separation images that compensate for the darkening effect of the disturbance on the process.

Standard printing, as used in this discussion, means printing and scanning conditions for which the color reproduction system has been previously adjusted. If these conditions remain constant, no adjustments to the color separation controls are needed. Of course, there are some changes in the process for which it is not possible to compensate fully in the color separation stage. If, for example, a change is made to an ink set with a much reduced gamut, an adjustment to the separation films can in no way restore that gamut.

The optimum color reproduction (set point) requirements of a particular original include the sub-objectives of compromise color reproduction, corrective color reproduction, and preferred color reproduction (see Chapter 11). These objectives, together with the creative adjustments that are sometimes incorporated into the color separations during the reproduction process, are usually evaluated through the use of a color monitor display and then also built into the color separations along with the corrections for process disturbances.

Color Management Systems

The systems engineering approach to color reproduction established a conceptual foundation for the color management systems introduced some 20 years later during the early 1990s. The modern color management systems (CMSs) were developed in response to the rapid growth in the number of desktop scanners, color monitors, and output devices. The proliferation of color input and output devices with different color response, display, or recording characteristics resulted in unpredictable reproduction quality. The color management systems are a software-driven approach that seeks to "manage" the input and output color values in such a way that reproduction quality becomes predictable.

The early closed-loop high-end color scanners and imaging systems used a proprietary approach to managing the color transformation process. Analog scanners were equipped with a vast array of potentiometer controls for making adjustments to compensate for both image capture distortions and printing characteristics. Operators used as many as 70 or 80 knobs to correct for such conditions as unwanted absorptions of the yellow, magenta, and cyan printed ink films; press dot gain; gray balance; black printer characteristics; and the representation of the original colors by the scanner's electro-optical system. Early scanners were not fitted with color monitors; therefore, operators also used the set-up controls to build in the tone scale enhancement and gamut compression desires of the customer. These latter adjustments, in particular, required expert judgment and the use of such tools as printed color charts, tone reproduction curves, and calibrated input scanning targets.

Today's color management systems require a standard calibration image for capturing the input device's color recording characteristics; a standard calibration image for representing the output recording device's color gamut; and a means of translating the color characteristics between multiple inputs and multiple outputs via what is known as "device-independent color space." Standard input and output targets, and the CIE XYZ and CIELAB color spaces (see Chapter 6) have now been adopted by the International Color Consortium (ICC) as the basis for a semi-consistent approach to color management. The ICC was formed in 1993 by major vendors in the imaging and computer technology fields.

The ISO IT8.7/1 (transparency) and IT8.7/2 (reflection print) targets are the images designed for characterizing the input devices (see Chapter 12). The standard images exist in

a number of forms because most manufacturers of photographic materials produce one or more versions of the target in order to fully represent their specific product range. The test image is scanned (or photographed by an electronic camera) and the resulting red, green, and blue signals for each element within the image are compared to a standard set of stored values in CIE color space. An input or "source profile," in the form of a multidimensional table representing the transformation of input response to standard color space, is generated from the test scan.

The ISO IT8.7/3 image is designed for characterizing output devices (see Chapter 9). The color separations of this image are printed via the output devices a company uses in normal production (e.g., direct and indirect proofing systems, and ink on paper output corresponding to the plant's normal combination of materials and processes). The target areas of the printed test image are each measured with a colorimeter or spectrocolorimeter linked to a color management system. An output or "destination profile" of the halftone dot values required to achieve a given set of CIE measures of color for a specific output recording system is created from the measurements.

In order to establish a destination profile for a cyan, magenta, yellow, and black printing process, the maximum percent black coverage, the maximum total percentage ink coverage, and the tone scale of the black printer (e.g., "light") must be chosen in advance when using most color management systems based upon the ICC specification. These choices are made in advance so that a unique solution may be obtained when transferring from the three-variable (R,G,B) input source to the four-variable (C,M,Y,K) output destination.

The color monitor characterization process uses a colorimeter placed directly on the screen to evaluate the monitor colors generated via characterization software (see Chapter 12). The colorimetric measurements are then evaluated by comparing them with color management system reference values. A monitor profile is subsequently created to compensate for the differences between the measured values and the CIE reference values.

Once color profiles have been generated for the relevant input devices, output devices, and color monitors, a conversion process is used to translate colorimetric data from one device to another. The objective of this process is to ensure

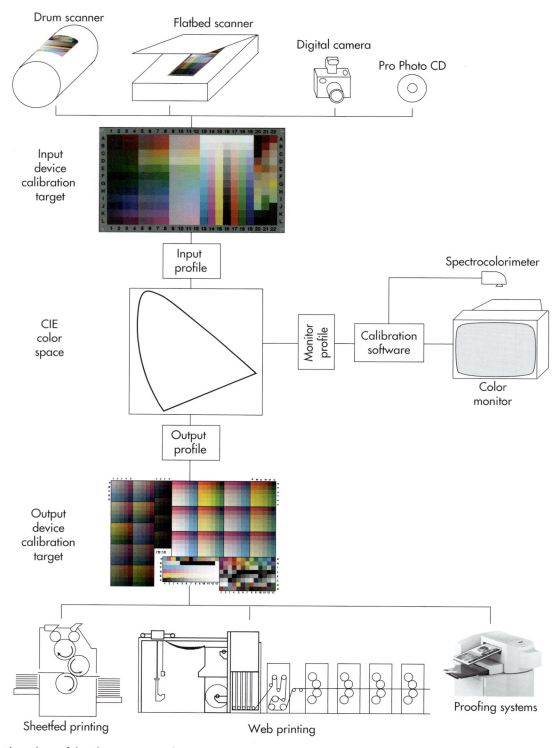

Drum scanner

Flatbed scanner

Digital camera

Pro Photo CD

Input device calibration target

Input profile

CIE color space

Spectrocolorimeter

Monitor profile

Calibration software

Color monitor

Output profile

Output device calibration target

Sheetfed printing

Web printing

Proofing systems

Flow chart of the elements in a color management system.

that the appearance of a given input color will appear the same on both the monitor and the color output device. In practice, a process called "profile concatenation" is used to transform data from a source to a destination color space. It is possible to make direct transformations from source to destination, but the use of an intermediate CIE color space "translating" step usually produces a better perceptual transformation. The success of these approaches is, however, limited because of certain practical considerations that are discussed in the following paragraphs.

The gamuts of the input original, the color monitor and the output recording (printing) process are not identical. Typically, the output device's gamut is smaller than those of both the monitor and the original. The output gamut defines the color space of the printed image; therefore, the color space of the monitor and the input original must be transformed to fit that of the printing process. The transformation of one device's gamut to fit that of another is called gamut mapping.

There are several approaches to gamut mapping (Kang, pp. 22–28, 1997). Out-of-gamut areas may be "clipped" or ignored in favor of reproducing the in-gamut colors as closely as possible. This approach is known as colorimetric color rendering and is chosen when reproducing critical original colors (e.g., fabric colors to be reproduced in a catalog). In fact, there are two types of colorimetric rendering in the ICC approach to color management: relative colorimetric and absolute colorimetric. Relative colorimetric represents color values relative to the substrate of the reproduction media, whereas absolute colorimetric represents color values in absolute CIE terms. Out-of-gamut areas may be compressed through the use of linear or non-linear algorithms for both the saturation and lightness dimensions. This approach is known as perceptual rendering and is chosen for most photographic images in order to retain saturation and tonal appearance distinctions. A saturation rendering option is also available for business graphics applications. The commonly used rendering intents for pictorial reproduction are perceptual and relative colorimetric.

A key limitation of algorithm-driven approaches to gamut mapping is that they are incapable of recognizing user- or application-defined areas of importance within the original. In practice, it is the user-defined "interest area" that determines the optimal tonal and saturation compression strategy for the reproduction. The interest area is not always a func-

tion of tonal distribution within the original (e.g., highlights within a high-key photograph), but is often a specific tonal area (e.g., face, hair, or jewelry areas of a portrait photograph) chosen for emphasis by the art director or print buyer. An algorithm-driven approach to gamut mapping may succeed in many cases, but it will invariably fail in others.

The usefulness of color management systems may be further constrained by incorrect calibration. The output device, in particular, is difficult to accurately characterize because of the random fluctuations that occur from sheet to sheet when printing by the lithographic process. A careful analysis of press variation should be made prior to selecting standard test sheets for systems programming purposes (Chapter 9).

Color monitor appearance will be strongly influenced by ambient lighting conditions; therefore, consideration should be given to establishing fixed room light conditions in order to lessen the chance that operators will make brightness or gamma alterations to the monitor setup. Color monitor phosphors can change over time, as can the input scanner's color filters and photoreceptor devices. Regular recalibration procedures should be implemented to monitor and correct drifts in calibration.

The particular make and type of input calibration target will influence the accuracy of the calibration. The calibration emulsion should be the same as that used for the supplied originals in order to ensure that the color separation input signals are valid.

A CIELAB-based system will not ensure appearance matching, especially as it concerns monitor displays and original color transparencies when they are compared with a printed image. Sophisticated color appearance models (Chapter 6) may improve the accuracy of the match, but for the highest quality work even they may fail. The color proof (or printing) approval process is not simply a technical problem: deviations in color vision (Chapter 4) of the evaluator from that of the CIE standard observer, the desire to incorporate creative refinements (Chapter 11) during the reproduction process, and the behavioral distortions of the approval process (Chapter 14), will all influence the color refinement process.

As a practical matter, color management systems may produce satisfactory results for newspaper editorial, on-demand short-run printing, real estate brochures and similar types of product. There is, however, considerable variation (Adams and Weisberg, 1998) between different types of color manage-

ment systems, and companies may have to evaluate the different philosophical approaches (Giorgianni and Madden, 1998, pp. 315–326) and performance before selecting the system best suited to the plant's needs. Those seeking more information on the fundamentals of color management and the related theoretical considerations are referred to Tony Johnson's book (1996) on the subject.

Concluding Analysis

Early approaches to color reproduction refinement were based on an understanding of appropriate technical and aesthetic factors but, by necessity, the implementation process required the use of lengthy manual retouching and local correction techniques. The subsequent widespread use of photographic masking methods did much to make the color reproduction process more systematic and predictable. Such approaches tended to focus upon the correction of pigment and press-related distortions and to minimize the unpredictable color adjustments required by the original. Given that many originals of that era were artist's drawings that conformed to the gamut of the reproduction process, this lack of emphasis was understandable. Once color photographs became the dominant type of original submitted for reproduction, however, tonal and saturation adjustment strategies assumed critical importance, especially when the original was a color transparency.

The development of systems engineering approaches to color reproduction, together with the introduction of improved equipment and materials, led to the eventual development of color management systems. It would be a mistake, however, to assume that a purely mathematical approach to high-quality color reproduction will be completely satisfactory for all reproductions. The inevitable corrections, compromises, and creative enhancements that require human judgment have to be evaluated on a color monitor or color proof (Field, 1997).

Color systems work from the 1960s to the present has done much to make photomechanical color reproduction a predictable process based upon measurement and analysis. The related technologies and materials have allowed system operators to realize vast improvements in productivity, which has resulted in today's widespread and unremarkable use of process-color reproduction.

4 Color Perception Fundamentals

What is Color?

Color is a complex visual sensation that is influenced by the physical properties of the illuminant and sample, but is determined largely by the physiological and psychological characteristics of the individual observer. Insights into the process of color perception may be gained through examinations of these distinct elements (illuminant, sample, human observer) and the manner in which they interact.

The Light Source

Printed matter is viewed under all forms of illumination, including tungsten light, fluorescent light, a wide range of daylight and sunlight, and mercury vapor or similar discharge lamps. The factors that determine the characteristics of illuminants include color temperature, intensity, color rendering properties, and degree of diffusion.

Color Temperature

The **color temperature** of a light source is a measure of the integrated spectral energy distribution of that source. The standard for measuring color temperature is based upon the temperature of a theoretical black body (Planckian) radiator. As the temperature is increased, the emission of the radiator changes from dull red to bluish white. The temperature reading is expressed in the Kelvin (K) scale (the same numeric values as the Absolute scale), which equals the Celsius reading plus 273°. In practice, most light sources do not duplicate the energy distribution of a black body radiator, so the term **correlated color temperature** is used to mean the color temperature that most closely resembles the light source in question.

Correlated color temperatures of natural and artificial illuminants.

Natural Illumination	Color Temperature (K)
Clear blue sky, midday	12,000–26,000
Overcast sky, midday	6700–7000
Noon sunlight plus light from a clear blue sky	6100–6500
Noon sunlight on a clear day	5400–5800
Sunlight at sunset	2000
Artificial Illumination	
Metal halide	4300–6750
Xenon	5290–6000
Fluorescent	3000–6500
Tungsten	2650–3400

Color Rendering

Color temperature alone is not sufficient to specify the spectral properties of illumination when some artificial light sources are used. Many illuminants (especially fluorescent lamps) do not have smooth or continuous energy distribution curves, but have regions of spike emission. Spike emissions can alter color appearance, an effect often noticeable when skin tones are illuminated by fluorescent light.

The term color rendering is used to describe the degree to which a test illuminant (e.g., fluorescent light) renders colors similar in appearance to their appearance under a reference illuminant (e.g., daylight) of the same color temperature. The term color quality is sometimes used to mean color rendering. The Commission Internationale de l'Éclairge (CIE) has defined a method for determining the Color Rendering Index (CRI) for any given source of illumination (Hunt, 1991). The optimal CRI (that for daylight or for such continuous sources

Spectral energy distribution curve for a typical fluorescent lamp.

Note the areas of spike or bar emission.

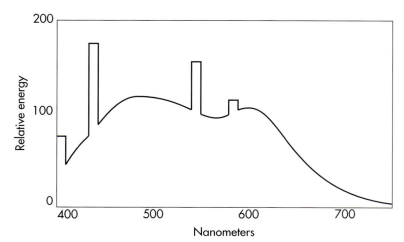

Nanometers

as tungsten lamps) is given as 100. Some common fluorescent sources may have a CRI as low as 50 or 60—a level that may cause serious color distortions. A source with a CRI of 90 or greater is generally classified as good.

Color rendering index of common artificial illuminants.

Tungsten illuminants	100
Xenon	93
Fluorescent	54–94
Metal halide	62–88

Intensity

It has been reported that the perception of color (especially reds) can change at very low levels of illumination. For normal viewing levels, however, the intensity of the illuminant can be assumed to have no significant effect on the appearance of a flat color. Where the intensity level is critical is in the viewing of such pictorial subjects as printed matter and photographs (see Chapter 5).

Diffusion and Viewing Geometry

Printed matter is often produced on textured paper or other rough surfaces. If a nondiffuse illuminant is used when viewing the printed sample, the sample's appearance will be highly dependent upon the geometry of the illumination and viewing conditions. The orientation of the sample is also important. A high-gloss sample is subject to appearance shifts with changes in the viewing geometry. In general, diffuse illumination is always preferred for viewing color reproductions.

Viewing Standards

It is clear from the above discussion that it is possible to alter the appearance of a color, and especially of a pictorial color reproduction, by varying the viewing conditions. The problems relative to achieving good color reproduction can become severe if the reproduction and the original are compared under incompatible light sources. **Metamerism**, where two colors may match under one illuminant but not under another, is an additional problem. Even when a print is being evaluated without reference to an original, it is possible that a critic will judge it satisfactory under one illuminant but unsatisfactory under another. Standard illumination for judging the quality of color reproduction is an obvious answer to these problems.

In the United States, the first color viewing standard for the graphic art industry was the American National Standards Institute (ANSI) standard ANSI PH2.32–1972.

Eleven industry associations recommended the use of the standard, including the American Association of Advertising Agencies, the Association of Publication Production Managers, the Magazine Publishers Association, and the Professional Photographers of America. The printing industry trade associations and such research institutes as GATF also endorsed the standard.

In 1979 another standard, ANSI PH2.45–1979, was issued for viewing small (35-mm and 2¼×2¼) transparencies. The standard specified that the transparencies should be enlarged from four to twelve times for viewing. Most viewers made to this standard enlarge the image six times.

A consolidation of the graphic arts viewing standards (and some from the photographic industry) was approved by ANSI in 1985 and revised in 1989. This latter standard specifies 5,000K color temperature for all evaluations, and a 90+ color rendering index for all light sources. (The real source, identified as 5,000K, is also represented by a mathematical relationship known as D50 for use in colorimetry.)

The GATF/RHEM Light Indicator makes use of the metamerism principle to determine whether or not the industry-standard 5000K viewing conditions are being used for color evaluation.

The GATF/RHEM Light Indicator (simulated), as shown under a 5000K standard light source. Stripes do not appear.

Stripes do appear when the Light Indicator (simulated) is viewed under non-standard light, such as incandescent.

Stripes will also appear when the Light Indicator (simulated) is viewed under other non-standard lighting, such as cool or warm fluorescent.

The transparency viewer's surface luminance is specified as 1,400±300 cd/m². Transparencies should be surrounded by a neutral gray border when they are placed on the viewer (see Chapter 5).

For reflection prints and photomechanical reproductions, the illuminance should be 2,200±470 lux for critical appraisal under normal viewing conditions. A provision is also made for a 800±200-lux level for routine inspection of color photographs. The light source, print, and observer should be positioned to minimize the amount of light specularly reflected toward the observer. To minimize extraneous influences, room lights, walls, ceilings, and floors are to be baffled so they contribute negligible amounts of light to the print-viewing surface and are not in the observer's field of vision. Chapter 5 has further details about viewing standards and conditions.

Proof being viewed under standard lighting conditions.

The Sample

The contribution to appearance by the object or sample is due mainly to its spectral absorption and gloss attributes.

Spectral Absorption

Spectral absorption is the measure of the light absorbed by a sample as determined on a wavelength-by-wavelength basis across the visible spectrum. White colors have very low spectral absorption and are close to being nonselective (i.e., the absorption is uniform across the spectrum). Blacks are also reasonably nonselective, but they have high absorption. A color takes on a particular hue and saturation because of the selectivity in spectral absorption; for example, a green color absorbs blue and red (and reflects or transmits green) and a magenta color absorbs green (and reflects or transmits blue and red).

The spectral absorption of a sample is measured with a **spectrophotometer.** This instrument sequentially illumi-

nates the sample with light from one particular point of the spectrum. The amount of this light reflected or transmitted by the sample is measured and compared to the amount incident to the sample. The reading is expressed as a percentage; for example, a reading at 550 nm could be 60%, meaning that the sample reflects (or transmits) 60% of the 550-nm radiation that illuminates it. Measurements are made at every wavelength of the spectrum until a complete spectrophotometric curve of the sample can be constructed.

Spectrophotometric curves displaying the reflectance (or absorption) properties of (A) a white paper, (B) a gray test card, and (C) a magenta printed ink film

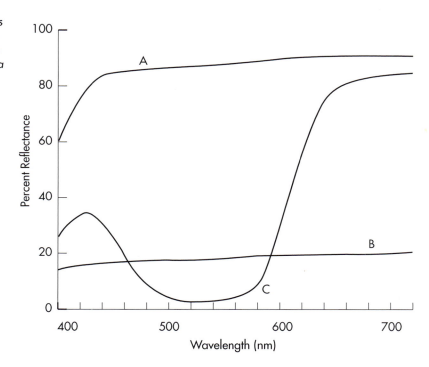

Gloss

Gloss is a property of reflection samples that influences the perceived lightness and saturation of the sample. Some light (4%) incident to a sample is always reflected from the surface without being allowed to penetrate the sample. This scattered, reflected light (in this example) is of the same spectral quality as the illuminating light source. If the sample has a very high gloss, the surface reflection will be highly directional at the same angle as that of the light incident to the sample.

Reflection of incident light as determined by surface smoothness.

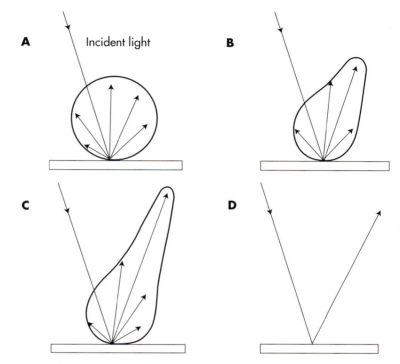

A. Reflection will be equal in all directions if the surface is perfectly diffusing.

B & C. Increasingly smooth surfaces cause the reflection to be increasingly more directional.

D. A perfectly smooth surface causes all incident light to be reflected at an angle equal to the angle of incidence.

If a sample has a very high gloss (and the viewing geometry is correct), the surface reflection will not reach the eye, and thus not influence the perceived color of the sample.

In cases where the surface of a sample has a low gloss, it is called a **matte** finish. Such finishes are characterized by multidirectional surface reflections. The angle of reflection of the light scattered at the surface of the sample bears virtually no relationship to the angle of illumination. In this case, the light scattered at the surface reaches the eye of the observer. The scattered light (of the same spectral characteristics as the illuminating source) is mixed with the light that passes into the sample and is selectively reflected. This results in, among other things, lower densities of printed ink films.

Metamerism

If two samples have exactly the same spectrophotometric curves (i.e., absorption characteristics) and the same surface characteristics, then all observers will perceive that these

samples match under all illuminants. If two samples have different spectrophotometric curves such that they match under one illuminant but not under others, or that they are perceived as matching by one observer but not another, they are said to be metameric. The phenomenon is known as metamerism (Hunt, 1991, pp. 124–134).

All photomechanical color reproductions are metameric matches. The reproduction is composed of cyan, magenta, yellow, and black halftone values; as opposed to the original, which may contain various dyes and pigments in the form of artists' paints, merchandise samples, or one of many kinds of photographic emulsions. The presence of metamerism in the color reproduction process partially explains why two or more people may not agree about the accuracy of a given match between original and reproduction. Viewing standards will help reduce illuminant-related metamerism, but little can be done to circumvent observer-related metamerism. Increased levels of GCR (gray component replacement, see Chapter 8) when producing color separations will, however, help to reduce metamerism. GCR substitutes black ink for balanced combinations (the "gray component") of yellow, magenta, and cyan inks throughout the reproduction.

Ink mixtures of the type designed to produce a match with a supplied color swatch, or an example of a previously printed job (e.g., a label with a special solid background color), may also be metameric. Always refer to the recorded mixture when remixing colors for reprint orders. Computer color matching systems are helpful in determining the component inks required to match a supplied color sample of unknown colorant composition. The color match computer programs typically offer a "minimum metamerism" match option.

Metamerism may also occur with changes in the field of view. A match under CIE 2° standard observer (see Chapter 6) may not hold for the CIE 10° standard observer. As a practical matter, this problem is most likely to arise when matches are established by colorimetric evaluations that are inadvertently based upon the wrong (i.e., different from that previously used) field of view.

A metamerism-like effect may occur when two samples with different surface characteristics match under one set of illuminating and viewing geometry conditions, but not under another. The gloss of both samples must be identical in order to eliminate this problem. Strict compliance with the graphic

arts viewing standard will theoretically render the problem nonexistent; however, the actual viewing conditions encountered in supermarkets, offices and homes will often differ markedly from those of the standard.

Fluorescence

Fluorescence occurs when a sample absorbs a band of short-wavelength radiation (usually ultraviolet) and re-emits it as a band of visible, longer-wavelength radiation. The magnitude of the re-emission depends upon the concentration of the dye or pigment in the sample, and upon the intensity of the illuminating light at the wavelengths of absorption.

Unwanted fluorescence can cause color matching problems, especially when fluorescing materials are present in color originals intended for reproduction. Unwanted fluorescence may be minimized by placing ultraviolet absorbers in front of the illuminant. In some cases, however, fluorescence is initiated by short wavelength radiation from the visible portion of the spectrum and is very difficult to eliminate. Further information on fluorescence is provided in Chapters 6 and 7.

The Observer

The aspect of color perception that is most difficult to define and measure is the eye-brain combination of the human observer. Some of these human factors are physiological in nature, and over the years of research some plausible color vision theories have been developed. Other human factors are aesthetic or psychological in nature, dealing with the areas of creativity and culture. Such perceptions tend to be quite personal and very difficult to quantify. The books by Ralph M. Evans (1948, 1974) are recommended to those seeking an integrated coverage of color phenomena that includes the physical, psychophysical, and psychological points of view.

Physiological Factors

Much of the following material has been adapted from *Color Vision*, by Leo M. Hurvich (1981). Professor Hurvich, together with Dorothea Jameson, is a pioneer in the opponent-process theory of color vision.

A diagram of the human eye is shown in the illustration. The **iris diaphragm** regulates the amount of light that passes through the lens to strike the retina. The **retina** is made up of a complex network of cells and neurons, and covers the entire back half of the eye (with the exception of the blind spot where the optic nerve joins the eye). The retina in cross-section contains ten levels of nerve cells. The cells that

*The human eye:
(A) horizontal section
through center; (B)
enlargement of dotted area
in A; (C) enlargement of
dotted area in B.*

*Adapted from Colour by
Hazel Rossotti.*

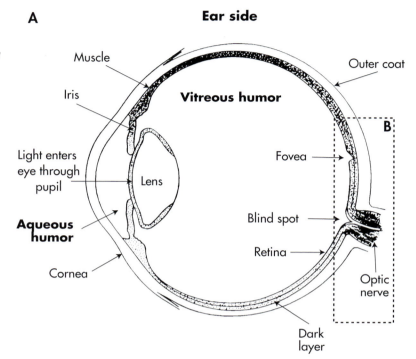

A

Ear side

Muscle

Iris

Vitreous humor

Outer coat

B

Light enters
eye through
pupil

Lens

Fovea

**Aqueous
humor**

Blind spot

Retina

Cornea

Optic
nerve

Dark
layer

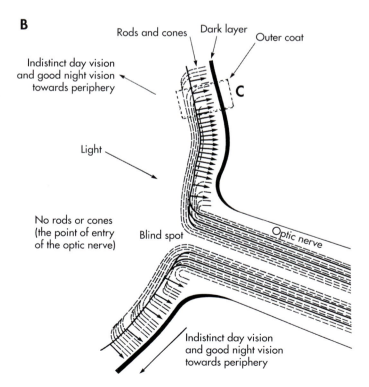

B

Rods and cones Dark layer Outer coat

Indistinct day vision
and good night vision
towards periphery

C

Light

No rods or cones
(the point of entry
of the optic nerve)

Blind spot

Optic nerve

Indistinct day vision
and good night vision
towards periphery

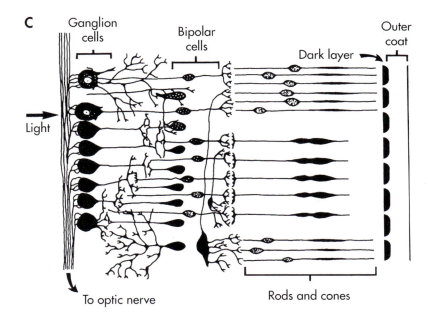

are sensitive to light are called the **rods** and **cones**—an esti-mated 120 million of them. The distribution of the rods and cones varies according to their position on the retina. The central area of the retina (called the **fovea**) contains cones exclusively. The cones are primarily concerned with vision at daylight levels of illumination, and as we move away from the foveal region, the number of cones per unit area drops off sharply. The foveal area is the area of sharpest vision. The rods, completely absent from the fovea, increase in number as we move toward the edge of the eye. The rods are most numerous about 20° from the fovea and fall off rapidly in number from this region out to the extreme periphery.

The rods are mainly concerned with night vision. Experi-ments have shown that the rods contain a photopigment called **rhodopsin**. When molecules of this pigment absorb light, they change their structure or form. These changes, in turn, trigger a physiochemical reaction, with an accompany-ing electrical change in the receptor itself. Different wavelengths of light affect rhodopsin differently.

In the case of cones, which are involved in normal color vision, it has not yet been possible to isolate a corresponding photopigment. This is mainly due to there being a much smaller number of cones than rods (6 or 7 million cones and over 110 million rods), thus making it difficult to extract the

pigment. Researchers generally agree that there must be three different kinds of light-sensitive pigments for color vision and that they are segregated into three different types of cone receptors.

The existence of three cone photopigments has been virtually proved by using a technique called microspectrodensitometry. A minute spot of light is imaged on individual receptors taken from the eye and the absorption spectrum of the pigment is measured by rapidly scanning the whole spectrum. This technique has shown the existence of three pigments with average peak absorptions at 450 nm, 530 nm, and 560 nm. It can be presumed that the action of light on these photopigments gives rise to electrical charges that travel to the brain.

Research conducted during 1996 at the Medical College of Wisconsin by Maureen Neitz and Jay Neitz has revealed that humans have up to nine genes for cones, which suggests that there may be more types of cones than previously thought. Apparently, two red cone subtypes have been found. Differences between the types and distribution of cones in the retina helps to explain the differences in color perception between individuals with normal color vision.

Color Vision Theories

The human color vision process is very complex and is still not completely understood. Over the years a number of color vision theories have been advanced as explanations for how we see color. These theories have ranged from the simple to the complex, with the latter providing us with a reasonably good explanation of color vision phenomena. Because the complex theories build upon the simple models, it is advisable to examine the simple before proceeding to the complex.

Young-Helmholtz theory. This approach to color vision is sometimes called the retinal approach, component theory or trichromatic theory. It was developed in the nineteenth century, initially by Thomas Young, and then refined by H. L. F. von Helmholtz. The theory postulates the existence of three kinds of receptors in the retina that are respectively stimulated by red, green, or blue light. These receptors are supposedly linked directly to the brain to produce red, green, and blue signals that are directly proportional to the color of light reaching the retina.

As previously discussed, experiments have shown that the cone receptors in the eye do indeed have different color

responses. They are not, however, unique red, green, and blue responses and tend to be much broader than suggested by the Young-Helmholtz theory. The theory does not offer a good explanation for abnormal color vision, nor can it explain satisfactorily how we perceive such unique colors as spectral yellow.

James Clerk Maxwell conducted an extensive series of experiments that explored aspects of the trichromatic theory of color vision. His color matching work with three primary-color lights established the color measurement methods that are widely used today. Maxwell's research into the trichromatic theory of color vision was so extensive that some (Sherman, 1981) believe that it would be fairer to call it the Young-Helmholtz-Maxwell theory.

Hering theory. Ewald Hering developed his theory of color vision in the 1870s. It is called the opponent theory. This theory suggests that the three kinds of color receptors in the retina have opponent sensitivities or reactions. That is, one receptor is red-green sensitive, another is blue-yellow sensitive, and the third one is white-black sensitive. By a process known as assimilation or disassimilation, the red or the green section (for example) of the red-green receptor sends a signal to the brain that represents the redness or the greenness of the light falling on the retina. The system is called opponent because it is not possible to have a reddish green or a bluish yellow; hence, these colors must oppose each other. The black-white receptor works slightly differently (it is possible to have a whitish black, or a gray). A black response is produced by a successive contrast effect. That is, a dark area next to a white area will tend to look black because the white-black receptors in the white area will induce the opposite effect in the same kinds of receptors on adjacent parts of the retina.

No evidence of any visual substance that can produce two separate effects by assimilation or disassimilation has ever been found. The bipolar cells that connect to the cones could help initiate the opponent signals, but no solid evidence has been advanced that this mechanism will account for all color vision phenomena. In particular, this theory cannot explain the two different kinds of red-green blindness. According to the Hering theory, there should only be one kind.

Opponent-process theory. This approach has also been called the zone theory or the Hurvich-Jameson theory after

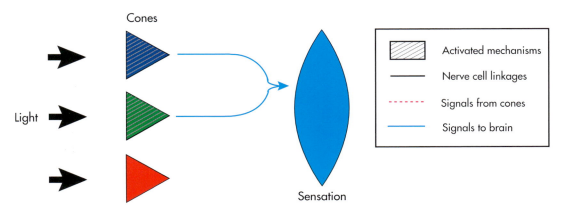

Young-Helmholtz color vision theory. The three cones respond in varying degrees to red, green, and blue wavelengths and send these signals to the brain, where they are mixed to create the color sensation.

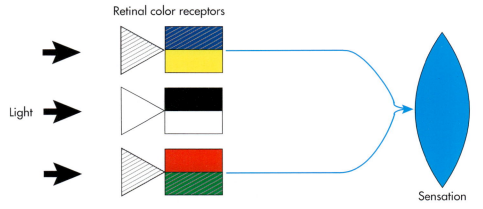

The Hering color vision theory. Retinal color receptors, which include the cones, are capable of discriminating between yellow-blue, red-green, or white-black. When a stimulus reaches a receptor, a coder is switched in one direction or the other depending on the color of the stimulus.

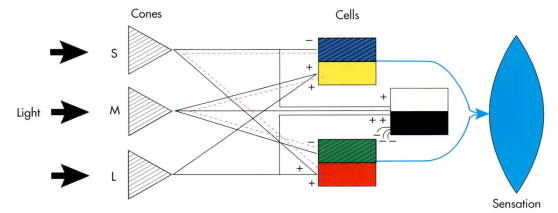

The opponent-process model (Hurvich-Jameson color vision theory). In this complete theory, the cones are each linked to three color discriminators. The signals from the cones stimulate or inhibit the discriminator cells, and the dominant factor causes the discriminators to switch in one direction or the other.

the primary proponents of this model, Leo M. Hurvich and Dorothea Jameson. This approach combines elements of both the Young-Helmholtz and the Hering theories.

The three individual response cones of the Young-Helmholtz approach are incorporated into this model. The responses of each cone are very broad, however, with peaks occurring at 450 nm, 530 nm, and 560 nm; thus, rather than calling the cones red, green, and blue receptors, they should be more correctly called long-wavelength (L), medium-wavelength (M), and short-wavelength (S) receptors.

The opponent idea from the Hering theory is incorporated at the nerve cell level. Some nerve cells are always in an active state, despite the lack of stimulation. If they are stimulated the pulse frequency increases, and if they are inhibited the pulse frequency decreases. Two opposing types of information can, therefore, be transmitted by the same nerve. It has been suggested that the ganglion cells, which are each connected to three cones, act as opponent cells.

The suggested linkages between the cones and the opponent cells are shown in the illustration. The color vision mechanism can now be explained in algebraic terms. Consider the blue-yellow opponent cell. Assume that the top half represents yellow and the bottom half represents blue. The top half (yellow) receives output from the long (L) and medium (M) wavelength cones. Let us assume that this output reacts to stimulate the cell. The stimulation can be represented as L+M. The lower half of the cell (blue) receives the output from the short (S) wavelength cones. We assume that this output tends to inhibit the cell, thus it can be represented by –S. The net activity of the cell can be represented by:

$$\frac{\text{Yellow} \ (+)}{\text{Blue} \ (-)} = (L+M) - S$$

If the right side of this equation is positive (i.e., if L+M is greater than S) then a yellow (stimulation) signal is produced. If S is greater than L+M, then a blue (inhibition) signal is produced. The red-green opponent cells work in a similar manner, thus:

$$\frac{\text{Red} \ (+)}{\text{Green} \ (-)} = (L+S) - M$$

Black is perceived because of lateral inhibition. Cells on one part of the retina induce the opposite kind of activity in simi-

lar cells on adjacent parts of the retina; therefore, black is a contrast effect. The red-green and blue-yellow cells also have lateral connections that are not shown in the illustration.

Perceptual Phenomena

The opponent-process theory has valid explanations for abnormal color vision as well as for certain perceptual phenomena. Simultaneous color contrast, edge contrast effects, and negative afterimages are perceptual phenomena that may influence the appearance of color reproductions.

Simultaneous color contrast. The lightness and chromatic values of a given color are influenced by the relative lightness and chromatic values of an adjacent or surrounding area. The effect is observed when colors that are identical appear different because of the influence of different color surrounds. This effect was first studied in a systematic manner by French chemist M. E. Chevreul in the early 19th century (Chevreul, 1987). Chevreul was concerned with the colors of threads in tapestries and the influence that certain designs had on color perception. Similar effects may operate when a number of graphic elements and photographs are combined into a page layout. It may become obvious that the color of an image element will have to be modified to compensate for the distorting effect of other areas within the field of view.

Simultaneous color contrast effect.

The four small colored disks are the same on the left- and right-hand sides. The apparent color differences are caused by the different surround.

Courtesy Leo M. Hurvich, Color Vision, 1981.

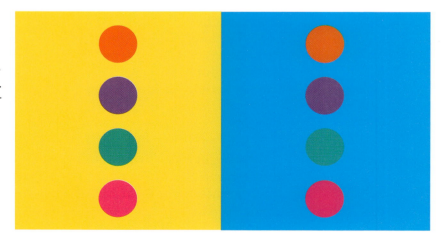

Edge contrast effects. Edge contrast effects occur when tonal values of different lightnesses abut each other. Within the boundary zone, the darker tone appears darker and the lighter tone appears lighter despite the fact that there are no measurable differences. This effect becomes particularly

apparent when the tones in question are flat, even values devoid of busy detail.

Edge contrast effect.

*The gray scale steps actu-
ally have uniform intensity,
but at each edge there is a
relative enhancement and
darkening on the two edge
sides of the edge.*

*Courtesy Leo M. Hurvich,
Color Vision, 1981.*

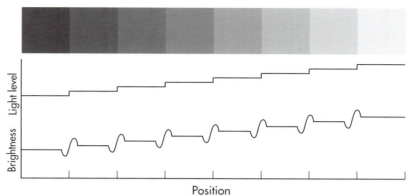

Afterimages. Successive contrast or afterimage effects can occur when an observer maintains a fixed gaze upon a chromatic area for an extended time (e.g., an operator modifying a color monitor display). When the gaze is shifted to a neutral area, the opposing colors of the formerly viewed image will appear. To demonstrate the afterimage effect, refer to the illustration. Stare at the spot in the yellow rectangle for about 20 seconds. Quickly shift your gaze to the spot in the adjacent white rectangle. You should see a blue rectangle, the opponent of yellow. This experiment may be repeated with any color to verify that the opponent color will always be visible in afterimage.

The explanation for these effects starts with the fact that the retina is made up of groupings of cells called receptive fields. These vary in size, with the ones near the fovea being about one-twentieth the size of those at the periphery of the eye. Apparently, there is evidence to suggest that the cells in a receptive field are all connected to a common ganglion cell.

Afterimage demonstration.

The opponent-process theory of color vision states that the neural systems are linked to each other to produce reciprocal lateral influences. The center of a receptive field, for example, may perceive red, whereas the edge of the field may record a reciprocal green response. Consider two identical green discs, one on a red field and the other on a gray field. The disc on the red field will appear more intense because the lateral reciprocal effect will tend to reinforce the green. The magnitude of the effect will vary according to the strength of the colors, their relative contrast, the size of the elements, and the viewing distance. The same sort of reciprocal interaction is suggested as explaining the apparent change in density at the edges of two gray tones that adjoin each other.

The afterimage effect occurs because an opponent effect is induced in the receptive field over time, and is reinforced by the opponent lateral interactions that were used to explain simultaneous contrast effects. When the object is removed from the field of view, the opponent color remains for some seconds. The opponent color may be readily seen when the gaze is shifted to a white surface, but it may also be observed if the eyes are closed. The afterimage hues are always complementary to those seen initially; i.e., the antagonistic response of red is green, of yellow is blue, and of black is white, and vice versa.

Abnormal Color Vision

To conclude the section on color vision, it is necessary to consider the case of those with abnormal color vision (the term "color blindness" is no longer a preferred term). This problem is essentially one affecting males—about 8% of the male Caucasian population, 5% of the male Asian population, and 3% of the male population of other races have a form of deficient color vision. For females (of all races), those with abnormal color vision only number about 0.4% of the female population. Studies of the incidence of abnormal color vision have been summarized in *Color: A Guide to Basic Facts and Concepts* (Burnham et al., 1963, p. 102).

Color vision abnormalities are inherited. The normal heredity pattern is for the deficiency to be inherited by sons of daughters whose fathers exhibit color-defective vision. Fathers pass this abnormality on to their daughters, who act as carriers. As stated above, very few females actually have color-defective vision, but a much larger number are carriers. This pattern may be explained by a consideration of the sex

chromosomes that reside in the nuclei of the cells in the human body. In females, the sex chromosomes are identical and are designated XX. In males, one chromosome is of the X type while the other is of the Y type. Male sex chromosome pairs are designated XY. Most of the genes found on the X chromosome are not found on the Y chromosome. It has been suggested that the X chromosome carries the gene for color vision and that because males have only one of these chromosomes, while females have two, that this explains why abnormal color vision is much higher in males than in females. A female with abnormal color vision would have recessive color vision genes on both X chromosomes. In theory, if 8 percent of Caucasian males have abnormal color vision, then only 0.64 percent (i.e., $0.08 \times 0.08 = 0.0064$, or 0.64 percent) of females would have abnormal color vision. The actual incidence appears to be lower than this estimate. In some families it is possible that not all the sons will inherit the abnormality from their mothers and that only some of the daughters in the same family may inherit the defective gene and become carriers.

The most common type of defective color vision is red-green confusion. Its various forms are **protanopia**, in which red and bluish green are confused, and relative luminosity of red is much lower than that for the normal observer (affects

X-chromosomal heredity recessive transmission of red/green deficiencies.

Courtesy Leo M. Hurvich, Color Vision, 1981.

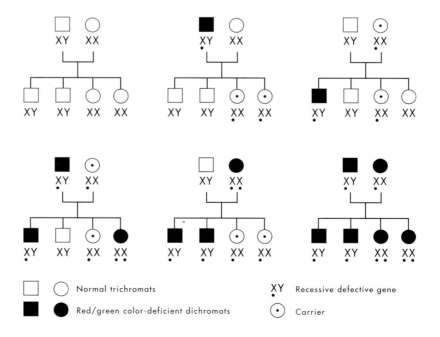

about 1% of Caucasian males); **protanomalous,** where in a red-green mixture more than a normal amount of red is required to match a particular yellow (affects about 1% of Caucasian males); **deuteranopia,** where red and green are confused, but the luminosity curve is nearly normal (affects about 1% of Caucasian males); **deuteranomaly,** where in a green-red mixture more than a normal amount of green is required to match a spectral yellow (the most common form of anomaly, affecting about 5% of Caucasian males). The other forms of defective color vision are **tritanopia,** where blue and yellow are confused and relative luminosity for blue is much lower than for normal vision (extremely rare, probably affecting no more than 0.0001% of the male population); and **monochromatism,** where discrimination of hue and saturation are completely lacking (also very rare, affecting about 0.003% of Caucasian males).

There are several testing devices available for detecting abnormal color vision. A good instrument for this purpose is the Nagel anomaloscope; however, its use is restricted to research laboratories because of its expense. The most popular form of testing is by using pseudoisochromatic plates. These come in booklet form, are inexpensive, and are easy to administer. The best known of these tests is the **Ishihara** test, where numbers composed of dots of varying size and color are superimposed on backgrounds made up of similar dots. The ability to discern the numbers from the background

The Ishihara test for abnormal color vision.

is a measure of normal color vision. Another version of this type of test is the American Optical Company's **Hardy-Rand-Rittler** set of plates. In this version triangles, circles, and crosses are used on gray dot backgrounds. Another widely used test is the **Farnsworth-Munsell 100-Hue Test** which is composed of color chips. The observer's task is to line up the series of chips sequentially so they form a continuous color series in terms of similarity. Variations in the correct order are used to diagnose color vision anomalies. All tests must be carried out under daylight illumination. The tests are generally very reliable.

The Farnsworth-Munsell 100-Hue Test.

Apart from abnormal color vision discussed above, it should be remembered that among those with normal color vision, one person does not see color the same as another. Much of this interobserver variation for individuals of the same age is probably due to the macula lutea (yellow spot), which is a yellow pigment that covers about a 5° elliptical area around the fovea. It has been shown to vary in amount between individuals from negligible to an amount which reduces by about two-thirds the light at 460 nm that is transmitted to the cones.

As we age, the lens of the eye also becomes yellower and transmits progressively less of the blue wavelengths to the retina. The yellowing of the eye's lens with age causes blues to look greener, violets to look bluer and purples to look redder. The ability to distinguish between the greenish yellow to purplish blue tray (caps number 43 to 63) of color samples in the Farnsworth-Munsell 100 hue test is impaired (Ancona, 1986). The saturation of colors is also reduced: a Munsell

The effect of aging on light transmission of the eye's lens.

Reprinted with permission from *Photomedicine*, Vol. 1. Copyright CRC Press, Boca Raton, Florida.

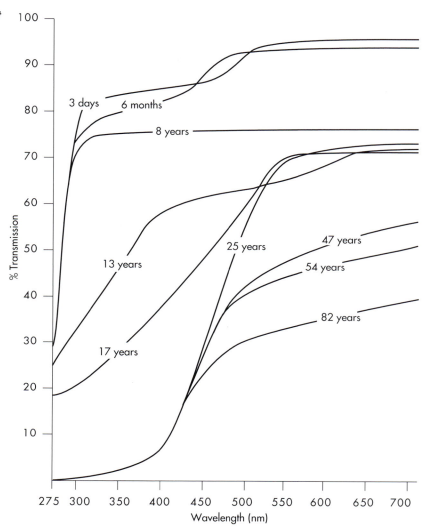

10RP 5/14 glossy chip reportedly appears 3–4 chroma steps grayer, and Munsell 5P 4/12, 3/10 glossy chips appear 2–3 chroma steps grayer (Granville, 1990). Actual hue and saturation shifts will vary according to age, and will also be influenced by the differences in cone sensitivities and macula lutea between individuals.

The influence of the aforementioned factors on the yellowness of vision may be assessed by the Munsell Color Corporation's MatchPoint slide rule (formerly the Davidson and Hemmengdinger Color Rule.) This device consists of two painted sliding color scales of constant lightness. One scale consists of a series of samples varying in hue from a purple

to a green. The second scale varies in a similar manner from a blue to a brown. The observer slides the rules by each other until a visual match is achieved between a sample on each scale. The differences between matches made by different observers may be used to assess relative yellowness of vision.

The yellowness of vision issue has been discussed in some detail by McLaren (1986, pp. 92–95) for a primary audience in the dye and pigment industry. His remarks about the significance of differences between individuals are also of particular relevance to the printing and related industries:

> Fortunately it is easy to assess the yellowness of vision and if every colourist knows his or her degree of yellowness then those differing markedly will realise that arguments are a waste of time. There is no point in trying to define the correct degree of yellowness. In practice, the correct degree is always that of the observer having the power to accept the batch as a good commercial match. (McLaren, 1986, p. 94.)

Color Judgments

The key remaining points concerning color vision, especially for color reproduction and color printing, are the problems that can arise when people with abnormal or distorted color vision make color judgments. It is difficult to generalize about this, but the following statements are probably reasonable guidelines.

- **Judging color quality.** For judgments concerning the quality of a color reproduction or the harmony of a color design, a judge should have normal color vision.
- **Color matching.** For matching one color with another, some persons with abnormal color vision are actually better than some of those with normal color vision. While this may be true for colors composed of the same pigments, it does not, however, apply when different colorant systems are being compared, such as between artwork or a photograph and a printed color reproduction. It may well be acceptable to have a press operator with defective color vision as long as one press sheet is being compared with another, but it is not acceptable to have a scanner/system operator or a designer/artist making comparisons between, for example, a hand-painted piece of artwork, a color monitor display and a printed reproduction. The ability of an observer to discriminate

among nonmetameric colors may also be assessed by the Farnsworth-Munsell 100-Hue Test.

Non-Physiological Factors

As difficult as the physiological factors are to explain, there is a well-defined science in this field that has produced some very plausible and useful theories of color vision. For the other human factors, we enter the fields of art, anthropology, and psychology. In art we find various rules, such as those of color harmony, which have been accepted by many professions that deal with the aesthetic aspects of color. From anthropology we can discover how particular cultures use color and of what significance it is to them. From psychology and medicine a new understanding of the emotional aspects of color is starting to emerge.

What many people believe about particular colors can be undoubtedly connected to some cultural tradition that has linked colors with events, feelings, or countries. Some examples of these are red and green, the colors of Christmas; black, the color of mourning (in Western countries); green for feelings of envy; blue for feelings of depression; and white for purity.

The question is not whether colors can evoke certain associations—most people would agree that they do—but rather, are these associations merely ones of habit, or is there an innate human feeling about color? This question is difficult to answer. It is probable that most of our feelings about colors are simply explained by tradition, but some evidence is emerging that shows there may be some fundamental human reactions to color. Placing disturbed persons in rooms of particular colors, for example, has been shown to alter their behavior. Apparently, the same effect has also been observed with infants who have not been taught color associations. Reported use of color therapy dates back to the 19th century, but little systematic research has been done until comparatively recently (Kaiser, 1984).

The principles of color harmony—colors that are closely adjacent in hue and those that are complementary form the most pleasing combinations—have a logical explanation. If two colors that are not harmonious are placed together, the hues may seem to change when the eye is shifted from one to the other. The afterimage of one color will momentarily affect the perception of the other color. Because the afterimages are complementary to the color, harmonious colors will not exhibit any hue shift. The afterimages of complementary colors will

appear to reinforce each other, while closely adjacent colors will not produce afterimages significant enough to induce a noticeable hue shift. The foregoing is meant to apply to color having uniform area, high saturation, and medium lightness. Naturally, the relative hue, brightness, saturation, and area are all factors that must be considered as explanations for color harmony, or the lack of it.

The final human factor concerning color is the creativity involved in the use of it. To be effective, the user must first understand the underlying principles of color, next know the purpose of the project or assignment, and finally apply imagination. In the printing and allied industries we think of the creative aspects of color as coming from the designer, the photographer, and sometimes the printer. Color is, of course, also used by such others as interior designers, fashion designers, artists, architects, industrial designers, and many more. Knowledge, purpose, and creativity are the keys to successful use of color in all of these fields. The book *Color Bytes* by Jean Bourges (1997) is recommended to those interested in the creative use of color in printing.

Concluding Analysis

The illuminant, the sample, and the observer are the three pillars of color perception. Of these, the observer provides the largest variable in color perception. Not only does a certain percentage of the population have defective color vision, but those persons of normal vision suffer from changes in color vision with both age and fatigue. Even after standardizing these factors, we still find that individuals differ from each other in their color vision. This should not be too surprising—individuals differ in such other senses as hearing, and in such physical characteristics as height, skin color, weight, sex, etc. The nonphysiological factors can add more variables—aesthetic beliefs, cultural background, and even possible innate color preferences. These are probably the most difficult factors to predict and control.

The next biggest color vision variable is the light source. Colors can undergo dramatic shifts when a different light source is used as an illuminant. A standard has been established for viewing printed matter, which, if followed, should do much to eliminate some of the confusion and problems in color judgment and communication.

The sample, which would appear to be a constant, can change in appearance depending upon the degree to which

gloss is present. Specifying a fixed viewing position helps to reduce this problem.

The problems that result from the above factors range from the predictable to the unpredictable. In the case of metamerism, the problem is well understood. Different spectral absorptions of the two colors in question cause these colors to match under one light source but not under another. Standard viewing conditions are the solution.

The problems of color that involve personal differences between two people are more difficult to resolve. It is possible that one or both have defective color vision, something people are often not aware of unless they have been tested. More likely, perceptual differences between individuals stem from a combination of the normal genetic variation between observers, and the yellowness of vision effects that come with age. Education in color fundamentals will help to reduce these kinds of personal perception-based color differences that have no clear resolution.

5 Complex Image Color Perception

Field of View Considerations

The primary focus of the previous chapter was upon color vision at the cellular level. The response of the cone receptors and the idea of opponency between yellow-blue, red-green, and black-white are important aspects of colorimetry and perceptual color space. From a printing industry point of view, colorimetry is an excellent tool for monitoring color variation during pressruns (i.e., three-color gray evaluation). Colorimetry also works well when making comparisons between samples made of identical materials (e.g., ink color swatches or printed labels) that are being evaluated under identical viewing conditions (e.g., a 5,000K standard viewing booth).

In those cases when a comparison is being made between images in different media (color transparencies, color monitor displays, and four-color ink-on-paper halftone prints) that are viewed under different conditions (images are different sizes, transmission and reflection sources are used, image surrounds are different), colorimetry will fail. Under such circumstances, a colorimetric match is not the same as an appearance match. The actual appearance of a complex image (as opposed to a large single-color swatch or flat area) is dependent upon the interaction of stimuli from the entire field of view. Some of the resulting appearance phenomena were introduced in Chapter 4, but a detailed understanding of the more important effects is required to fully appreciate the limitations of colorimetry and the potential of color appearance models.

Chromatic Adaptation

A major contributor to appearance is the ability of the eye to adapt to different viewing conditions. The eye's adaptation to lighting intensity (quantity) changes is well known. The iris diaphragm will gradually open to accommodate the

differences in illumination that occur when walking into a dimly lit house from bright outdoor sunlight. Complete adaptation may take many minutes. On dark nights it may take an hour or longer to achieve complete dark adaptation for faint stars to become visible (Kuehni, 1997).

The eye's adaptation to light source color (quality) differences is also a relatively slow process. The eye adapts along with the slow change in the color of daylight from sunrise to sunset. This effect is called **chromatic adaptation**. The color of objects viewed under these changeable conditions seems to be approximately the same to an observer despite the extreme differences that may be captured on a non-adaptive system (e.g., a camera-film system) throughout the day. When there are abrupt changes in the color of indoor viewing conditions it may take as long as 15 minutes before adaptation is complete. The cone receptor characteristics gradually change under the influence of the prevailing illumination.

Color Constancy **Color constancy** is an instantaneous effect that allows the visual system to recognize colors of objects in scenes under different lighting conditions. Apparently, the visual field establishes the color of a given object relative to other objects in the scene. This effect varies among individuals—a fact which gives rise to the terms **partial color constancy** or **approximate color constancy**. The color constancy effect, which is instantaneous, was first demonstrated from a scientific point of view by Gaspard Monge at the Académie Royale des Sciences in May of 1789 (Mollon, 1995). Edwin Land's related **Retinex Theory** of color vision postulated, among other things, that objects retain their color identity under a great variety of lighting conditions (Land, 1977). The concept of memory color may be related to this observation. The strength and immediacy of the color constancy effect have been demonstrated by a number of researchers (Land and McCann, 1971, for example). The influence of color constancy on color reproduction is not altogether obvious, but it may permit discounting of some color casts in originals.

The terms chromatic adaptation and color constancy are sometimes used interchangeably, but they are distinct effects that are apparently based upon different mechanisms. Chromatic adaptation requires many seconds of time and occurs for simple visual scenes, whereas color constancy asserts itself immediately and is most powerful in complex visual scenes (Brill and West, 1986).

The initial color vision experiment of Edwin Land. The top photograph shows how the scene was photographed by a special camera through green and red filters to produce two monochrome negatives. The lower photograph displays the red and white light projection system used to produce full-color perception from positive transparency images of the two negatives.

Color appearance models attempt to quantify chromatic adaptation effects together with a number of other perceptual effects that number ten or more. In practice, however, the chromatic adaptation effects are usually considered significantly more important than the combined influence of the other effects (Fairchild, 1998).

Viewing Conditions

Color appearance of pictorial subjects can vary greatly with changes in viewing conditions. In order to minimize such variations, the graphic arts viewing standard should be used

when evaluating printed results or when making comparisons between an original and a reproduction (proof or printed sheet). The standard's specifications for color temperature, color rendering, degree of diffusion, and environmental conditions within the viewing booth are essentially fixed and, as such, should exert a consistent effect on the viewed images.

Some aspects of the standard viewing conditions are, however, open to user interpretation or choice. The most significant of these choice factors are intensity and the image surround conditions. The viewing geometry may also exert an influence (especially if gloss, texture, or luster are significant surface characteristics), as may the ambient room conditions (wall and ceiling color, and stray light from windows or room lights). The ambient conditions are especially important when evaluations are made of color monitor displays.

Some viewing standards for evaluating reflection originals or photomechanical reproductions may provide the option of two intensity levels. A high level of around 2,000 lux is intended for "critical appraisals." Ideally, this condition should be interpreted as applying when making comparisons between proof and makeready sheet, or OK sheet and production run samples. The critical appraisal condition is used for evaluating consistency. In practice, visual evaluations between an OK proof and run samples (or between a proof and makeready sheet) may have limited validity because wet ink films have appearance properties that differ from those of dry ink films.

A low-intensity (around 500–700 lux) option could be used for "judging or routine inspection" tasks. The lower intensity option is around the level of a well lit home, library, or office, and therefore represents the viewing intensity used by most consumers for evaluating color reproductions. Changes in viewing source intensity can significantly influence the appearance of reproductions—both the contrast and the saturation of the image will appear to increase with an increase in the level of illumination. If, for example, a reproduction is adjusted to appear satisfactory when illuminated by a 2,000-lux source, then the resulting appraisal with typical 500-lux illumination will appear "muddy" (Johnson, 1977). At the time of writing, the committee charged with evaluating the current international color viewing standard (ISO 3664:1975) was considering incorporating a section in the standard to allow image color quality evaluations to be made at 500-lux intensity.

The ANSI color transparency viewing standard calls for intensity of 1,400 cd/m^2 for both the direct and projection viewing devices. The standard also specifies screen evenness and permissible variations in intensity. The remaining variables that will affect the evaluation of transparency images are the transparency surround and the ambient lighting conditions. Image surround conditions will also influence evaluations of reflection originals, proofs, and printed reproductions.

The standard specifies that the transparency viewer shall be located within the illuminated area provided for viewing the reflection reproduction (i.e., within a viewing booth). Surround specifications are somewhat more complex. The U.S. ANSI PH2.30-1989 standard specifies that transparencies be:

> Surrounded on at least three sides by an illuminated area of at least 2 inches in width. Average luminance of the surround shall be at least one half the maximum level in the viewing area with the transparency removed. The illuminated surround shall not exceed four times the transparency area. Any illuminated area in excess of this ratio shall be covered with an opaque gray border of approximately 60% reflectance (Munsell notation N8/).

The ISO 3664:1975 direct viewing section of the standard allows that the surround mask may have a density of 1.00 (10% transmission) when assessing transparencies in isolation (i.e., not in comparison with reproductions). This higher density surround reduces image-veiling flare and produces an image display that will be impossible to match by reflective media. In fact, the idea behind ANSI specifying a surround of about 0.30 density (50% transmission) or less is to introduce a degree of flare that will make the transparency appear more like the reflection reproduction. Surround-induced flare will not necessarily produce a perceptual effect that will match the desired tone reproduction curve. It may be desirable, for example, to expand the tonal separation in dark areas when reproducing a low-key original. The ANSI transparency surround requirements will reduce the perceived tonal separation in dark areas; i.e., the opposite of the desired example condition. If, however, an opaque surround is used to increase the perceived tonal separation in dark areas, then color saturation will appear greater than what may be reproduced.

The dilemmas of viewing condition selection have been fully explored by Johnson and Scott-Taggart (1993). There is no easy solution for the transparency viewing problem. It is possible to vary intensity and surround to make a print look like a transparency, and vice versa. Such variability in viewing conditions negates the concept of a standard and should not be recommended as a general practice. One possible answer to the transparency viewing dilemma may be the calibrated color monitor. The intermediate monitor image provides a means of incorporating tonal and saturation com-

The influence of surround on the appearance of a color transparency.

pression algorithms that are far more precise than attempts to control surround- and intensity-induced compressions at the transparency viewing stage. The problem of color reproduction evaluation would be greatly simplified if the transparency is not even viewed after it has been scanned. The monitor display (or a direct digital proof) would then become an interactive original, the appearance of which is constrained by the gamut of the printing system. The key drawback of this approach, however, is that color monitors and their viewing conditions are not standardized.

An adjustable-intensity 5,000K viewer being used to match the image brightness of a typical color monitor.

Courtesy Graphic Technology Inc.

The normal reference white point for a color monitor has a color temperature of 9,300K. This point is adjusted to conform to the graphic arts viewing conditions of 5,000K via the use of software or (less commonly) by adjusting the gain controls of the red, green, and blue channels. No such adjustment can be made to increase the monitor's intensity from its 50–80 cd/m^2 range to match a transparency white point intensity of about 600 cd/m^2 (assuming a transparency highlight density between 0.35 and 0.40). It is possible, in some cases, to dim the transparency viewer to match the intensity of the monitor. It must be borne in mind, however, that contrast and saturation perception within pictorial images may be unduly distorted by reduced-intensity viewing devices and monitor displays.

The ambient lighting conditions will exert a significant influence on the perception of color monitor images. The use

of anti-reflection coatings on the monitor screen's surface to reduce glare from light sources within the general environment is recommended. Further recommendations (Jackson et al., 1994) include:

- Room lighting should be neutral
- Strongly colored decorations or objects within the operator's field of view should be avoided
- Ambient illumination brightness should be similar to that of the monitor
- Use directional lighting to illuminate work areas, thus preventing interference with the monitor display. Shields may also be used for the same purpose.

The image surround within the monitor's display may be set to any desired value, but the viewing intensity differences and ambient lighting conditions may make it difficult to establish the optimum surround. In any case, any surround added to a monitor (or around a transparency) should always be neutral. Image size differences between the original, the display and the reproduction will add further perceptual distortions, as will the inability of the monitor to fully capture the surface characteristics and image structure of the reproduction. Despite these difficulties, a color monitor is an excellent aid in the hands of a skilled operator who is able to discount certain distortions and imagine certain outcomes. A direct proof onto the final substrate is required for optimal judgments, as well as for contractual purposes.

Color Appearance Models

The mathematical representation of complex visual phenomena is required if completely computer-driven color imaging systems are to achieve reasonable-quality results. The circumstances that would allow strict colorimetric matches to be made between original and reproduction almost never occur in practice; indeed, strict color matches are not usually even the color reproduction objective. Successful models must incorporate, to one degree or another, the complex color image effects that were described earlier in this and the previous chapter.

Chromatic adaptation is, by far, the most important of the appearance factors that must be incorporated into a model. Johannes von Kries published the details of a chromatic adaptation model in 1902 (translation in MacAdam, 1970, pp. 109–119) that, in modified form still serves as a useful color appearance model. The von Kries model incorporates coeffi-

cients for independently adjusting the L, M, S cone responses to reflect proportional fatigue and adaptation effects.

The more well-known of the color appearance models, as described in the book *Color Appearance Models* (Fairchild, 1998), are:

CIELAB

The 1976 CIE color space transformation of CIE XYZ to a more perceptually equal space uses equations that are suited to appearance modeling applications.

von Kries

Primarily a color adaptation transform, it may be used with CIELAB for improved results.

Hunt

Generally regarded as the most complete and most complex of the models. Developed by Dr. R. W. G. Hunt (City University, University of Derby, and formerly Kodak Ltd.) in about 1980 and continuously refined. The current published version is known as Hunt 94.

Nayatani et al.

Developed by Yoshinobu Nayatani and a number of fellow workers at Osaka Electro-Communication University during the late 1980s and subject to ongoing refinement. Primarily intended for lighting industry applications.

LLAB

A modified CIELAB model developed in 1991 by M. Ronnier Luo and a research team at the Loughborough University of Technology. The model was based upon data generated in one of the most comprehensive color vision experiments ever undertaken. Luo, who is now employed by the University of Derby, is engaged with others in the ongoing revision of this model.

ATD

This model, developed by S. Lee Guth of Indiana University, is primarily an adaptation model. Based upon an ATD color space, the 1991 version of this model was refined

and applied to image science applications by Edward M. Granger of Light Source Computer Images.

RLAB Based upon the 1991 work of Mark Fairchild of the Rochester Institute of Technology, this model was designed for cross-media image reproduction applications. It is a modified CIELAB model that incorporates an improved chromatic-adaptation formula.

Interested readers are referred to Fairchild's comprehensive book on color appearance models for the mathematical details of the models and a complete set of references to the original research. The appendix of this text introduces the 1997 CIE Color Appearance Model (CIECAM97), which was developed by R.W.G. Hunt and M.R. Luo to include features from various prior models. CIECAM97 is available in two versions—a simple version (CIECAM97S) for use in limited conditions, and a comprehensive version (CIECAM97C). CIE Technical Committee TC 1-34 formally adopted CIECAM97S at its May 1997 meeting in Kyoto.

Model Applications

Color appearance models, theoretically, may be used to good effect in a color reproduction system made up of diverse input, output, and display devices. Initially, a color management system (Chapter 3) and associated procedures are used to convert source (e.g., scanners) colors, destination (e.g., ink-paper-press) colors, and display (e.g., color monitor) colors into a common device-independent perceptual color space. Next, a color appearance model is used to convert CIE values (together with the related appearance parameters) into a perceptually corrected display. Tonal, saturation and related image modifications are made by the operator at this stage prior to the application of the appearance model in reversed form to convert the data back to CIE values, and then to CMYK halftone values.

Concluding Analysis

The response of the eye's receptors at the cellular level is a critical element in the science of colorimetry. The evaluation and control of individual colorants (e.g., textiles, paints, plastics, printed ink films) have been well served by colorimetric measurement techniques. In the case of color images, however, colorimetry cannot adequately capture the appearance

properties of one image (an original) that may be compared with those of another image (the reproduction).

Variations in viewing conditions between originals and reproductions of different media and sizes contribute greatly to appearance differences between the images. In order to more accurately capture these differences in appearance, it becomes necessary to move beyond the cellular level of color vision and consider the influence that the viewing field has on the appearance of areas within the image. This concept is best expressed by the words of Gaspard Monge from 1789:

> So the judgements that we hold about the colours of objects seem not to depend uniquely on the absolute nature of the rays of light that paint the pattern of the objects on the retina; our judgements can be changed by the surroundings, and it is probable that we are influenced more by the ratio of some of the properties of the light rays than by the proper-ties themselves, considered in an absolute manner. (Mollon, 1995)

The 1902 paper of von Kries established the foundation for color adaptation modeling. The introduction of CIELAB color space in 1976, and the increasingly widespread availability of powerful desktop computers, led to the development of a number of color appearance models. The first of these, by Robert Hunt, has undergone several refinements, and stood as the most complete model prior to the introduction of CIECAM97. In practice, simpler models may be quite suit-able for the image reproduction requirements of the printing industry.

It must be borne in mind, however, that differences in color vision between individuals, and variations between viewing conditions, will always lead to different perceptual experiences. The difficulties of modeling individual vision and viewing realities will somewhat limit the usefulness of models based upon a "standard" observer and a "standard" viewing specification. The use of color appearance models within color imaging systems will, nevertheless, lead to improved quality for routine color reproduction work in the printing industry. For the high-quality segment of the mar-ket, however, the services of skilled system operators will also be required for the idiosyncratic and demanding requirements of this type of work.

6 Color Measurement and Specification

Introduction

Despite wide differences in illuminants and considerable variation in human visual processes, there is a need for a standard color measuring system and instrument. Such a device would at least permit communication of color specifications and tolerances, and lay the foundation for the science of color. The difficulty with numerical specifications, however, is that they tend to be shunned by such people as artists and designers, who have a need for a system made up of physical samples that allows direct selection and comparison. Many of these color sample systems, consequently, have been developed over the years, the first probably dating back to the color atlas of the Swedish scholar Brenner in 1680. The final and most common method of color specification is verbal. This is the least accurate of all specification methods, and little progress has been made toward a general acceptance of standardized terminology.

The printing industry has a special need for good measurement and specification systems because of the close interaction between creative and manufacturing tasks. Another reason is that printing deals with colors in a variety of forms; i.e., pictorial and flat, high and low gloss, and metallic and fluorescent, all on a wide variety of substrates. The demands for a universal specification system are quite high, but impossible to satisfy; therefore, the industry has adopted a multiple-solution approach to color measurement and specification.

The Attributes of Color

Over the years, a considerable body of scientific knowledge has been assembled concerning the specification of color. From the printing industry viewpoint, we have primary interests in quantifying the colorimetric and surface aspects of color.

Colorimetric Properties

The **colorimetric properties** of color are those that describe its *hue, saturation,* and *lightness.* The **hue** of a color is the name of a color. It identifies whether a color is red, blue, green, yellow, or some combination term as greenish yellow or bluish red. Such other terms as magenta or crimson are often used as hue names. Hue may have an infinite number of steps, or variations, within a color circle. A circle displays all the hues that exist; indeed, it can be said that any reproduction process is capable of matching any given hue.

The **saturation** of a color is its purity property. A gray-green, for example, has low saturation, whereas an emerald green has higher saturation. A color gets purer or more saturated as it gets less gray. In practice this means that there are fewer contaminants of the opposite hue present in a given color. To illustrate this concept, imagine mixing some magenta pigment with a green pigment (the opposite hue). The green will become less and less saturated until eventually a neutral gray will be produced. A gray scale has zero saturation. The illustration shows the magenta-green saturation continuum. Magenta becomes desaturated by the

The hue component of color shown on an abridged color circle.

The divisions are approximate.

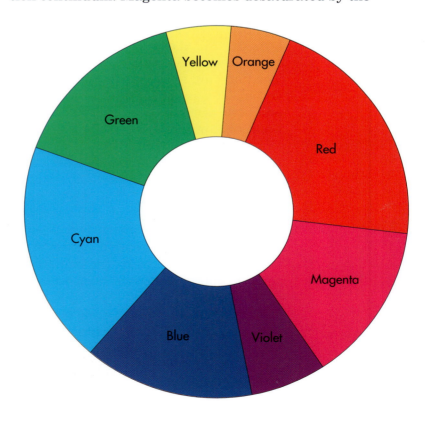

The saturation component of color for the magenta-green hue axis.

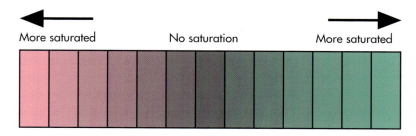

More saturated No saturation More saturated

addition of green in the same way green becomes desaturated by the addition of magenta.

As a color becomes less saturated, it is said to be dirtier or duller, and as it becomes more saturated, it is described as cleaner or brighter. There is a limit to how desaturated a color can be (it will always reach neutral gray) and there are practical limits in reproduction processes to how saturated a color may appear. These practical limitations in printing are due to the characteristics of the chosen ink-substrate combination.

The **lightness** of a color describes how light or dark it appears (e.g., a light green as compared to a dark green). In fact, the terms lightness and darkness are synonymous. Lightness or darkness of a solid color may be changed by

The lightness component of color for a green.

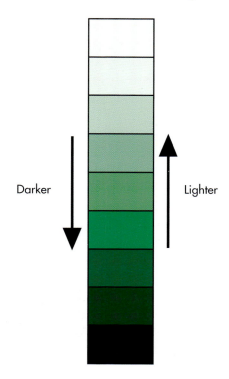

Darker Lighter

mixing either white or black ink with the color. In process-color printing this is achieved by printing a color at various halftone percentages from 0 to 100 (mixing with white), then overprinting the 100% solids with increasing percentages of black (mixing with black). The illustration on the preceding page shows the lightness aspect of color.

In practice both lightness and darkness have limits. In printing, the lightness of a color is limited by the properties of the substrate. It is generally possible, for example, to achieve lighter colors on a good coated paper than on newsprint or uncoated recycled paper. The darkness of a printed color is limited by the gloss of the substrate and the ink, and the amount of ink (and pigment) that can be physically transferred to the substrate. Drying, trapping, dot spread, and economic factors restrict the thickness and number of ink films that can be sequentially printed.

Surface Properties

The **surface** characteristics of an ink-substrate combination are *gloss, texture* and *luster*. The influence of **gloss** on color may be observed in the lightness and saturation dimensions. A color with a glossy surface, for example, appears darker than one with a matte surface. This is because the matte surface scatters some of the incident light back to the eye of the observer. This light "dilutes" the other light reflected from the colored area or object and, for example, turns a dense black into a gray.

Some printed matter is overprinted with a high-gloss varnish in order to improve the color gamut. This practice, along with using high-gloss papers and inks, generally improves pictorial reproduction up to the point that it creates objectionable glare.

The **texture** of a surface is somewhat related to its gloss— the more texture, the lower the gloss. Texture can be deliberate or unwanted, regular or irregular.

Regular texture patterns include silk, pebble, and grained finishes. Textures are generally created by rotary embossing techniques during the papermaking process. One intent of such finishes is to add a tactile element to the product. In printing, textured substrates are sometimes used for greeting cards, annual reports, and calendars. These finishes lower the lightness range of the reproduction and reduce resolution. Texture effects may also introduce a regular or irregular pattern to smooth tonal areas. Although the human eye (subjective) and the glossmeter (objective) agree in rank-

ing the gloss of smooth surfaces, they usually disagree in evaluating embossed (textured) paper.

Irregular textures are usually encountered on uncoated paper, commonly called vellum, antique, natural, etc., finishes. The paper fibers form an irregular texture that varies according to fiber type, degree of calendering, paper additives, and other papermaking factors. Artist's watercolors or designer's drawings that are prepared on uncoated paper usually reproduce well on this type of paper surface.

Deliberate textures can be either regular or irregular. They are chosen by the designer to enhance the tactile properties of the printed piece with the knowledge that this choice will limit aspects of color and image quality. These limitations may not be significant when reproducing wash or pencil drawings but are usually undesirable when reproducing photographic originals.

Unwanted textures usually come from the use of lower-grade (and cost) papers. They are always irregular.

Luster is the property of a sample that results in selective spectral reflection from the surface of the sample. For printed samples, this effect is best represented by such metallic inks as gold or silver; however, it also can be characterized by the **bronzing** that occurs inadvertently with some inks (this is caused by toner migration to the surface of the ink). In both cases, some of the incident light is reflected by randomly distributed particles that lie on the surface of the sample. The spectral composition of the specular reflection from the particles is determined by the kind of particles (gold, silver, or bronze). The incident light not reflected by surface particles penetrates the surface of the sample, is selectively absorbed, and reflected back to the observer. The specular reflection from the random surface particles is mixed with the background (mostly diffuse) reflection from the underlying colorant. The perceived color depends upon the spectral absorption properties of the underlying colorant, the spectral absorption (if any) of the surface particles, the viewing geometry and degree of diffusion, and the number and distribution of surface particles. The surface reflection component is highly dependent on the viewing geometry; therefore, the perceived color will change as the sample is moved. This is desirable for metallic finishes but may not be so for other ink films. Luster cannot be measured satisfactorily by instruments.

Colorant–Illuminant Interaction

The appearance of some colors is strongly influenced by the color temperature of the incident light. Actually, all colors change appearance if they are illuminated by different light sources; however, in many cases the eye adapts to the source in question and perceives the color as being the same as it appeared under a different source. The eye readily accepts, for example, the same piece of paper as being white when illuminated alternatively by noon sunlight and indoor tungsten light. The eye adapts, within limits, so that the paper appears white regardless of the illumination. This phenomenon is called color adaptation (see Chapter 5).

A nonadaptive system such as the emulsion of color film records two very different colors when photographing the white paper under the two illuminant conditions described above. There are, however, instances described below when, regardless of the adaptation of the eye to a reference white, a color is perceived as different under a different illuminant.

Fluorescence

Fluorescence occurs when a pigment has the property of absorbing radiant energy of a given wavelength and then emitting this energy at a different wavelength. Some papers, particularly bond papers, have these pigments added in the manufacturing process. Energy in the near-ultraviolet region (380–400 nm) is absorbed and then emitted as visible energy around 420–430 nm. This extra blue-light reflection helps to neutralize the natural yellowish color of most papers. Fluorescence can also occur when visible radiation is converted into visible radiation at a longer wavelength. Generally, the fluorescence process converts short-wavelength, high-energy radiation into longer-wavelength, lower-energy radiation. Light rich in short-wavelength radiation (noon sunlight) produces more fluorescence than light rich in longer-wavelength radiation (tungsten sources).

Metamerism

Metamerism is the condition when two or more color samples match under one illuminant but appear different under another illuminant. Generally, the colors most likely to show this effect are of relativity low saturation. Metamerism occurs when different pigments that have significantly different spectrophotometric curve shapes are combined to produce a new color. It is possible, for example, to combine various proportions of green, magenta, and white ink in order to achieve a neutral gray under a given light source. Another gray can be prepared to match the first by mixing

Spectral radiance curves of fluorescent orange printing ink (A) irradiated with a source that resembles daylight; (B) the same source with the ultraviolet component removed; and (C) tungsten filament incandescent lamp.

Courtesy IOP Publishing Ltd., from *The Colour Science of Dyes and Pigments* second edition (by K. McLaren).

black and white inks. If the illuminant is changed, the black–white–gray will still be neutral, whereas the green–magenta–white–gray will no longer be neutral. This problem of the metameric match is most likely to occur when mixing inks to form a special color, or when making comparisons between the original and the reproduction.

Samples that match under at least one illumination condition for one observer are called metameric matches, metameric pairs, or metamers. A metamerism index may be derived from color difference measurements of a metameric pair under other illumination–observer conditions (see Chapter 4 for a further discussion of metamerism).

Metamerism effects may also occur when two observers attempt to make a color match under identical conditions. Observer metamerism often occurs, for example, when making three-color gray selections for gray balance determination (see Chapter 9). Another kind of observer metamerism occurs when a color scanner "sees" the colors of an original differently from that of the human observer.

A major purpose of using standard illuminants when judging color in the graphic arts is to overcome the problems of fluorescence and metamerism. A standard source produces a fixed fluorescent effect for a given pigment; likewise, a standard source reduces many metamerism problems.

Spectrophotometric curves of a halftone black tint (A) and a CMY halftone gray tint (B) of the same density that are a visual match under 5,000K illumination but differ under tungsten illumination.

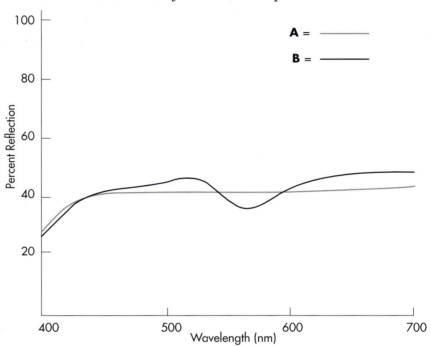

Color and Appearance Measurement

The measurement of color and appearance by instrumental methods is necessary if we want to quantify these factors. Quantification is particularly useful when we need to communicate color specifications or establish quality control limits. If the numbers are related to a universal standard, and the measuring instruments are precise, then numerical specification is the least ambiguous and most flexible of all the color measurement and communication systems. Unfortunately, color and appearance are not easy attributes to measure. Many aspects of the human visual system are still not clear to vision scientists, hence making it very difficult to develop instruments to simulate this complex system. Reliable instruments have been developed, however, that allow us to quantify certain aspects of color.

Spectrophotometers

The **analytical spectrophotometer** is used to quantify, on a wavelength-by-wavelength basis, the radiation reflected (or absorbed) by a given object. In practice, abridged spectro-

photometers are frequently used to make these measurements every 10 or 20 nm instead of continuously.

The light reflected (or absorbed) at a given wavelength is expressed as a percentage of the incident light at that point. A perfect white, for example, reflects 100% of the incident light at every wavelength, regardless of the overall spectral composition of the illuminant.

The percentage of light reflected by an object is plotted against the corresponding wavelength where the measurement was made. A curve drawn through the resulting points is called a **spectrophotometric curve**.

The spectrophotometer is the most accurate method of characterizing the absorption properties of any given color. The spectrophotometric curve, however, is an abstraction that does not lend itself to easy color visualization; furthermore, spectrophotometers are precision instruments that require knowledgeable operators. In the printing industry, a primary use of the spectrophotometer is for pigment-mixing computation and ink-color quality control. These uses are largely confined to ink manufacturers, but some of the larger packaging companies also employ spectrophotometers for these purposes.

Computer color matching procedures are based upon the 1931 work of Kubelka and Munk, who developed an equation that showed an exponential relationship between spectral reflectance and a coefficient of absorption, and one of scatter for colorants. The initial work was refined by Kubelka, and later by others, to produce computationally efficient equations. McLaren (1986) has described the evolution of computer color match prediction technology. The primary printing industry application of these equations is to produce solid color matches (Genshaw, et al, 1984, for example) rather than for halftone color reproduction tasks.

Spectro-colorimeters

A **spectrocolorimeter** is an instrument that initially records the spectral absorption of a colorant by spectrophotometric methods (i.e., by making measurements every 10 or 20 nm and expressing them as a percentage of the incident radiation at the wavelength band that was used for each respective measurement). Software within the spectrocolorimeter converts the spectral data into equivalent colorimetric values. The software typically offers the operator the choice of CIE Standard Observer (2° or 10°), illuminant (A, C, D50, D65, etc.), color space (CIE XYZ,

Hunter Lab, CIELAB, etc.), and color difference equation (FMC-2, CMC, CIELAB, etc.).

Software may also be used to convert spectral data into density readings. Typically, the program will develop the filter profile best suited to the color being measured; i.e., one that produces the highest density value. This feature is of interest when special color inks are being used that do not produce a high density reading when measured through conventional filters. The software may also be used to generate standard filter profiles for more routine applications. Dedicated instruments of this type are often known as spectrodensitometers. Some instruments are capable of functioning as either spectrocolorimeters or spectrodensitometers.

Most of today's spectrophotometers are, in fact, spectrocolorimeters. The availability of inexpensive computer systems and software provided the opportunity for making a simple upgrade of a sophisticated electro-optical-mechanical device that was difficult to resist. The software always offers the operator the choice of operating the spectrocolorimeter as though it were a spectrophotometer.

Colorimeters

Colorimeters are designed to "see" color the same as the human observer. The foundation for the development of this instrument was established in 1931 when the Commission Internationale de l'Éclairage (CIE) defined their standard observer for a 2° field of view (the 2° field of view corresponded with the fovea region of the retina). The 1931 CIE Standard Observer was based upon experiments conducted by W. D. Wright in 1928 and 1929, and those by J. Guild in 1931. These experiments required each subject to vary three primary light sources to match a series of adjacent spectrum colors. Guild had his seven subjects use different primary sources from those used by Wright with his ten subjects. The CIE later chose monochromatic matching stimuli of 700 nm (red), 456.1 nm (green) and 435.8 nm (blue) for purposes of deriving their standard observer.

The color-matching results of Wright and Guild were sufficiently similar to allow the CIE to mathematically transform their data to establish standard observer color matching functions. The resulting curves were further transformed to eliminate negative portions and to make one (Y) of the resulting functions identical to the brightness response of the visual system. In 1964 the CIE established a standard observer for a

The CIE color matching functions for the 1931 2° observer and the 1964 10° observer.

From F.W. Billmeyer and M. Saltzman, *Principles of Color Technology* second edition. Reprinted by permission of John Wiley & Sons, Inc.

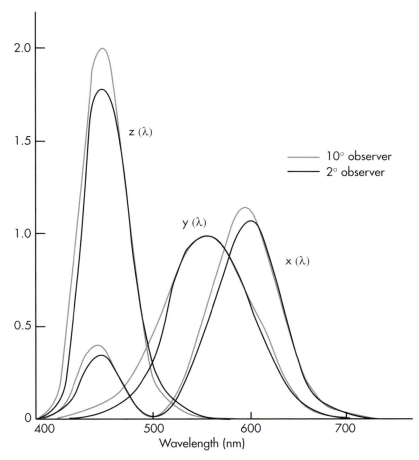

10° field of view. The illustration above shows the CIE 2° and 10° standard-observer color-matching functions.

The color-matching functions for the 2° or 10° observer are applied mathematically to the data recorded by the spectro-colorimeter. This approach has rendered the three-filter tristimulus colorimeter almost obsolete. Tristimulus color-imeters are quite suitable for routine color applications (e.g., printing solid color labels), but they lack the flexibility of spectrocolorimeters.

The values X ("red"), Y ("green"), Z ("blue") derived from the tristimulus response of the colorimeter are converted into chromaticity coordinates (x, y) for display purposes. The following formulas are used:

$$x = \frac{X}{X + Y + Z} \qquad\qquad y = \frac{Y}{X + Y + Z}$$

The resulting point on the chromaticity diagram is an indication of the hue and saturation of the color.

Lightness is the third dimension (Y) of color and can be visualized as points suspended in space above the diagram. Lightness may be represented by a number next to a point on the chromaticity diagram. The higher the number, the lighter the sample.

Colorimeters measure a sample in terms of different color temperature light sources. The original CIE standard sources are source A (2,856 K), source B (4,874 K), and source C (6,774 K). Source B is now obsolete. In recent years a series of D illuminants has been defined by the CIE to more closely simulate the ultraviolet component of daylight. Standard Source C has too little energy in the ultraviolet region for making valid measurements of fluorescing samples. These D illuminants exist as mathematical specifications only and cover the range of 5,000 K to 7,500 K. They are called the CIE

The CIE chromaticity diagram showing the locus of a black body at different Absolute temperatures.

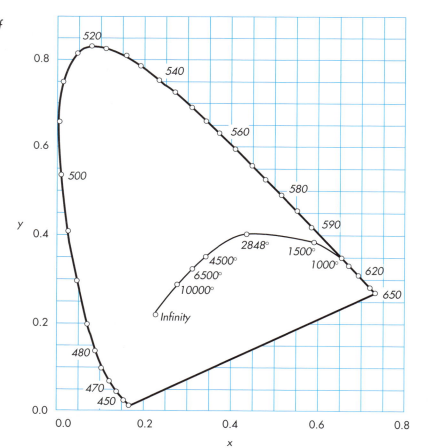

Daylight Illuminants and are recorded as D50 to D75 in the technical literature.

The CIE chromaticity diagram has several drawbacks; namely, it was designed for measuring the color of light sources rather than the color of objects, equal distances on the diagram do not correspond to equal visual differences, and it is conceptually awkward to explain in terms of normal color descriptors.

The Hunter Lab system represented a significant advance over the CIE chromaticity diagram. Colors were displayed in a three-dimensional space that was based upon opponent color relationships (see illustration). The "L" value represented lightness (white–black), the "a" value represented redness or greenness, and the "b" value represented yellowness and blueness. The Hunter color space was much more perceptually uniform than the CIE color space and it had the added advantage, from the printing industry point of view, of being designed specifically for evaluating objects by reflected light.

In 1976 the CIE introduced two new color space representations. They are the L*, a*, b* system (also known as CIELAB) and the L*, u*, v* system (also known as CIELUV). Both are more perceptually uniform than the original, x, y, Y system. These systems are somewhat similar to the Hunter

The Hunter L,a,b Color Solid.

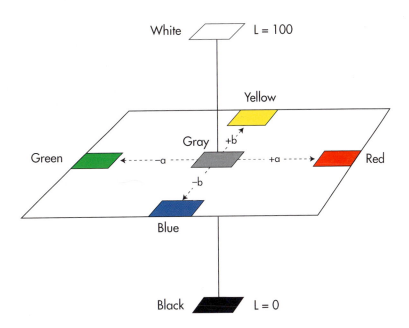

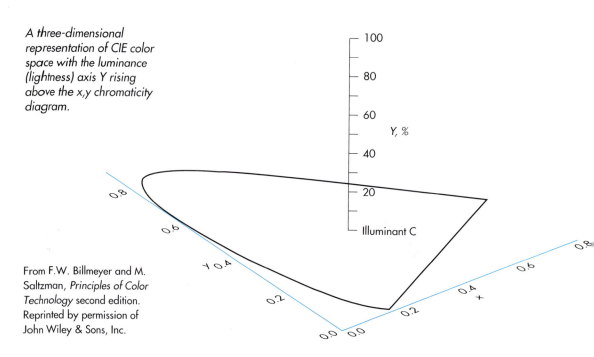

A three-dimensional representation of CIE color space with the luminance (lightness) axis Y rising above the x,y chromaticity diagram.

From F.W. Billmeyer and M. Saltzman, *Principles of Color Technology* second edition. Reprinted by permission of John Wiley & Sons, Inc.

system in that a* or u* indicate redness-greenness and b* or v* indicate yellowness-blueness.

The CIELUV color space was recommended by the CIE for applications that used additive color mixtures (e.g., color television and color computer monitors). The CIELUV chromaticity diagram is a more perceptually uniform distortion of the original chromaticity diagram.

The CIELAB color space has been widely adopted for surface color measurement applications (e.g., printed products). The mathematics of CIELAB color space are such that a uniform chromaticity space (i.e., mixtures of two lights in various ratios plot on straight lines) is not possible; therefore, CIELAB uses an opponent-colors space (similar to Hunter Lab) for graphical presentation of data.

There is general agreement that either of the successors to the original chromaticity diagram is an improvement; however, the perfect color-space system does not exist. None of the present systems will represent equal visual differences as equal distances on the color diagram for all regions of color space. They are, however, close enough for many quality control applications.

Color Difference Equations

Colorimetric systems and instruments typically incorporate color difference equations in the computer section. These formulas express, in terms of just noticeable differences, how

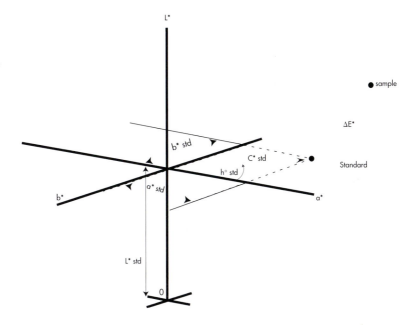

*Three dimensional repre-
sentation of L*a*b* color
space illustrating overall
color difference (ΔE*)
between a standard and a
sample.*

far a given color is from some reference standard that had
been previously incorporated into the memory. Mathematical
details of the major equations are presented in Appendix C.

A just noticeable difference (or a just perceptible differ-
ence) is usually referred to as a MacAdam unit after David
L. MacAdam's research that was conducted in 1942 and
later. MacAdam and other workers have derived ellipsoids
that represent the average spread in color difference percep-
tibility within CIE color space. These ellipsoids vary in size
according to the color being matched; that is, the human
color vision system is not equally sensitive to all colors.

In practice, color differences are usually expressed in units
that are from two to four times as large as MacAdam units.
Among these larger units are the CIELAB, CIELUV, Hunter,
and NBS. None of the color difference formulas has gained
universal acceptance; therefore, colorimeters usually provide
the option for computing color difference in terms of two or
more individual equations.

The FMC-2 (Friele-MacAdam-Chickering) color difference
equation was based on the MacAdam ellipsoids. The result-
ing ΔE (overall color difference) that is computed by the
FMC-2 equation is expressed in terms of MacAdam units.

The widespread use of color difference equations was pos-
sible when inexpensive computers became available. FMC-2

was, for some time, a commonly-used equation but its popularity has faded with the introduction of improved equations. Deane Judd at the U.S. National Bureau of Standards (NBS), now the National Institute of Standards and Technology, developed a scaled color space in 1935. The NBS unit also became a measure of color difference. Judd's initial 1939 formulation was modified by Hunter in 1942 to create the unit most widely cited as an NBS unit. In time, a number of competing color difference equations were developed and converted into either NBS or MacAdam units. The characteristics of individual equations, when combined with the conversion equations, produced a good deal of confusion because different equations produced different results from the same samples. The meaning of a MacAdam unit or NBS unit became unclear without reference to the equations used to make the computations. It was not possible to convert units from one equation into units for another equation.

The Hunter color difference meter of 1948 was based on a general opponent-color vision model: the "L" value designated lightness, "a" was red–green and "b" was yellow–blue. The instrument achieved considerable popularity because it allowed the user to make direct color difference measurements without having to make complicated supplementary calculations. The Hunter Lab color space was perceptually more uniform than the CIE color space, and the color difference unit was found to be quite satisfactory for industrial color control applications. The NBS unit used by Hunter was roughly equal to 2 or 3 MacAdam units. The MacAdam "just perceptible" units were derived under conditions that were designed to explore the thresholds of human color vision.

The CIE introduced new color difference equations along with the recommended CIELAB and CIELUV color spaces of 1976. These formulas (especially the popular CIELAB version) did much to help standardize the field of color difference evaluation. In time, however, a number of researchers developed new equations to help solve some of the nonuniformities of CIELAB. The best known of these formulas is the CMC (l:c) equation that was developed by the Colour Measurement Committee, Society of Dyers and Colourists, Great Britain.

There are two versions of the CMC equation. The difference between the equations have to do with the weights assigned to the correction factors l and c. The 2:1 version of the equation is best suited for establishing color tolerance levels for quality control, whereas the 1:1 version is best

suited to applications where the threshold sensitivity of the eye is the region of interest. The latter equation gives lightness variation more influence that the 2:1 version.

Tests of various equations by Berger-Schunn (1994, pp. 35–56) suggest that CMC (2:1) is better than CIELAB in terms of representing equal tolerances in all regions of color space. Berger-Schunn also cautions that despite the successful application of color difference equations to industrial practice, a number of warnings should be heeded concerning their use:

- The color difference (ΔE) is meaningless unless the formula used for the calculation is specified.
- Color differences calculated by one formula cannot be simply transformed into those calculated by another formula.
- No color difference formula is absolutely uniform across all regions of color space.
- The light source for visual evaluation is invariably different from that used to make the color difference computations.
- The sensitivity of the observer's color vision is invariably different from that of the CIE standard observer.

Densitometric Analysis

Strictly speaking, densitometers cannot be used to measure color. Spectrophotometers measure the physical absorption characteristics of a color sample. Colorimeters measure a color relative to how the human visual process sees that color. A densitometer is not related to either of these basic color measurements but is simply an electronic instrument used to measure optical density.

Densitometers are frequently used in the printing industry to monitor ink film thickness on press. A sufficiently good relationship exists between the density scale and the physical ink film thickness (IFT) for this to be a successful application of densitometry. The measurements that are made of IFT are not measures of color because they are made

Density matrix and color coordinates for the Preucil measurement system.

Ink	Blue Filter	Green Filter	Red Filter	Hue	Gray
Yellow	1.04	0.06	0.02	3.9	1.9
Magenta	0.45	1.14	0.08	35.0	7.0
Cyan	0.08	0.30	1.02	23.0	7.8

through only one filter, usually the color complement of the ink being measured.

A system for quantifying color that is based on densitometry was developed by Frank Preucil. The system involves making measurements of a printed ink film through each of the red, green, and blue filters (Cox, 1969). These measurements are converted to percentage hue error and grayness values by using these formulas:

$$\text{Hue Error \%} = \frac{M - L}{H - L} \times 100$$

$$\text{Grayness \%} = \frac{L}{H} \times 100$$

where L = the lowest densitometer reading, M = the middle reading, and H = the highest reading.

Hue and gray values are then plotted on appropriate color diagrams. The lightness dimension theoretically extends vertically from the page.

The color triangle is useful for describing the color gamut of an ink set (see Chapter 7) and for determining ink color correction requirements (see Chapter 12). The color circle is preferred over the triangle for making comparative plots of many ink sets or printing conditions (see Chapters 7 and 8).

Densitometric measurement of colors is not related to the visual appearance of these colors; furthermore, different densitometers often read the same color differently because of the lack of universal color response specifications. The relatively recent specification of standard color filters (Status T, in particular) has helped to reduce inter-instrument variability when using density-based color diagrams.

Another densitometric diagram that has been used for representing the color of printed ink films is the color hexagon (really trilinear graph paper). This diagram displays only the hue and lightness color dimensions. The hexagon is normally used for comparing proof and press solid and overlap colors, or for investigating ink trap behavior (see Chapters 8 and 13.)

Optical Geometry Considerations The surface characteristics of printed images can vary considerably because of the differences between substrate properties, the use of overprint varnishes or coatings, and the degree of ink film gloss present. Under such circumstances, the geometric relationships between the illuminating source and

the sensing device of a color measuring instrument can exert a considerable influence on the resulting measurements.

Instruments are manufactured with a wide range of optical geometries. One of the simplest is the 45/0 design: the surface is illuminated by a beam that is 45° incident to the surface, and is analyzed by a sensing device that is perpendicular to the surface. The reverse geometry, 0/45, may also be used. This kind of geometry is most sensitive to such directional effects of the sample as paper grain. The orientation of the sample influences the measurement; hence, care must be used when positioning the sample. The 45/0 geometry agrees quite well with visual rankings of samples with both matte and glossy surfaces.

The problem of sample directionality effects may be eliminated from 45/0 geometries by configuring the instrument for circumferential illumination of the sample. A single source together with a circumferential reflector system or a fiber optic network is used to provide the required configuration. The reverse geometry may also be employed; i.e., illumination normal to the surface and collection via a circumferential collection device that directs the reflected light to a single sensing point. Optical geometries of this type are quite common and seem to perform better than integrating sphere instruments for certain tasks (Rich, 1988). There does not appear to be significant differences between the 0/45 and 45/0 configurations, but it is important that these instruments are manufactured to strict tolerances.

One form of integrating sphere geometry uses a single illuminant at about 8° away from perpendicular to the sample. The light reflected from the sample is reflected within a matte-white finished spherical enclosure. The resulting diffuse light is collected by a photodetector that is positioned in an aperture of the sphere. In practice, a geometrical configuration with the reverse illumination and collection placement from that just described is quite common. Integrating sphere instruments allow the operator to include or exclude the gloss component from the measurement. A specular reflection light trap is set within the boundary of the sphere at an angle equal to the angle of incidence. The specular component is excluded by placing a black trap over the aperture. The specular component is included by placing a white plug in the aperture. It is difficult to completely exclude the specular component because sample gloss is always less than 100% and, consequently, the light trap aperture is almost

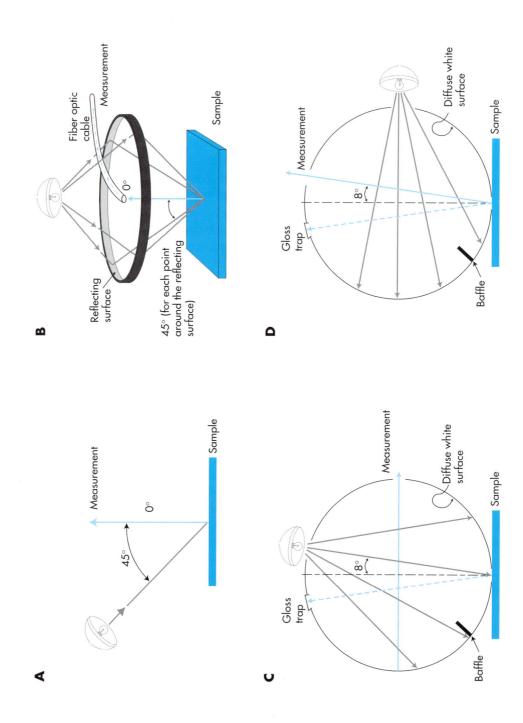

Schematic diagrams of the measurement heads for (A) 45/0 direct; (B) 45/0 circumferential; and (C and D) integrating sphere geometries.

100% and, consequently, the light trap aperture is almost never large enough to trap all of the specular reflection.

The measurement of fluorescent samples is influenced by the optical design of the instrument. There are two basic configurations that may be chosen for capturing the wavelength-by-wavelength reflection of a sample by a spectrophotometer: individual wavelength (monochrome) radiation may be isolated before the light falls on the sample or after the reflection from the sample. The former case will not capture the fluorescence effect because fluorescence involves absorption at one wavelength and emission at a completely different wavelength.

The fluorescent sample must be illuminated by polychromatic (full spectrum) light to generate the fluorescing effect prior to the reflected light being passed through a diffraction grating (or, less commonly, a prism). The diffraction grating splits the reflected light into a spectrum. A mask with a slit that corresponds to the required bandwidth is used to sequentially isolate reflectance across the spectrum; alternatively, the light falls on a segmented linear diode sensing device that records each bandwidth directly without the need of an isolation mask.

A potential source of fluorescent sample measuring variability is the light source in the instrument. In order to cause a sample to fluoresce it must be illuminated by radiation of the appropriate wavelength and intensity. The CIE D illuminants are mathematical representations of daylight conditions that will induce fluorescence; but, because the D illuminants do not exist as actual sources, there is no simple way to predict the resulting spectrophotometric curve. In practice, a pulsed-xenon light source provides the most convenient means of inducing fluorescence within a measuring instrument. Xenon sources do vary, and absorption characteristics of elements in the optical path will also shift the light that illuminates the sample further from daylight. In short, it is difficult to accurately characterize fluorescent samples.

The spectral reflectance radiance factor that represents the fluorescence effect may be isolated by making a set of measurements on a special instrument. In one case, the sample is illuminated by monochromatic light, and in the other case, by polychromatic light. The difference between the reflectance values at each wavelength defines the spectral reflectance radiance factor. Specialized sources (e.g., Hunt, 1991, pp. 187–198, or Grum, 1980) should be consulted for

detailed information on the measurement of fluorescent materials.

**Color
Measurement
Applications**

Reductions in instrument cost and the introduction of simplified operational procedures have greatly expanded the type and number of color measuring instruments in use in the printing industry. The common applications, together with the instruments and computations that are used, are as follows:

Paper and ink manufacturing. A spectrocolorimeter is used to generate the initial data, which may then be displayed as a spectrophotometric curve or converted into CIELAB or similar perceptual color space. Each measure will be used to characterize certain properties (e.g., fluorescence, whiteness, absorption) of papers or inks, or to ensure that the materials conform to such specifications as those established through industry-wide committees (e.g., SWOP, SNAP, GRACoL).

Pigment mixing. A spectrophotometer is used to measure colors for matching by single solid ink films rather than halftone values. A computer program uses the spectrophotometric curves of stored pigments to decide the proportion, type, and number of pigments that shall be used to match the spectrophotometric curve of the supplied sample.

Color gamut evaluation. A colorimeter is usually preferred for making color gamut measurements. In general, such opponent-color display systems as Hunter Lab or CIELAB are chosen for this application. A two dimensional scale that plots the hue and saturation dimensions is accompanied by a single dimension scale that represents the lightness values.

A densitometer may be used in conjunction with the GATF Color Triangle to quantify the hue and saturation dimensions of color gamut. This representation is a relative display that does not correspond to visual perception. There are, however, some useful practical applications of this method when reflection color originals are being used.

Press makeready. Densitometers are used for measuring ink trapping, density evenness across the image, halftone dot area, print contrast ratio, and solid density value. Density values of solids may be plotted on a GATF Color Hexagon

diagram for making graphical comparisons between proof or standard values, and the makeready image.

Press running. Densitometers are used for measuring changes in solid color density, which is a surrogate measure for ink film thickness. A densitometer may also be used to measure the ongoing variation in the factors discussed in the press makeready section. A spectrodensitometer is used to generate a filter absorption profile best suited for monitoring ink film thickness variations in special or non-process color inks.

A spectrocolorimeter is used to monitor three-color gray field variations in process color printing. Color difference equations are used to express gray field variations in terms of ΔE units.

Proofs. The same instruments, equations, graphs, and methods used for evaluating press makeready and running may be used to evaluate proof production.

Originals. Reflection originals may be measured with a colorimeter to evaluate whether a particular color falls within the color gamut of a particular ink-paper combination. In practice, however, it may be difficult to make satisfactory measurements because of variations in image detail within the color region of interest.

Gloss Measurement

Gloss is an important element of appearance for printed products. The substrate's surface characteristics and the type of overprint varnish or coating are carefully chosen to enhance the aesthetic and technical excellence aspects of the reproduction. Certain overprint varnishes or coatings also provide a protective barrier that is important for such products as folding cartons, book jackets, and labels.

Just as a spectrophotometric curve characterizes the color of a sample, a goniophotometric curve characterizes the surface properties of the sample. A **goniophotometer** is a somewhat complex device that is used for quantifying surface reflection effects. In one case the illuminating source is fixed at a given angle to the sample to establish a steady profile of surface reflection. The collection and sensing of the reflected light occurs at multiple angles in both directions from the sample's orientation. In other cases, both the illuminating and collecting angles may be varied. In either case, a

Principle of the glossmeter.

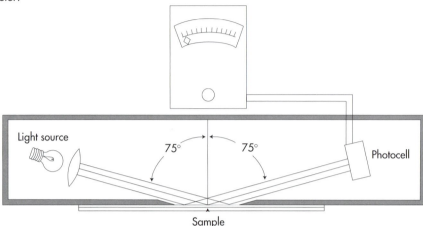

Light source

75° 75°

Photocell

Sample

series of measurements are made to establish the reflectance profile from the surface of the sample. Goniophotometric profiles are used mainly to ascertain the optimal angles for making gloss measurements.

As a general rule, goniophotometers are not suitable for routine production applications. Glossmeters are much simpler instruments that produce rankings of samples with good correlation to visual rankings. There are, however, several kinds of gloss (Hunter and Harold, 1987), which precludes the use of a single geometry for measurement purposes.

The three general kinds of gloss of most interest to the printing industry are specular gloss, sheen, and contrast gloss (luster). The TAPPI standards for gloss measurement of paper specify the following glossmeter geometries: for coated papers, gloss is measured 75° from perpendicular or 15° from the plane of the paper (this is a sheen-type of gloss measurement); and for cast coated papers gloss is measured 20° from perpendicular or 70° from the plane of the paper (this is a specular-type of gloss measurement). Contrast gloss, or luster, may be examined by making a series of goniospectrophotometer measurements, but there are no routine techniques for measuring this effect.

Visual Color Order Systems

Numerical expressions of color do not convey much real sense of what the color actually looks like. Artists, designers, many workers in the printing industry, and the general public are likely to place low, if any, value on numbers that represent color appearance.

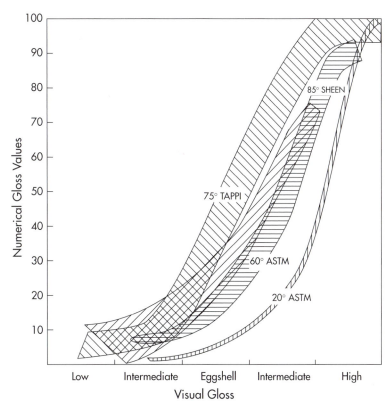

Difference between values of four numerical gloss scales as plotted against visual ratings of gloss.

Reprinted with permission from R.S. Hunter and R.W. Harold, *The Measurement of Appearance* second edition (1987).

Most people are more comfortable describing color in terms of an existing sample. To facilitate this kind of specification and communication, many color order systems that consist of physical color samples have been devised. There are two basic types of color order systems: one is an absolute system, made up of permanent color chips and generally can be expanded up to the theoretical color limit whenever new permanent colors are discovered; the other is a relative system, where the color gamut is fixed by a given set of colorants and does not allow or need expansion.

Absolute References

Examples of absolute systems include Munsell, Ostwald, Colorcurve, Natural Colour System (NCS), Deutsche Industrie-Norm (DIN), Optical Society of America Uniform Color Space (OSA-UCS), and the Colorid System. Absolute color order systems are either open-ended systems that allow the continuous addition of new colors, or are based upon a regular geometric solid. They are all based on three-dimensional constructs that represent the color attributes of hue, saturation, and lightness. Billmeyer (1987) has reviewed most of these systems in some detail.

The open-ended systems include the Munsell Color System, the OSA Uniform Color Space (UCS), the DIN Color System, the Colorcurve System and Colorid System. These systems are generally based on polar coordinates. The notable exception is the OSA-UCS, which is based on a cubo-octahedral coordinate system.

The **Munsell System** has been chosen to illustrate the open-ended absolute reference system. Munsell is probably the most frequently used of all the color order systems.

Munsell uses the terms hue, chroma (saturation), and value (lightness) to describe the attributes of color. Five basic hues make up the notation system: red, yellow, green, blue, and purple. The transition from one color to another, e.g., blue to green, proceeds as follows: 10 B; 5 B; 10 BG; 5 BG; 10 G; 5 G. (B = Blue, BG = Blue-Green, G = Green.) Instead of each hue being divided into two, it can be divided into four, or as many as ten, discrete steps; therefore, there may be as many as 100 hue steps in the Munsell circle. The perceptual spacing of hues is larger at high chroma than at low chroma.

The value scale ranges from 1 (black) to 10 (white) with (perceptually) equally spaced shades of gray. The chroma scale is open-ended, starting at zero in the center of the solid

Munsell hue spacing (circumferentially) and chroma (radially).

Munsell Color Space.

and increasing radially. From a practical viewpoint, chroma is limited by the availability of high-chroma samples.

The color identification scheme is given as hue value/chroma. For example, 7 BG 4/3 indicates a bluish green color of hue 7 BG, value 4, and chroma 3. The colors of the gray scale are indicated by the letter N, so N5/ is a gray with the value of 5.

Munsell colors have been produced in both matte and glossy finishes. The *Munsell Book of Color* contains the complete range of samples. They were designed for daylight viewing, but only minimal distortion is likely under other light sources. The color spacing in the system apparently was determined against a relatively light gray background; therefore, the spacing of dark colors is somewhat distorted.

The geometric-solid types of absolute color reference are based on mixtures of white, black, and chromaticity. The Natural Colour System is a good example of this approach.

The **Natural Colour System** (NCS) was developed in Sweden. It is called "natural" because it is based on Hering's psychophysical classification of color according to the six elementary color sensations: red, yellow, green, blue, white, and black.

The NCS color solid takes the form of two cones placed base to base. The four unique hues—yellow, red, blue and green—are placed 90° apart around the hue circle. White is located at the top of the solid, and black is located at the bottom. A vertical slice through the solid will reveal a hue plane in the form of an equilateral triangle; i.e., if the white-black axis is vertical with white at the top and black at the bottom, the pure version of the hue will lie to the right (or left) of the axis such that its distance from both the white and black points is equal to the distance between white and black.

In all, there are forty equal hue triangles in the NCS system, each containing 66 color locations (55 if the gray scale is excluded). The NCS Colour System Atlas contains 1530 samples out of the 2200-plus color space.

The notation system indicates the degree of similarity to the fundamental sensations of white, black, and the hues in question. An orange color, for example, may be identified as 30 yellow, 30 red, 25 white, and 15 black, with the sum always being 100.

The Natural Colour System has the advantage of being conceptually useful to artists and designers while retaining room for expansion. Its major drawback is that differences

The Natural Color System (NCS) showing (top) the color triangle representing a hue slice, and (bottom) the color circle based on yellow-blue, red-green division.

The white-black-color principle of the Ostwald and NCS systems for a single hue plane.

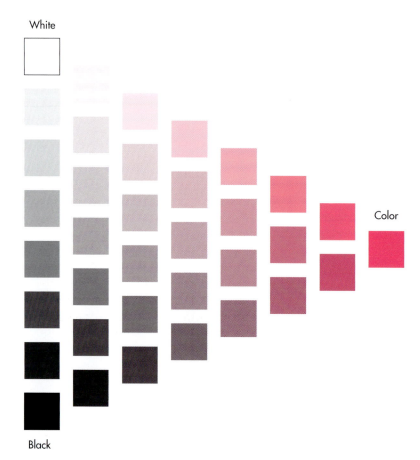

White

Color

Black

between neighboring unique colors are not the same. If we go from unique yellow to unique red in ten equal hue steps, keeping lightness and saturation constant, we would require between twenty and fifty steps of the same size to go from unique red to unique blue. The cubo-octahedral coordinate system of the OSA Uniform Color Space System overcomes this problem along with the problem of high-frequency color sampling near the central axis of polar coordinate systems.

Relative References

Relative references are usually confined to the printing industry and take one of two forms. The first type is the halftone reference, where varying percentages of yellow, magenta, cyan, and black are printed in many combinations on a variety of substrates. (Charts may be produced using more than four colors.) The intent is to characterize the gamut of a given ink-substrate-press combination and to facilitate color prediction and color communication. The second type is the ink-mixing reference, where solid colors, mixed from a standard

set of basic colors, are printed on coated and uncoated substrates. The intent is to record the ink-mixing formula for a given special color. A color selected by a customer may be matched by mixing the basic inks in the proportions listed for the color in question. A detailed review of these approaches has been published (Field, 1987).

It is probable that many hundreds of halftone color charts have been devised over the years. They usually consist of grid patterns, initially containing two colors, each ranging from 0% to 100%. The next page of the chart duplicates the first, except that it adds a uniform percentage of the third color. Each page adds an increasing percentage of the third color until it reaches 100%.

Each individual page may now be overprinted with varying degrees of black in order to complete the range of available colors. An example of a commercially available preprinted chart of this type is the *Color Atlas* by Harald Küppers.

Master film sets for halftone color charts tend to be both difficult and very expensive to produce. The printed charts are often inconvenient to use because of the number of pages and the distance between similar hues (i.e., a lack of color order).

The Foss Color Order System (Foss and Field, 1974) is the only halftone screen tint chart to fully represent CMYK color space in color order. Carl Foss based his system on a cubic color solid. The eight corners of the solid represent the white, black, cyan, blue, magenta, red, yellow, and green gamut limits of the primary colors that are produced by a given ink-substrate-press combination.

In order to form a two-dimensional color chart from a color solid, it is necessary to sample sections of the solid, develop them, and lay them in order on a sheet.

The sampling procedure selected for the Foss Color Order System was to dissect each of the three uppermost surfaces from one corner to the opposite corner diagonally through the cube. This treatment produced six solids called quadri-rectangulartetrahedras.

The development of the outer surface of these solids produced parallelograms. These were shifted into square order to make the chart more compact. The inner planes of the cube were similarly sampled and developed.

The resulting color chart consists of six color pages: blue to magenta; magenta to red; red to yellow; yellow to green; green to cyan; and cyan to blue.

The Foss color cubic solid.

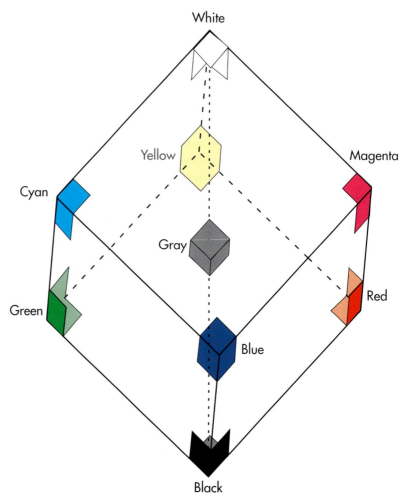

The trichromatic form of the Foss Color Order System.

The black in the system is incorporated by overprinting each of the tricolor areas with discrete steps of black. In order to keep the number of overprintings to a minimum, special black images are used that divide each color square into four. Two black plates will give eight black levels. The complete system contains 5,381 colors.

The nine tone values in the Foss Color Order System were selected to give approximately equal visual increments between each of the nine tone steps. The values are: 0 = 0%, 1 = 4%, 2 = 13%, 3 = 23%, 4 = 33%, 5 = 53%, 6 = 74%, 8 = 87%, 9 = 100%.

An important feature of the Foss Color Order System is that it was produced in the form of master films rather than as a printed chart. (Printers make plates from the films and print their own charts with their inks, papers, and presses.) The films were available in both sheetfed and webfed versions.

The Rochester Institute of Technology Process Ink Gamut (PIG) chart is also a halftone color system that is presented in color order (Elyjiw and Yule, 1972). This chart is restricted to displaying the gamut colors and is intended more as a tool for evaluating the performance of given ink-paper-press systems than for color specification.

Relative color order systems cannot be used as universal reference systems because the printed colors vary from one manufacturing system to another. They do, however, completely and uniquely describe the color space that is available for a given manufacturing system. Absolute color order systems are not flexible enough to give the desired color discrimination for a specific colorant system; also, many printed colors may lie outside the color space of an absolute system, which uses only permanent color samples in its collection. Finally, unlike a relative system, an absolute system does not indicate how to match a given color with printing inks.

The GATF and other color surveys have revealed substantial differences between process-color printing conditions. For this reason, a relative color order system that is generated under the printer's own conditions is the best color reference system available to the industry. Absolute color order systems can sometimes be used for color specification, but "off-the-shelf" printed color charts sold as dot percentage color guides should not be used for accurate color specification or control.

The ink-mixing reference type of relative color order system has existed in many forms. Every ink manufacturer and probably most printers have produced color drawdown samples resulting from combinations of two or more inks. These samples, plus the corresponding mixture records, serve as guides for selecting and mixing future colors. The colors so selected are often printed as the second color in a duotone job or a special background color for a label or a carton.

Various companies have developed color mixing systems that consist of a series of colors (typically nine) plus white and black. Each page of their printed color reference contains up to seven solid colors. The central color on each page is made up of one or more of the basic chromatic colors. The other colors on the page have either white or black added to the central color formula. The sample books are printed on both coated and uncoated substrates to very close tolerances. These printed guides may often be used as semi-absolute references as long as faded or discolored books are replaced on a regular basis. The PANTONE®* MATCHING SYSTEM (formerly called PMS), which was introduced in 1963, is probably one of the most commonly used of the ink-mixing color systems.

Ink-mixing reference types of color order systems can be likened to the Natural Colour System, where the gamut colors are obtained by mixing either white or black with a chromatic color. The color displays of the ink mixing systems are generally restricted to gamut colors; therefore as color order systems, they are incomplete. For the ink-mixing demands of this type of system, however, the color availability is probably satisfactory: selections of second or special colors made by designers would most likely be the more saturated colors shown in the guides. Of course, the system can be expanded to include more combinations of the basic colors if desired.

A process-color halftone version of the gamut colors has been published by Bourges (1997) in a visually balanced form that is intended for graphic design applications. This system consists of 20 basic hues, each of which is formed by either a single process color primary, or by solid and halftone combinations of no more than two primaries. Each basic hue is printed in an 11-step scale (a 5% step, and tones at every

Pantone, Inc.'s check-standard trademark for color reproduction and color reproduction materials.

The master chart of the Bourges System.

Reprinted with permission from Jean Bourges.

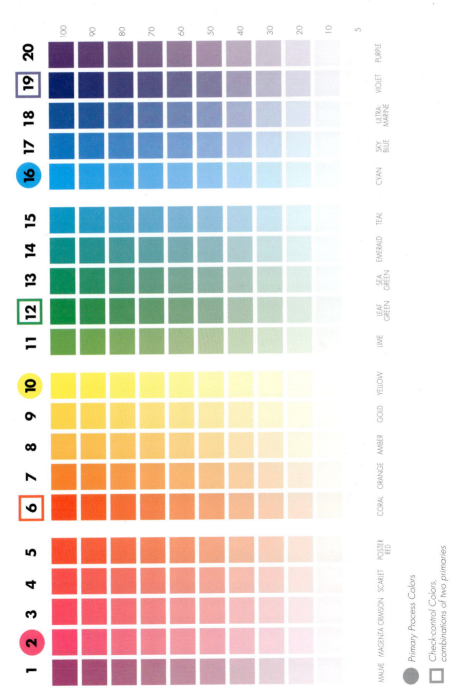

10% to the 100% solid) to establish a 220-color master chart. A 4-level black image (10, 30, 50, and 70% values) may be printed over the master chart to create the darker tones.

The production drawbacks (ink and substrate variability, trapping, and dot gain differences) normally associated with preprinted halftone reference systems have been generally circumvented in the Bourges system. The basic colors are placed within an absolute reference framework by identifying each with spectrophotometric curves, CIE chromaticity diagram plots, and CIELAB values. These notations make it possible for production personnel to use color management systems to reconstruct the original color values within any given production system that has a similar gamut.

Verbal Color Description

Numerical descriptors of color are usually too abstract for most people. Color sample descriptors are sometimes inconvenient to obtain, locate, and use. Verbal descriptors, by contrast, are used extensively in all fields of human endeavor. The key problem with verbal descriptors is that they do not have universal meanings, and therefore make specification and communication somewhat imprecise.

There are several aspects to the problem of using words to convey color descriptions. The first is the language itself. Some cultures have only two words, black and white, to describe all colors. The maximum number of basic color terms that are included in a language is eleven. They are added in this approximate order: white, black, red, green, yellow, blue, brown, purple, pink, orange, and gray (Berlin and Kay, 1969). A key problem with using words to describe color is that there are no universally accepted names for colors. Indeed, marketing managers often invent new names to replace existing names in an attempt to convey the impression that a particular product is now available in a new color.

A further problem with verbal description is the lack of universally accepted terms for describing changes in color. Such terms as lightness and darkness, vividness, brilliance, paleness, and deepness are often used to modify color names or to indicate the direction of a desired change.

The problem of color naming was addressed by the Inter-Society Color Council (ISCC) in 1931. Work by the ISCC and the National Bureau of Standards (NBS) led to the NBS publication *The ISCC-NBS Method of Designating Colors and a Dictionary of Color Names* by Kenneth L. Kelly and Deane B. Judd (1955). This landmark work (which is periodically

ISCC-NBS hue descriptors.

ISCC-NBS Hue Descriptors

Red	Yellow Green
Pink	Olive Green
Yellowish Pink	Yellowish Green
Reddish Orange	Bluish Green
Orange	Greenish Blue
Brown	Blue
Orange Yellow	Purplish Blue
Yellowish Brown	Violet
Yellow	Purple
Olive Brown	Reddish Purple
Greenish Yellow	Purplish Pink
Olive	Purplish Red

The ISCC-NBS color designators for the purple hue segment of color space.

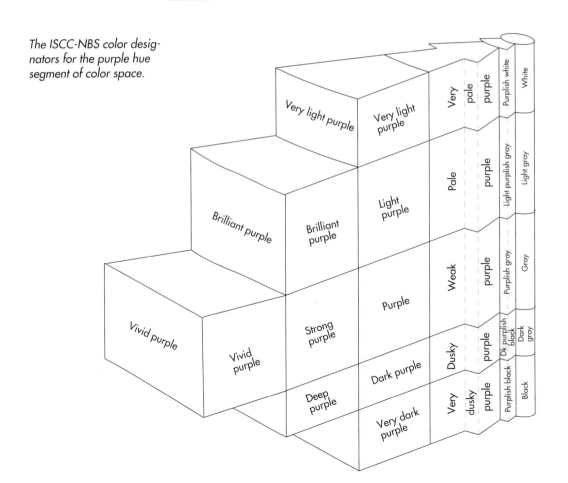

updated) classifies thousands of color names under only 267 designations. These designations are identified by Munsell notation, therefore making it possible to determine the approximate appearance corresponding to any given color name.

The hue names selected by Kelly and Judd are listed in the accompanying table. The accompanying illustration shows the qualifying adjectives and adverbs used to describe the blocks in the purple segment of the color solid. Each hue segment does not necessarily have a regular shape; also, the qualifying terms and areas vary slightly from hue segment to hue segment.

It will be noted that the adjectives light and dark are used only for the colors near the black-white axis. The terms whiteness, grayness, and blackness are confined to colors of low saturation. The terms vividness, depth, strength, and brilliance are applied to the more saturated colors.

The use of the ISCC-NBS color name system would reduce much of the ambiguity in color identification; however, with 26 hue terms and approximately 19 hue descriptors for each, a convenient system of specifying color change is not easy to achieve. In the printing industry it is common for a print buyer to mark up a color proof with specified color changes. These changes are often rather cryptic or vague; thus there is a strong need for a satisfactory method of verbal communication of color requirements and alterations for the printing industry (see Chapter 14.)

Concluding Analysis

The color attributes of hue, saturation, and lightness can be measured instrumentally, located in a collection of color samples, or described verbally. Some other attributes of color appearance (e.g., gloss) can also be characterized by these methods. No one system satisfies the requirements of precision, convenience, and familiarity; consequently two or three of the methods may be used in a given situation.

Instrumental methods offer the apparent surety of numerical specification. It must be remembered, however, that quantitative systems of color description are based upon certain assumptions (a standard observer, a particular illuminant, and a fixed geometry) that may not apply in practice. Deviations of the measurement system from actual viewing conditions are not important if the instrument is being used to control the color consistency of a process following the visual approval of a reference standard.

Sample-based systems are invaluable for specifying color. The absolute-reference type of color order system has, however, limited valued for the photomechanical color reproduction and color printing processes. The relative-reference types of color order systems have the great advantage of defining the production conditions required to match a selected color. The references must have been produced under the exact (or very similar) conditions that will be used for production, otherwise they may prove to be invalid. Ink- and paper-based reference systems are subject to fading and discoloration, and must be replaced on a regular basis.

Verbal specification of a desired color rarely occurs; therefore, it is unlikely that any such system will ever gain significant popularity in the printing industry. Verbal descriptors are commonly used to request color shifts from those displayed on a proof; hence it is this application that is most in need of a standard system. Color communication issues and suggested solutions are covered in Chapter 14, and the role of the proof in this process is discussed in Chapter 13.

7 Paper and Ink

Optical Properties of Printing Materials

The appearance of a printed sheet or product depends, to a very large degree, upon the optical properties of the constituent substrate and inks. A number of appearance properties are also influenced by the optical interactions that occur between printed ink films and the substrate. The discussion within this chapter deals separately with paper and ink except on those occasions when a treatment of the ink-substrate interaction is appropriate. The physical factors that influence the color and appearance of a printed sheet are also addressed here and in the color printing chapter.

Printing materials are evaluated by printers from two points of view: choosing the most suitable products, and monitoring product consistency. The choice of materials is based upon such factors as optical quality requirements, physical properties, and cost or other business factors. Material consistency evaluations are also influenced by the quality requirements of the printed product, as well as the production printing considerations. The most suitable materials will depend upon a given company's color quality and business strategies (Chapter 15). The primary focus of this chapter, however, is upon those factors that influence color reproduction quality. A detailed analysis of the broader printability and economic aspects of materials selection is beyond the scope of this book. See the references by Bureau (1995) and Eldred and Scarlett (1990) for more detail.

Paper and Other Substrates

Because the vast majority of color printing is produced on paper or paperboard substrates, this section focuses on their characteristics. Other substrates, namely films, foils, and metals that are primarily used in the packaging industry, are discussed briefly at the end of the section.

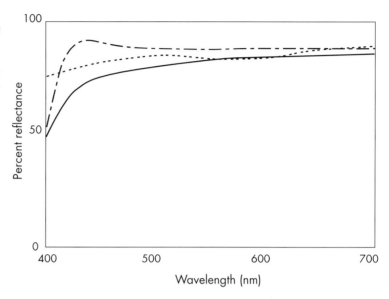

Spectrophotometric curves of paper samples collected as part of a GATF survey.

The peak of about 440 nm for one paper is due to the optical brighteners added during the paper-making process.

Reflectance

The optical properties of whiteness and brightness can be best understood by reference to spectrophotometric curves. The curves in the accompanying illustration were derived from measurements of white paper samples collected during a GATF Color Survey. These curves represent the reflectance of visible radiation as measured at every 10 nm relative to a barium sulfate standard. A perfect white would reflect 100% of each wavelength across the visible spectrum.

Whiteness

The whiteness of a substrate is defined here as the absence of a color cast, or the ability to reflect equal amounts of red, green and blue light; that is, a white sheet is a neutral sheet. A white substrate also has a high brightness level.

The illustration above shows papers with consistently higher red- and green-light reflection than blue-light reflection. This typical yellowish cast is due to the natural color of the pulp used in papermaking, and this color may be partially neutralized by the addition of blue dye or fluorescing agents during pulp preparation or coating formulation. Fillers and coatings will also influence whiteness.

In order to avoid printed color distortion, it would seem logical that the substrate be as neutral as possible. For most printing substrates, however, the observer mentally adjusts to a slight color cast, takes it as a reference white, and perceives all other colors relative to that reference. This works well when viewing a sheet in isolation, but when comparing it to a proof or previously printed job, substrate color differences become more influential.

The best way to determine whether paper color will cause problems in color reproduction is through a visual comparison. Simply compare samples of the unprinted substrates side by side and do not use those that appear significantly different. Several thicknesses of lightweight papers should be used when making this evaluation in order to neutralize poor opacity, which may cause a false color bias. Standard viewing conditions must be used for the evaluation, and final rankings should reflect the combined judgment of several evaluators. Densitometer readings of the unprinted substrates are not particularly useful because the density scale poorly discriminates in light tonal or color areas. If numerical results are required, a colorimeter should be used. The illustration shows colorimetric x–y plots for a sampling of white papers.

Brightness

The **brightness** of a substrate, from a color reproduction viewpoint, can be defined as the total reflectance of light from that substrate. The papermaking industry, on the other hand, defines brightness as the 45° reflectance at 457 nm. This measure is used to control the brightening agents added during the papermaking process.

Generally, the more light reflected from a sheet the better. A substrate that reflects 90% of the red, green, and blue light that falls on it produces a better reproduction than a substrate that reflects only 75% of the incident red, green, and blue light. The lower-brightness paper produces reproductions with lower contrast and sharpness.

The evaluation of brightness is best done by visually ranking unprinted samples of substrates as part of the neutrality evaluation that was described in the previous section. Colorimetric measurements should be made when quantitative evaluations are required. The numbers beside each point on the diagram (p. 120) specify the lightness values. More light is reflected by papers with the higher lightness values.

A colorimetric method for quantifying whiteness, incorporating neutrality and brightness concepts, has been suggested by Ganz (1979):

$$W = Y - 8(x - x_o) - 1700(y - y_o)$$

where W is the whiteness measure, Y is the luminosity dependent tristimulus factor, x, y are chromaticity coordinates for the sample, and x_o, y_o are the chromaticity coordinates for the perfect diffuser (a standard based on magnesium oxide).

An enlarged section of a chromaticity diagram showing a selection of average printing substrates.

The points lie along a blue-yellow axis. The numbers beside each point represent the lightness values that extend vertically from the page.

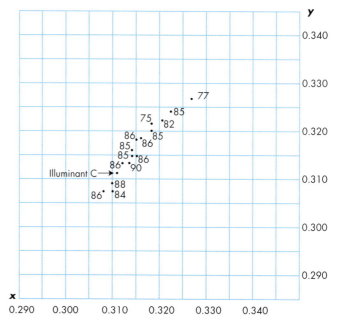

Fluorescence

Fluorescence is a complex property that may exert negative or positive influences on color reproductions. Fluorescence in paper, for example, can contribute to a loss of saturation in pale yellow colors (Preucil, 1961). Metamerism problems may also occur if a printed sheet has fluorescing properties that differ from those of a comparative image (e.g., a proof). In general, however, fluorescence-induced increases in paper whiteness and brightness are positive effects.

Fluorescence occurs when a substance absorbs radiation of one wavelength and emits it at a higher wavelength within the range of the visible spectrum: e.g., invisible ultraviolet (UV) radiation is converted by a fluorescent material into visible blue light. Papermakers often make use of this principle during the paper manufacturing process. Paper is made to appear more neutral by using optical brightening agents to increase its blue-light reflection.

Fluorescence can be detected by illuminating the samples in question with a **black light** (a source rich in ultraviolet and low-frequency blue radiation) in a darkened room. A simple visual ranking of the substrates is then made. Fluorescence effects may be quantified, but the necessary procedures are rather complex; consequently, it is usually advisable to rely upon the expertise of specialist laboratories

for such services. Colorimetric measures of fluorescent materials are influenced by the spectral characteristics of the illuminating source, and also by the absorption characteristics of any optical elements between the source and the sample. The same instrumental conditions must be maintained when making periodic measurements of samples that fluoresce, or are suspected of fluorescing.

Gloss

Gloss is a measure of the specular or directional reflection of light from the uppermost layer of a surface. Gloss effects may be compared by illuminating the surface of the samples being evaluated with a focused light beam, and positioning the eye so that the angle of incidence and the angle of reflection are equal. A glossmeter is used to make accurate measurements of gloss. For most papers, the standard method is to make measurements 75° from the perpendicular (or normal). Paper is a nonuniform substrate; therefore, readings are usually taken in both the grain and cross-grain directions. High-gloss papers (cast-coated, extrusion-coated, film-laminated, etc.) and high-gloss inks, varnishes, and coatings often are measured at 60° or 20°, which produces lower percent gloss readings but enables better objective analysis of samples.

While it may be stated that a glossy surface generally improves the reproduction of photographic originals, there are other cases where gloss can be detrimental. An artist's watercolor or drawing that was prepared on a matte surface should be printed on a matte surface in order to retain the integrity of the original; furthermore, there are some photographic originals with a particular mood and texture that would be disturbed if high-gloss substrates and inks were used. Another consideration is that text and illustrations often appear side by side in such printed matter as magazines, newspapers, some books, annual reports and advertising brochures. High gloss contributes to eye fatigue when reading text; therefore, what may be beneficial for pictorial reproduction is poor for text printing. Packages, book and magazine covers, posters, postcards, and labels have no text to speak of and are often finished with a high gloss.

Luster (also known as contrast gloss) is the ratio of specularly reflected light to diffusely reflected light from the same surface. A special glossmeter equipped with a polarized light source is used to quantify this effect.

Internal Light Scattering

Some substrates, especially paper, are not perfectly dense, opaque materials; therefore, when light strikes the paper surface, or when it passes through the printed ink film, there is scattering of light among the fibers and other materials that make up the substrate. Some of the light that passes through the ink film eventually emerges from the paper in an unprinted area and shifts the color of that area towards the color of the ink film. This effect makes light-tint color tones appear cleaner (less gray or more saturated) than the same tint printed on a substrate having less internal light scatter.

Some light that strikes the unprinted areas around halftone dots will be scattered within the substrate and emerge under the ink films that form the halftone dots. This phenomenon makes halftones appear darker than would be predicted by physical measurement. The darkening of halftone values is called optical dot gain.

The degree of internal light scattering largely depends upon the amount and type of coating applied to the substrate. Uncoated papers exhibit the highest scattering, followed by clay-coated paper, and finally by white ink or enamel coated onto metal, which exhibits very little scattering. Internal light scattering is related to opacity—the more opacity per unit thickness, the less internal light scattering. Opacity may be measured with an **opacimeter**, which, when divided by the caliper, provides a measure of unit opacity. For all but very thick papers, this measure gives some indication of the propensity for internal light scattering.

There are good and bad aspects of internal light scattering. Light color tints tend to be cleaner when there is light scattering, but the image loses sharpness and tonal values appear darker. Compensation may be made at the color separation stage for the darkening of tonal values; therefore, the issue is reduced to a trade-off between sharper images and improved color rendition of light tones. In practice, however, it is impossible to consider the internal light-scattering properties of paper in isolation. High scattering is associated with uncoated paper, which in turn is associated with low gloss, higher absorbency, and lower resolution. Such originals as low-resolution artist's watercolors containing many pale colors, will probably reproduce very well on papers with high internal light scatter. For most other types of reproduction, a coated paper with moderate or low internal light scattering is probably better than uncoated papers with high internal light scatter.

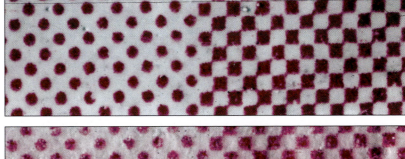

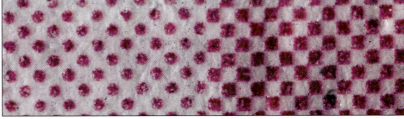

The influence of substrates with low (top) and high (bottom) internal light scattering on the appearance of halftone images.

Absorptivity and Paper Surface Efficiency

Although a physical and not an optical property, the absorptivity of paper has been shown to influence shifts in the color of the printed ink film. Preucil (1962) was able to integrate absorptivity and gloss measurements into a measure called Paper Surface Efficiency (PSE). He found that high gloss and low absorptivity produced a high paper surface efficiency; that is, the minimum distortion of the printed ink film color by the substrate. Metals and plastics had high PSEs. Low gloss and high absorptivity, typical of uncoated paper, produced a low PSE with significantly higher shift of the printed ink film colors: cyans became grayer and magentas became redder.

Absorptivity can be measured by the use of **K and N testing ink**, a special gray ink. The K and N ink is applied to the papers being tested for two minutes. The ink is then wiped off and the density of the resulting stain on the paper is measured with a densitometer. Darker stains indicate high absorptivity. Croda Ink Company also has a similar red absorption test ink. In addition to the objective measurements, the ink stain should be ranked for absorption uniformity or the tendency to mottle.

The density values of the K and N stain are converted into percent reflectance prior to calculating paper absorptivity via this equation:

$$\text{Paper Absorptivity} = 1\tfrac{1}{3}\,(100 - \text{K\&N\% Reflectance})$$

Paper surface efficiency (PSE) is then calculated via this equation:

$$\text{PSE} = \frac{(100 - A) + PG}{2}$$

A = paper absorptivity
PG = paper gloss (75° geometry)

Printed samples of the same cyan ink on different papers.

From the color reproduction viewpoint, it is desirable to have substrates with low absorptivity to minimize degradation of the printed ink film color. Such other printability concerns as drying and ink transfer, however, ultimately impose the minimum absorptivity requirements.

Smoothness

The other physical substrate property that influences color printing is smoothness. Smoother papers reduce halftone graininess, and produce higher resolution images (finer halftone screens may be used when printing smoother papers). Smoothness (surface topography) has also been shown (MacPhee and Lind, 1994) to be the single most important paper property that influences the density of solid ink films.

Matte-finish coated papers have a very fine micro surface structure that gives them many of the high resolution and good maximum density advantages of the smoothest high-gloss papers. Smooth matte-finish papers are particularly suitable for printing books that contain text and color photographs throughout. These papers do not have the distracting glare of glossy papers that causes text readability difficulties.

Texture

The surface of some substrates is embossed during manufacturing to create a patterned or textured effect. The embossing may follow a regular pattern similar to the silk finish of some photographic papers, or may consist of a more irregular, grainy pattern. The embossing may be light or heavy, and the pattern may be fine or coarse.

Textured substrates possess less smoothness than untextured substrates; therefore, image reproductions may appear grainy in tonal areas that would otherwise be smooth and

even. For certain kinds of reproductions, however, a textured substrate adds a tactile quality that more than outweighs the loss of image smoothness.

Nonpaper Substrates

Plastics, foils, metal, and glass fall into the category of **nonpaper substrates** and are commonly used in the packaging industry. Generally, these materials are selected more for their barrier and strength properties than for their optical or color reproduction properties.

The nonpaper substrates usually can be thought of as having low absorbency and lacking a white, bright surface. Some surfaces are metallic, others transparent, e.g., plastic. These substrates also are very smooth and usually have high gloss. In practice, nonpaper substrates are often coated with an opaque white ink or enamel that acts as the printing surface. (In the case of flexible packaging films, the white "base" is applied after the colors and the web is turned over for use). The net effect of the opaque white coating is to produce a neutral surface with low internal light scattering, high gloss, and low absorbency.

Ink

The formulation of ink largely depends upon the requirements of the particular printing process. Such concerns as drying, picking, chemical ghosting, and mottle, while important to overall print quality, do not pertain directly to color reproduction and therefore will not be considered. The discussion is limited to the color properties of inks.

Process Ink Terminology

The process-color inks—yellow, magenta, cyan, and black—are commonly abbreviated as Y, M, C, and K. The letter K is used for black rather than B to avoid any confusion with the word "blue." In some printing companies the cyan ink is called "blue" or "process blue," and "red" or "process red" is sometimes used to describe magenta inks. These alternative terms are technically incorrect.

The use of "red" and "blue" for magenta and cyan can cause confusion. It is, for example, correct to refer to red-, green-, and blue-filter color separations; also, it is correct to use the terms red, green, and blue overprints when discussing ink trap. If the terms red and blue are used to describe the magenta and cyan inks, they are likely to cause misunderstandings. The color reproduction process is already complex enough without the use of terms that will make the process even less clear.

Pigment Color The pigment is the key coloring compound in an ink. Toners are additional coloring compounds that are used in some formulations.

The important optical characteristics for process ink pigments are absorption and transparency. Absorption, in this case, refers to the pigments' ability to selectively absorb certain wavelengths of light. The yellow pigment, for example, should absorb blue light and transmit green and red light.

Transparency refers to the pigments' ability to transmit (rather than reflect) those wavelengths that are not absorbed by the pigment. A perfectly transparent yellow, for example, will fully transmit green and red light, whereas a perfectly opaque yellow will fully reflect green and red light. Transparent and opaque yellows should both fully absorb blue light.

Ideal process ink pigments absorb one third of the visible spectrum and transmit the other two thirds: yellow should absorb blue and transmit green and red; magenta should absorb green and transmit blue and red; and, cyan should absorb red and transmit green and blue.

In practice, neither process color completely absorbs its complementary color. A more serious concern, however, is that neither color perfectly transmits the remaining light. In the case of yellow pigments, this is not a particularly serious problem as the lack of green and red light transmission is minor. Magenta pigments have poor blue light transmission characteristics (but relatively good red light transmission), and cyan pigments have poor green and blue light transmission.

Spectrophotometric curves of typical process inks are shown together with two sets of theoretically ideal curves (see pp. 128–129). There are, in fact, many ways to design an ideal set of pigments (Hunt, 1995, pp 177–193). The color gamut will be different for each, and no one design will provide clear gamut advantages over the others. The key design decisions have to do with the exact positioning and width of the absorption bands, and whether the absorption bands are straight sided or slope sided. It is clear that improvements in color gamut will be realized if pigments can be developed that are closer to the ideal than present pigments; however, it is less clear that continued development will always produce color gamut improvements.

The restricted color range, or gamut, that is available from typical process inks is most obvious in the blue-purple-magenta colors. Yellows and reds are quite good, but the green and cyan also leave something to be desired. Propor-

tionality failure (see Chapter 9) further degrades the lighter tints of the colors that already have restricted saturation because of unwanted absorptions by the pigments.

Restricted color gamuts may be expanded, to some degree, by the use of supplementary fifth, sixth or seventh colors. The absorption characteristics of the extra colors will vary according to the application. Some companies will use red, green and blue inks as the supplementary colors, while others use green and orange. Greeting card manufacturers have long used pink (magenta plus white) and light blue (cyan plus white) as supplementary colors because of the need to enhance the saturation or cleanliness of pale colors rather than of the darker colors.

Ink color may be characterized by spectrophotometry, colorimetry, or densitometry. The spectrophotometric curve is the most complete record of the ink's absorption properties. In order to minimize the influence of the substrate on the color of the printed ink film, such readings should be made from a sample of the ink that has been printed at normal densities onto a high-gloss, nonabsorbent substrate (white plastic, for example).

Colorimetric readings complement the spectrophotometric data. Color difference equations may be used for quality control purposes to quantify the differences between two or more pigments. Bassimer and Lavelle (1993) have developed procedures for linking colorimetric measurements and ink film thicknesses. Lind (1990) has developed procedures for establishing colorimetric tolerances as part of an ink evaluation program. Samples with carefully controlled printed ink films must be used in order to realize the benefits of colorimetric measurement.

Three-filter densitometer readings may be converted into hue error and grayness values and plotted on a color triangle or circle. The color plots in this system are not as dependent upon ink film thickness as is the colorimetric system. On the other hand, densitometric measurements do not have the precision of spectrophotometry or colorimetry; therefore, the method should not be used as the exclusive method of color analysis.

Transparency and Opacity

In a theoretically ideal system, light strikes a printed ink film, is selectively absorbed, and then the remaining light is reflected by the substrate back through the ink film. In practice, all inks are somewhat opaque, which means that some

Two versions of "ideal" inks, straight-sided and slope-sided, as they would appear if printed on a substrate with 100% reflectance: yellow (top), magenta (middle), and cyan (bottom).

Spectrophotometric curves of typical process inks as they appear when printed on a typical substrate: yellow (top), magenta (middle), *and* cyan (bottom).

The top curve in each illustration represents the spectrophotometric curve of the substrate.

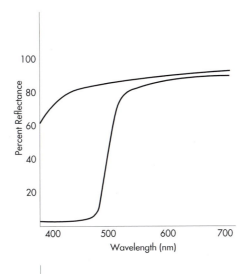

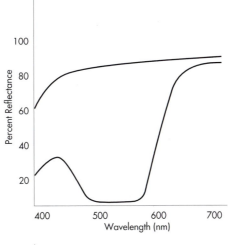

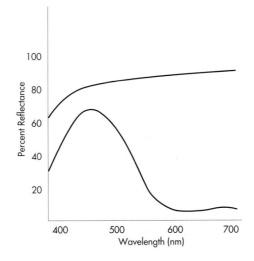

of the light striking the ink film is reflected by the pigment particles within the ink film, rather than by the substrate under the ink film.

An ink film is transparent because it contains a pigment with the same specific gravity as the vehicle in which it is dispersed. When the specific gravity of the pigment is higher than that of the vehicle, the incident light is refracted in such a manner that some light is reflected by pigment particles before it is able to reach the substrate. This means that the resulting color, when two or more ink films are overprinted, will be skewed towards the hue of the top-down color. This problem is most noticeable with yellow pigments.

In some cases, opacity is a desirable property for pigments to possess; i.e., when it is necessary for a color to completely obscure the surface or color underneath. Such requirements exist for some screen-printed posters, metallic colors, and the "backup" white used as a base for metal or flexible packaging printing.

Transparency may be evaluated by making a drawdown of the test ink across a black bar printed on white paper. If the black bar appears unchanged, the ink is quite transparent. If the black bar has shifted towards the hue of the ink under test, the ink is partially opaque.

A method for measuring the transparency of process inks has been developed by Bassimer and Zawacki (1994). The method requires that carefully controlled layers of the test ink are printed at a variety of thicknesses onto a standard coated black substrate (Leneta Opacity Chart 105C). The unprinted substrate and the areas overprinted with the test ink are measured with a (0/45° geometry) spectrophotometer.

The spectrophotometric readings are converted into colorimetric parameters and the ΔE^* value is computed. The ΔE^* values at one-micron ink film thicknesses may be used as measures of transparency; alternatively, the inverse slope of the ΔE^* vs. ink film thickness curve will provide a transparency measure that is less sensitive to experimental conditions. The units for this measure are micrometers of ink per ΔE^* unit.

Sample inverse-slope transparency (T) values for a set of SWOP inks were: yellow T=0.09, magenta T=0.28, cyan T=0.41. Higher numbers equal higher transparency, that is, cyan is the most transparent process ink and yellow is the least transparent of those tested. Spectrophotometric curves of the sample overprints are shown.

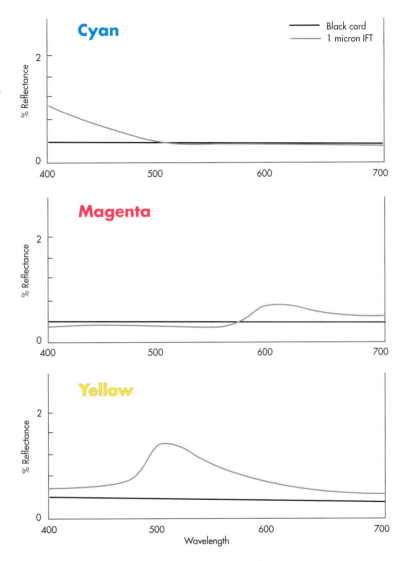

Spectrophotometric curves of sample SWOP yellow, magenta, and cyan inks printed on Leneta 105C black card produced as part of an ink transparency study.

Reprinted with permission from R. Bassemir and W. Zawacki, TAGA Proceedings (1994).

Masstone and Undertone

The masstone is the color of a thick ink film, and the undertone is the color of a thin film of the same ink. The masstone and undertone aspects of printed ink films are related to the transparency of the ink.

The color of an opaque ink film does not vary with thickness because the light is reflected from the top layer of pigment. In other words the masstone and undertone for opaque inks are identical.

In the case of fully transparent inks, however, light penetrates the ink film and is reflected back through the ink film by the substrate. The appearance of a transparent ink film is, therefore, highly dependent upon the thickness of the

film. In other words, there is a very substantial difference between the masstone and undertone of transparent inks.

The color shifts associated with variations in the thickness of transparent ink films are related to the unwanted absorptions of the individual pigments. In short, increases in ink film thickness will slightly shift the hue of yellow towards orange, shift the hue of the magenta towards red, and increase the grayness of cyan. The most noticeable of these shifts occurs with the magenta ink where the hue changes from a bluish undertone to a reddish masstone as the thickness of the ink film increases.

Color Gamut and Pigment Selection

The gamut, or color range, of an ink set is largely determined by the selection of pigments that are used in the inks. The objective, from a color reproduction point of view, is to choose those pigments that will produce the optimal color gamut.

The color gamut, or more correctly, the printed color gamut, is not only a function of pigment selection; rather, it is the net effect of combining a set of inks in a particular sequence at a given density onto a certain substrate via a particular printing process. Such factors as ink trapping, ink transparency, substrate gloss, pigment color, printing sequence, halftone screen structure, substrate internal light scattering, substrate whiteness and brightness, ink film thickness, and substrate absorbency will all influence the printed color gamut.

Color gamut may be characterized by using standard plant procedures to print a color chart such as the Rochester Institute of Technology's (RIT) Process Ink Gamut Chart. The RIT chart, shown in the illustration, displays a full range of gamut colors in a compact format. Once a chart has been produced, a colorimeter should be used to quantify the color gamut. Such records are important for quality recordkeeping, color communication, employee training, and scientific research purposes.

The GATF Color Triangle may be used to prepare a graphical representation of the color gamut without having to produce a printed chart. The procedure is as follows: select a printed image that contains solids of the inks in question on the desired substrate; measure the yellow, magenta, and cyan solids through each of the blue, green, and red filters of a densitometer; compute hue error and grayness; plot the resulting values on the Color Triangle; and, connect the points with straight lines. The area thus formed represents the color

The Rochester Institute of Technology's Process Ink Gamut chart, which (apart from being a useful tool for the evaluation of process ink sets) may be used to investigate the influence of substrates and press variables on the printed gamut.

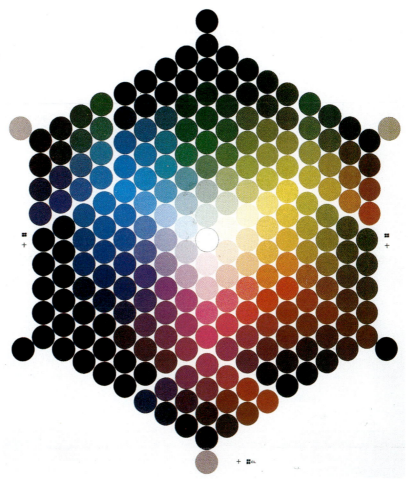

gamut for the measured conditions. Two-color red, green, and blue overprint colors, if available for measurement, should theoretically lie on the connecting lines between the primary ink colors. In practice, of course, visual evaluation of color gamut is preferable to instrument measurements and graphical presentations, but ideally, both are used.

The illustration displays the gamut that may be achieved with good yellow, magenta, and cyan printing inks. The evidence of restricted gamut should not obscure the fact that an uncountable number of highly successful printed color reproductions are produced every day. The gamut afforded by commercial process inks is quite sufficient, it seems, to produce very satisfactory results.

Independent studies by Field (1996b) and Paul (1996) estimated that the maximum number of distinct colors that may be printed by four-color lithography is, respectively, about

The use of the GATF Color Triangle for color gamut determination.

Lines drawn between the plots of the primary colors will define the approximate hue-saturation boundary of color gamut.

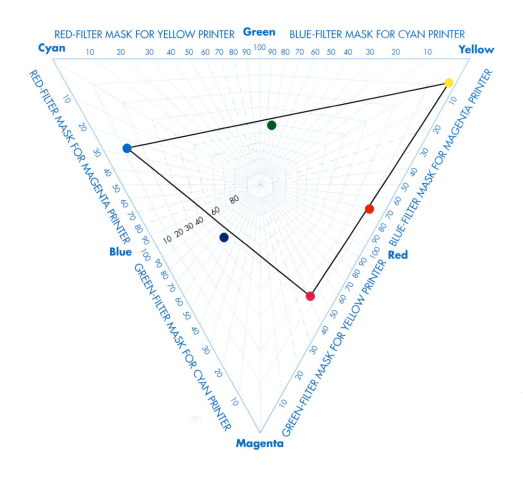

1,200,000 and just over 1,000,000. Paul estimated that seven-color lithographic printing (extra red, green, and blue inks) is capable of producing over 1,300,000 colors. In practice, however, the use of extra inks will not always improve the quality of the reproduction. There is no point in enhancing the gamut in the blue areas if there are no saturated blues in the original. Indeed, many colors reproduce very well with common process inks and will not be improved by extra colors. There are, of course, many circumstances where color reproduction will be improved by the use of supplementary colors. There is, however, no universal set of extra inks that will uniformly enhance all sectors of the color space. Highly saturated red, green, and blue inks will add saturation and strength to reproductions of neon lights, deep red roses, purple flowers, deep blue skies, and to certain clothing or other product colors. These inks, however, will not enhance the saturation of medium-to-light colors.

The key consideration to keep in mind when selecting extra colors is not what is available; rather, the focus should

The gamut of a good commercial process ink set plotted on a CIE chromaticity diagram.

The outer perimeter represents the human visual system.

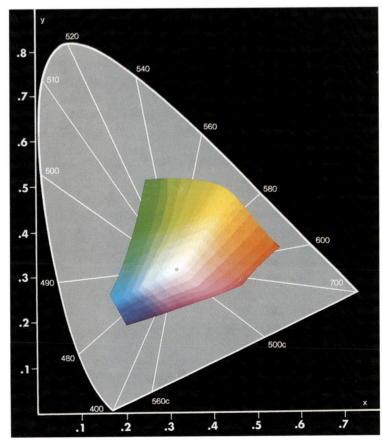

be upon what printed colors are desired. As stated earlier, the greeting card industry decided many years ago that saturation enhancement of medium-to-light colors was important for their product range, and that this objective could be achieved by the appropriate use of pink and light blue as supplementary colors.

Selection of process color pigments is based upon a number of considerations that include transparency, light fastness, spectral absorption, fineness of grind, cost, chemical resistance, texture, toxicity, environmental safety, specific gravity and wettability. GATF color surveys revealed that printers do choose a wide range of process inks (Field, 1972). The illustration shows the typical spread of yellow, magenta, and cyan printed colors: the yellows are clustered, but tend towards orange; the magentas are spread over a wide hue range extending from bluish magenta to a near-true red; and, cyans vary somewhat in both grayness and hue. The color circle plots are influenced by the substrate and the ink film thickness, as well as the hue of the pigment. A fairly pure magenta, for example, would plot much redder if it had been printed in a thick layer onto a substrate that had a low paper surface efficiency.

The pigments commonly used in process inks are: for cyan, a green shade of copper phthalocyanine blue (CI Pigment Blue 15:3); for magenta a blue shade of Lithol Rubine (4B Toner) (CI Pigment Red 57:1); and for yellow, one of the Diarylide Yellows, i.e., in the U.S., AAA (CI Pigment Yellow 12) or OA (CI Pigment Yellow 17), and in Europe MX (CI Pigment Yellow 13) (Bassimer and Lavelle, 1993). The Rhodamine Y pigment (CI Pigment Red 81) is also used in magenta process inks.

The table on page 138 displays a selection of common printing ink pigment properties that are of interest for color reproduction. The cost index explains why the lithol rubine pigment is a more popular magenta than the spectrally purer rhodamine Y—the lithol rubine costs about one quarter that of the rhodamine pigment. The superior light resistance of hansa yellow pigment (vs. diarylide yellows) is of interest for outdoor poster printers, but other factors limit its use.

Pigment choice, and other factors, are the subject of national specifications or standards for the magazine publishing industries around the world. The specifications, which are periodically revised, focus upon the proofing conditions for advertising page reproduction. A discussion of these specifica-

Typical industry-wide variations in cyan, magenta, and yellow printed ink films due to differences in pigments, substrate characteristics (gloss and absorptivity), and ink film thickness (masstone vs. undertone effects).

The complete CMY survey plots are displayed on a GATF color circle, whereas the accompanying CIE chromaticity diagram just records the extreme and average values.

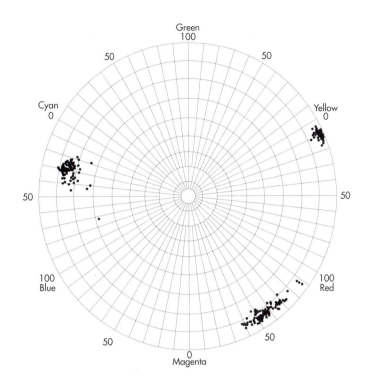

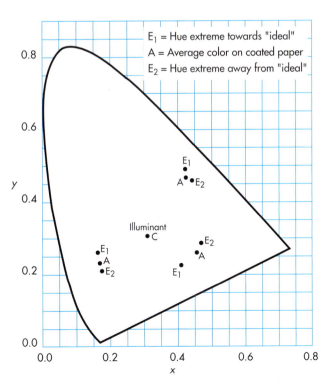

Selected properties of pigments used in process color inks.

C.I. Pigment Name	Number	Descriptive Name	Bulk Value*	Lightfastness (Blue wool scale)	Approx. Relative Price
Yellow 1	11680	Hansa G	65	7	20
Yellow 12	21090	Diarylide Yellow AAA	72	3–4	22
Yellow 13	21100	Diarylide Yellow AAMX	80	5–6	30
Yellow 17	21105	Diarylide Yellow AAOA	77	6	30
Red 57:1	15850	Lithol Rubine	68	4	15
Red 81	45160:1	Rhodamine Y	47	5–6	60
Blue 15	74160	Pthalocyanine Blue	60	7–8	32

*A measure related to color strength, with higher values indicating greater strength per unit volume.

tions is presented in Chapter 13, and a list of the appropriate standards is located in Appendix B. The constant, and necessary, publicity about the specifications (SWOP in the U.S., for example) may create the impression that they are de facto standards for the entire printing industry; this is not the case, nor should it be.

The magazine industry specifications are generally based upon relatively inexpensive restricted-gamut production inks and substrates. There is no reason, from a color gamut point of view, to use these specifications for other segments of the industry. Significant improvements in color gamut, relative to the magazine specifications, may be realized by using a variety of substrates and ink sets that are better suited to the quality and creative needs of the printed products in question.

Color management systems have helped make it simpler to produce color separations matched to any given color gamut. The controlled flexibility inherent in such systems assists companies in achieving consistently optimal color reproductions for a wide variety of printed products that are made from many kinds of substrates and ink sets.

Tinctorial Strength

The **tinctorial strength** of an ink is a measure of the amount of ink per unit area required to produce a given strength of color: the lower the amount of ink, the higher the tinctorial strength. Tinctorial strength is influenced by pigment selection and quantity of pigment used in the formulation. The color strength of the chosen pigment, together with the printing performance considerations (viscosity, tack) and gloss requirements largely determine the pigment concentration for a given ink. The initial color strength of a pigment is related to its chemical composition, particle size, and distribution.

In general, high-tinctorial-strength inks are preferred over low-tinctorial-strength inks. With high-strength inks, thin ink films may be run, thus minimizing dot gain and maximizing resolution, and probably reducing trapping and drying problems. Less ink will be consumed; however, high-tinctorial-strength inks generally cost more than the lower-strength inks, so unit cost and total volume must be considered together in order to determine total cost. Possible drawbacks to high-tinctorial-strength inks include lower gloss, higher viscosity, and the increased forces required to split thin ink films, which, in turn, can lead to picking of the substrate. These and other considerations will, therefore, restrict tinctorial strength for a particular pigment. In practice, consistent tinctorial strength is more important than the absolute level.

The main problems arising from variations in tinctorial strength are those encountered when trying to match a press proof to pressruns. If the proofing inks have high tinctorial strengths while the printing inks have lower strengths, a satisfactory match between proof and press sheet may be impossible to achieve. When color saturation in the press sheet solids is correct, dot gain will be too high. When dot gain is satisfactory, solid colors will be desaturated.

The bleach test is used for comparing tinctorial strengths of inks. One part (0.4 gram) of the test ink is mixed with fifty parts (20 grams) of a white bleaching compound (for example, titanium dioxide dispersed in a vehicle compatible with the ink under test). In practice, an opaque white ink is often used as the white bleach. One part of the standard ink also is mixed with fifty parts of the white bleaching compound. Samples of each of these mixtures are then simultaneously drawn down in a thick film on white test paper so that the drawdown films adjoin each other. A visual comparison is made immediately (within five seconds). It is possible to cal-

A drawdown of two inks being evaluated for pigment concentration via the bleach-out test.

culate the tinctorial strength of one ink relative to the other by adding (5% at a time) white bleach to the darker of the two mixtures until both mixtures match.

The strength of the test ink, relative to the standard, is calculated via this formula:

$$\text{Relative Strength (RS)} = 100 \ \frac{T}{S}$$

where T is the amount of base ink added to the test ink, and S is the amount added to the standard. If, for example, a match was achieved when 25 grams of white were added to the standard and 20 grams were added to the test ink, then:

$$\text{Relative Strength (RS)} = 100 \ \frac{20}{25}$$

$$\text{Relative Strength (RS)} = 80\%$$

That is, the test ink's pigment concentration is 80% that of the standard. In practical terms, this means that a 25% higher-than-standard IFT is required when printing the test ink in order to match the density of the standard on press.

The testing procedure must be carefully controlled in order to achieve accurate results. Specialized testing laboratories, such as those at GATF, may be used for ink and paper tests that require equipment or procedures beyond those normally used by printing companies.

Gloss

For most pictorial reproduction, high gloss is desirable because it improves contrast, saturation and sharpness. For artist's watercolor or poster color originals, a matte finish is more desirable.

Ink gloss is dependent upon the type and amount of vehicle, relative to pigment, in the ink. Gloss is measured with a glossmeter, at a 75° angle from normal, from a rollout of the ink under test on the paper that will ultimately be used for printing. Substrate gloss (see the earlier section of this chapter) will influence printed ink film gloss.

Other Characteristics of Ink

Other perceptual attributes of ink include color fastness, fluorescence, and metallic appearance. Printed ink films can fade, bleed, or change color in the presence of light, water, heat, alkalis, acids, soap, detergent, oils and fats, waxes, or various foodstuffs. Fading of color due to exposure to light is a common problem for virtually all inks. Some pigments are much worse than others; the organic yellows commonly used in process inks, in particular, are not very lightfast. Type of vehicle and pigment concentration have also been shown to affect the color permanence.

Fluorescent inks are readily available. They are usually used for solid type and background colors on packages, as well as for some screen-printed posters. Some inks, however, exhibit unwanted fluorescence, which can cause problems in color matching—a fact that stresses the importance of using a standard light source for color viewing. As noted earlier in this chapter, fluorescence may be detected by illuminating printed ink film samples with black light in a darkened room or viewing booth.

Metallic finishes can be either undesirable or desirable. The undesirable type results from the migration of toners to the surface of a printed ink film. Reflections from the surface of the ink film mix with light reflected from the substrate through the ink film, thus distorting the intended color. Black and blue colors are usually the ones most affected. This problem is sometimes called bronzing, and changing color sequence can help to hide it. On the other hand, desirable metallic finishes are produced by making inks with aluminum or bronze particles suspended within the vehicle. They are usually quite opaque.

Printed Ink Film Evaluation

The evaluation of ink and substrate consistency can be conducted by evaluating the materials independently; however, many color properties cannot be measured until there is an interaction between ink and substrate. This requires that samples be produced that simulate the ink-on-substrate appearance of normal printing. The ultimate way to produce samples is by running a special test form, such as a full-color chart or the RIT PIG chart, on the actual press to be used in practice. The on-press test captures information that is not normally revealed by simple bench tests. In the case of lithographic printing, for example, the effects of plate type, fountain solution, blanket type, and press settings all combine to produce information on the final print that would not be captured by a simple drawdown of ink on the substrate. Of course, the big drawbacks with press testing are time and cost. Press tests must be run on an occasional basis, but for routine sample generation, other methods should be considered.

Producing Samples

Combination ink-and-substrate samples can be generated by a number of methods. The most simple, and probably the most common, is the finger tap-out test. Wet ink is simply tapped out with the finger until the ink film density is the same as normal printed density. Obviously, this method has drawbacks: ink film thickness is unknown, the tapped-out area is small and generally uneven, and moisture and dirt from the finger may influence the color of the ink film.

Another common method of producing ink-substrate samples is the drawdown. A drawdown ink knife spreads a small sample of ink over the substrate. Two inks may be drawn down side by side, thus making the test useful for comparing two inks at the same time. Again, the big drawback is that ink film thickness is unknown; also, it is particularly difficult to get a good drawdown on low-absorbency glossy papers.

The other off-press methods of producing samples involve the use of precision ink-metering devices and a system for transferring under precise conditions a known quantity of ink to paper. These range from the Quickpeek rollout test through the printability testers to the flatbed proof presses. As might be expected, the time, cost, and space requirements of these pieces of equipment increase along with their ability to produce a sample that most accurately predicts actual press performance. For most routine work, a rollout tester like the Quickpeek is satisfactory. The biggest problem with this method is controlling roller pressure when making ink

transfers. With practice, a single operator is able to obtain reasonable consistency. It is best not to use just one method of producing test samples. Different methods should be used depending on the circumstances.

Optical Evaluations

The sample dimensions for optical evaluation vary according to the measuring instrument. Most color measuring instruments can successfully measure areas as small as ¼×¼ in. (6×6 mm). On the other hand, glossmeters usually require samples about 1×1 in. (25×25 mm).

When using the densitometer to evaluate printed samples, it can be either calibrated to its supplied reference or zeroed to the substrate. If the densitometer is calibrated to the reference, measure the printed ink film, measure the unprinted substrate, and subtract the substrate density from the printed ink film density in order to eliminate the density effect of the substrate.

Spectrophotometers and colorimeters are usually calibrated to a reference plate that is linked to such standard whites as barium sulfate. Colorimeters and spectrophotometers, unlike densitometers, often offer a choice of measurement conditions—specular component included or excluded, fluorescence included or excluded, and, for colorimeters, the choice between CIE illuminant A, C, D50 or D65. For printed ink films the 0/45° geometry most closely approximates normal viewing conditions, and illuminant C or D65, if D50 is not available, comes closest to the 5,000 K industry standard viewing source. To simulate normal viewing conditions more closely, the fluorescent component should be included in measurements.

Glossmeters are available in a variety of different geometries, or in some cases, adjustable geometry. When measuring coated papers, the incident and reflected beams should be 75° from normal. For cast-coated papers, the 20° geometry should be used, and for printed ink films, the 75° geometry is the most common.

Readings should be made both with the paper grain and across it when either measuring unprinted paper or printed ink films. This is particularly important when directional geometry rather than diffuse geometry is used. When comparing readings from wet and dry samples, it must be realized that wet readings will be higher than dry readings. As the ink dries, the gloss decreases, thus increasing the first surface reflections and lowering the density. Ideally, all

readings should be taken dry. Alternatively, a correction factor may be used to convert wet to dry density readings. This factor varies according to the ink and paper in use. To compute it, measure the printed ink film wet, measure the same spot when it is dry, and record the difference between the two readings as the correction factor. Polarized densitometers read wet and dry densities alike.

Physical and Chemical Evaluations

Tests for physical and chemical evaluations are often run under the actual conditions that the product is being asked to withstand. For fading tests, prints are placed 1 ft. (0.3 m) from a south (in the northern hemisphere) window for thirty, sixty, or ninety days. Fadeometers and other special laboratory testing machines are available for testing light exposure as well as other outdoor exposure conditions. For evaluation of resistance to various chemical or animal products, the printed sample is either dipped in or wrapped around the substance under test. Changes in the printed ink color can be characterized by the previously discussed optical measuring instruments and methods.

Concluding Analysis

The ink and substrate are the printed product; therefore, their characteristics make a very large contribution to the ultimate appearance of the end product.

It is impossible to select a single set of inks and a substrate that will produce the highest quality results for all circumstances. Different kinds of printed products will require different materials, and certain originals may require supplementary colors to enhance particular image areas. Keeping these caveats in mind, the following factors should be considered when choosing materials for color reproduction excellence: for the substrate, high whiteness (neutral and high brightness), low absorbency, high opacity, high smoothness, medium to high gloss, and low internal light scattering; and for ink, high transparency, moderately high pigment concentration, medium to high gloss, and close-to ideal process pigment colors as is practical. Supplementary ink colors should be chosen to enhance the specific reproduction at hand. Standard "special" colors is a contradiction in terms.

Purchasing agents, estimators, the sales force, production management, press operators, and anyone else likely to make decisions about paper and ink selection should be aware that what may seem to be subtle distinctions between different inks or papers may in fact produce serious color-

matching problems. The nature of these problems usually becomes apparent only when the job is on press. To lift the job from the press at this stage not only wastes money but also loses time.

An important point to remember is that cheaper inks or papers usually correlate with lower-quality printing; for example, inks with low tinctorial strength are cheaper than those with high strength; however, satisfactory solid densities will require thicker films of the low-tinctorial-strength ink (hence increasing total cost), which in turn can create dot gain and drying problems. The use of low-tinctorial-strength inks on press compared to high-tinctorial-strength inks when proofing is a major reason for the classic "why-won't-the-print-match-the-proof?" problem.

The testing of ink and substrates for various optical and physical properties can become a full-time activity. For the average printing plant, however, such testing will not only be quite expensive, but, in many cases, unnecessary. Routine visual comparisons of paper whiteness, brightness, and gloss should satisfy most needs. Occasional K and N absorbency tests of paper, and rollouts of ink for visual or instrumental color and gloss comparisons will generally take care of most optical testing needs. Tinctorial strength is important, but it is not a convenient test to run. Such tests, however, should be run whenever changing ink manufacturers, using new ink batches, or checking the quality of ink from current suppliers. For more elaborate, but occasional, testing needs, samples can be sent to the laboratories of GATF or similar organizations.

8 Color Printing

Introduction

After the selection of the ink and substrate, the printing press is the other factor that determines the characteristics of the color reproduction process end product—the printed sheet. The machine that transfers ink to paper can control printed ink film thickness, ink transfer—both to paper and to previously printed ink films—dot gain, register, and resolution.

Of course, the reproduction also depends upon the image on the plate, which is structured to suit the printing process by adjusting the preceding film images or digital files. The characteristics and performance of the printing press dictate the aimpoints and objectives of the previous stages.

The most important color printing processes, in terms of production volume, are lithography, gravure, and flexography. Screen process printing is usually restricted to short-run work, and the recently introduced electrophotography printing process serves the short-run, on-demand market. Letterpress, once a dominant color printing process, has declined in popularity.

Printing Methods

Lithography

The **lithographic printing process** was developed in 1798 by Alois Senefelder in Germany. The original process consisted of crayon drawings on a special stone. These stones were dampened with water and then rolled up with ink. The ink adhered to the greasy crayon image and was repelled by the dampened stone area. The inked image was then transferred to paper via a flatbed press.

Lithography emerged as a major printing process when the rotary press, offset cylinder, and the wraparound metal plate were introduced. It took until the 1950s before lithographic platemaking technology and lithographic inks and papers were developed to the point where consistently high-quality lithography became a possibility. With the refine-

ment of webfed presses and the rapid spread of four-color presses, lithography became the dominant color printing process (see ref. GATF, 1994 for more detail).

The primary advantages of offset lithography include low-cost platemaking, high-speed production, economical production for short or long runs, the ability to print on a wide variety of surfaces (smooth and rough), and high resolution. Lithography's biggest problem is the control of ink-water balance.

Gravure

The modern **rotogravure process** was developed from the intaglio process in 1890 by Karel Klic in England following his earlier work in Austria. The gravure image areas consist of cells recessed into the surface of a cylinder. The cells are about 0.005×0.005 in. (0.127×0.127 mm) in area and vary up to 0.002 in. (0.05 mm) in depth. Electronically engraved gravure has cells of varying size and varying depth. Other gravure cell systems include varying area and common depth, and constant area and varying depth. The cells are filled with ink; a doctor blade scrapes the excess ink from the cylinder surface, and the ink is transferred, under pressure, to the substrate. Transfer is aided by the capillary action of the paper fibers or coating, and by electrostatic assist systems (see ref. GEF and GAA, 1991 for more detail).

The primary advantages of the gravure process include consistent print quality, high-speed production, long-lasting cylinders, and good color saturation and strength. The major disadvantages include high cylinder cost and the necessity to use smooth substrates. Gravure is generally restricted to printing long-run magazines, catalogs, folding cartons, flexible packaging, and specialty items.

Flexography

The **flexographic printing process** dates from about 1905, when the first aniline press was built by C. A. Holweg of France. The process used a relief rubber plate, web feeding, and rapid-drying inks, which consisted of dyestuffs dissolved in spirits. The early plates were duplicates made from letterpress engravings; today most flexo plates are made of soft photopolymers directly from negatives. The inking system is one feature that sets flexography apart from letterpress. Flexography uses a fluid petroleum solvent- or water-based ink that is distributed to the plate by a single engraved cylinder called an *anilox roll*. A nip roller or a doctor blade

Principles of the offset lithographic printing process.

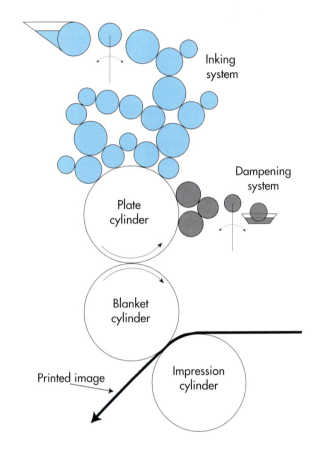

Inking system

Dampening system

Plate cylinder

Blanket cylinder

Printed image

Impression cylinder

Principles of the gravure printing process.

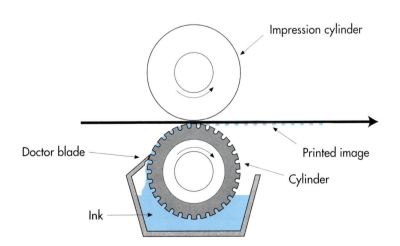

Impression cylinder

Doctor blade

Printed image

Cylinder

Ink

removes the excess ink from the anilox roll before it inks the plate (see ref. FFTA, 1991 for more detail).

The primary advantages of flexography include high speed, variable image cut-off length, the ability to print on many surfaces, and relatively inexpensive and simple printing presses. The disadvantages are those associated with relief image carriers. They include limited resolution, halftone image pressure differentials, and image distortion on uneven substrates.

Screen Printing

The use of a stencil to form an image is probably the oldest method of producing duplicate images. The modern **screen printing process**, however, derives from the 1907 silk screen printing patent of Englishman Samuel Simon, in which a hand-cut stencil was applied to a silk mesh that was stretched tightly across a wooden frame. Ink was forced through the stencil and mesh onto the substrate by a brush. Today's screen printing process is virtually identical. Mesh screens of nylon or polyester and photographically produced stencils are now used together with a squeegee, instead of a brush.

The advantages of the screen printing process are that it can print on any substrate (curved or flat), it can lay down an extremely thick ink film, and it does not even require a printing machine, although they are commonly used for high-quality work. The big drawbacks with screen printing are that it is slow, has limited resolution, and requires the use of drying racks or tunnels. The process is well suited for short-run, high color-saturation work printed in any size on any substrate. Large posters and showcards are often printed by the screen printing process.

Electro-photography

The **electrophotographic printing process** evolved from the Xerox black-and-white photocopying machine of 1950. Color copiers entered the marketplace in the 1970s, but it was not until direct computer interfaces and precision substrate transport mechanisms were developed or added that true electrophotographic color printing machines were introduced during the 1990s (see ref. Fenton and Romano, 1997 for more detail).

Unlike other printing processes, the electrophotographic process does not have a permanent image carrier; a new image is created for each impression. The imaging process is based upon the principle that light will discharge a photoconductor. An electrostatic charge is initially applied to a

*Principles of the flexo-
graphy printing process.*

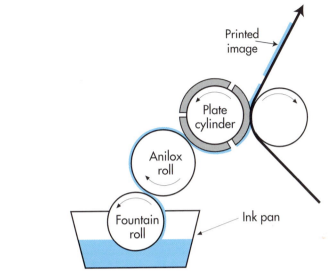

*Principles of the screen
printing process.*

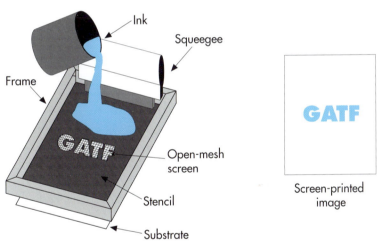

*Principles of the electro-
static printing process.*

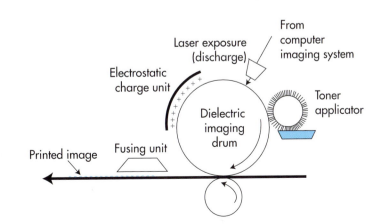

photoconductive drum; next, a laser beam is used to discharge the nonimage areas of the drum; the positively charged image areas remaining on the drum now attract negatively charged toner particles (in powder or liquid form) and, after this image formation process has been completed for all four colors, the toner layers are transferred to a substrate and heated to fuse the image.

The primary advantages of the electrophotographic process are: the image may be changed for each impression, film and plate production processes are eliminated, and the cost of short-run work is low relative to other printing processes. A major drawback of the process is its printing slowness and, consequently, prohibitively high cost for longer run jobs. The color saturation of electrophotographic printing is quite good, but image resolution and smoothness are generally below that of the best lithographic and gravure printing. The future growth of the process depends upon the growth of the short-run color printing market.

Letterpress

Letterpress is the oldest of the printing processes, dating back to the use of relief woodblock printing by the Chinese in 593. Johannes Gutenberg further developed the process in Germany during 1455, by linking typecasting, ink manufacture, composing, a press, and paper into a single workable printing system. The process uses a relief image carrier and a paste-type ink. The ink is broken down into a thin film by a series of rollers, and then transferred from the image carrier to the substrate by direct impression.

The major advantages of the process, compared to lithography, are high color strength and saturation, and consistent

Principles of the letterpress printing process.

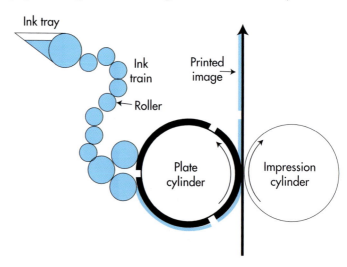

quality printing. The drawbacks include slow speed (for platen and cylinder presses), the necessity to use smooth papers, lower resolution than lithography, expensive plates, and the need for differential packing when printing half-tones. The use of letterpress for process-color printing declined rapidly in the United States after long-run reliability was established for the lithographic process. The lack of enough rotary letterpress presses capable of producing high-quality work left the expanding process-color market to lithography and other processes.

Printed Image Quality Factors

Each of the above printing processes has its own character-istic print qualities that are influenced by a number of equip-ment, materials, and operational factors. The following quality considerations apply to each of the printing processes, but the primary focus is upon the most difficult process to control—lithography. Although the discussion assumes the use of four-color printing, many of the considerations also apply to printing more than four colors.

Ink Film Thickness

The ink film thickness that is run on press influences a number of print factors other than the color properties. Films that are too thick cause drying and setoff problems. Those that are too thin (in lithography and letterpress) may cause picking problems. Thin ink films also result in mottled or uneven solids.

The image quality factors that are influenced by ink film thickness (IFT) are listed below. The dot gain and trapping factors due to IFT change are listed under those headings.

Color Saturation and Strength

Increasing the ink film thickness naturally produces a darker color (i.e., lower lightness values); however, the other dimensions of color—hue and saturation—may also shift because of the higher IFT. Higher magenta IFTs, for exam-ple, shift the hue towards red, and higher cyan IFTs cause the color to lose saturation or become grayer.

The reason for the hue shift can be explained by reference to the masstone and undertone of the ink (see Chapter 7). The color of a normal printed ink film is a combination of masstone and undertone. The effect of masstone becomes greater if a thicker than normal ink film is run. The under-tone becomes predominant if the ink film is thinner than normal. A magenta with a bluish undertone will print as a warm red if run heavy and as a cold pink if run light.

Gloss Higher ink film thicknesses produce higher gloss.

Color Tint The shifts in halftone color tints due to changes in IFT may
Distortion be different from the shifts in solids of the same color. Pro-
 portionality failure occurs when the hue or the saturation of
 a tint is different from the solid. The tints tend to be dirtier
 than the solids. This effect is more noticeable with coarser
 screen rulings, coated substrates, and higher ink film thick-
 nesses. Proportionality failure is discussed in more detail in
 Chapter 9.

Sharpness Increasing the ink film thickness increases the print contrast
 and hence the image sharpness.

IFT Adjustment The ink film thickness can be increased or decreased in litho-
 graphy or letterpress by opening the ink fountain blade,
 increasing the fountain roller sweep, or increasing the ductor
 roller oscillation frequency.
 For gravure, ink film thickness can be increased on press
 by lowering the angle of contact of the doctor blade or by
 using a thicker or duller doctor blade. Deeper cells in the
 cylinder will also enable higher ink film thicknesses to be
 achieved.
 In flexography, the anilox roll screen coarseness, doctor
 blade adjustments (the same as gravure), ink viscosity, plate
 composition, printing pressure, and the softness of the inking
 roller all influence the attainable ink film thickness.
 Greater IFTs may be obtained in screen printing by using
 a thicker stencil, a higher caliper mesh, a coarser weave
 mesh, increased squeegee pressure, a softer squeegee blade,
 a lower squeegee angle, lower screen tension, lower squeegee
 speed, and lower squeegee sharpness.

Ideal IFT The ideal ink film thickness for any given ink is difficult to
 determine. One practical method of establishing a target IFT
 (Schirmer and Tollenaar, 1973) requires that the solid den-
 sity and the density of a 75% tint is used to derive a Print
 Contrast Ratio (PCR) via the following equation:

$$\text{Print Contrast Ratio \%} = \frac{D_s - D_t}{D_s} \times 100$$

 where D_s = the density of the solid, and D_t = the density of
 the 75% tint. The PCR range for good printing usually

ranges from about 28% to 30%. This equation may help to balance ink film thicknesses from color to color and press to press, but it will not necessarily lead to the ideal ink film thickness for a given set of circumstances.

From time to time, color gamut-based theories of ideal IFT are advanced. One such method is visual color efficiency (also known as vivacity), which requires that the ink's maximum density be set to the level where visual color efficiency is maximized (Preucil, 1965). The chosen density has an inverse relationship with the ink's grayness, that is, low grayness inks should be printed at high density and higher grayness inks should be printed at lower densities (yellows would print at about 1.30 and magenta and cyans would have a density around 1.00). This approach places emphasis upon the grayness dimension (roughly related to saturation) to the detriment of the lightness (density) dimension. A literal implementation of the visual color efficiency approach will also cause overprint color distortions (red and green overprints are skewed towards yellow).

An overprint-hue approach to optimal IFT for the magenta and cyan inks was suggested by Elyjiw and Preucil (1964). This method required that the cyan and magenta IFTs were adjusted until the red (#25), green (#58), and blue (#47) filter density ratios of the red and green overprints met these targets: 0.85–1.00 for the green to blue filter ratio of the red overprint, and 0.90–1.10 for the red to blue filter ratio of the green overprint.

Single-outcome (overprint hue or visual color efficiency) gamut enhancement approaches to optimum IFT are bound to fail in practice because of the three-dimensional nature of color gamut. An emphasis in one dimension usually causes a loss in another dimension.

A maximize-the-total-gamut volume strategy may also prove to be inadequate because it assumes that all parts of color space are equally important. In practice, an approach to IFT optimization that maximizes one region of the gamut, while reducing the overall gamut, may be preferred for certain classes of printing (e.g., fruit label printing that consists of predominantly red, orange, yellow, and green colors).

Although the optimal density of printed solids cannot be specified because the optimal IFT is not known, this does not mean that a plant should not try to establish an internal reference standard. Such a standard is desirable in order to

provide an objective target for the production of color separations and proofs.

House standard densities will depend upon the substrate smoothness and the pigment concentration of the ink. The higher both properties are, the higher the density that may be achieved. The major appearance trade-offs that are at the control of the press operator are the density of solids, hue and saturation (solids and tints), gloss, dot gain, sharpness and trapping. All of these factors can be influenced by changes in ink film thickness.

The best ink film thickness to run avoids such problems as setoff or picking and is easy to run consistently; that is, it will probably be a midrange ink feed setting, for which the ink is not at one extreme of thickness or thinness. The objective is to produce running conditions that are the most reproducible. The press operator may deviate from this level in order to optimize a given job, but the objective should be to make ready to the midrange settings. If the color separation images have been produced for the midrange press conditions, then the resulting print should be close to the desired appearance. The appearance may be refined, on occasion, by slight adjustments in the press inking levels. The press should not be adjusted, however, in order to compensate for poor separations. Such attempts are usually doomed to failure.

Dot Gain

In order to transfer ink to a substrate, it is necessary to use pressure; because ink is a somewhat fluid substance, this pressure not only forces the ink into the substrate but also causes it to spread sideways. Some pressure is necessary to transfer ink, therefore, some ink spread is also necessary; hence, dot gain (which is caused by ink spreading) should be thought of more as a characteristic of a given process rather than as a fault of the process.

Dot gain is one aspect of halftone dot distortion. The other aspects are slur and doubling. **Slur** is a directional form of dot distortion; a round dot on the plate prints with a shape close to an ellipse.

Doubling is the double printing of a dot so that the two images are slightly out of register. One of the images is generally much lighter than the other.

Graininess is another dot distortion problem that appears when dot gain is quite high. The uneven pattern, which is especially noticeable in smooth, even tones, is related more to the distortion of image detail than tonal value.

Halftone dot distortion: doubling.

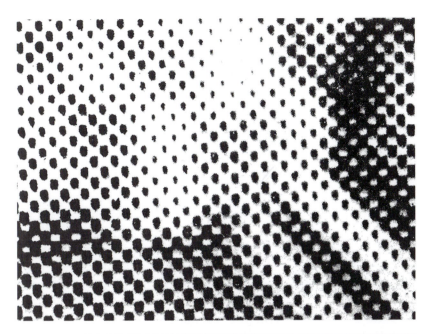

Photomicrographs showing, from left to right, increasing halftone graininess.

Lithography. Dot gain is present to one degree or another in every printing process. The following list presents those factors that influence dot distortion in lithography.

- *Ink film thickness.* The thicker the ink film, the greater the dot gain.
- *Impression pressure.* The greater the pressure, the greater the dot gain. Pressure may be adjusted by plate and blanket packing or cylinder position adjustment.
- *Offset blanket.* Compressible blankets distort less than conventional blankets and thus produce less dot gain.
- *Ink-water balance.* Too much water feed causes the ink to become waterlogged which, in turn, causes greater dot gain.

- *Plate and blanket tension.* If the tension is not high enough, doubling may occur.
- *Press speed.* Increased speed tends to decrease dot gain, assuming the press is in good mechanical condition and is properly adjusted.
- *Paper factors.* Smoother papers and papers with more coating exhibit less dot gain.
- *Ink factors.* Higher-tack inks and inks with higher pigment concentration exhibit lower dot gain.

Many of the above factors apply to all of the printing processes, although some apply exclusively to lithography. The factors pertinent to other processes are listed below.

Gravure. Dot distortion in gravure takes the form of dot spread, due mainly to the capillary action of the paper. The greater the volume of the cell and the lower the viscosity of the ink, the more likely the occurrence of dot spread.

Flexography. Flexographic dot gain contains elements of both gravure and lithographic gain factors. In addition, the coarser the screen on the anilox roll, the greater the dot gain. A lower angle of doctor blade contact increases dot gain. Other factors that increase gain include thicker doctor blades and softer rubber inking transfer rollers.

Screen printing. The screen printing dot gain factors are unique to that process. Thicker stencils, mesh, and increased squeegee pressure tend to increase dot gain. Softer squeegees, lower squeegee angles and speed, and lower ink viscosity also increase dot gain. If the end of the squeegee is rounded instead of sharp and if the mesh or screen tension is low, dot gain increases.

Letterpress. Because letterpress and lithography use similar paste-type inks, many of the factors affecting one also affect the other. One exception is the differential pressure exerted by different tonal values in letterpress printing. If the packing is adjusted to print satisfactory solids and dark tones, the light tonal values show increased dot gain. To counter this problem, it is necessary to vary packing on the basis of tonal value (i.e. more packing for darker tonal values).

**Dot Gain
Indicators**

Dot distortion may be determined by visual or densitometric methods. The visual approach relies upon the use of test images that emphasize or magnify the distortion. All of these images use high-resolution patterns of dots or lines that are very sensitive to change in the factors that influence dot distortion.

The GATF star target allows the printer to clearly identify the cause of dot distortion as being either dot gain, slur, or doubling. The star target also amplifies dot gain to such a degree that it is possible to monitor changes in gain by examining the center of the star target. The density of this target also may be measured. The illustration shows photomicrographs of tint and star target areas from two press sheets. The table presents the density measurements from these and the solid areas. Note that an 8% variation in solid density results in a 26% variation in tint density and a corresponding 60% variation in the density of the center of the star target. The high sensitivity to dot gain afforded by this target allows the press operator to detect changes before they develop into major problems.

Monitoring dot gain by density measurements.

Sample	Solid	Tint	Star Target	Dot Area
#1	1.36	0.38	0.64	54%
#2	1.26	0.30	0.40	48%
Difference	8%	26%	60%	

Photomicrographs of halftone tints and Star Targets on two sample press sheets.

The center of the Star Target serves as an extremely sensitive indicator to changes in the conditions that affect dot gain.

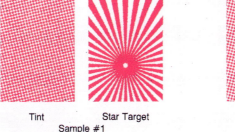

Tint Star Target
Sample #1

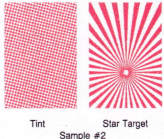

Tint Star Target
Sample #2

**Dot Area
Measurement**

The other method of determining dot distortion is through the use of density measurements. Typically, density is measured from solid and tint values of a given print for purposes of calculating dot area by either the Murray-Davies equation or the Yule-Nielsen modification of the Murray-Davies equation (see Appendix D). Most densitometers are programmed with the Murray-Davies equation for easy calculation of dot area.

The Murray-Davies equation produces measurements that incorporate both the physical and optical aspects of dot gain. The physical is the actual spreading of ink; the optical is the apparent increase in dot size due to light scattering within the substrate. The Yule-Nielsen modification removes the light-scattering effect, and consequently measures the physical dot size. The values for printed dot area may now be compared with the transmission dot values of the original films in order to determine the gain from film to print.

The Murray-Davies equation, and the modification, do not distinguish among dot gain, slur, and doubling. It is important, therefore, to also use a visual target when examining dot distortion problems.

Minimizing Dot Distortion

Although it is generally desirable to reduce dot distortion to a minimum, some of the reduction strategies may have unwanted consequences. If, for example, ink film thickness is reduced, dot distortion will be reduced. The unwanted consequence is that the maximum color density is also reduced. If the ink has more pigment added to it to help compensate for the reduced density, the flow properties may be impaired to a degree that makes the ink impossible to use. One partial solution for offset printing is to use a compressible blanket rather than a conventional blanket. This substitution, however, may not be satisfactory when such large solids as labels are being printed. The slight distortion caused by the conventional blanket helps even out large solids, often covering marks or spots that would otherwise be obvious with a compressible blanket.

Impression pressure, ink feed level, and other factors should be adjusted to minimize or eliminate halftone graininess, slur, and doubling. The resultant dot gain should not be thought of as a fault needing correction, but rather as a characteristic of the ink, substrate, plate, blanket, and press that are being used. As long as dot gain is consistent, it is possible to characterize it and to then build allowances into the color separation films. The GATF Halftone Gray Wedge was devised to help characterize tonal distortion on press.

Halftone Screen Factors

Screen ruling is usually a key predictor of dot gain for conventional halftone screen structures: the finer the ruling, the higher the dot gain for a given increase in IFT or printing pressure. This relationship is due to the disproportional influence of a constant (for a given IFT and pressure) ink

spread effect. The spread forms a higher percentage of a fine dot's total area than it does for a corresponding coarse-screen dot of the same tone value.

As may well be expected, fine near-random stochastic screen images produce greater dot gain effects than do conventional screen images. There comes a point, however, when the use of finer (e.g., 20-micron vs. 30-micron) stochastic screens actually results in less dot gain than if coarser stochastic screens were used (Tritton, 1996). This effect is probably related to the ink-carrying capacity of the printed dot; that is, very fine dot elements do not carry sufficient ink to allow the same dot boundary spread effect as the higher-carrying capacity of coarser elements. This effect may also explain why stochastic images exhibit less dot gain variability (for a given IFT change) than that for fine-screen regular halftones. Coarser-screen regular halftones will, of course, exhibit less absolute gain and lower variability than either fine-screen regular halftone or stochastic images.

Typical dot gain curves for different halftone screens: (A) stochastic, (B) conventional 150 lpi, and (C) conventional 65 lpi.

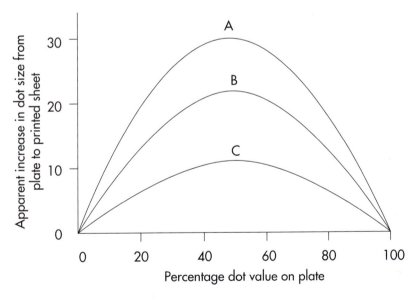

Dot Gain Terminology

Dot gain is normally expressed as an additive quantity; that is, if a 50% dot value on the film is printed as a 55% dot, that dot has gained 5%, even though, mathematically speaking, the dot is now 10% larger. Dot gain is also a function of the original film values; that is, a 0% dot and a 100% dot cannot gain. A 99% dot can only gain 1%, but a middle tone value has the potential for considerable gain. The nonlinear aspect of dot gain is shown in the graph for three kinds of screens.

The area of peak gain is the tonal value that has the largest dot perimeter. In many cases this will be the 50% dot, but it could be higher or lower, depending upon the halftone dot shape.

Average Dot Gain

Various industry surveys have found that overall lithographic sheetfed dot gain (physical and optical combined) averages about 20% at the 50% film value. The film-to-print gain is different according to whether positive or negative plates are used. A positive plate loses about 4% at the 50% value, while a negative plate gains about 2%. When a plate or a printed sheet has a dot value that is less than that on the film, the dot is said to have sharpened.

Color Sequence

When printing the four process-color inks, there are twenty-four possible color sequences. Most printers use one of three: yellow, magenta, cyan, and black (YMCK); cyan, magenta, yellow, and black (CMYK); and black, cyan, magenta, and yellow (KCMY). There are a number of reasons why one sequence may be preferred over another.

Optical Factors

These factors are established by the optical properties of the printed ink films.

Transparency. The research of Bassimer and Zawacki (1994) that was cited in Chapter 7 presented sample measurement of SWOP ink transparency. The measures of the differences between a black substrate and the inks printed separately over that substrate at one micrometer thickness were yellow $11.0\Delta E^*$, magenta $5.2\Delta E^*$, cyan $4.5\Delta E^*$ (from Fig. 13 in the paper; different measuring geometries produce different absolute values). By these measures, process yellow ink is about double the opacity (one half the transparency) of either the magenta or cyan.

The color of overprints shifts toward the color of the top-down ink if that ink is not perfectly transparent. The density of the four-color solid (and hence the contrast of the printing) may be reduced if imperfect transparency colors are printed over black, compared with printing black over those colors. Another unwanted effect will be a shadow tone color cast. These effects are especially noticeable when yellow is the last-down color. The KCMY sequence may reduce the dry trap maximum four-color density by about 0.40 in comparison to YMCK or CMYK (Field, 1983).

Moiré. The moiré patterns that occur when yellow, magenta and cyan halftones overlap may vary with ink sequence. The actual pattern is dependent upon the size of individual halftone dots (i.e., the overlap) and the specific spectral absorption properties of the inks being used. Ink trap will also influence moiré. Unwanted patterns may often be reduced by changing the printing sequence. If, for example, an unacceptable moiré occurs between magenta on unit two and yellow on unit three, magenta should be moved to unit one in place of cyan, which should be moved to unit two. Unacceptable patterns appear less likely if the contributing colors do not immediately follow each other in the sequence.

Bronzing. Certain inks (notably black, but sometimes cyan and magenta) have toners as part of their formulation. In rare circumstances, these toners can migrate to the surface of the printed ink film and change its appearance. Until the problem is corrected, this bronzing effect may be minimized by printing the offending ink earlier in the sequence.

Production Problem Factors

These factors occur when press, ink, substrate, and plate are combined under production conditions. When the results are not satisfactory, a press operator may alter color sequence in order to minimize a given problem and thus improve the appearance of the final print. The problems that the operator seeks to minimize are listed below.

Trapping. The ability to transfer one ink to a previously printed wet ink (trapping) depends upon a variety of factors, including ink tack. Sequence affects this transfer if the inks are not run in their correct tack sequence. To achieve good trapping, the first-down ink should have the highest tack, with each succeeding ink having slightly lower tack.

Doubling. Under some circumstances, the form of dot gain caused by doubling can create printing problems. This is especially true when very heavy ink films are being run. To minimize the effect of this factor, the most critical color (for example, magenta in a catalog job containing many skin tones, or black when a full-scale black separation is used) could be run on the last unit.

Mechanical problems. A particular printing unit may be causing slur or misregister due to the mechanical problems

of that unit. Until repairs are made, the noticeability of the problem may be minimized by running yellow, the least visually discernible color, on the defective unit.

Printback. On long runs with heavy ink films (carton printing, for example), the gradual contamination of one ink by the preceding ink is sometimes observed. This contamination could take the form of magenta contaminating yellow and turning it towards orange. The printback problem may be minimized by printing lighter colors before darker colors; for example, yellow before black will not result in any noticeable contamination, but the reverse could result in serious contamination.

Backtrap mottle. A variety of factors can contribute to the phenomenon known as backtrap mottle. Large solids composed of approximately 100% cyan and 70% magenta seem most likely to show backtrap mottle. Changing color sequence so that the heavy form overprints the light form minimizes most mottle. Printing the offending color (usually cyan) last will eliminate backtrap mottle in that color and its overprints, but the problem may then occur in another color. Changing paper may be required.

Ink coverage. It is easier to wet trap heavy-coverage ink films over light-coverage ink films than vice versa. The reason may be explained by the interactions between halftone dot area, dot gain and ink film thickness factors. The "Printing Dynamics" section explores these and other interactions in more detail.

In practice, however, area coverage will vary according to the subject: landscapes will have high cyan coverage and portraits will have high yellow coverage. If full-scale black color separations are used, then black will have high coverage. A given layout will usually consist of a variety of subjects, each with differing area coverages for each color. Under such circumstances, area coverage cannot be used to influence the color sequence selection process.

Color Sequence Recommendations It is strongly recommended that black follow yellow in the sequence. The probable loss of maximum density (D_{max}) when printing yellow over black aggravates the problems of print contrast, tone reproduction, and image sharpness. The

greenish-yellow cast over neutrals (when yellow is last down) is objectionable and cannot be corrected by adjustments to any of the other colors (Field, 1987). The gravure industry practice of yellow, magenta, cyan, black, and the lithographic industry (especially web offset) practice of cyan, magenta, yellow, black are good choices for standard sequences. (See the "Printing Dynamics" section for a discussion of why these different sequences work quite well for the processes in question.) Regardless of what sequence a given plant chooses, the important factor is that it be kept constant for all but the rarest circumstances.

Ink Trap

Ink trap, or trapping, refers to the transfer of one ink film over a previously printed ink film. Ink trap percentage refers to how well a printed ink film covers a previously printed ink film relative to its coverage of unprinted paper. An 80% ink trap, for example, means that the ink film thickness of the second-down ink over the first-down ink is 80% of the thickness of the second ink on an unprinted substrate. The terms *wet trap* and *dry trap* refer to whether the first-down ink was wet or dry just prior to being overprinted by the second ink.

It is possible to achieve perfect trapping, undertrapping, or overtrapping, with the most common condition being undertrapping. The factors that influence trapping, together with the direction of influence, are presented below.

Tack of Inks

In order to facilitate the transfer of one ink to previously printed inks that are still wet, the tack of the ink being printed should be lower than that of those already printed. If the tack of the second ink is higher than the first, back trapping may result; i.e., some of the first-down ink may be pulled off the paper by the second-down ink. In practice, quick-set inks are commonly made with unit tack values. The tack differential occurs when the tack of the first-down ink film increases during the time lag between the first and second printing units.

Ink Film Thickness

If the first-down ink film thickness is substantially higher than the second-down ink film thickness, undertrapping may result. In practice, the ink film thicknesses of all the colors should be approximately equal; but for improved trap, the IFT should increase slightly from unit 1 to unit 4, while the tack of the inks should correspondingly decrease.

Ink Temperature An increase in temperature lowers the tack of an ink and therefore affects its trapping performance. All inks should be maintained at about the same temperature.

Time Between Impressions The longer the time delay between the first impression and the second, the more time there is for the first ink film to start to set. The tack of the printed ink film will start to increase when it starts setting. This tack increase eases the trapping of subsequent colors. Drying or partially drying the first ink film between impressions can also help to improve trap. If too long a time elapses between impressions (for example, when a six-color job is being printed on a four-color press and a two-color press), dry trap problems may result. Various additives in the initial inks, such as waxes, may migrate to the surface and act as a barrier to the subsequent inks.

Printing Press Design Printing press design establishes the distance between the printing nips, or impression points, of each color, which, in turn, influences ink drying or setting time. In the case of sheetfed presses being run at 7,600 impressions per hour, the time difference between the first and second impressions on a common-impression-cylinder press is 0.12 seconds. The corresponding time on a separate-unit-construction press is 1.00 second. If insufficient time is allowed between impressions, a preceding ink film may not set (i.e., increase in tack) sufficiently to allow good trap of the following ink.

In cases when ink setting time between any two impression nips of a press is insufficient to achieve good trap with unit-tack inks, they should be replaced with tack-graded inks. The first-down ink should have the highest practical

Separate unit construction type of multicolor press.

P = Plate cylinder
B = Blanket cylinder
I = Ink cylinder
T = Transfer cylinder

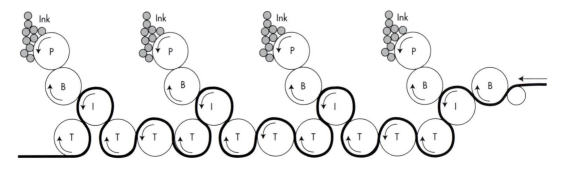

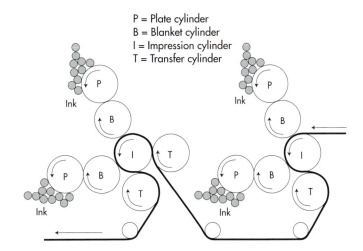

Common impression cylinder type of multicolor press.

P = Plate cylinder
B = Blanket cylinder
I = Impression cylinder
T = Transfer cylinder

tack for the substrate and printing conditions. Each subsequent ink has a tack about two points lower than its preceding ink. The first-down ink, for example, may have a tack of 18 and be followed by a 16-tack-value second ink. Ink manufacturers measure tack with an Inkometer, a laboratory device which operates at speed, temperature, and ink thickness that simulates printing.

Ink-Water Balance

In lithography, the water feed rate can influence ink tack and, consequently, trapping. If too much water is fed, the ink tack usually will decline. If not enough water is fed, the ink tack normally will increase. The reason for this behavior is that lithographic inks take up to about 40% by volume of water. The water take-up normally reduces the viscosity of the ink and lowers the tack. This influence usually outweighs the corresponding tendency for the tack to increase because of the cooling effect of the water. Maintaining correct ink-water balance for all of the colors is crucial for all aspects of lithographic printing quality. Correct balance avoids snowflakiness and scum or catch-up.

Paper Absorbency

The more absorbent the substrate, the quicker the penetration of the ink vehicle into the substrate. This action causes an increase in the tack of the surface ink, which eases the trapping of the next ink.

Trap Measurement

The key purpose of a trapping equation is to measure the relative transfer of the second-down ink to the first-down ink. The most convenient method of measuring ink trap

*Color circle plots of varia-
tions between companies
in the red, green, and blue
two-color overprint.*

*These plots are influenced
by the primary (CMY) ink
densities, ink transparency
(or opacity), and trapping
efficiency.*

within a printing plant is through an equation that is based
upon density measurements. A series of trapping equations
were evaluated (Field, 1985) against laboratory measures of
actual ink transfer, and it was found that the Preucil equa-
tion (Preucil, 1958) was the only one to correlate with the
transferred ink film thickness of the overprinted (second-
down) ink. Densitometer readings are made of the first-down
ink, the second-down ink, and the two-color overprint all
through the filter complementary to the color of the second-
down ink. If, for example, magenta is the second-down ink,
the readings are taken through the green filter. The densito-
meter is zeroed to the substrate before taking readings. The
Preucil equation:

$$\text{Percent Apparent Trap} \;=\; \frac{D_{op} - D_1}{D_2} \times 100\%$$

where D_1 is the density of the first-down ink, D_2 is the den-
sity of the second-down ink, and D_{op} is the density of the
two-color overprint.

The densitometric method of trap evaluation does not pro-
duce exact measurements of the actual ink film thickness
percentage. This occurs because of these influences: first-
surface reflection and gloss, multiple internal reflection,
opacity of the second-down ink, back transfer, and the spec-

tral response of the densitometer. The use of narrow-band versus wide-band densitometer filters, in particular, will influence the apparent trap calculations. An actual trap of 100% may normally have an apparent densitometric trap anywhere between 95% and 105%, or, in some cases, even beyond those limits.

As with ink film thickness, the optimal trap may depend upon a given job. In practice, it is normal to aim for 100% trap, but commercially acceptable values of 75–95% are more the norm for wet-on-wet printing. Apart from achieving a given target value, trapping consistency is also important.

The GATF Color Hexagon is a good diagram for documenting changes in ink trap. The red, green, and blue densities of the overprint and primary colors are plotted on the diagram together with the theoretical values for the overprints (i.e., perfect additivity). Proof and press sheets are often compared on this type of diagram (see Chapter 13).

Another way of evaluating trap is simply to look at a printed target through a filter complementary to the color of the second-down ink. The second-down solid and the overprint solid should appear about equal for 100% trap.

An example of poor magenta trap over yellow (left) and how it would appear if viewed through a green filter (right).

Register

The register between individual color images influences the quality of the color reproduction. Register variations can result in loss of resolution and sharpness. Moiré patterns may also be exacerbated by misregister.

The degree of misregister that can be tolerated largely depends upon the screen ruling and the sharpness of image detail. Soft-focus pictures have a greater tolerance for register variation than do sharp-focus pictures. Coarse screen rulings do not show a given linear misregister as noticeably as fine screen rulings. Research by Jorgensen (1982) has shown that register variation of up to one-half row of dots (± 0.002 in. for a 150-lines-per-inch-screen) would probably be acceptable for most printed images.

Some color variations can be attributed to misregister. If two halftone dots print side by side, the resulting color will be the additive combination or fusion of the light reflectances from the white paper and the color of the inks used to print the dots. If a slight misregister causes the two dots to print on top of each other, the resultant color will be the integration of the white paper reflectances and the overprint dot reflectances. Because of additivity failure, the reflectances of the overprint differ from the combined reflectances of the individual inks. Register variations, therefore, produce color variations. The degree of color variation depends upon the screen ruling, the percentage dot value of each of the colors, the actual register variation, and the additivity factors for the ink films in question. This register-induced color shift is one of the primary reasons why same-angle separations are not used. Same-angle separations give superior resolution by comparison with conventional four-angle separations.

In those cases when one color type is printed against a background of another color, a slight misregister shows as a white line separating the two colors. In order to counter this problem, the type is spread (enlarged slightly) or the background is choked (shrunk slightly) to provide a very slight overlap between the two colors. This process is called image trap to distinguish it from ink trap that was discussed earlier. In practice, however, the term trapping is used to describe either process.

Mechanical Ghosting and Other Problems

Mechanical ghosting, or starvation, sometimes occurs in lithographic and letterpress printing. The reason mechanical ghosting occurs, for large areas of coverage, is that the inking systems of lithography and letterpress cannot replenish ink at the same rate as it is consumed. For light coverage layouts this is usually not a problem; but, when a window-frame pattern is printed, the bars perpendicular to the direction of travel print higher in density than those parallel to the direction of travel.

Sharpness loss with out-of-register printing (top) compared to in register printing (bottom).

Image with sharp- and soft-edged detail.

Misregister will be more apparent in the sharp-edged foreground detail.

Mechanical ghosting induced by the selection of a "windowframe" design printed by lithography.

Mechanical ghosting induced by the selection of a "windowframe" design printed by lithography.

Apart from the problems caused by windowframe designs, mechanical ghosting can contribute to color variation within a sheet of such heavy ink coverage images as labels. In some cases, the lead image is the darkest, with each succeeding image a little lighter. In other cases, the images may print lighter and then heavier. The exact pattern depends upon the inking system design. Density variation from front to back could be as much as 0.15 (Hull, 1973).

Starvation or mechanical ghosting problems may be minimized by avoiding windowframe designs, using opaque inks, laying out the form so that heavy coverage images do not print in line with each other, adding an oscillating rider roller above the last form roller, using a special oscillating last form roller, or using minimal water during lithographic printing.

Other inking-system-induced color problems in lithography are due to the intermittent feed of ink from the fountain to the ink roller train. A surge of ink is transferred at a frequency that depends upon mechanical timing of the ductor roller. This noncontinuous feed contributes to slight cyclical sheet-to-sheet variation in density.

Printing Dynamics

The dynamics of the printing process are not completely understood, but experience has shown that there are cross-interactions between ink film thickness and dot gain, between dot gain and ink trap, and between ink trap and color sequence. The following discussion establishes the theoretical foundations of the production strategies and tech-

niques that have been developed to help minimize some of the cross interaction problems. The practical implications of these production aids are also explored.

Ink Film Thickness and Dot Gain

The relationship between IFT and dot gain is well known: if IFT is increased, then dot gain also increases. In practice, saturation in solids is sometimes sacrificed to avoid halftone graininess and dark middletones. The only way to resolve the IFT-dot gain tradeoff, apart from increasing the pigment concentration in the ink, is to use coarser halftone screen rulings.

As explained earlier, the ink spreading effect that occurs when pressure is applied during printing affects fine-screen halftones more than coarse-screen halftones. The spread effect around a dot's perimeter forms a greater fraction of a printed fine-screen dot than a coarse-screen dot with the same spread effect. In other words, a certain ink spread effect may increase the dot area of a fine-screen 50% halftone dot to 70%, but may only increase a coarse-screen 50% halftone dot to 55%.

Coarse screen rulings are quite satisfactory for billboard posters, which are viewed at a considerable distance, but are not suitable for high-quality art reproduction books that are viewed at a short distance. The screen-ruling production choices are based upon substrate and printing processes, and the end use resolution requirements. Chapter 9 covers screen ruling selection in some detail.

Dot Gain and Ink Trap

The relationship between dot area coverage and trapping efficiency was previously discussed from the backtrap mottle point of view. It is easier to trap a heavier-coverage image over a lighter-coverage image than vice versa. This principle forms the foundation of the undercolor removal process, which is used to help improve trapping in the dark tonal areas of four-color process printing.

Undercolor removal. Magazine printers, in particular, typically specify that color separation films incorporate certain levels of undercolor removal (UCR) to help improve wet-on-wet trapping. The term undercolor removal refers to the partial (usually) removal of yellow, magenta, and cyan inks that would normally print under the black ink in dark tonal areas. The technique was first used on a large-scale basis by the U.S. magazine printing industry. This industry initially

used four-color rotary letterpress machines and printed in a yellow, magenta, cyan, black color sequence. The removal of color from under black was accomplished by printing reduced percentages of the "undercolor" yellow, magenta, and cyan. If 100% values of the four solid colors are reduced to 55% yellow, 55% magenta, 65% cyan, and 85% black, the total coverage amounts to 260%, compared to the previous 400%. These films are described as having 260% UCR.

For a complete explanation of how UCR works, it is necessary to consider dot gain. Most of the UCR users are publications printers. This industry uses inks that must run at high speed on fairly lightweight paper. To prevent picking the paper, it is necessary to avoid thin ink films. The thicker ink films that are used result in higher levels of dot gain. For 100% dot values, no gain is possible; therefore, the ink that does not penetrate into the paper remains in a relatively thick film on top of the paper. For 60% dot values, however, the ink spreads sideways (i.e., we have dot gain) upon impression. Some ink penetrates into the paper, and the remainder spreads across the paper to a degree that corresponds to the dot gain of the system; consequently, the thickness of the printed ink film is lower than the no-UCR case, and it is easier for the next ink to trap on the first.

The major drawback with UCR is that, as UCR is increased, the maximum density of the printed sheet decreases. Reduced D_{max} means reduced contrast and reduced sharpness; therefore, avoid using UCR whenever possible. When good-quality materials are available, and the press has been set to minimize dot gain and to maximize trapping, UCR may not be needed (Schläpfer and Keretho, 1979). For high-speed magazine production and similar types of work, some UCR could be desirable. The recommended UCR values range from 260% to 300%.

Gray component replacement. Gray component replacement (GCR) differs from UCR in that the reduction of colors under black is not confined to dark, neutral tones. The process is used, like UCR, to help improve trapping in areas of heavy coverage, but also to help minimize the effects of color variation on press.

The theory behind GCR is that whenever dots of yellow, magenta, and cyan are present in the same color, there is a gray component to that color. That is, if the smallest of the three dot values were to be removed from the color, together

with appropriate amounts of the other colors in order to produce a neutral gray tone, then that gray tone could be replaced by a dot of black. Following this reasoning, it is possible to achieve almost any given tertiary color by using two of the three colored inks plus black.

GCR improves trapping in the same manner as UCR: thinner ink films result when reduced-area halftone dots gain in size during printing without fill-in occurring. Thinner early-down ink films then help to improve the transfer of subsequent heavier-coverage ink films. If significant levels of GCR and UCR are used, the black printer will have the heaviest coverage. This is another reason why black should be run last in the sequence.

Another advantage of GCR is that variation of the yellow, magenta, or cyan printers during the run exerts less influence on the appearance of the print than a similar variation would produce in a case where GCR was not used. This advantage is particularly applicable to cases of near-neutral colors that would otherwise be produced with the three process color inks, but less so for strongly saturated colors.

A major concern with GCR, like UCR, is reduced density of darker colors. For many jobs this is not a serious problem, but for others it may be. A coverage of 300% is noticeably lighter than 400% coverage; therefore, in cases where good shadow detail or strong, dense blacks are required, the undercolor addition (UCA) process should be used to add color back to the near-neutral and neutral darker tonal values. A related problem with excessive GCR (without compensatory UCA) is that the gloss of the reproduction will be reduced.

The amounts, and the starting points, for UCR and GCR can be continuously varied between 0 and 100 on most color separation systems. The method of designating GCR, however, varies according to the scanner or software manufacturer. A 60% GCR set of separations made by one scanner will not necessarily appear the same as a 60% GCR set made by another scanner. See Chapter 12 for more detail on GCR, UCR, and UCA.

Ink Trap and Color Sequence

The interaction of a number of factors will influence the appearance of overprint colors. Ink trap and ink transparency are two key influences. Consider the case of magenta printing over yellow. If the trapping of magenta over yellow is imperfect, the resulting red overprint area will appear too

orange. Suppose that the sequence is now reversed and yellow prints over magenta: imperfect trap of yellow over magenta will bias the resulting red overprint more towards a true red (i.e., less orange). The transparency of the inks also plays a role. For inks having less-than-perfect transparency, the hue of the overprint will be biased towards the second-down color. As stated earlier, the yellow ink has less transparency (i.e., is more opaque) than the magenta ink, so if perfect yellow-magenta trap (in either sequence) occurs, the position of yellow in the sequence will exert a greater influence on the overprint color than will the magenta. Under this circumstance, if yellow is printed over magenta, we do not want perfect trapping because the relatively poor transparency of the yellow will shift the color of the overprint red towards orange.

Ink transparency considerations alone suggest a yellow, magenta, cyan sequence; however, less-than-perfect wet-on-wet trapping paradoxically produces good red, green, blue overprints when a cyan, magenta, yellow sequence is run. On the other hand, in those cases (e.g., gravure) when the ink films are dried before overprinting, near-perfect trap occurs and the best sequence, from the ink transparency viewpoint, is yellow, magenta, cyan.

Regardless of the cyan, magenta, and yellow placement within the sequence, black should always be printed last, or at least after yellow. The quality of certain jobs (e.g., black shoe catalog, black automobile brochure) will be significantly lower if black is not printed last in the sequence.

Printed Image Analysis and Control

Many aspects of printed image quality are best monitored and evaluated by using a test image alongside the job image. The three primary uses of press control test images are: makeready evaluation, monitoring printing consistency, and troubleshooting. Those seeking more detail on lithographic color control are referred to Kelvin Tritton's comprehensive book (1993) on this subject.

Each job differs from preceding jobs (except for reprints), so it is important to use a common test image (also called color bar or color strip) alongside the job image to evaluate whether the press has been made ready to plant standards. Scanning densitometers may be used to make rapid measurements of many print quality factors across the entire width of the sheet. The makeready data are then compared with the stored standard values and, if there are significant differences, the press

is adjusted prior to generating a new sheet for analysis. The overall quality of the printed job is ready for evaluation when the makeready sheet is a close match to plant standards. In practice, the actual running standard may differ from the makeready target, but the initial evaluation should still occur at the target values.

Once an OK sheet or standard has been established, it is used for ongoing comparisons with printing produced during the rest of the run. High-speed production rates often make it impractical to make detailed analyses of printed sheets during the run. Press operators often rely upon side-by-side visual comparisons of test strips to provide rapid indications of production variability. Scanning densitometers or spectro-colorimeters also provide rapid feedback about the printing conditions. In either case, a test image is required. The layout and design of test images make visual comparison or instrumental evaluation quick and easy.

In the absence of a test image, it is difficult to judge whether a poor reproduction is due to a poor set of color separations or poor presswork. A test image makes it possible to isolate the contribution of the printing stage and, furthermore, it indicates the nature of any press problems. Test images are designed to magnify and isolate the effect of printing variation. Certain elements (e.g., the gray field), within the test image are used to monitor variations, while other elements may be used to help troubleshoot the reasons for the variation and, subsequently, to work out the correction strategy.

Test Image Design

Test images may take several forms, but in practice an image for monitoring and evaluating the printing performance should contain the following areas: solids of each of the printing colors, halftone tints (at the appropriate screen ruling) with 40–50% dot areas for each of the printing colors, fine-line resolution (microline) targets for each color, two-, three- and four-color overlaps of the process colors, and a three-color neutral gray halftone tint. A 75% screen tint of each color is also required for print contrast ratio determination.

The other design issue, apart from the test strip's configuration, is the size of the individual image elements. If the elements are too large, paper waste increases; they are too small, it may be difficult to make measurements. In practice, larger test strips are frequently used for proofing purposes, with smaller versions being reserved for trim areas on production jobs. The illustration on page 179 of one GATF test

image for production print applications incorporates most of the recommended image analysis areas.

Color register influences resolution, sharpness, moiré, and, to some extent, the color of overlapping halftone tints. Apart from direct inspection of the image area, register is best monitored by register marks positioned at the corners of the job image. Register marks on color bar test strips should not be used for controlling the register of the production image; the marks placed at the four corners of the image area are more reliable.

Test Image Placement

Color bar test images should be positioned across the cylinder at either the tail or gripper edges (for sheetfed printing). A bar with tail placement tends to be more sensitive to image distortion than one with gripper placement. The tail bar is also more apt to be influenced by mechanical ghosting (ink starvation) patterns than one placed at the gripper edge. Test image placement within glue flaps and similar sections of folding cartons is a further layout option. The important point is that test image placement should be consistent in order to minimize the effect of intra-sheet density variations. If more than one set of master images is used to cover the full width of the sheet or web, it is important that the halftone dot values and microline target resolution be identical on each set.

Selecting Samples for Evaluation

The samples selected for consistency analysis should be statistically valid representations of the printing conditions. Consecutively printed lithographic sheets may vary from each other within the intermittent ink feed induced cycle by up to 0.05 density (see the table on page 181); therefore, a valid single sample may consist of 4–7 consecutive sheets, which are measured and averaged prior to evaluation.

Sample selection frequency for monitoring production depends upon the stability of the printing process and the difficulty of the job. The sampling rate may be determined by customer specifications that are part of a quality assurance program.

A single sheet is all that is required for OK reference purposes. The selection should be deferred until the makeready process has been completed—the images are in register, the inking across the sheet or web is even, and the test image control points (trap, density, dot area, etc.) match the plant's makeready standards.

The GATF Compact Color Test Strip, which is suitable for monitoring the consistency of a pressrun.

C M Y K

GATF Digital Compact Color Test Strip (version 1.0)

Key to color patches, starting with the first patch at the left.

Patch	Definition	Patch	Definition
1	100 C	14	100 C
2	100 C + 100 Y	15	40 C
3	100 Y	16	100 Y
4	100 Y + 100 M	17	40 Y
5	100 M	18	100 M
6	100 M + 100 C	19	40 M
7	100 C	20	40 M + 40 Y
8	100 C + 100 M + 100 Y	21	40 C + 40 Y
9	40 C + 40 M + 40 Y	22	40 C + 40 M
10	40 C + 30 M + 30 Y	23	C Star
11	40 K	24	Y Star
12	40 C + 20 M + 30 Y	25	M Star
13	100 K	26	K Star

A single sample is also all that is required for evaluating such feedback control test images as the gray balance chart that is used to determine color separation film tone scales. The chosen sample should, however, represent the average of 4–7 consecutive sheets for litho printing. In the case of the color chart type of feedback test image that may be widely distributed to customers, sales personnel, and production workers, sheets should be carefully selected from the run to ensure that the color differences between charts are minimal. In order to protect the integrity of the charts as a color communications tool and production guide, those sheets not selected should be discarded.

The ideal density, trap, and dot gain target values for producing such feedback control images as color charts are those most easily reproduced in subsequent pressruns. The target values are usually averages obtained over a period of months from a process capability study. These averages double as the makeready target values for a given ink set and substrate combination. Different target values have to be determined for significantly different ink sets or substrates.

Image Analysis Philosophy

There are two ways to look at the analysis of printed images from the color-quality point of view. The elemental or individual component approach focuses upon measures of dot gain, trapping, and solid densities for each of the colors. The careful control of each element results in a high-quality press sheet image. The integrative or systems perspective, on the other hand, focuses upon the overall image and uses gray field analysis strategies for monitoring quality.

Individual analysis of each color is required when deciding what and how much adjustment to make for a given color to match a specific standard. The underlying theory is that the individual adjustments will add up to equal a standard quality image. This approach is most useful when establishing a target makeready or reprinting a job. Elemental analysis is also particularly useful for troubleshooting purposes.

Integrative analysis of the image is required for overall assessment of quality. Once the makeready targets are achieved, the press is often adjusted to "fine tune" the quality of the job. Such deviations from standard are, of course, restricted to variations within the control limits for SWOP and similar specifications. Once an acceptable or OK image has been established, gray field analysis is used to monitor ongoing consistency.

Elemental Analysis

Elemental analysis requires that the color test image is measured in these areas: solids, two-color overlaps, halftone dot tints, and other areas that will depend on the design of the control image. The data, which are normally obtained with a densitometer, are converted into such measures as percent trap, dot area (and dot gain) and print contrast for each color. The resulting values may be used for diagnostic purposes or to serve as makeready targets for similar jobs.

The three-filter density readings of the individual process colors and their overlaps may be plotted on a GATF Color Hexagon. This form of data display and analysis is particularly useful when attempting to match a proof to a press sheet, or vice versa. It is covered in more detail within Chapter 13.

Specific solid density values or dot area computations may be plotted on process control charts for analyzing statistical variation. Such charts are useful components of process capability studies and are often used to identify unusual variation patterns. Certain published specifications for publications printing also express print factor tolerances in terms of the

Variations in consecutive sheet densities for a sheetfed lithographic press.

| Consecutive | Densities | | | |
Sample	Yellow	Magenta	Cyan	Black
1	1.00	1.09	1.17	1.66
2	1.00	1.10	1.16	1.63
3	1.01	1.11	1.19	1.66
4	1.00	1.13	1.21	1.63
5	1.01	1.12	1.15	1.64
6	1.00	1.12	1.15	1.63
7	0.97	1.12	1.17	1.66
8	0.99	1.13	1.15	1.63
9	1.00	1.12	1.17	1.66
10	1.01	1.10	1.21	1.65
11	1.01	1.09	1.19	1.66
12	1.00	1.08	1.18	1.63
13	1.00	1.09	1.16	1.63
14	1.00	1.12	1.19	1.63
15	1.00	1.12	1.17	1.63
16	0.99	1.13	1.19	1.65
17	0.99	1.12	1.18	1.62
18	1.00	1.12	1.18	1.66
19	0.99	1.12	1.17	1.61
20	1.00	1.11	1.20	1.63

measures made during an elemental analysis of a color control test image (e.g., density and dot gain targets and ranges).

The success of the elemental analysis approach is dependent upon making a sufficient number of appropriate measurements. It is not enough, for example, to only make measurements of ink solids and their overprints. Dot gain evaluations are also a critical part of the quality assessment process.

In practice, an elemental analysis requires, at a minimum, three filter readings from the solids and the overprints, and single filter readings of the black solid and the single-color halftone tint areas. A total of 23 separate density readings and seven calculations (three for trap and four for dot area) are required to characterize one group of targets on one sheet. If the readings from five sheets are averaged for, say, eight groups of targets across each sheet, then over 900 density readings will be required. A scanning densitometer, interfaced with a computer for computation and averaging tasks, is the only practical way to perform a thorough analysis of this type. Manual density readings made from a single

group of target areas on a single sheet are useful, but they do not have the statistical validity of the more complete analysis; therefore, they should not be used for process capability study purposes.

Elemental analysis of a single group of targets is quite satisfactory when adjusting the press towards makeready standards, or performing an analysis to determine why a color shift has appeared in the gray field of the color control image. The analysis provides guidance for making gross press adjustments, but the lack of statistical reliability will exclude the use of single target measurements for fine adjustments in press settings.

Integrative Analysis

Integrative analysis starts with the approval of the OK sheet and is driven by the need to control the balance between the yellow, magenta, and cyan printers for the subsequent press run. If any one of the three process colors experiences significant shifts in dot gain, trap, or solid density, the hue of the overall job image will shift. Such shifts may, depending upon the color, magnitude, and the importance of the areas experiencing the shift, be grounds for rejecting the job.

Shifts in color balance are most easily detected by monitoring the changes in the three-color halftone gray target within most color control test images. The gray field halftone values are usually chosen to produce a neutral under a given set of production conditions (SWOP proofing, for example) and will not appear gray under other conditions. The lack of universal neutrality is unimportant; the target's value is used as a reference color rather than as an absolute gray.

A makeready sheet approved for running may, for example, contain a gray target that appears yellowish-gray. This target becomes the standard for color balance: subsequent sheets should also appear yellowish-gray in the three-color gray field. Such comparisons may be made by placing the OK and run image side by side. The eye is an excellent comparator, therefore, any hue shift from OK will be readily apparent.

The GATF Compact Color Test Strip, introduced in August 1968, was the first practical system of gray field analysis for lithographic printing. This test image (Elyjiw, 1968) incorporated two three-color gray fields—one balanced to produce a neutral with a rubine magenta, and the other balanced to produce a neutral with a rhodamine magenta. A reference neutral halftone black area was printed between the two three-color grays.

The GATF Offset Color Control Bar, a proof control target that also incorporates a three-color gray field, was introduced during February of 1968. The gray field in this test image appeared neutral when a proof was made to the AAAA/MPA (predecessor of SWOP) standard proofing conditions for magazine advertising.

John MacPhee (1988) developed the structured system of gray field analysis and control displayed in the flowchart on the following page. He proposed that the press operator visually monitor the gray field prior to using a combination of visual and densitometric assessment during any subsequent troubleshooting and adjustment operations.

Felix Brunner's system of gray field analysis used densitometry to quantify the target areas (Brunner, 1987). He also conceived an image classification scheme for ranking press control difficulty. Near-neutral images, for example, required very tight control ($\pm 2\%$ dot size in the middletones) whereas images containing strong saturated colors could tolerate more variation ($\pm 6\%$ dot size in the middletones) before becoming unacceptable. Brunner's method of gray field analysis, via densitometry, does not have the advantages afforded by colorimetry.

The pinnacle of gray field analysis was that introduced by Heidelberger Druckmaschinen AG at the 1990 DRUPA exhibition. Heidelberg's CPC-2S analytical system scanned a printed OK sheet test strip image with a spectrophotometer, and then converted the gray field data into colorimetric form. The subsequent three-dimensional data are plotted on two separate diagrams. The gray field (regardless of its neutrality) now becomes the standard for the pressrun (Kipphan, 1993).

The key feature of the CPC-2S (now called the CPC-21), however, is its use of color difference equations to quantify color balance shifts from the OK target. Control radii are set at 1, 2, and 3 ΔE units around the standard according to either the critical nature of the image, or to the consistency requirements of the customer. The measured ΔE shifts in the gray field may be used to guide a press control system that will automatically make the necessary adjustments to bring the subsequent press sheet gray fields back to the reference values. A similar system for the on-line control of gravure printing has also been developed.

Flowchart for a gray field control strategy that uses visual evaluation and densitometric analysis techniques.

Reproduced with permission from John MacPhee, *TAGA Proceedings* 1988.

Test images and a densitometer are used to monitor and control the production mode of color printing. When process is in control, operator activity consists of periodic visual checks along the path indicated by solid lines. If a problem arises, a densitometer is used to speed analysis of cause, following alternate paths indicated by dotted line.

Start

Check gray balance patch

Is it OK?

No — Check 2-color overprints for hue shifts

Are they OK?

Yes

Check black star target for dot size and quality

Is it OK?

No — Find and correct problem in black unit

Yes

Check cyan, magenta, and yellow star targets for dot size and quality

Are they OK?

No — Find and correct problem common to all three printing units

Yes

Check solid color bars for uniform ink laydown

Are they OK?

No — Find and correct problem causing poor ink laydown

Yes

Check halftone bar of each overprint for change in dot size

Are they OK?

No — Find and correct problem causing dot gain (loss)

Yes

Check solid bar of each color for change in ink film thickness

Are they OK?

No — Find and correct problem causing change in ink film thickness

Yes

Check trapping using overprinted solid and solids of each color

Is it OK?

No — Find and correct problem in trapping

Yes — Check parameters (e.g., ink and paper) for changes that affect hue shift

9 Printing Systems Analysis

**Process
Capability**

The color separation process is the art and science of produc-
ing separation images that will, when printed, produce the
best possible results within the constraints of the printing
process. Color separation must, therefore, be guided by knowl-
edge of the printing process capabilities. In general, there are
two broad classes of printing process capabilities of interest to
the color separator: color gamut and image resolution.

Color Gamut

The color gamut of an ink-paper-press system is dependent
upon the absorption characteristics of the ink (i.e., primarily
the pigment), the optical and absorption properties of the
substrate, the ink film thickness, the color distortions due to
the halftone screening process, and the color distortions asso-
ciated with the ink transfer process. Substrate gloss, texture,
and the use of overprint varnishes may also exert an influ-
ence on the color gamut of the system.

The ideal absorption and transparency properties of pig-
ments for color reproduction were discussed under the "Ink"
section of Chapter 7. In general, process-color inks should
absorb about one-third of the visible spectrum and fully
transmit the other two-thirds.

Desirable substrate characteristics were discussed under
the "Paper and Other Substrates" section of Chapter 7. The
unambiguous substrate properties are whiteness and bright-
ness; both should be high. The ideal gloss, texture, absorption
and smoothness requirements will depend upon printing
process requirements, the aesthetic intent of the designer,
the characteristics of the original, and the printing market
requirements.

Ink film thickness (IFT) issues have been discussed on
two prior occasions. The concept of optimal printed ink film
thickness selection was covered in Chapter 8, and the broad

color gamut effects (masstone and undertone) associated with ink transparency and IFT were addressed in Chapter 7. As IFT increases, the proportional transmittance of light through the film is not constant. In theory, a magenta ink film with 90% transmission of red light and a 30% transmission of blue light (i.e., a 3:1 ratio) will change to 81% transmission ($90\% \times 90\% = 81\%$) of red light and a 9% transmission ($30\% \times 30\% = 9\%$) of blue light (i.e., a 9:1 ratio) if the IFT is doubled. The effect will not be this severe in practice because of the surface and interimage reflectance factors, but there will be a significant shift from bluish to reddish in the magenta's hue. Cyans will turn grayer (i.e., less saturated) and bluer with increasing IFTs, and yellows will turn (very slightly) orange.

The following are the color gamut tradeoffs of varying IFT. Increasing IFT will increase density values, which will result in improved image contrast (tone reproduction) and image sharpness. Saturation also increases when IFT increases; but once the IFT reaches a certain point, the saturation starts to decrease (i.e., the masstone effect becomes dominant). The hue of the ink film will shift towards the color of greatest transmission (i.e., magentas shift towards red, cyans shift towards blue, and yellows shift very slightly toward red). There is no simple specification of IFT that will produce the optimal results for all situations.

Proportionality failure occurs when halftone tints of a given solid ink film fail to retain their proportional reflectances. Tint colors are proportional if their ratios of blue, green, and red light reflectance are identical to those of solid colors.

Proportionality failure occurs because of first-surface reflections, multiple internal reflections and the halftone dot structure. The most important factor by far is the halftone effect.

Halftone proportionality failure occurs most strongly for coarse screens on coated paper and least strongly for fine screens on uncoated paper. The screen ruling effect is due to light penetrating the halftone dot's ink film, entering the internal structure of the substrate, and being reflected back to the observer through the unprinted region around the halftone dot. If the screen ruling is fine (i.e., the dots are close together) and the substrate is uncoated (i.e., there is ample opportunity for light scattering) then the light that emerges in the unprinted area around the halftone dots will

Graphical representation of proportionality failure.

Perfect proportionality is represented by the dotted lines between the maximum and minimum points.

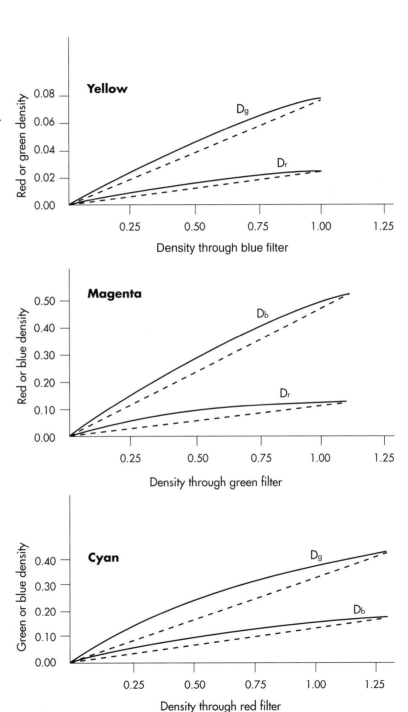

have a greater influence in the halftone surround than in those cases when the halftone dots are further apart (i.e., coarser screen ruling) or the substrate is coated (i.e., little

% Dot	Magenta		Cyan	
	Hue Error	Grayness	Hue Error	Grayness
100	57	12	30	10
70	60	15	41	13
50	61	14	47	14
30	58	14	52	13

opportunity for internal light scattering). In other words, the halftone fringe scattering effect is a constant (for a given substrate), therefore, it exerts a proportionally greater effect with fine screen rulings.

Halftone proportionality failure occurs most strongly for those pigments having the greatest unwanted absorptions, i.e., those that are furthest from "ideal." The accompanying graph shows that proportionality failure effects are the greatest for cyan and the least for yellow. The Murray-Davies equation (see Appendix D) may be used to predict proportionality failure effects. The basic equation is rearranged to solve for the density of the halftone tint. The equation is then solved sequentially for the red, green, and blue filter density values, and for a range of halftone dot areas.

The graying effect of the halftone process on light colors represents a serious reduction in color gamut. The impact of proportionality failure-induced gamut reduction will be most obvious in reproductions of originals that contain light, pure tonal values. Proportionality failure effects may be overcome by using supplementary inks. Mixtures of cyan with white and of magenta with white are commonly used as fifth and sixth colors for countering proportionality failure effects.

The gravure process rarely experiences proportionality failure problems. The reasons for this are that the highlight cells transfer thinner ink films than the shadow cells, and that the fluid nature of gravure ink ensures that the dots undergo physical spreading (and further thinning). In other words, the gravure image approaches the ideal of continuous films with varying thicknesses. In fact, because of masstone-undertone effects, the thinner highlight ink films are cleaner or purer than corresponding solid or shadow tonal areas.

Additivity failure occurs when the densities (red, green and blue filter readings) of a two-color overprint fail to equal the sum of the densities of the two primary-color inks used to produce the overprint (the same concept applies to three or more color overprints). The optical factors that contribute to

additivity failure include the lack of perfect ink film transparency, first-surface reflections, and multiple internal reflections. The physical factors that influence additivity failure are undertrapping or overtrapping of the second ink film to the first ink film, and back transfer of the first ink to the second ink. The spectral response of the densitometer will also influence the additivity measurements. Light scatter within the substrate will further contribute to the non-additivity of halftone tints.

Additivity failure results in poor saturation of solid overprint red, green and blue colors. The impact of additivity failure-induced gamut reduction will be most obvious in reproductions that contain strong, saturated colors. Additivity failure effects may be overcome by using supplementary red, green, and blue inks in conjunction with stochastic or random-dot halftone screening techniques (i.e., to avoid moiré).

The nonadditivity of densities.

Printed Colors	Blue Filter	Green Filter	Red Filter
Yellow solid	0.83	0.07	0.02
Magenta solid	0.70	1.15	0.14
Cyan solid	0.11	0.43	1.21
Yellow+magenta	1.53	1.22	0.16
Red overprint	1.28*	1.13*	0.14
Yellow+cyan	0.94	0.50	1.23
Green overprint	0.82*	0.49	1.23
Magenta+cyan	0.81	1.58	1.35
Blue overprint	0.67*	1.37*	1.21*

* = additivity failure of more than 0.05 density

Additivity failure rarely occurs in gravure printing because each ink film is dried before overprinting the next (i.e., undertrapping does not occur). In fact, the superadditivity that is often observed for gravure printing on lower-grade papers is due to the overtrapping that occurs when the first-down ink seals the substrate and presents a less absorbent surface to the second ink. The wet-on-wet trap difficulties associated with lithographic printing are the primary cause of additivity failure for this process. If ink trap efficiency could be improved (e.g., by drying the ink films between

printing units) in lithography, the overprint red, green, and blue saturations would approach those of gravure (or screen process printing) and probably eliminate the need for special red, green, and blue supplementary colors.

The maximum density of the four-color solid combination also helps determine the color gamut. Higher D_{max} values make it possible to produce color separations with less tonal compression. Higher maximum density also results in sharper images.

Additivity failure effects limit the maximum four-color solid density. As might be expected, the dry-between-colors approach of gravure produces higher average D_{max} values than the wet-on-wet ink transfer approach used by the lithographic process. Average high-quality gravure D_{max} values are around 2.30 whereas comparable lithographic printing rarely exceeds 2.00.

Overprint varnishes or coatings are sometimes used to help raise the contrast and saturation of lithographic printing to more closely equal that of gravure. Much of the same effect may be achieved by eliminating the additivity failure effects that are due to less-than-perfect wet ink trap in lithographic printing. Printing black after yellow in the color sequence will also help to ensure that D_{max} is maximized for a given combination of materials.

A comprehensive discussion of proportionality and additivity failure theory is presented in Chapter 8 of John Yule's *Principles of Color Reproduction* (1967). This source should be consulted by those seeking more details of these gamut-constraining effects.

Image Resolution The resolution of a photomechanical reproduction system is of importance for at least two reasons. The most obvious reason is the retention of fine image detail. Higher-resolution systems are more capable of reproducing such fine detail as fabric patterns and facial detail than lower-resolution systems. The other reason to prefer high-resolution systems is related to the number of distinct tonal values that may be rendered by a given halftone screening system. This latter reason has become a matter of some concern since digital image recording technologies were introduced during the early 1970s.

Resolution limits are established by the smallest spot size that may be consistently reproduced by a printing process.

Lithography, with around an 8-micron minimum spot size, is probably the highest-resolution process. The physical engraving requirements for gravure and relief process image carriers probably dictate a coarser resolution for those processes, while the supporting mesh required for screen printing certainly restricts the resolution of that process.

The smoothness of the substrate generally influences resolution; coarser screen rulings are normally preferred for rougher papers. The ink rheological properties will also influence resolution. Inks for gravure, flexography and (less so) screen printing processes have lower viscosity than the paste-type inks used in lithography and letterpress, and are therefore more likely to cause reduced resolution. In fact, the gravure process relies upon the diffusion of the ink around the printed cell perimeter to produce text and solid images without the cell wall structure pattern that is part of the cylinder image.

Resolution may be restricted in lithography by the plate. Plates that are imaged directly from the data files sometimes produce lower-resolution images than in the indirect case (record to film and then contact to plate). Direct-recording proofing systems and indirect proofing systems often have less resolution than lithographic printing systems. Indeed, some of the difficulties associated with stochastic screens are due to the fact that some proofing systems cannot resolve the fine image elements that are part of stochastic halftone structures.

Digital halftone dots are formed by selective laser exposures within a 12×12 (or higher) grid structure. The overall 12×12 grid represents one halftone dot at a particular screen ruling. If finer screen rulings are required, the laser spot must be made finer to retain the same 12×12 grid. If the

Screen rulings generally used for given processes and substrates

Process and/or Substrate	Ruling (lpi)
Screen printing—textiles	50
Letterpress—newsprint	65–85
Screen printing—smooth substrates	85–100
Flexography	85–133
Letterpress—machine finished	100
Lithography—machine finished	120–133
Letterpress—coated	133–150
Gravure—all substrates	150–200
Lithography—coated	150–250

spot size has reached a limiting value, it may not be possible to expose a halftone grid finer than (say) 8×8. An 8×8 grid allows 64 tone steps whereas a 12×12 grid produces 144 steps. The tradeoff between fineness of halftone screen ruling and number of tonal steps is a well-known one that is dictated by the system's minimum addressable spot size. If there are too few tonal steps, then "banding" effects occur in vignettes, and tonal fidelity is limited. The problem may be resolved by reverting to analog screening technologies, but the controllability problems of this process are severe enough to ensure that digital halftoning will not be displaced.

Print quality aspects of resolution have been discussed in a number of papers by George Jorgensen (1960, 1963, 1967). These sources should be consulted for a more detailed analysis of resolution and lithographic image quality.

Quality Thresholds

A study of human visual performance and printing system capabilities concluded (Field, 1996b) that a 250-lines-per-inch (lpi) halftone screen ruling was sufficiently fine so that any increases beyond this level could not be discerned by most human observers. The study also concluded that 145 tonal steps (i.e., 144 plus white paper) usually provided satisfactory tonal transitions.

The preceding study also estimated that about 1,200,000 distinct colors could be printed by lithography and that about 1,500,000 colors could be printed by gravure. The 25% increase of the gravure gamut over that of lithography is probably attributable to the proportionality and additivity effects that were discussed earlier.

The quality thresholds for a specific ink-paper-press system will differ from those of other systems. The absolute levels for a given system are based upon market considerations (see Chapter 15) that are established by use and economic factors. Once a set of conditions (e.g., SWOP, GRACoL, high fidelity, SNAP) have been established by the market, the task at hand is to maximize the quality within the constraints of the system.

Process Characterization Test Images

Feedback information from the printing process (see Chapter 3) is required for making optimum color separation system programming or setup decisions. Test targets are used to collect feedback information that, after analysis, is incorporated into the color separation images.

An important first step is to ensure that the printing process is running consistently before attempting to generate special feedback information tests. Stable operation ensures that the samples are truly representative of future operations, and that the feedback information is accurate. If conditions are unstable, the color separation department is trying to hit a moving target.

Stable printing conditions include the use of plant-standard inks, paper, plate type, and other materials. These materials are used in a consistent manner to achieve standard solid densities, overprint colors, dot reproduction, gloss, register, and other print quality factors.

In practice, it is very difficult to standardize on one combination of printing conditions. A general commercial printer must respond to many different customer specifications. On the other hand, there are some printers (e.g., publications printers) for which standardization is quite feasible.

Certain procedures can result in a significant reduction of variables in commercial printing. They include the use of a standard ink set, color sequence, color bars, and densitometers, together with systematic press maintenance and control. Paper becomes the biggest variable, but it is possible to establish sets of specifications based on an average coated paper and an average uncoated paper.

We can now reexamine the systems concept introduced in Chapter 3. The **process** aspect of the color reproduction system includes the steps through platemaking, ink, paper, and other materials selection, to the final act of printing. Consider a particular tonal value in the color separations that is reproduced as a certain color in the printing process. This color reflects all the distortions inherent in the press-related aspects of the process. To produce color separations having the desired tonal values, we must identify the distortions and then attempt to compensate for them in the color separation stage. There are, however, limits to the adjustment of color separation characteristics.

The **feedback signal** aspect of the color reproduction system uses special charts representative of the printing process. These charts are available as master film sets or data files from such organizations as GATF. The images are used to generate plates that are mounted on press to print with house-standard inks and papers. If a variety of papers is used for a sheetfed printing plant, it would be normal to print the charts on a selection of papers. The charts are

printed as closely as possible to the average or standard printing quality for that set of conditions.

The types of test image chosen for characterizing the printing process are influenced by the method used for processing feedback information within the color separation system. There are three general approaches: computational from equations (eight-color mosaic target), computational by multiple regression fit (color space sampling target), and graphical (tone scale and color correction targets).

Eight-Color Mosaic

The Neugebauer equations (Appendix D) may be used to derive tristimulus values for a sampling of color space that may, in turn, be used to create a lookup table (LUT). The minimum test target requirements for solving the three-color version of the Neugebauer equations includes white paper and solid yellow, magenta, cyan, red, green, blue, and three-color areas. Halftone values and their overlaps should also be included so that correction factors for interimage optical distortions may be computed. A four-color version of the equations will require that a solid black and appropriate overprints are also part of the test target. The GATF Color Reproduction Guide is ideally suited to this purpose, but smaller test images may also be satisfactory.

An enlargement showing the eight fractional microcolor areas within a halftone color reproduction.

The Neugebauer equations make use of the colorimetric properties of these fractional areas when deriving the relationships between halftone dot areas and tristimulus values.

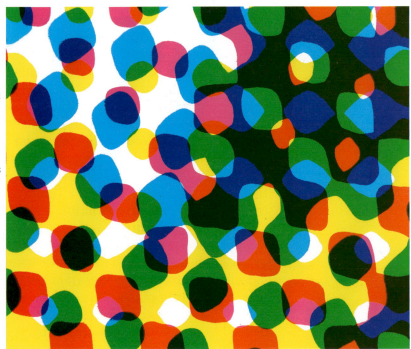

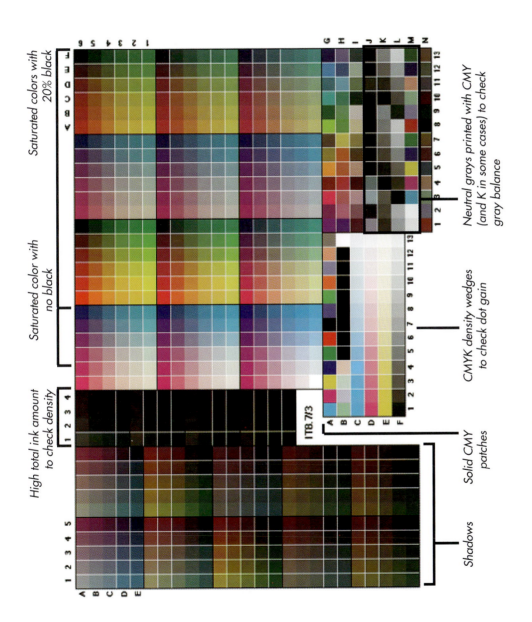

The IT8.7/3 feedback information target often used for developing output or destination profiles for use in color management systems.

Color Space Sampling

A multiple-regression approach to LUT generation requires that a test image with up to hundreds of color patches is produced under plant standard printing conditions. The required number of target areas will depend on the accuracy of the interpolation process that is used to compute in-between colors. Test images with a larger number of target areas produce more accurate results. The IT8.7/3 target series is often used to characterize printing systems.

Tone Scale and Color Correction

A gray balance chart and a color reproduction guide printed under plant standard printing conditions form the basis of a graphical approach to scanner and system programming. The gray balance chart is used to incorporate press dot gain and tone scale balance requirements within a Jones-type diagram. Color separation tonal requirements are read from this diagram. A GATF color triangle may be used to represent data from the color reproduction guide; the required color correction for the ink/paper combination may be derived from the triangle via graphical techniques.

System Feedback Programming

The color separation system is programmed with feedback information from the printing process to ensure that, when printed, the separation images will produce the optimal results. The methods of system programming differ at the data collection, analysis and setup stages, but all have the common objective of efficiently transferring red, green, and blue input signals into yellow, magenta, cyan, and black output halftone dot signals. The tone reproduction, gray balance, and color correction approach was, until comparatively recently, the dominant method of system programming. Today, the regression-analysis-driven method of LUT generation from a sampling of color space is now the most common approach.

In general, the following methods of system programming are theoretically equal in terms of final printed output quality. The differences between them are based, in part, upon these issues: LUT computation efficiency, LUT memory requirements, LUT interpolation accuracy, ease of generating input color values, and system programming simplicity. In practice, systems will vary in performance because of proprietary differences between manufacturers.

Mathematical

Good color separations are those that contain dot values that, when printed, will yield the desired colors. If the color

separator can determine the colorimetric specifications of the desired colors and obtain the characteristics of the printed colors for a specific ink-paper-press combination, then the required halftone dot values may be computed.

The first attempt to mathematically determine the halftone dot values required to reproduce a given color where the equations developed by E. Demichel (1924). His equations* were based upon the premise that any given halftone color area may be considered to be combinations of the following eight elements: unprinted white paper; the individual process inks (yellow, magenta and cyan); the two-color overprints (red, green and blue); and the three-color overprint (black). A given area could contain any or all of the eight colors with any value. The eight fractional areas are fused by the eye to create a uniform color sensation. This way of looking at halftone color reproduction is similar in concept to the pointillist painting technique used by Impressionist artist Georges Seurat in the nineteenth century.

The fractions for each of the eight colors are translated into yellow, magenta, and cyan dot values that may, in turn, be expressed within an equation as a value between 0.00 and 1.00. Hans Neugebauer extended this concept by incorporating the color properties of the specific process inks into the basic equations (1937).

In the 1940s, A. C. Hardy and F. L. Wurzburg, Jr. developed an experimental color scanner that solved the Neugebauer equations for dot area on a point-by-point basis (1948). This approach was too slow for practical application.

The equations in their original form were not accurate because of additivity and proportionality failure effects. Light scattering within halftones (often described as "optical dot gain" today) introduced further inaccuracies.

The first major modification to the Neugebauer equations was a correction for light scattering within the halftone areas (e.g., Pobboravsky and Pearson, 1972). This was achieved by using the Yule-Nielsen modification of the Murray-Davies equation. The Murray-Davies equation makes it possible to compute halftone dot area from density readings made from a halftone tint and a solid of the same color (Murray, 1936). The Yule-Nielsen modification to Murray-Davies uses an empirically derived n factor to compensate for light scattering within the substrate (Yule and Nielsen, 1951).

*The mathematical details of these and the following equations are presented in Appendix D.

The potential computational problems associated with using broadband density measurements were addressed by Viggiano (1990) who used spectral measurements at every 20 nm to replace density readings.

The additivity and proportionality failure problems that limit the accuracy of the Neugebauer equations were first investigated by Warner (1979) and Inoue and Warner (1984), who suggested the use of empirically-derived "overcolor modification" (OCM) factors. A test target with both solid and halftone target areas was used to compute the OCM factors. Heuberger et al (1992) also used a calibration target that contained halftone values to help improve computational accuracy. This approach has been described as the "cellular" Neugebauer equations because CMY color space is represented by eight cells within a cubic color solid. Each cell (i.e., a smaller cube) uses a particular combination of 0%, 50%, and 100% cyan, magenta and yellow corner values.

A combination of the cellular approach, spectral measurement and a Yule-Nielsen correction (n) was evaluated by Rolleston and Balasubramanian (1992). They found that spectrally modified models performed as well as the computationally more-complex cellular versions of spectrally modified models. The use of n correction factor improved the performance of all models. The average ΔE errors were in the 2.0 to 3.0 range for the trial conditions; however, the maximum ΔE errors were in the range of about 8.0 to 10.0.

A four-color version of the Neugebauer equations was developed by Hardy and Dench (1948) and, more significantly, a way of solving them. There is no unique solution for four unknowns (CMYK) when there are only three equations (RGB). Hardy and Dench specified that K equals a value that reduces at least one of the C, M, or Y values to zero. The critical value for k is computed by first solving the three color versions of the equations and using the smallest of the y, m, and c signals to actuate a circuit that will supply a k signal to the equation-solving network just large enough to reduce at least one of the Y, M, or C values to zero.

It was reported (Rudomen, 1985) that the Eikonix 8000 scanner and imaging system used the Neugebauer equations to compute color lookup tables. A 200-element printed color chart was first scanned to represent the original in terms of CIELUV values. Modified Neugebauer equations computed other values that were not in the chart. It reportedly took

twelve hours for a powerful (by 1985 standards) mini-computer to generate a complete set of lookup tables.

A memorial seminar to mark the work of Hans Neugebauer was held in Tokyo during December of 1989. The paper by W.L. "Dusty" Rhodes (1990) that was presented at this meeting should be consulted to gain a more complete understanding of how the Neugebauer equations have been used and refined over the years.

Empirical

The required values for LUT entries may be determined by empirical methods instead of using an equation-based approach. Two general empirical strategies have been used to determine optimum scanner setup. The early approach used regression analysis techniques to establish the optimum color correction control settings for analog scanners. These scanners were based upon the masking equations (Yule, 1967, pp. 266–272). Later versions of these scanners retained the masking equation approach but were based on digital computers. In order to save scanner programming time, LUTs were derived (and stored for future use) from the optimal control settings.

The other empirical approach to LUT generation first involved printing a large target image that contained a representative sampling of the printed color space. The printed target was scanned into computer memory, and regression techniques were used to correlate input to output and create an LUT.

F. R. Clapper was the first (1961) to take an empirical approach to the quantification of color reproduction requirements. He initially printed a test form that consisted of all possible combinations of 0%, 50%, and 100% values of yellow, magenta, and cyan (in other words, there were 27 different areas) and then measured the color patches through filters that had a high colorimetric quality. The density values thus obtained were used to solve empirical equations that related the colorimetric values of the original to the amounts of the individual inks. Clapper's study also used an expanded target to address the four-color situation. A second-degree least-squares solution produced very low residual standard errors.

Clapper extended his approach to include the development of a technique for determining the optimal settings for the analog color correction controls of a color scanner. Linear regression techniques were used to make a least-squares fit of potentiometer settings to suit a particular set of inks. He

A feedback target used by F.R. Clapper to develop multiple regression solutions for optimal analog scanner color correction programming.

published (1969) an impressive demonstration of his technique where it was shown that near-identical reproductions of the same original could be achieved with completely different ink sets.

Pobboravsky extended the approach that Clapper took to the quantification of the relationship between the tristimulus values of a printed color and the dot values used to generate those colors. He first generated a 310-color test form and made both densitometric and colorimetric measurements of each individual color patch. The density data were expressed in the form of Equivalent Neutral Density (END); that is, in terms of the density of a neutral a given colorant would produce if overprinted with sufficient values of the other colorants to achieve a neutral. A second-degree mathematical model was fitted to the data by regression analysis.

Pobboravsky found that this empirical approach gave him the tools needed to measure any given color in terms of colorimetric density, calculate the required dot areas, and achieve a very close color match between the original color and the printed color (for gamut colors). In a separate study, he also worked out a way of transforming the three-color system into a four-color system (1964).

The first major change from the masking equation type of computation was introduced in 1970 by Nathaniel Korman of the Ventures Research and Development Group in Princeton, New Jersey. His experimental scanner was the first to use a general-purpose digital computer for color computation and a lookup table for generating output dot values (1971).

This scanner was programmed by first generating a set of halftone color chart films, which were used to produce a 512-element printed color chart under the same production conditions that would normally be used. The printed chart was placed on the scanner's input table and scanned. The computer's memory stored the tristimulus values of the scanned color chart, along with the initial halftone dot values that were generated on the color chart films. In other words, the computer contained a set of tristimulus values and the dot percentages that would produce those values when printed under specified conditions.

When an original was scanned, the signals were first subject to appropriate tonal compression and then were used as references in "looking up" the corresponding tristimulus values in the computer's memory. If the exact values was not in the memory, it was calculated by interpolation. Once the tristimulus values for a given color in the original were located in the lookup table (or were computed), the computer "printed out" the halftone dot values that produced those tristimulus values.

The Korman scanner did not reach commercial development for a variety of reasons; however, the principles of

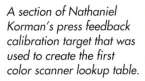

A section of Nathaniel Korman's press feedback calibration target that was used to create the first color scanner lookup table.

digital computing and the use of lookup tables, having been proved by Korman, were adopted by other manufacturers.

The first production scanner to use digital technology for color correction was the Crosfield Magnascan 550 in 1975. The lookup table in this scanner was generated using color-correction techniques similar to those Crosfield had used in its earlier Magnascan scanners; i.e., the masking equations were used to generate a pre-solved color space (Pugsley, 1974).

The destination profiling stage of color management system characterization (see Chapter 3) is a direct outgrowth of the early methods of empirical LUT generation. The primary difference now is that most device profiling systems convert the printed color space sampling into a visual color space notation.

Graphical

Graphical analysis is used to determine the system feedback programming requirements for the component approach, which involves correcting for the separate system characteristics without concern for individual colors. If corrections are made for the overall system, then the individual colors should also be corrected. The system characteristics that are of concern are tone reproduction, gray balance, and color correction.

Tone reproduction. The two aspects of tone reproduction are the tonal compression for a given original and the tonal adjustments due to the platemaking and printing conditions. While the optimal tone reproduction curve will vary for given originals, the relationship between the scanner output halftone values and the resultant printed color should be constant for a given printing system. The tonal distortion due to the printing conditions may be determined by the use of the GATF Halftone Gray Wedge.

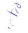

The halftone gray wedge does not require a special press-run in order to generate the necessary data, but rather, is positioned in the trim area of a typical job. After printing, a representative sample is chosen for analysis. Reflection density measurements are made along the printed scale at fixed intervals, e.g., 1 cm. Transmission density measurements are then made of the original film wedge at exactly the same places that were measured on the printed wedge. Although it is possible to convert these density values into halftone dot values, it is not strictly necessary.

A Jones diagram (named after its inventor, Lloyd A. Jones) is typically used for tone reproduction analysis (Jones, 1931).

Quadrant I of the illustrated Jones-type diagram shows the desired relationship between the original and the reproduction. Quadrant II shows the relationship between the halftone dot values on the film and the corresponding printed density values (i.e., the reproduction). Quadrant III may be used if there are such additional images as halftone positives in the reproduction system. In this case Quadrant III is blank; therefore, a 45° line is used to transfer the halftone dot values from the x axis of Quadrant II to the y axis of Quadrant IV.

The Jones diagram method of tone reproduction analysis.

The desired appearance of the reproduction is tracked from Quadrant I, through the printing conditions in Quadrant II, to the specification of the color separation negative requirements in Quadrant IV.

To determine the negative requirements, any point on the curve in Quadrant I is selected. A horizontal line from this point is then extended to the curve in Quadrant II. A vertical line is dropped from this intersection until it reaches the 45° line in Quadrant III. A horizontal line is extended from this point into Quadrant IV. Finally, a vertical line is dropped from the original point in Quadrant I until it intersects the horizontal line in Quadrant IV. This intersection represents the relationship between a density in the original and the halftone negative tone value that is needed to produce the desired reproduction of the original density. This procedure must be repeated for several points on the tone curve in order to characterize the complete tone curve of the negative.

For process-color work, the procedure for tone reproduction analysis is only a little more complex than outlined above. Such an analysis is usually performed as part of gray balance determination.

Gray balance. A gray balance analysis is performed in order to determine the correct color balance of the yellow, magenta, and cyan tone scales. Equal tone scales will not produce a neutral gray scale because of the unwanted absorptions of yellow, magenta, and cyan inks. This effect may be illustrated, if we assume that ink density measurements are additive, by adding the three-color densities of each color. The table presents the densities of typical process inks.

The table indicates that more red and green light is reflected (i.e., lower densities) than blue light; therefore, the appearance of the color will be a warm brown. A neutral scale will require that proportionally less yellow and magenta than cyan is printed throughout the tone scale.

Densities of typical process inks.

	Filters		
	B	**G**	**R**
Yellow	1.00	0.05	0.02
Magenta	0.65	1.30	0.10
Cyan	0.12	0.34	1.20
Total	1.77	1.69	1.32

The color distortion discussed above is not limited to just the gray scale. If the gray scale is too warm (i.e., too much yellow and magenta relative to cyan), then the other colors in the picture will also look too warm. It is more convenient to determine color balance through examination of the neutral scale rather than individual color areas because the color areas may also have distortions that are due to color correction rather than color balance. It is almost impossible to separate the two effects from an isolated individual color area.

Considerable research into gray balance determination occurred during the 1950s and 1960s. The computational methods (some of which used the Neugebauer equations) provided important insights into the nature of the gray balance problem, but did not produce a practical solution for the printer. The first gray balance chart for printing companies to establish the color balance of separation films for their own printing conditions was introduced by GATF (Cox, 1969).

The procedure followed in determining gray balance is first to print a standard (e.g., GATF or RIT) gray balance chart under the actual printing production conditions. After printing, the chart is analyzed in order to find the overlapping values of yellow, magenta, and cyan that will produce a neutral gray. Neutrals are selected with the aid of a gray scale (such as the GATF Halftone Gray Wedge) that has holes punched at points that roughly correspond to the density of each gray balance evaluation grid. The tone step in the gray scale that is closest in density to the gray balance grid being analyzed is used to evaluate the grid to identify the three-color neutral. The gray scale that provides the reference gray should be a printed scale that uses the same black ink and substrate that will be used for the printed job. The reason for this requirement is that the eye adapts to off-color whites and blacks and actually perceives them as reference neutrals; therefore, if a magazine is printed with a given black ink on a white paper, the eye will accept these as neutral references, and judge all color reproductions in the magazine within that framework.

Using a printed Halftone Gray Wedge target as a visual reference to locate neutral grays within a gray balance chart.

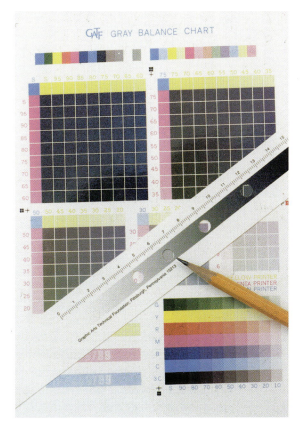

Once the neutral areas have been located in each of the grids, the percentage dot values of each area are noted, along with the reflection densities as measured through the visual filter. These data are now used to construct Quadrant IV of a Jones diagram.

The procedures used to determine the halftone requirements in Quadrant IV are the same as were previously described for one color, except that each of the curves in Quadrant II is used to help construct corresponding curves in Quadrant IV. The negatives described by the curves in Quadrant IV are corrected for tone reproduction and gray balance. If these films are printed under the conditions used to generate the data for Quadrant II, the resulting gray scale will be neutral and have tonal separation corresponding to the interest area that dictates the selection of the curve in Quadrant I. If a pictorial subject is included with the gray scale, it will also appear correct for tone reproduction and gray balance.

Incorporation of gray balance data into a Jones diagram.

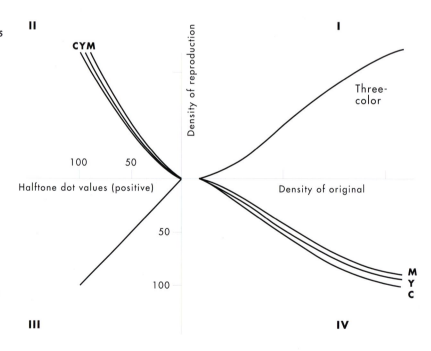

Color correction. While tone reproduction and gray balance are the two most important aspects of color reproduction, color correction must also be incorporated into a set of color separations in order to achieve the best results.

Color correction is applied during the color separation process to compensate for the unwanted absorptions of the printing inks. The term color correction is also used to describe corrections that are made to compensate for deficiencies in the original or to achieve customer alterations. The following discussion applies only to the unwanted ink absorption aspect of color correction.

The primary aspect of color correction concerns the unwanted absorptions of the solid cyan, magenta, and yellow inks. Ideally, a cyan ink should reflect all blue and green light and absorb red; a magenta ink should reflect all blue and red light and absorb green; and a yellow ink should reflect all red and green light and absorb blue; i.e, if any given ink were to be measured through the three filters of a densitometer, two of the readings should be 0.00 (100% reflection), and the other reading should be a high density (a 2.00 density, for example, is equivalent to 99% absorption or 1% reflection).

Reflection density values for a typical set of process inks.

	Filters		
	B	**G**	**R**
Yellow	0.95	0.04	0.02
Magenta	0.50	1.20	0.12
Cyan	0.15	0.30	1.25

The inks used for color reproduction are not ideal. The table shows the reflection density values for a typical set of process inks. The unwanted absorptions are the key concerns.

The color correction process may be illustrated by reference to the cyan ink in the tables. This cyan has 0.15 blue-light density and 0.30 green-light density where, in fact, these values should equal zero. If these absorptions remain uncorrected, the reproductions will not reflect enough blue and green light. It is not possible to increase the blue- and green-light reflection of the cyan ink; therefore, it is necessary to reduce the blue- and green-light reflection of the yellow and the magenta inks in those areas wherever cyan prints.

Another way of thinking of the color correction process is to consider that the cyan ink has been contaminated with small amounts of yellow and magenta ink, causing the unwanted blue- and green-light absorptions. The only way to remove this unwanted contamination is to reduce the yellow and magenta inks wherever cyan prints. The unwanted absorp-

tions of the yellow and magenta inks must be similarly corrected; therefore, cyan and magenta must be reduced wherever yellow prints, and yellow and cyan must be reduced wherever magenta prints.

The amount of correction that is needed for any of the unwanted absorptions can be calculated by expressing the unwanted absorption as a percentage of the ink where it is a wanted absorption. For example, the 0.30 green density of the cyan ink is an unwanted absorption, but the 1.20 green density of the magenta is a wanted absorption. Expressing 0.30 as a percentage of 1.20, we get 25%. This means that the magenta must be reduced by this amount wherever cyan prints in order to compensate for the unwanted green-light absorption of the cyan ink. Each of the unwanted absorptions must be corrected, thus resulting in six color correction requirements for the solid inks.

Fewer than six color-correction masks (or signals) were needed in most practical situations because three of the unwanted absorptions (red-light absorptions of yellow and magenta, and the green-light absorption of yellow) were very small and could often be ignored. The remaining three unwanted absorptions could be corrected by two masks if "balanced inks" were used. The cyan and magenta were said to be balanced if the ratios of their blue and green actinic densities were equal (Field, 1971). If this balance was achieved, the yellow separation could be corrected for the unwanted blue-light absorption of both magenta and cyan by one mask. The second mask was used to correct the magenta separation for the unwanted green-light absorption of the cyan.

The color correction percentages may also be determined with the GATF Color Triangle by using a method suggested by F. R. Clapper (1971). The yellow, magenta, and cyan colors are plotted on the color triangle. Next, a straight line is drawn from each color through the other two colors to continue so that the line intersects the edge of the triangle. The value indicated at the point of intersection is the percentage correction that must be applied to the original color separation. The percentage corrections correspond to solutions of the masking equations, a set of three linear equations that are used to calculate the color correction requirements of a given set of inks.

In order to use the above methods for determining color correction percentages in practice, it is necessary to express the density values in the form of actinic density. These actinic values reflect the influence of the following: absorption charac-

*Use of the GATF Color
Triangle to determine
percentage mask strengths.*

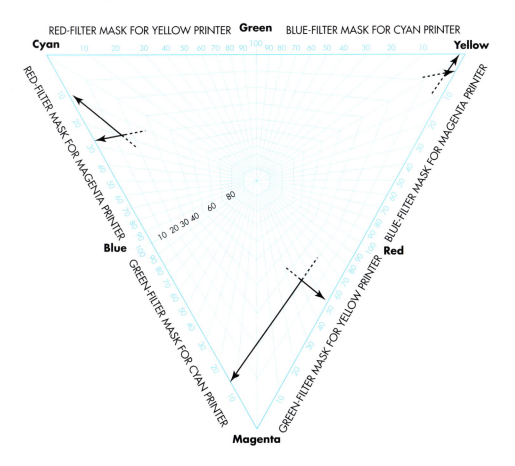

RED-FILTER MASK FOR YELLOW PRINTER **Green** BLUE-FILTER MASK FOR CYAN PRINTER

teristics of the inks; absorption characteristics of the color sep-
aration filters; spectral emission of the light source; spectral
response of the color separation sensors; and the absorption
characteristics of the lens or other optical elements.

The next aspect of color correction concerns the overprint
colors: the solid red, green, and blue areas. In theory, the
color corrections that were calculated for the unwanted
absorptions of the yellow, magenta, and cyan should also
correct for their overprints; that is, if the densities of the
overprints are simply the sum of two primary colors, then a
correction for the primary color is automatically a correction
for the secondary, or overprint, color. In practice, additivity

failure effects require the application of different corrections to the overprint colors than those used for the primaries.

The color correction objective now becomes that of matching the appropriate actinic densities of the primary colors and the secondary (overprint) colors. In the case of the magenta color separation, the actinic densities of the magenta (primary), red (secondary), and blue (secondary) colors must match. These colors are called wanted, or black, colors in the magenta separation. The other requirements for the magenta separation are that the yellow (primary), green (secondary), and cyan (primary) must match. These colors are called the unwanted, or white, colors in the magenta separation.

The color correction requirements discussed so far can be summarized by the "rule of three"—that is, in any color separation, the three wanted colors must separate so they appear equal in density to each other and to black (or the three-color patch). The three unwanted colors in the same separation must also separate so they appear equal in density to each other and to white. The GATF Color Reproduction Guide (Elyjiw and Preucil, 1964) may be used when making color separations or programming the color separation system in order to determine if these objectives have been or will be achieved. The Color Reproduction Guide is useful for determining the color correction requirements of the inks, but it will not indicate the color correction requirements of the original.

The final aspect of color correction concerns the color halftone tint values. Ideally, the color correction percentage needed for the solid value of an ink would also be the same for the lighter tint values of that ink. In practice this is not so. Halftone tint values require more color correction than solids of the same color because of proportionality failure.

The percentage correction requirements for tint values can be calculated in the same manner that was previously described for solid colors. For very light tints, three-place density numbers may be needed for accurate results. Halftone printing requires proportionally more color correction in the lighter tones than in the solid colors.

The color correction circuits of color scanners produced efficient initial solutions of the masking equations. Supplementary controls were provided to allow the operator to make additivity failure corrections. In practice, however, the required proportionality failure corrections were difficult to achieve (Field, 1989).

The GATF Color Reproduction Guide and the subsequent color separation images indicating that corrections have been made for the unwanted absorptions of the inks.

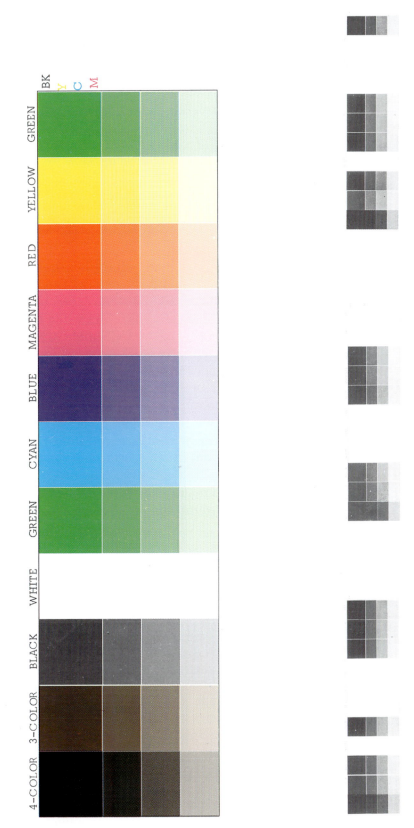

Tone scale (gradation) adjustment, gray balance setup, and the black printer gradation and correction requirements were also handled efficiently by analog-computer-based color scanners. The analog computers were faster and more precise than digital systems, but the setup requirements were so lengthy that they were gradually replaced by digital-computer-based color correction devices. Further details of the theory and calibration of the analog color computer (and the digital version) type of scanner are available in *Color Scanning and Imaging Systems* (Field, 1990). The procedures for programming two types of scanners to achieve gray balance adjustment and color correction for two different sample ink sets have been published by Warner et al (1982).

The black printer. Black is usually used in four-color printing to extend the density range of the reproduction. The black is also used, in some cases, to substitute for a portion of each of the process colors when they print together in a given color (e.g., the UCR and GCR processes). A further reason for using the black printer is to increase the sharpness of the reproduction.

The accompanying illustration shows the contrast range extension effect of adding a skeleton black (see Chapter 12) printer to a three-color reproduction. In this case the maximum density has increased from 1.60 to 2.10. The first printing dot of black occurs at the point where the densities in the desired optimum tone reproduction curve cannot be achieved by just the three colors alone. This point usually occurs around the middletone area.

The extension of the density range of a three-color reproduction by the addition of the black printer and the determination of the black printer tonal characteristics.

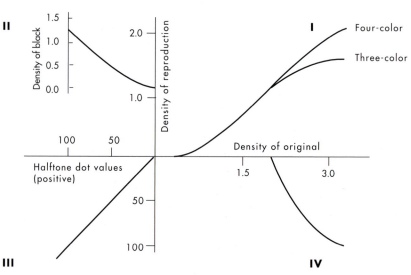

The tonal range of this type of black separation should be made to modify the three-color curve shape to that desired in the four-color reproduction. In order to determine the black curve, it is necessary to know the additivity failure characteristics of three-color versus four-color systems and the desired starting point for the first printing dot of black. The table presents the densities of a typical three-color, a black, and the resulting four-color areas. Using this example, it is now possible to plot the required black separation characteristics, as shown in the Jones diagram on the previous page. Quadrant II presents the black printing characteristic on unprinted paper. The scale is configured to accommodate the black starting point and the additivity failure effects. The other quadrants are similar to those described in earlier discussions of the Jones diagram. The difference between the desired four-color curve and the three-color curve represents the density contribution of the black printer.

The GATF Color Reproduction Guide is a useful device for gathering black printer additivity failure data. Black channel density readings are made from the four-color, three-color, and black solid (100%) tone values.

Additivity failure of the black printer.

	Density on Coated Paper	Density on Uncoated Paper
Three-color proof	1.30	1.00
Black proof	1.15	0.90
Additive density	2.45	1.90
Actual four-color proof	2.00	1.30

In cases where undercolor removal (UCR) is required, the yellow, magenta, and cyan tone values are reduced in the neutral scale. The reduction of these values can be total or partial and can start anywhere from the lightest highlight to the darkest shadows. The value of black is increased to equal the three-color density that was removed.

The use of black to substitute for one of the three process colors, a process called gray component replacement (GCR), is discussed in some detail in Chapters 8 and 12. As with UCR, the amount and starting point for GCR can be adjusted within wide limits. The theory behind GCR is that where three colors overlap, there is a component of equal densities of red, green, and blue (i.e., a gray tone) that may be removed from CMY and replaced with an appropriate value

of black. In practice, it is not common to totally replace (100% GCR) one of the process colors (together with proportionate amounts of the other colors) with black; rather, levels of about 40–80% GCR seem more popular. High values of GCR (and UCR) can reduce the D_{max} of the reproduction and, therefore, lower contrast and reduce sharpness. The undercolor addition (UCA) process is used to add back cyan, magenta, and yellow to the darker tone values that would otherwise be rendered too light. The GATF Ink Coverage Target may be used to assess the influence on D_{max} of increasing amounts of UCA.

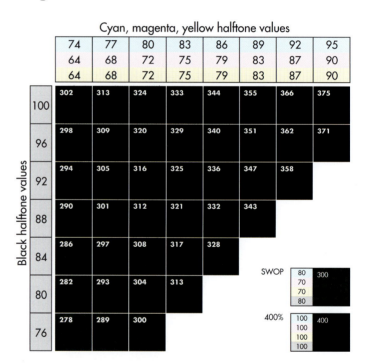

The GATF Ink Coverage Target used to help determine the desired level of undercolor addition required to achieve the target D_{max}.

The color correction requirements for the black printer are the same regardless of whether a short-range, long-range, or GCR black is required. No dot of black should print in the primary color solids, overlaps, or tints of a GATF Color Reproduction Guide. When GCR is used, black will print in areas that would usually require three process colors. These values must be computed for each given ink-paper-press combination.

Visual Visual programming of feedback from the printing system may be incorporated after the mathematical, empirical, or graphical programming steps have been applied. The nature

of visual programming is such that a printed halftone color chart with a complete sampling of color space is required. Naturally enough, the color chart must have been printed on the ink-paper-press system that is being used.

Visual programming techniques are used when it is necessary to program a particular set of CMYK values into a given area of the reproduction. The first step is to determine the desired area on the color chart. In many cases, this will be chosen by the customer. Next, the code numbers specifying the CMYK halftone dot values that were used to generate the color in question are noted. Finally, the halftone dot values of the desired area within the original are modified to match those of the chosen area of the color chart.

The photomultiplier tube (PMT) type of scanner often allows the operator to align the scanner input head over the area in question and to then adjust the dot values as required for each color channel. A digital readout of the dot values for the area of interest are used to guide the operator.

In the case of charge-coupled device (CCD) scanners, it is not possible to examine one given area within the original without first recording the entire image. The scanned image is displayed on a color monitor; a convenience that allows the operator to examine the present halftone content of a given tonal area, and to then make an adjustment that reflects the desired color chart values.

Individual adjustment of localized areas within the color separations are possible if the area in question can be isolated from other tonal areas where no changes are required. In practice, visual adjustments to individual areas are more likely to be required because of customer changes, distortions associated with the original, and creative enhancements, rather than for ink-paper-press fine-tuning feedback adjustments.

Concluding Analysis

The incorporation of feedback information from the printing system into the color separations is a crucial requirement for achieving consistently high quality color reproductions. System programming of feedback must be preceded by two important steps at the printing stage: achieving optimal press setup, and establishing stable running conditions. Once these objectives have been met, valid feedback information test images may be produced.

There are two broad approaches to system feedback programming. The traditional approach (the "component" approach, see Chapter 11) used tone reproduction, gray bal-

ance, and color correction adjustment controls, or masks, within a system that addressed the explicit deficiencies (e.g., unwanted blue-light absorption of magenta pigments) or characteristics (e.g., dot gain) of the ink-paper-press system. The photographic methods of color separation used this approach, as did the analog-computer-based color scanning systems. The component approach to system programming produces excellent results if the correction controls are set to optimum values, a task that requires the knowledge and judgment of skilled color separation technicians.

Low-cost digital computers made it possible to bypass the correction-based component strategy in favor of a method (the "integrative" approach, see Chapter 11) that was based on a point-by-point transfer of input values via simple matching (or "lookup") techniques to pre-solved CMYK output dot values. The RGB values used to search the lookup tables central to this approach are used to simply look for the desired color (also represented by CMYK values) without need for the more complex computation and setup required by the component approach.

The Neugebauer-equation-based approach to lookup table generation has the advantage of being based upon a compact test image that may be produced as part of routine print production runs. The drawback to this computationally based approach of lookup table generation is the time it takes to solve the rather complex modified Neugebauer equations. This drawback is becoming less and less important with the continued reductions in computer memory cost, and increases in computation speed.

Empirical methods of LUT generation are based upon special feedback test images that are produced via special press runs. The subsequent creation of the LUT is achieved through the use of direct measurement techniques (i.e., no computation) that, in the absence of an automated measurement system, can be tedious.

The output quality of digital LUT-based systems is limited by several factors that were not an issue when the analog-color-computer-based component approach was the dominant method for producing color separations. Such factors as interpolation algorithms, image compression strategies, digital halftoning compromises, and the assumptions that govern the color encoding process will all influence output color appearance. The output quality of analog-based component-approach scanners was not degraded by the mathematical and compu-

tational technologies, but was highly dependent upon the skills of an expert scanner operator.

The LUT-based integrative approach is restricted to producing a first approximation of the described reproduction because the mathematical models that transfer input color to output color are incapable of handling the subjective aspects of color reproduction. The need to make image adjustments for achieving optimal reproduction will ensure that color monitors are always part of integrative systems.

The computationally-based component approach may be programmed to incorporate some of the subjective color requirements via selective color adjustment controls. These adjustments may be made without the benefit of a color monitor, but the success of the adjustment will very much depend upon the skill of the scanner operator.

The differences between the component and integrative approaches to system programming comes down to matters of operator skill and computing cost. Declining digital computing and memory costs have opened up the craft of color separation to a wide range of individuals. The use of color monitors has also made it possible to incorporate creative decisions and trials into the color separations. It seems that the skills required of color separators are continuing to shift from those based exclusively on analysis and computation, to those that require some subjective judgment and aesthetic appreciation.

10　Color Originals

Creating Originals

The selection of the type of original to be used for color reproduction purposes is usually a creative act. Of the available originals, photographs and artist's sketches and drawings are created specifically for the purpose of being reproduced. Other originals for reproduction include fine art and merchandise samples. These latter originals often cause problems in the manufacturing process because their primary purpose is not to serve as originals for photomechanical reproduction; rather they are each an end in their own right.

Many problems in printing arise when a designer or a photographer produces an image without considering how well it will reproduce. This is a futile exercise, as it thwarts the best attempts of everyone in the reproduction process to produce a satisfactory reproduction. The end result is all-around dissatisfaction. The best originals are those that take into account the characteristics of the reproduction process so that the ultimate reproduction is the most pleasing and best that can be obtained with the ink, substrate, and printing process being used.

The best commercial artists or graphic designers are those who can produce creative work within the constraints of the manufacturing process of which they are a part. In practice, it may be easier for some to indulge in the unconstrained creativity afforded by the field of fine art, where the discipline of the reproduction process can be ignored. The graphic designer must, however, keep the objectives of commercial art and fine art quite distinct. Sometimes frustrated, fine artists turn their hand to commercial art without understanding the constraints of the reproduction process. At other times these constraints are deliberately ignored in order to produce gallery-quality art masquerading as commercial art. Such actions may produce an impressive

portfolio of original artwork for the designer, but it will not produce an impressive portfolio of printed samples. The primary intent of this chapter is to explore the factors that make an original suitable or unsuitable for reproduction purposes and to develop guidelines for the selection of the appropriate photographs or artwork for reproduction.

Photographic Originals

The type of original used for a given purpose depends upon the degree of realism or abstraction desired by the designer. Photographs are generally preferred when a high degree of realism is required. The more abstract design usually employs hand-drawn artwork, although some photographs also can be used for this purpose. For the ultimate in realism, the actual object or piece of merchandise may be submitted for use as an original.

Photographic originals take the form of either prints or transparencies. Electronic photographs also fall into the category of photographic originals and are discussed under the "electronic originals" section of this chapter.

Color Prints

The integral tripack type of color print is commonly used for reflective color reproduction originals. One form of this material consists of a paper base that is coated with red-, green-, and blue-sensitive layers that form, during processing, cyan, magenta, and yellow dye layers. This is known as the dye coupling process. Depending on the film type and the processing technique, tripack materials can be used to make prints from color negatives, color transparencies, or directly from the original scene in the case of "instant" photography. The dye bleach process, on the other hand, consists of predyed emulsion layers that are selectively removed in processing. The prints can be made only from transparencies in this process.

One possible problem that can be encountered when reproducing color prints is due to the fluorescence of the substrate, a factor that can affect the reproduction of light tones. Substrate fluorescence can be countered by mounting UV absorbers over the illuminating light source.

It may be desirable to use prints instead of transparencies when the photographer has no control over the lighting of the original scene. It is possible to make adjustments when making the color print in order to make it conform more closely to the desired appearance. The print is, furthermore,

Photographic originals:

(A) 4×5-in. color transparency;
(B) 35-mm color negative;
(C) 35-mm color transparency.

A

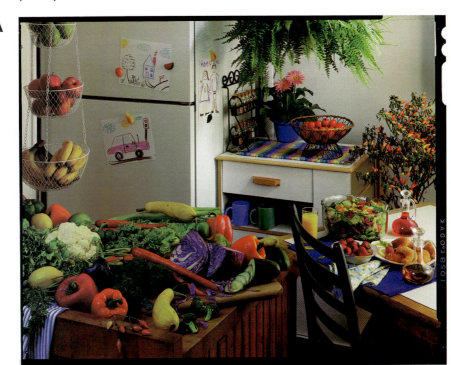

B

C

a reflection original with a contrast range and gamut close to the photomechanical printing processes. Such originals are, therefore, generally easy to match. Customer comparisons of original to reproduction are relatively uncomplicated when color prints have been supplied.

**Color
Transparencies**

Color transparency films all have integral tripack types of emulsions coated onto film bases. Unlike photographic print materials, color transparency materials vary greatly in terms of resolution, sharpness, graininess, speed, and color rendition. In general, the lower the speed the higher the image quality.

The creative demands of the job may determine the color transparency format. Large-format 8×10-in. (20×25-cm) cameras cannot be used satisfactorily for high-speed action photography. The 35-mm camera with its light weight and motor drive is preferred in these situations. On the other hand, 35-mm cameras are not suitable for architectural photography. The swings and tilts of large-format cameras must be used to overcome the converging parallels common with 35-mm and other fixed-plane cameras.

Films that are designed for viewing by projection in a darkened room, such as 35-mm transparencies, tend to have a higher-contrast range than sheet film transparencies. All transparency materials, however, have a range greater than 3.0 optical density. Each individual color film distorts the original colors in its own way. No one color film can be selected as the best for all photographic assignments, but whenever possible, the same film should be used throughout a given job.

A specialized type of color transparency film is duplicating film. This material is primarily used for making transparency conversions from reflection copy. Transparency conversions are made from reflection copy when the original is too large or too inflexible to be wrapped around the drum of a color scanner. Duplicates generally have lower density ranges than original transparencies.

Transparencies have several advantages over prints. Higher resolution and sharpness, and the ability to wrap around a scanner drum (a factor if supplied prints are mounted on a rigid base) are the more important factors.

**Color
Negatives**

Color negatives can also be used as photographic color originals. These materials have the advantage of being (like color transparencies) first-generation originals and are therefore likely to have better image quality than such second-generation materials as color prints or duplicates. Color negatives generally have built-in orange photographic masking images in order to produce a satisfactory color print. The big drawback with color negatives is that they are extremely

The emulsion spectral response for two color transparency films.

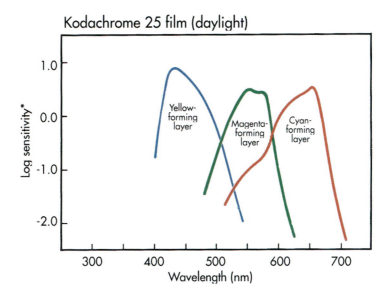

Kodachrome 25 film (daylight)

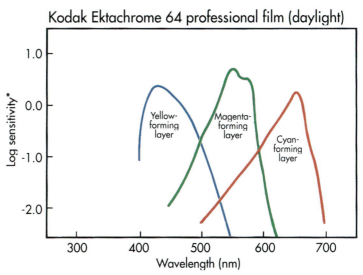

Kodak Ektachrome 64 professional film (daylight)

* Sensitivity equals the reciprocal of exposure required to produce specified density.

difficult to visually judge. They are most commonly used as originals in the newspaper color market segment.

Problems with Photographic Originals

Color transparency photographs, in particular, can cause a number of problems within the photomechanical color reproduction system. These problems, largely unavoidable, are due to reproduction scales other than 100%, and color gamut and density range differences. The fact that transparencies are viewed by transmitted light and printed reproductions

are viewed by reflected light also causes difficulties when it comes to assessing the printed results. Color prints are not problem free, but they do not have many of the problems associated with color transparencies. Such image qualities as resolution, sharpness, and graininess cause the major quality problems associated with the use of color print originals.

Reproduction scale. The preferred reproduction scale is same size, or 100%. The reasons for this preference are as follows:

- Too great an enlargement emphasizes defects in the original. A customer, on seeing the defect in the reproduction, may elect to believe that this is a fault of the reproduction process rather than an inherent defect of the original. Photographic grain is one such defect that becomes more noticeable with high enlargements.
- Too great a reduction loses detail from the original. The customer will be able to see detail in the original and may blame (justifiably, but unfairly) the reproduction process for losing this detail. This problem is especially acute with fine-pen-line artist's drawings.
- Tonal perception is different when comparisons are made between small originals and large reproductions or vice versa. This problem is discussed in Chapter 11. The middletone values have to be lightened or darkened in order to overcome the effects of great reductions or enlargements. This effect is somewhat complex, and if the viewing distances are varied, the tonal perception may change.

Nongamut colors. The problem of nongamut colors, where colors in the original are outside the gamut or range of the ink-substrate combination, is discussed in Chapter 11. In the case of color photographs, and in particular, color transparencies, not much can be done about nongamut colors. Likewise, fine art and merchandise samples have to be accepted as they are. The only way to reproduce these colors accurately is to expand the color gamut of the process ink set. This can be done in many cases through the use of five, six, or even more colors. In the absence of the extra-colors option, the reproduction has lower saturation than the original.

Density range. Situations where the density range of the original exceeds that of the reproduction are also discussed

in Chapter 11. This difference is largely unavoidable for transparency reproduction. For the commercial artist's original, there is no good reason why the density range of the artwork cannot be made equal to or less than the range of the reproduction process. Likewise, it is often a reasonable objective to produce color photographic prints that have a density range similar to that of the reproduction.

Artist's Originals

Artist's originals exist either as fine art, which is created with no thought of reproduction, or as commercial art, which is created specifically to be reproduced. A wide variety of artist's mediums is available as a carrier and binder for the pigments. Some of these mediums are listed below:

- *Oil paint.* Refined linseed oil is used as the base for oil paints. They are available in a vast range of colors and can be applied by one of several techniques to a variety of substrates.
- *Watercolors.* Available in liquid (tube) and solid (pan) forms, watercolors include glycerine to soften them. Most of these materials are transparent, but some are available as opaque gouaches. An airbrush may be used for applying these colors.
- *Poster paints.* Poster paints are gouaches that are available only in a small range of opaque primary colors. These materials are sometimes also referred to as tempera colors. (Tempera is also used to describe the process of painting where pigment is combined with size, casein, or egg yolk.)
- *Pastels.* Pastels contain pure, high-quality pigments in a minimum of binder. They are available in about 200 hues and tints.
- *Drawing inks.* The colors in drawing inks are transparent. They can be applied with brush or pen.
- *Felt-tipped pens.* Felt-tipped pens are used to dispense colored inks. The colors are not particularly permanent.
- *Acrylics.* Acrylics are fast-drying plastic emulsions that may be used instead of oil or watercolor.
- *Chalk.* Wood charcoal falls into the category of chalk. It is still a very popular black for making sketches. Colored chalks are also used for sketches.
- *Colored pencils.* Art pencils are available with dense, smooth, and permanent colors.
- *Waxy watercolors.* Waxy watercolor pencils can be used on glossy surfaces, unlike conventional watercolors or

wax material. Opaque pigments are suspended in this base material.

Problems with Artist's Originals

The medium chosen to produce a given piece of art depends upon the creative intent of the artist. Certain materials convey a particular mood, sensation, or color more successfully than other materials. Some problems may arise, however, when trying to reproduce artwork that has been prepared using these techniques. The kinds of problems that can been countered include the following:

Nongamut colors. The heavy intensities and saturations of oil paintings may be difficult to reproduce, especially if there is a lot of dark shadow detail. The clear, light colors of pastels may also cause problems in reproduction, especially in

Fine art originals may contain colors that fall outside the color gamut of the reproduction system (painting by Lina Gadêlha Ashcroft).

the halftone processes. Extra colors may have to be used to achieve satisfactory reproductions.

Nongamut colors should not exist in commercial artwork. The graphic artist or designer should understand the gamut restrictions of average process inks on coated and uncoated papers. The colors that are selected for the artwork in question must fall within the range that is reproducible by the production conditions. If some colors outside the gamut are chosen, these colors will be reproduced at lower saturation. Those other colors within the gamut will be reproduced correctly; therefore, with some correct and some incorrect colors in the final reproduction, the designer's original intent becomes distorted.

Fluorescence. Certain felt-tipped pens and markers and some substrates may fluoresce, thus upsetting the visual color balance of the artwork. Ultraviolet absorbers over the light sources will eliminate the contribution of UV to fluorescence, but the visible radiation fluorescence will still be present.

Surface texture. It is often desirable, especially for oil paintings, to capture the texture of the paint in the reproduction. This effect may be achieved by using unidirectional lighting when copying the painting. Unfortunately, this technique produces uneven illumination; therefore it is necessary to shade the copy with a black sheet of board in order to attempt to equalize the illumination. The original should be placed on the copyboard so that the shadow of the texture appears natural; that is, the reproduction must look like it has been illuminated from above.

Specular reflections. Oils and acrylics often have a high-gloss finish. If the camera lights are not properly adjusted, specular hot spots may result from this type of artwork.

Highlight dropout. For watercolor, pastel, and crayon artwork, it is usually desirable to drop all halftone dots out of the bare base material. If very pale highlight colors or fluorescent colors are used, it may be very difficult to drop out the background white. In these cases, image retouching techniques must be used.

Color permanence. Felt-tipped-pen colors may fade on exposure to light. In turn, this fading makes comparisons between original and reproduction particularly difficult. This type of artwork should be covered when not being used.

Physical damage. Oil paintings should not be sandwiched under the camera copyboard glass because of the risk of damaging the artwork. Oils should be mounted on the front of the copyboard. Because pastels can be smudged through careless handling, they must be treated with extreme care. Other artwork (e.g., watercolors and poster colors) may be damaged by water; therefore, such work should be kept well away from running water where the danger of splashing exists. A clear, protective film should be placed over this type of artwork.

Unwanted transparency. Sometimes an artist, especially when working with oil colors, paints over unwanted detail with another color. Although the detail underneath is invisible to the human eye, the camera may "see" it. Hand retouching of the separations is the only way to correct this problem.

Black line detail. Some artwork is prepared with watercolor background colors and black ink lines. The objective is to print the black lines solid without any halftone screen breaking the lines and to have the adjacent white areas print free of any halftone dots. This effect is very difficult to achieve when the black ink lines and the watercolors are on the same piece of artwork. These objectives can be realized if the line work is prepared on a separate overlay of clear film.

Merchandise Samples

In those cases where a very accurate color match is required, an actual sample of the product is sometimes supplied for use as an original. Examples are paint chips, fabric swatches, linoleum squares, or upholstery samples.

Problems with Merchandise Sample Originals

There are several difficulties that are encountered when making reproductions from these originals.

Nongamut colors. In addition to the normal problems encountered with nongamut colors, some samples may also contain metallic colors. Metallic inks must be used to make satisfactory reproductions from these originals.

Texture. One advantage of using the merchandise sample as an original is that the original detail and texture are captured quite well by the reproduction process. Some adjustment of lighting may be necessary to create the ideal effect.

Fluorescence. The pigments or dyes in the merchandise samples may fluoresce. The corrective measures outlined earlier in this chapter should be used to compensate for unwanted fluorescence.

Retouching Considerations

In general, supplied artwork should never be retouched by the color separator or printer. The dangers of ruining artwork or an original photograph are too high. If the customer will not accept the return of the artwork for the purposes of retouching, the color separator or printer should, as the best alternative, do all retouching work on the color separation files or images.

If the artwork has been generated in-house, or if a conversion transparency has been made from the original, retouching can be safely undertaken. The major color reproduction problems that are created with retouching have to do with the retouched area separating differently from the non-retouched area. In cases when the retouching is not visually apparent on the original but shows up on the separations, the problem is a form of "observer" metamerism.

It is very difficult to tell if a given retouching dye will cause color separation problems. Use of the Kodak Retouching Target affords one method of checking retouching dyes. Retouch the target with the dyes in question so that the colors match the target colors. Next, color-separate the target to see what dyes pass the suitability test. Because different color separation systems "see" color quite differently from each other, the test may have to be repeated several times.

The Kodak Retouching Target is made on E-6 Ektachrome duplicating film. To test dye compatibility on other films or prints, make a copy photograph from the target on the appropriate films. Apply the test retouching to the new films and color-separate as before.

Retouching marks are the other major problem encountered with retouching: brush marks and other signs make it obvious that this process has taken place. One way of getting around this problem is to make the image about twice the reproduction size. Imperfections and blemishes are more difficult to see when the original is reduced to one-half size.

The Kodak Retouching Target.

In practice, however, electronic imaging systems are always preferred when retouching images. The image in question can be enlarged many times and the image removed, changed, or created on a pixel-by-pixel basis if necessary. The color match between retouched and nonretouched areas is perfect because pigments or dyes are not involved.

Technical Requirements of Originals

The technical requirements of ideal originals for photomechanical reproduction can be discussed under the headings of photographic transparencies, photographic prints, and artist's originals.

Photographic Transparencies

Color transparencies for reproduction should generally be as large as practical. The exception occurs when they must be reduced for reproduction, as is often the case in label printing.

Transparencies should be ultrasharp and free from objectionable graininess. Transparencies also should not be excessively contrasty. When possible, "measured photography" lighting techniques should be used to produce transparencies with density ranges similar to that of the printing process (Stanton, 1994). On the other hand, transparencies should not be washed out or desaturated, which can be caused by overexposure.

Finally, there should not be any general objectionable color casts due to incorrect illumination, inappropriate filtration, poor processing conditions, or defective film; nor should there be any localized color casts due to unwanted reflections from colored objects either within or outside the photograph.

In practice, it is not always possible to achieve all the requirements for ideal transparencies that are stated above. Even so, the objectives of high sharpness (especially for 35-mm transparencies) and the absence of color casts would seem to be minimal requirements that could be easily satisfied. Graininess increases with the speed of the film. High-speed film is required for poor lighting conditions, stopping movement, or both; therefore, low graininess may not be possible for certain photographic assignments. In these cases, the color film format should be as large as possible.

From an image quality point of view, duplicate color transparencies should not be used. Duplicates are one more step removed from the original scene, therefore, they are not as sharp as the first-generation original. Some duplicates may also compress highlight or shadow detail and introduce color distortions. In cases where a rigid reflection copy must be converted to a flexible transparency in order to allow separation on a scanner, however, a duplicate transparency is almost indispensable.

All of the color transparencies for a given job should be made on the same brand, type, speed, and batch of transparency film. Each particular film has its own particular way of reproducing color; therefore, the use of different films cause differences not only in the color renditions of the same objects, but also in the color separations. Of course, it is possible to adjust color scanners to compensate for the dye sets of different films, and it is also possible to retouch film or electronic images in order to correct for unwanted color distortion caused by the color sensitivity of the transparency films. Such adjustments and corrections can be expensive and are unnecessary if the same transparency film can be used for all photographs within a given job.

In general, color transparencies are often preferred over other kinds of originals for color reproduction purposes because they are first-generation originals and are usually sharper than a color print that has been enlarged from a color negative; also, unlike many reflective originals, transparencies are flexible and therefore can be wrapped around the drum of a color scanner. Finally, color transparencies are

A selection of 35-mm color transparency films that have been exposed under identical conditions.

Certain films reproduce colors more accurately than others, but no film accurately reproduces all colors.

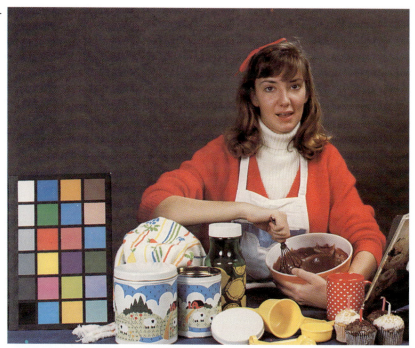

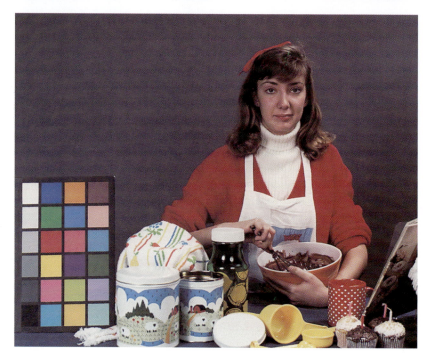

much less likely to have color-incompatible retouching that sometimes is present on reflective color prints.

The major drawbacks with transparencies have to do with their size and their mode of viewing. Virtually all transparencies have to be enlarged in the reproduction process. Indeed, many transparencies are 35-mm format and consequently have to be enlarged quite substantially. The problems of comparing small originals to large reproductions were discussed earlier. The color transparency, specifically the 35-mm format, was designed for projection by a tungsten light source in a darkened room. The lighting conditions for viewing printed color reproductions are quite different; therefore, the question arises as to how valid a comparison can be made between the two. Research continues on this matter, but in the meantime, the viewing conditions for 35-mm to 2¼-in. (57-mm) square color transparencies and transparencies 4×5 in. (102×127-mm) and larger are the subject of national and international standards (see Chapters 4 and 5).

Customers should be cautioned about holding transparencies up to desk lamps or windows or other unsuitable illuminants. Some sales personnel carry portable transparency viewers for customers to use. Some companies even buy standard viewers for the exclusive use of their customers.

The apparent saturation of a transparency can be increased by surrounding it with an opaque border. Since color reproductions almost always have a white border, such a comparison between the original and the reproduction is usually invalid. An appropriate transparent gray surround should be provided for the transparency in order to create the correct visual flare. A comparison between the original and the reproduction can then be made under somewhat similar conditions.

Photographic Prints

Color prints should be made to the final reproduction size. Larger prints are also acceptable. Prints should be sharp and free from grain. These qualities depend (for non-"instant" prints) on the sharpness and graininess of the negative or transparency used to make the print. The surface of the print should be smooth and flat; i.e., textured paper is not acceptable. The maximum density on the print should not be greater than about 2.0. The print should be free of color distortions that are due to problems with the negative or to incorrect filtration, exposure, or processing of the color print paper. The comments on color transparencies concerning

color casts and saturation also apply to prints. Finally, the print should be unmounted so that it could be wrapped around the drum of a color scanner.

One advantage of prints over transparencies is that prints can be manipulated in order to eliminate some of the lighting and other defects inherent in the negative; therefore, almost all of the above objectives should be readily achievable. Prints have important advantages over transparencies because they are often made to final size, and then compared side by side to the reproduction. The major disadvantage with prints is the loss of image definition as compared to transparencies. This loss is sufficient reason for most people to specify that transparencies rather than prints be used as originals for reproduction.

Artist's Originals The key requirement for hand-drawn artwork is that it does not contain any colors that are outside the gamut of the reproduction process. All artists and designers should have a representative printed color chart on both coated and uncoated substrates. The chart should be consulted before selecting the colors for the artwork.

Another major requirement for artwork is that it not contain fluorescent colors, either as a pigment or as the substrate. If a job is to be printed with fluorescent inks, it is usually better to prepare preseparated artwork in black and white and simply make line separations for each color.

The artwork should be prepared to the final printed size and ideally should have a smooth surface. The normal physical requirements for artwork—namely, that the work is clean, the colors even, and a protective overlay attached— also apply. In order to facilitate separation by a rotary drum color scanner, a flexible base should be used for the artwork.

Other Originals The other kinds of originals submitted for reproduction are very rare. Of these, color negatives can create problems for color-scanner operators because the negatives have built-in color correction masks and are negative images. Their requirements regarding grain, sharpness, etc., are the same as for color transparencies. Merchandise samples and fine art are never created specifically for reproduction purposes; therefore, no specific guidelines can be established for this type of original. Merchandise samples should be clean and representative of the product.

Electronic "Originals"

Electronic originals are intangible images that are supplied to the color separation process in the form of digital signals. A computer and a color monitor must be used to generate a visible image from these signals.

A feature of electronic originals is that they do not require film and chemical processing systems (in the case of electronic photography) or the use of paints, brushes, substrates, etc. (in the case of electronic artwork and layouts). Other advantages of this kind of original are a smooth interface between the creative and manufacturing processes, the minimization of certain metamerism problems, and the simplification of the workflow.

The key disadvantage of electronic originals is the appearance constraints imposed by the inherent limitations of color monitors. Such surface qualities as texture and gloss cannot be successfully displayed, and there are difficulties associated with judging sharpness and resolution on color monitors.

Until recent times, most draw and (especially) paint software systems could not match the rich variety of art techniques at the disposal of the graphic designer. Current systems do, however, offer a substantial array of creative effects.

A drawback of most electronic photography systems is their restricted resolution; nevertheless, they are still quite suitable for a number of applications. Compact disk images have fewer resolution constraints and are generally suitable for a wide range of applications. The electronic systems offer high speed, easy image erasability, image storage capability, and true interface between design and manufacturing.

Electronic Artwork and Layouts

A number of fine artists and graphic designers create images with computer graphics systems. Images displayed on color monitors can be transferred to magnetic disks and then to color image processing systems for producing color separations. In other words, the original artwork does not exist as a tangible object but only as a monitor display.

Electronic layouts display the image elements in combined form. Photographs, line work, text, tint panels, illustrations and other elements form the layout. Photographic images may be scanned at a coarse resolution and then cropped and combined to final appearance in such layouts; however, these low-resolution files are unsuitable for reproduction. Low-resolution images are satisfactory for the "rough layout"

phase of design work, and have the advantage of being quick to manipulate in the kinds of computer systems that are used for design work. The photographs are rescanned at high resolution during the production process and dropped into the electronic layout in place of the low-resolution design images.

Electronic Photography

Most electronic photography is based upon charge-coupled device (CCD) technology. A CCD is a solid-state device that consists of light-sensitive elements in linear or area array form. Light that falls on the elements is converted into an electrical signal that is, in turn, converted from analog to digital form and stored on a RAM chip, card, or disk.

Several kinds of electronic cameras are available. A hand-held electronic camera suitable for photographing moving objects contains either a single area CCD with alternating red, green, and blue filter-covered image elements, or a three-CCD split-beam system, with each CCD covered by either a red, green, or blue filter. The former system has relatively low resolution, while the latter system is rather bulky.

Some hand-held CCD cameras are standard 35-mm cameras equipped with a special CCD back, while others are purpose-built CCD cameras. In either case, the image is stored on an internal hard drive or removable PC card (formerly called PCMCIA cards). Several seconds are required to transfer the image to the disk or card, thus limiting how frequently exposures may be made.

Hand-held CCD cameras are particularly useful for remote-site (e.g., sports) photography with data transfer links to the image processing home base. Images from this type of camera are also suitable for relatively coarse-screen reproductions that do not have to undergo significant enlargement.

The studio-type of electronic camera is generally equipped with linear array CCDs. Two types of systems are available—one uses a single CCD and makes three separate passes, or scans (changing the filter each time), while the other has three CCDs, each covered by either a red, green, or blue filter, that makes one scanning pass. The linear-array camera is, in effect, a flatbed color scanner configured as a camera. Such systems are capable of achieving extremely high image resolution but are only suitable for still life studio applications.

Linear-array studio cameras require several minutes to complete the image recording process. Under such circum-

Conventional vs. electronic images: (top) an enlargement from a 35-mm transparency and (bottom) an enlargement from a hand-held electronic camera image.

stances, lighting can become a significant concern. In order to avoid "banding" (stripes or bands of unevenness in smooth tones) problems, special flicker-free light sources must be chosen when using electronic studio cameras. Generally, these lights generate considerable heat and do not offer the photographer the flexibility of conventional studio lighting. CCDs are quite sensitive to infrared (IR) radiation; therefore, IR-absorbing filters may have to be fitted to the CCD camera back to counter the influence of heat on the sensors. CCD camera backs are normally used on standard view cameras. A SCSI (small computer systems interface) cable connects the CCD back to a computer workstation. The image is generally stored on the computer's internal hard disk drive or on a dedicated external drive.

One particularly good use of CCD studio cameras is for photographing reflection artwork that is too large or rigid for normal scanning. These cameras are also used with considerable success for certain types of catalog photography.

Pre-recorded Images

Pre-recorded images are those scanned from a conventional photographic image and recorded onto a CD-ROM. The Eastman Kodak PhotoCD system is a well-known example of this type of system. The consumer version of PhotoCD is used to record 35-mm color negative or transparency images. The resulting files have resolution sufficient for making magazine-page size reproductions at 133 or 150 lines per inch screen rulings. A professional version of PhotoCD accepts film input images up to 4×5 in. which may be used to generate fine screen reproductions up to about 16×20 in.

For best results, PhotoCD's CCD-based scanner requires that the range of the original color negative or transparency not exceed about 2.80 density. All color negatives will certainly be suitable, but some transparencies will not.

The PhotoCD scanner uses a scene balance algorithm to correct for film type and exposure when processing image scans. The algorithm attempts to make the reproduction look like the original scene, which is a worthy goal for the consumer market, but may not work if special exposure and lighting effects have been used with professionally-created images. The problem here is akin to photofinishing of conventional film: a consumer-market photofinisher will aim to produce a generally pleasing result that may happen to negate or distort the special requirements of professional images. Photofinishing and scanning services that are

geared specifically to the needs of the professional color reproduction industry should be used for best results.

The stock photography business is based, to a considerable degree, on PhotoCD or other types of writable CD systems. In some cases, a CD serves as a catalog of available images. Once an image has been selected, a company will purchase the reproduction rights. A high-resolution image will then be sold or leased to the company. In other cases, a CD may be sold outright as a set of royalty-free stock images to be used in any way the purchaser desires.

A key image transfer issue for color separators is that the CD data are convertible into standard formats for image processing. Kodak's PhotoCD image is produced by scanning the original, converting the data into YCC color space, compressing the data, and then writing to a special PhotoCD PCD file format. The disks can be read on any extended architecture (XA) CD player linked to a computer. The YCC image may be converted to RGB or, in some cases, to CMYK color systems. The file format is converted into such systems as TIFF for image editing and color separations. Some PhotoCDs may be written directly in TIFF.

Concluding Analysis

The creation or selection of original artwork or photographs is one of the most important stages in the color reproduction cycle. The quality of the final reproduction is very dependent upon the quality and nature of the original.

This chapter has addressed a series of problems or constraints in color reproduction that are due to the type of color original that was chosen. In some cases, these problems cannot be corrected or overcome within the reproduction process. In other cases, the problems can be overcome, but only at a substantially higher cost than that for satisfactory originals. In many cases the persons, equipment, and materials used in the reproduction process get the blame for failure to match the copy. The true blame often lies with the designer, photographer, or art director for supplying unsatisfactory originals. Some blame must also be borne by the sales force who accepts unsatisfactory originals. The overzealous sales representative who says, "We can reproduce anything," may be causing untold grief for production personnel and low profits for the company through ignorance of the problems inherent in certain kinds of originals.

In general, however, unretouched photographic prints or transparencies will reproduce well. Artist's originals can cre-

ate difficulties in the reproduction process due to the use of mixed media, fluorescent materials, textured base or paint, or nongamut colors.

Viewing conditions for evaluating originals are critical; therefore, an ongoing area of research in color reproduction is how best to compare transparency originals with reflective reproductions. The image-comparison problem is exacerbated when the transparency original is much smaller than the reproduction. Transparencies should always be viewed with an appropriate surround, and when possible, 35-mm and other small transparencies should be viewed with one of the standard graphic arts projection viewers.

Ideally, originals should be sharp, free from image defects, and the same size as the final reproduction. They should not contain any nongamut colors, should not be made of materials that will fluoresce, and should not have a longer density range than the reproduction process. In order to facilitate color separation with a rotary-drum scanner, originals should be flexible enough to wrap around the scanner drum, and the surface should be smooth and clean.

Electronic originals offer some advantages over traditional tangible originals: no chemicals and supplies, and "instant" availability. There are, however, some drawbacks that will always restrict the use of electronic originals. Color monitor displays cannot capture the surface characteristics of materials viewed by reflected light, nor can they adequately capture the image structure characteristics of the reproduction. It is also difficult to make visual comparisons between self-luminous monitor displays and reflective originals or reproductions. The monitor image is, of course, intangible and therefore is not particularly satisfactory for contractual specification purposes. A hard copy image may be generated from the electronic files, in order to negate some of the drawbacks of electronic originals, but only at the cost of making electronic photography more like conventional photography.

The decision to use electronic photography will be guided by the subject considerations, image quality requirements, and speed requirements. Such applications as newspaper photography or still life studio photography would seem well suited to electronic photography. Images that require great enlargement and good image detail within production systems that involve a number of stages and contractual arrangements may be better served by conventional photography. Pre-recorded stock CD images offer important cost

advantages that will make them popular for many imaging applications independently of other types of electronic photography.

Customers will never supply ideal originals all of the time, but as long as defects in the original and reproduction problems are pointed out before the color separations are made, the appearance of the color proofs will come as less of a surprise. Management should be aware of the problems that certain originals can cause in the reproduction process and submit a price quotation that reflects the extra time needed to attempt to adjust the reproduction to correct these problems. If possible, samples of unsatisfactory artwork and the subsequent reproductions should be kept by the sales personnel to be used as examples of what can go wrong when poor originals are submitted.

11 Color Reproduction Objectives and Strategies

Types of Color Reproduction

Robert Hunt (1970) has identified six different kinds of color reproduction (spectral, exact, colorimetric, equivalent, corresponding and preferred). His explanation of these ways of looking at color reproduction has particular relevance to comparisons between original scenes and photographs. Lighting differences between the scene and the reproduction greatly influence the kinds of color reproduction that are possible in practice.

Printed color reproductions differ from other color reproduction systems because an "original" (a photograph or an artist's rendition) is used as the starting point in the reproduction process, rather than the original scene. The original often represents the desired appearance of the reproduction, and the reproduction is usually evaluated alongside the original under standard lighting conditions. Printed color reproduction, therefore, is a special kind of color reproduction that usually fits into one of the three categories which are described below.

Exact Color Reproduction

The objective of exact color reproduction applies to situations that require the reproduction to be a visual match to a color original (an artist's drawing, a merchandise sample, or a color photograph) when both are viewed under identical conditions. Hunt defines the conditions for exact color reproduction as equal chromaticities and relative luminances, as well as equal absolute luminances of colors in the original and the reproduction. The eye's adaptation must be the same when viewing the original and the reproduction, i.e., the luminance and color of the surround, the angle of subtense, and glare. The observer's vision should match that of the CIE standard observer for the reproduction to be perceived as exact under these circumstances.

Optimum Color Reproduction

The usual application of the term optimum color reproduction is to those situations where certain compromises or corrections must be made in the reproduction because of reproduction system constraints or distortions in the original. The term "optimum" means the best possible reproduction under the circumstances. Further circumstances that contribute to compromises within the reproduction process are the: viewing conditions, scale of the reproduction relative to the original, surround conditions, surface characteristics, and the colorimetric and tonal distortions of certain originals (especially color transparencies).

Hunt does not use optimum as a type of color reproduction, but one of his terms does apply to this category. **Preferred color reproduction** is that term used to describe the preferred distortion of color between original scene and reproduction. Printed postcards, for example, generally reproduce sky and water as a clean blue regardless of whether they appeared this way in the original scene. Sometimes, the original photograph may incorporate the preferred distortion, but in other cases, the distortion will be made at the photomechanical reproduction stage.

Corrective color reproduction refers to the adjustments that are made during the reproduction process to correct the unwanted distortions inherent in the original. The unwanted distortions in the original photograph could include highlights too light or too dark because of exposure errors, and color casts due to poor processing, improper filtration, wrong lighting or careless storage conditions. The color sensitivity and dye absorption characteristics of the photographic emulsion in question also imposes particular distortions on the reproduction (see Chapter 10). Related distortions that may be caused by the image capture system are discussed in Chapter 12.

Compromise color reproduction is the third aspect of optimum color reproduction. The objective in this case is to emphasize the color or tonal relationships in particular parts of the reproduction, relative to those in other parts of the reproduction, in order to increase the perceived excellence of a given printed image. The compromises account for the gamut differences between the original and that of the reproduction system; the differences in maximum density (D_{max}) between the original and the reproduction; the viewing anomalies caused by the size of the reproduction relative to the size of the original; the perceptual differences between

transparent originals and reflective reproductions (surround, light source color temperature, intensity, and color quality); and the surface characteristic differences between originals and reproductions. Image structure (sharpness, resolution, graininess, moiré) differences between original and reproduction may also exert an influence on the desired color in parts of the reproduction.

Optimum color reproduction is the goal for most printed color reproductions. This kind of reproduction is the end result of adjustments and manipulations made during the color separation process to achieve the compromise, corrective, and preferred color reproduction objectives. The

Preferred color reproduction adjustments are made to alter the natural appearance of an original (top) to produce a rendition that more closely resembles how most observers would wish to remember a particular scene (bottom).

Corrected

Tungsten illumination (3200 K)
Kodak Wratten 80A filter

Uncorrected

Tungsten illumination (3200 K)
No filter

Fluorescent illumination (cool white)
Kodak Wratten CC30M filter

Fluorescent illumination (cool white)
No filter

Corrective color reproduction involves the removal of such unwanted color casts as those shown in the illustrations on the right. The illustrations on the left are cast-free and represent the correction objective.

resulting reproduction is the technical excellence facet of quality that is discussed in Chapter 15.

Creative Color Reproduction

Creative color reproduction refers to those changes made to the reproduction during the iterative color production processes in order to produce a more effective or attractive reproduction. This aspect of color reproduction is the aesthetic facet of color quality (see Chapter 15) and serves the fantasy image market; i.e., that which places a high value on the final appearance of the reproduction without regard to the appearance of the original scene or photograph.

Creative color reproduction strategies also apply in those cases when image elements are combined to create new images, either within a single picture, or in such multiple-image layouts as a catalog page. The juxtaposition of new image elements changes the perception and balance of the overall image, which, in turn, may prompt color adjustments within individual areas in order to produce a more pleasing and effective image.

Creative color adjustments are most often, and most properly, made before or at the color separation stage; but in some cases, modifications may be made at the press stage. Extra printings of a primary color or the addition of an overprint varnish are examples of press-related creative color reproduction decisions that may be made after the initial colors have been printed.

Color Reproduction Objectives

The answer to the question, "What are the objectives of a color reproduction system?" depends upon the characteristics of the ink-paper-press system, the type of original, the color separation process, and, most importantly, the requirements of the print buyer and the expectations of the end user or consumer of the printed piece. The set point of the systems diagram introduced in Chapter 3 represents the setting required for the desired reproduction. The set point requirements are best understood by referring to the color reproduction objectives of particular types of originals.

Reproducing Artwork

Artwork prepared by a graphic designer is produced for the sole purpose of being reproduced; therefore, exact reproduction can be clearly stated as the objective. In some cases the designer will specify the ink and paper to be used for the printed product, whereas in other cases, he or she will be aware of the materials being used prior to preparing the art-

work. A designer preparing artwork for reproduction in a magazine, for example, should be aware of the appropriate standard proofing conditions and choose colors that are within the available gamut. If the artwork cannot be reproduced by the specified manufacturing conditions, then the artwork is at fault. Unlike fine art, which is produced as an end in itself and is only incidentally reproduced, the intent of commercial art is to serve as the starting point in the reproduction process. If the artwork is impossible to reproduce under the specified conditions, it has failed as commercial art and should be redone. In cases when the designer does not know the intended manufacturing conditions, he or she should, at the very least, try to ascertain whether coated or uncoated paper will be used and to then choose available colors from an appropriate color chart.

Reproducing Merchandise Samples

Clothing, paint chips, floor tiles, automobile color samples, and furniture fabrics are all examples of products that are illustrated in catalogs or brochures. The consumer often orders products based upon their appearance in a catalog and consequently expects the product, when delivered, to be a close match to the catalog representation. To ensure close reproduction, actual samples of fabrics or paint are often supplied as guides for the color separator or system operator. In some cases, the separations are made directly from the samples themselves.

The objective for merchandise samples is exact color reproduction, but this must be qualified. To achieve an exact match of a flat paint chip is one thing, but to achieve an exact match of the paint color on a product—e.g., a car—is something quite different. In the latter case, the color has been distorted by the color film used to capture the scene; also, the shading, reflections, surround colors, lighting contrast, and color temperature of the light illuminating the scene all influence the perception of the paint color in the supplied photograph. Such other factors as texture, gloss, sharpness, resolution, and tone reproduction must be considered in addition to color exactness. The whole picture is judged, rather than just the color in isolation.

The reproduction of a flat color, if it is within the gamut of the ink/paper combination, is fairly straightforward. If the supplied color lies outside the normal gamut, then it is not uncommon to use five or more colors to achieve a match.

The accurate reproduction of a particular color within a complex scene is not so easily achieved. For reasons to be explained later, compromises must be made when reproducing photographs. The product colors in such reproductions only convey a general sense of the original color.

Reproducing Fine Art

Original oil paintings and watercolors that are painted as ends in their own right are occasionally reproduced in catalogs or books, on posters, postcards, or calendars. Exact color reproduction is the objective in this case. The person purchasing an art book wants the reproduction to express the color and tonal properties of the original as closely as possible. It may only be possible to achieve this objective by using more than the normal process inks.

If the colors in the original exceed the gamut of the reproduction process, the fine art reproduction process is treated more like the photographic reproduction process; i.e., tonal and saturation compressions must be made. Further corrections may be required if the piece of art in question is photographed prior to the color separation process. Copy transparencies are often made from large oil paintings that cannot be accommodated on most scanning systems. The "original" in this case, from the color reproduction objective point of view, is the oil painting and not the transparency.

Reproducing Photographs

In the case of certain color print originals, exact color reproduction may be desirable and possible. For most photographic originals, however, optimum color reproduction is the objective. The color separations made from these originals will be modified to remove the unwanted distortions and to incorporate the wanted distortions. Tonal and saturation compressions are also made, as necessary, to produce the best possible reproduction within the constraints of the reproduction system. The specific correction and compromise strategies used to achieve optimum color reproduction are discussed in some detail later in this chapter. Judgments of optimum quality are best made by the same method used by the final consumer; that is, by evaluating the printed reproduction on its own merits, and not by comparing it to an intermediate reproduction (the photograph used as the original).

A color photograph (print or transparency) is a reproduction of an original scene or object. The accuracy of this reproduction depends upon the brand and type of color film, the illumination of the original object or scene, the exposure

of the film, and the processing of the film. In the case of electronic photography, the filter absorptions and the sensitivity of the CCD will influence the color record. The optical system of the camera may also introduce distortions.

The types of distortion inherent in photographic color reproductions include hue, lightness, and saturation shifts of colors; image defects caused by loss of resolution, the presence of grain and poor sharpness; and tonal distortions caused by the emulsion characteristics.

The perception of distortions is influenced by several viewing conditions, including the degree of magnification, the color temperature and intensity of the viewing light source, and the surround conditions. Fortunately, the viewing conditions for photographs have been standardized by various national standards organizations. The kind of color film that is used by photographers, however, can never be standardized. From the creative viewpoint, such standardization would be unnecessarily restrictive. The key point concerning color photographs is that they are distortions of reality.

The appearance of the optimum reproduction generally differs from that of the photograph. The reproduction may need to be closer to the original scene or object colors; it may have to be even further distorted to be considered optimum. The photograph submitted for reproduction is merely a starting point, not an end in its own right.

Creative Enhancement

Almost all images may be subject to creative manipulations during the reproduction process, but the ones most likely to undergo enhancement are those produced for the advertising, fashion, entertainment, and the other creative and artistic communities. The degree of creative manipulation that may be employed during production will be constrained by production delivery deadlines and costs.

Creative decisions are usually made at points during the electronic imaging process that extends from design through the prepress stages. The designer manipulates low-resolution image files of the originals to create the initial effect. The image is then refined on the production workstations as needed.

The unplanned color interactions that result from combined image layouts may prompt further creative adjustments during the production process. These adjustments are usually part of the overall modifications that include iterations for achieving optimum or exact color reproduction.

Unprecedented control over the selective manipulation of image elements can, however, be counterproductive to good quality reproduction. Extensive enhancement can destroy the natural photographic appearance of the image. The preservation of natural appearance in cases when one element has been extensively modified often requires the services of a system operator with expert skill and plenty of time.

Creative color adjustments may also be introduced at the printing stage via overprint varnishes. Some on-press color enhancement (e.g., a different color sequence) may improve a particular image, but such changes should be made with great caution and only in extremely rare circumstances. It must be remembered that any press change made to enhance one image will usually degrade another image within the same layout. Press running conditions should be kept as standard as possible in order to establish a predictable color reproduction system.

Color Reproduction Strategies

Once the objectives of color reproduction have been established (i.e., exact, optimum, or creative), two basic strategies plus one supplementary strategy may be chosen to achieve the desired results. The oldest of the basic strategies is the component approach, which relies upon the separate adjustment of the tone reproduction, color balance (gray balance), and color correction requirements of the original relative to the reproduction process characteristics. The other basic strategy is the integrative approach which relies upon the use of a lookup table (LUT) to produce a particular transformation from input red, green, and blue color separation signals to output cyan, magenta, yellow, and black printing values.

The supplementary strategy uses, as a point of departure, a color-monitor display of the output image that results from the initial application of either the basic component or integrative strategies. The color-monitor display is used to guide the "fine-tuning" adjustments that must be made to the reproduction to achieve the precise color objective. Such adjustments are almost always required when the integrative approach has been used, but may not be required in those reproductions that are based upon the component approach. In cases of creative color reproduction, however, monitor-assisted adjustments will almost always be required regardless of the basic strategies employed.

The Component Approach

The component approach to color reproduction is that used from the early days of color photography. Traditional graphic arts color scanners are programmed via this approach. The scanner operator presets the gradation, gray balance, and color correction controls to suit the tone reproduction, color balance, and color saturation requirements (as discussed below) of a particular original with respect to a given reproduction process (inks, substrate, and printing press). Skilled scanner operators are often capable of producing high-quality color separation images that require no further modification prior to printing.

Tone reproduction. Virtually all researchers in the optimum-color reproduction field agree that good tonal reproduction is the first and foremost objective in achieving good color reproduction. The printer has to work from original transparencies that often have a contrast range greater than 3.0. The contrast range of printed matter rarely exceeds 2.0; therefore, a density of 1.0 must be sacrificed. The nature of the tonal compression from original to reproduction greatly influences the resulting quality.

The tone reproduction work of Bartleson and Breneman (1967) is frequently cited to support the recommendation that a linear compression of relative brightness be made when the range of the original exceeds that of the reproduction process. This strategy may produce a reasonable first approximation but in practice, the situation is more complex. A comprehensive study of tone reproduction by George Jorgenson (1977) concluded that:

- Evaluations of tone reproduction quality appear to be based upon what the observer perceives as the main interest area of the photograph.
- There may be more than a single main interest area in a photograph, and the area selected by an observer will be influenced by that person's interest, taste, or bias. (Note: this difference in personal viewpoints preclude a single best or optimum tone reproduction for a given photograph.)
- If the main interest area is located in the highlight end of the tone scale, the observer prefers a different tone reproduction curve than when the main interest area is in the middletones or shadows.

"High-score" tone repro-duction curves for black-and-white high-key and normal prints.

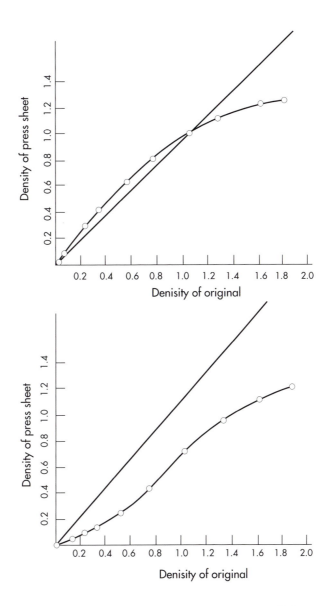

- High-score tone reproduction curves will have a slope of about 1.0 in the interest area of the photograph (i.e., the lightness intervals should be approximately equal in the original and the reproduction even if the lightnesses are not reproduced at equal values).

The studies reported here were conducted on black-and-white reproductions, but it is highly probable that the general findings are also applicable to color reproductions.

Two reproductions from the same original that empha-size different "interest areas": (top) shadow tone (hair) emphasis, (bottom) highlight tone (lace) emphasis. The context of the reproduction deter-mines the desired interest area; e.g. will this illustra-tion be used in a shampoo advertisement, or in one to promote lace?

The concept of variable interest areas within a given photograph may be illustrated by considering the context in which it will be used. Suppose, for example, that a supplied original is a photograph of a young woman with dark brown hair and medium complexion, who is wearing a light-colored sweater that contains an intricate woven pattern. The interest area in this photograph depends upon its context.

If the photograph is used in a shampoo advertisement, the luster and shine of the hair should be emphasized. In this case, shadow tone separation will take precedence over other parts of the tone scale (i.e., highlight tonal separation will be flattened). However, if the photograph is used in a clothing catalog to sell sweaters, then the texture and detail of the sweater will form the interest area; highlight detail will be enhanced and the shadow tones flattened. A final possibility is that the photograph depicts a local celebrity and will be reproduced in an entertainment magazine. Facial detail (skin, eyes, lips, teeth) now serves as the interest area. Middletone values will be enhanced (i.e., good tonal separation) while both highlight and shadow tones will be flattened (i.e., reduced tonal separation).

Customers may insist that all parts of the tone scale are equally important and, as such, should be accurately reproduced. The printer (under such circumstances) may suggest the use of five, six, or more colors, and perhaps an overprint varnish to provide the tone reproduction that the customer desires. If the printer is restricted to using four process colors and no overprint varnish, tonal compression is inevitable for most originals. In this instance, the key to good tone reproduction is a non-linear compression that favors the interest area of the photograph.

The interest area of a photograph may seem obvious (e.g., the highlights in a high-key photograph), but in practice depends upon the context of the reproduction. Good scanner and system operators may be able to correctly choose the interest area in a photograph, but it is really the responsibility of sales representatives to unearth the customers' objectives and then to accurately convey this information to color separation personnel.

The preceding discussion applies to determining the desired tone reproduction at a 100% reproduction scale. If the original is going to be greatly reduced, the middletones may appear too dark if the 100% tone curve is used. Like-

wise, if the original is greatly enlarged, the middletones may appear too light.

To counter the scale change effect, it is necessary to reduce the middletone values when making reductions and to increase the middletone values when making enlargements. Ralph Girod (1984) suggested the adjustments shown in the following table.

Middletone corrections for enlargement and reduction.

Scale of Reproduction	Midtone Dot Change	Scale of Reproduction	Midtone Dot Change
20%	Reduce by 15%	600%	Increase by 5%
40%	Reduce by 10%	1000%	Increase by 7%
60%	Reduce by 5%	1500%	Increase by 9%
80%	Reduce by 3%	2000%	Increase by 10%
100%	No change		

Color balance. Research has supported the importance of reproducing a good gray scale. That is, neutrals in the original scene must be reproduced as neutrals on the printed page. If the neutrals are correctly reproduced, many of the colors will also be satisfactorily reproduced.

The two reasons for poor reproduction of neutrals are incorrect gray balance and poor neutrals in the original. Gray balance is dependent upon the colorimetric properties of the printing inks and substrate, and the subsequent image

High-key photograph reproduced with a tone curve designed to emphasize the lighter tones.

Normal key photograph reproduced with a tone curve designed to emphasize middle tones.

Low-key photograph reproduced with a tone curve designed to emphasize darker tones.

Examples of incorrect color balance caused by improper gray balance settings.

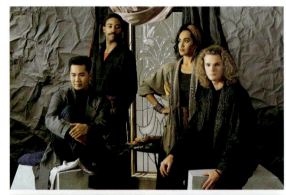

Incorrect yellow tone scale

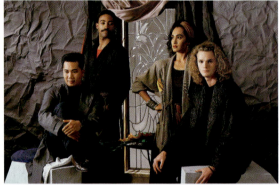

Incorrect magenta tone scale

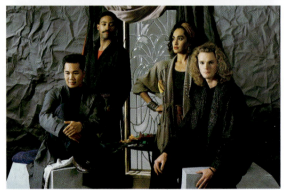

Incorrect cyan tone scale

Example of correct color balance

The application of three different tone curves to the same photograph for illustrating the corresponding emphasis in different regions of the tonal scale.

distortion caused in the printing process. Gray balance can be determined for any given press-substrate-ink combination by printing a test gray balance chart and analyzing it to determine the specific yellow, magenta, and cyan dot values that produce a neutral scale. Once this objective is achieved, the press aspects of color balance are satisfied.

Problems with the color balance of originals are usually related to using a color film under the wrong lighting conditions. If, for example, a film intended for daylight use is used indoors with tungsten illumination, the subsequent photographs will appear too warm. Poor color balance in photographs may be neutralized by using Kodak Wratten color correcting (CC) filters. These filters are available in a variety of values in yellow, magenta, cyan, red, green, and blue. CC filtration is added to a transparency until balance is restored. For example, a greenish transparency is balanced by the addition of CC magenta filters. Color negatives are usually balanced by adding CC filtration at the color print-making stage. The subsequent print, which is then submitted for reproduction, should not have any color balance problems.

Color saturation. The reproduction of nongamut colors has received some attention from research workers. The major difficulties with nongamut colors concern saturation and lightness. Hue can always be matched. To some degree, lightness can be satisfactorily adjusted when modifying tone reproduction to emphasize an interest area. The findings are mixed concerning how saturation should be modified. Some researchers suggest a uniform compression of all saturations. Others point out that this treatment sometimes sacrifices the saturation of important colors (Rhodes, 1971). We must conclude that the optimal saturation compression varies according to the circumstances.

Suppose, for example, a photograph of a person wearing a brick-red ski jacket standing beside a scarlet-red sports car is submitted for reproduction. If the color gamut of the reproduction system is capable of matching the ski jacket red, but not the sports car red, then the color separator must make a saturation compression decision, the nature of which will depend upon the context of the reproduction.

If no saturation compression is applied, i.e., the ski jacket color is reproduced accurately, the sports car red will reproduce at a saturation value noticeably lower than the red in

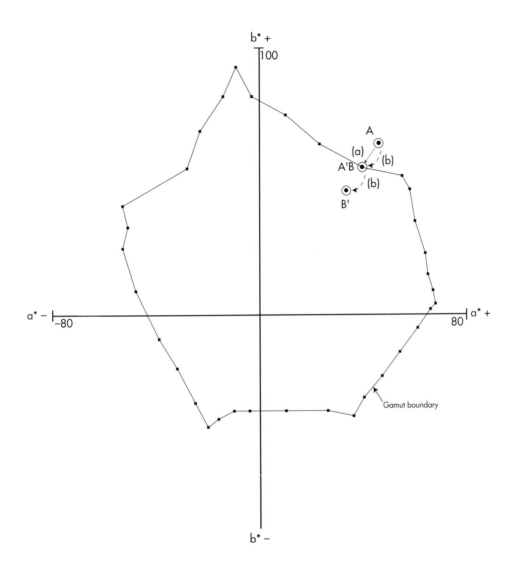

Color saturation compression: the point on the CIELAB hue and saturation diagram, identified as A, is a color that falls outside the color gamut that is possible with a given icombination of process and special inks; the color marked B lies on the color gamut boundary; (a) if color B is reproduced accurately and color A is ignored ("clipped"), both colors will reproduce at the same point (A'B) on the color gamut boundary (i.e., the saturation difference between colors A and B will be eliminated); (b) if the saturation of the color separations is adjusted such that color A lies just inside or on the color gamut boundary (at A') then color B will be reproduced at a lower saturation (B'), or less accurately, than it could have been (but, the approximate saturation difference between colors A and B will be preserved).

The effects on saturation of using low (top), normal (middle), and high (bottom) degrees of color correction (or kinds of "rendering intent") when making color separations.

Colors appear too 'dirty' or gray (low saturation)

Colors appear natural (normal saturation— approximates a "perceptual rendering" compression)

Improved "cleanliness" of gamut color is achieved by sacrificing the gamut and non-gamut color saturation distinctions (high saturation—approximates "colorimetric rendering")

the original. It may be, in fact, that the sports car red and the ski jacket red now appear identical. This lack of saturation differentiation may be unimportant if the photograph appears in a ski clothing catalog because the saturation interest area (the ski jacket) is reproduced accurately. The color of the sports car is relatively unimportant in this case.

On the other hand, the color of the sports car is important if the photograph is used to advertise that product. In cases when an important color exceeds the color gamut of the reproduction system, the saturation of the picture is compressed so that the nongamut original color is reproduced at the gamut boundary, and all other colors of the same hue are reproduced at reduced saturation. In the case of the example, the sports car red is reproduced at the gamut boundary, and the ski jacket red is reproduced at a less saturated or grayer value (i.e., the ski jacket is deliberately reproduced worse than it could have been in order to retain some of the saturation distinction between the sports car and the ski jacket). The reproduction will be successful because the colors in the picture are internally consistent with each other, regardless of whether they actually match the original scene (Evans, 1971).

The color separator's normal strategy is to compress the saturation of the original (using color correction controls) so that the most saturated color (of a particular hue) is reproduced at the gamut boundary and all the other colors of that hue are reproduced at a proportionally reduced saturation. There will be occasions when this strategy will not produce optimal results. Important product colors for mail order catalogs should be reproduced as accurately as the printing conditions will allow. Merchandise samples may be supplied to serve as a target for color matching.

It is, of course, possible to match the hue of any color, but in practice, it may not be desirable. The effects of saturation compression and tone reproduction (lightness) compromises may be such that compensatory shifts in hue may be required to achieve optimum results. The exact direction and magnitude of such hue shifts are difficult to predict and are best achieved through a change-and-evaluate iterative process using a color monitor.

There is some evidence suggesting that excellent reproductions do not necessarily contain colors that are all reproduced equally well. In practice, as long as good tone reproduction, color balance, and the satisfactory reproduction of the important picture areas are achieved, a loss of saturation in some

areas is probably not significant. Of course, improved color saturation is possible if extra printing inks are used. The desaturation of light tones is primarily due to the halftone process (the coarser the screen ruling, the greater the desaturation). The use of supplementary light pastel ink colors can help overcome this problem. Desaturation of darker colors is generally related to the process-ink pigments, the ink film thicknesses of these inks, and ink trap imperfections. Extra printings of such colors as red, blue, green, orange, or purple are sometimes used to help improve the saturation of strong colors.

Deliberate color distortion. One preferred color distortion is Caucasian skin tone. Research has shown that people prefer to have this color reproduced slightly tanner than its actual color; also, water and sky colors are often preferred bluer than their actual appearance in nature. Tourism brochures, for example, are usually reproduced with saturated blues (sky or water) and greens (grass) that do not match reality. Colors are sometimes altered to create a particular mood or atmosphere in a picture. In most cases, the color films used to take the photographs already have some of the desired distortions built in, such as tanner skin tones and bluer skies. Under such circumstances, the objective of the reproduction process is to reproduce the distorted colors in the photograph as closely as possible. This is reasonable if the desired colors lie within the gamut available from the given printing conditions.

The Integrative Approach

The integrative approach has achieved widespread use following the development of lookup table (LUT) based methods of transforming input signals into output records. The LUT method, first used experimentally in the 1971 Ventures Research and Development Group scanner (Korman and Yule, 1973), achieved commercial status in other scanners and imaging systems during the late 1970s. The advent of desktop color publishing systems accelerated the use of the LUT approach to color image processing.

The foundation of the integrative approach is an LUT based upon the ink/paper/press combination used for the reproduction. The LUT may be generated by empirical or computational methods. The empirical approach requires that a color chart is first printed under the production conditions and then measured to create a file that links red,

green, and blue separation signals with corresponding yellow, magenta, cyan, and black halftone values in the printed chart. The computational approach may use the Neugebauer equations (see Appendix D) and measurements from a compact color target printed under production conditions to compute the LUT. Interpolation is used in both cases to derive the halftone values for the colors that lie in between the table entries. High-quality imaging systems contain about 8,000 LUT entries, a number that affords more precise interpolation than the 1,000-entry LUTs of less expensive systems that have smaller memory. The LUT is recomputed for changes in the ink/paper/press system. In some cases, device profiles (the term used to identify the LUT of a given output or destination device by the computer software industry) may be edited to suit different output options.

Mathematical models. Some attempts have been made to introduce a degree of quantification and predictability to the color reproduction process. A color reproduction index (CRI) has been developed by Michael Pointer (1986) for evaluating how well a given color reproduction system reproduces a specific original. His experimental mathematical model relies, in turn, upon appearance measures from Hunt's color appearance model (see Chapter 5). In theory, computer-program-driven adjustments may be made to a color imaging system to automatically maximize the CRI for a given original when using a specific LUT. Such an approach to color reproduction would be computationally intensive, but continued improvements in computer costs and performance could lead to the future use of color reproduction mathematical models for a number of routine applications.

There are good reasons, however, to doubt whether a CRI model will be of significant value to the high-quality end of the color printing business. The primary reason for the limited applicability of model-based approaches in the printing industry is due to the fundamentally different production realities and quality requirements in this segment of the color reproduction business.

The color prints produced each year by the photofinishing industry for the amateur or consumer market are based upon a pleasing color quality criterion. Certain segments of the printing industry have similar quality requirements. The application of predictive models in these situations will generally be successful.

The key distinction between printed color reproduction and other types of color reproduction is that thousands, or even millions, of copies of each image are produced when printed reproductions are made, versus one or two copies for most amateur photographs. Many television images are produced, but these are transitory and subject to adjustment by the viewer and are, therefore, not strictly comparable.

The multiple-copy production requirements of printing markets means that time and money spent to perfect a set of color separations will form a very small part of the total cost of printing the job. A double-page advertising layout in a national magazine with many millions circulation may cost as much as $250,000 for the space. Under such circumstances, the costs of the separations are minuscule, regardless of whether as many as two or three reproofings are required to perfect the image.

Another important distinction between printed color reproductions and other types of color reproductions concern the shift in emphasis when establishing judgment criteria. The emphasis for the amateur color print market (for example) is upon producing pleasing reproductions of a variety of scenes. The emphasis for the color printing market is upon incorporating the requirements of the customer into the reproduction. The differences between the consumer evaluator's content focus (is the scene as I would like to imagine it?) and the professional print buyer's market focus (is the product color accurate? or, is the highlight detail delineated?) is a very clear one. Indeed, this difference is the same as that between amateur photography and professional photography. A wedding photographer, for example, will use selective print exposure techniques (dodging or burning in) to enhance such important picture details as the bride's dress or veil. Landscape photographer Ansel Adams (along with many other fine art photographers) routinely crafted his prints to serve the creative intent that he had in mind.

The selective modification of the printed (or proof) image to produce the best possible aesthetic and technical quality is also quite routine at the higher end of the printed color reproduction market (e.g., greeting cards, art books, advertising materials, luxury item catalogs, certain magazines, and all forms of packaging). Printed color reproductions (or proofs) are scrutinized very carefully by professional print buyers or art directors prior to being approved. The evaluators know that any imperfection at the proof stage will be

repeated in (perhaps) millions of printed products; therefore, the logic is compelling for a customized approach to color perfection in the color printing business.

The degree of perfection that could be built into the proof image was somewhat limited in the past by time and cost constraints. The introduction of color-monitor-based proofing systems and digital image manipulation techniques has, however, greatly reduced the time and cost required to achieve excellent results. The color-monitor-based iterative approach to color reproduction is now the dominant method used by the printing industry for achieving optimum quality.

Iterative refinement. Calibrated color monitor images are commonly used today to guide software-driven iterative refinements of the reproduction. This approach to optimizing color reproduction quality was first actively advocated by Rhodes (1971). The widespread availability of powerful desktop computers and sophisticated image manipulation software has placed color adjustment technology into the hands of amateur and professional users alike. Many instructional aids are available to guide the user when refining basic images that have been displayed on a color monitor. One such aid, the book *Makeready*, by Dan Margulis (1996) takes the reader through an extensive series of sample images that exhibit a variety of tone and color manipulation options. Detailed explanations of the methods achieving particular outcomes are presented in his text.

Skilled color system operators do make use of the setup strategies used by traditional scanner operators: color casts are removed, important tonal detail is enhanced, and suitable saturation compressions are applied. The primary difference is that the scanner setup is based upon careful prior measurement and analysis, while the monitor-display approach is driven by visual feedback.

The Fine-Tuning Supplement

The need to "fine-tune" a color reproduction is based upon the notion that the concept of color excellence is not knowable until it is seen. Such iterative fine tuning has always been a part of the photomechanical color reproduction process. The early photoengravings were sequentially etched, proofed, and evaluated until the reproduction was optimized. Photolithographic reproduction processes placed less reliance on this iterative process and more upon the use of sophisticated color separation and masking procedures. Film dot

etching and reproofing strategies were more expensive and time consuming in the photolithography process than in the photoengraving process.

Fine tuning takes place for three reasons: adjusting color accuracy, exploring creative possibilities, and compensating for the visual effects of image juxtaposition. In practice, separate adjustments are not made for each of these objectives; rather, they are made simultaneously whenever possible. A color monitor is used to guide most of the color adjustments, but a hard-copy proof is generated for certain judgments that are impossible to make on a monitor (e.g., surface effects, large-format images, interference patterns, and image definition).

Adjusting color accuracy. Color accuracy is achieved when the color reproduction process produces the desired color. If exact color reproduction is the objective, color accuracy occurs when there is an exact match of the reproduction to the original. If optimum color reproduction is the objective, color accuracy occurs when the printed color matches the observer's perception of the ideal compromise appearance of the original color. If creative color reproduction is the objective, color accuracy occurs when the printed color achieves the creative intent, regardless of the original.

Adjusting color accuracy is a difficult task on a color monitor because of calibration drifts or errors, the absence of surface reflection influences, and the distortions caused by ambient lighting. For really precise matches (e.g., product color swatches) the monitor image should be considered an approximation prior to generating a hard-copy proof.

The general tonal and saturation relationships within a picture may be satisfactorily evaluated on a calibrated monitor in most cases. The control of ambient lighting is, however, critical; the light source should not shine directly onto the screen, ambient lighting should conform to industry standards, and the screen should be shielded from any other light that may degrade the image to an excessive degree. Naturally, sufficient light should be provided to illuminate the general work area, and provision must be made for adjacent transparency and reflection standard viewing devices.

Exploring creative possibilities. The real-time display of image adjustments encourages the experimental manipulation of colors in order to explore creative possibilities. The fact that the original image remains untouched allows opera-

tors and designers to consider more radical adjustments than was the case with conventional photoengraving and photolithography. If dot values on engravings or film were reduced too far, the job often had to be redone at considerable expense. No such restriction applies to digital retouching as the original image can always be recalled to restore excessive adjustments.

Some image enhancement possibilities such as glossy or textured finish can only be evaluated by generating a hard-copy proof. The rapid manipulation and evaluation cycle afforded by color-monitor-based evaluation will, however, allow quick and inexpensive exploration of most creative possibilities that would normally be contemplated by art directors and designers.

Visual field effect compensation. When two or more images are combined to form a single image element, the color and tonal properties of any one image may influence the desired perception of the other images that make up the composition (see Chapter 5). The effects of this interaction are difficult to predict in advance, therefore, operators usually rely upon a color-monitor display to reveal these effects. A similar effect may be observed when discrete images are combined into a page layout along with such graphic elements at tint panels, type, and other line images. The color and size of such elements will influence the overall perception of the page and the individual interpretation of a given image within the page. This interaction effect is well known in the field of fine art and has been described by Josef Albers (1963) in his book entitled *Interaction of Color*. The strength of the interaction effect depends upon the viewing distance and the size of the image (i.e., the angle of subtense) and may not, therefore, be fully illustrated by a reduced-size monitor display. A full-size hard-copy proof may be required to properly display the effect.

Related Considerations

For flat-color areas, the colorimetric aspects of optimal color reproduction (hue, saturation, and lightness) are the significant properties. For pictorial subjects, the quality of the image is also important. Resolution, sharpness, graininess, and moiré patterns may override colorimetric considerations in the judgment of overall quality. Such other appearance factors as gloss and texture also influence perceived color quality.

Image Structure Factors

A designer will sometimes specify the use of a particularly coarse screen ruling or a special-effect grainy screen when reproducing a given original. The purpose of such a treatment is to attract the viewer or to express a certain creative intent, rather than to reproduce the picture accurately. The following discussion assumes, however, that the objective is to reproduce the picture as naturally as possible. The main image structure elements to be examined are resolution, sharpness, graininess, and interference patterns.

Reproduction quality aspects of resolution concerns the relative importance of fine detail areas within the original and how closely they are reproduced. Soft focus portrait reproductions do not have particularly high resolution requirements. Catalog reproductions of equipment and machinery may, on the other hand, have very high resolution requirements. Fine art and photography books may similarly have high resolution requirements.

Resolution, from the observer's perspective, concerns the visual acuity of the human eye and the viewing distance. More detail may be resolved at close distances than at far distances. Visual acuity declines with age.

Optimum resolution requirements of a reproduction, therefore, are dependent upon the nature of the original and the viewing distance. At one extreme, an original with important fine detail that will be viewed at closer-than-normal reading distances will require a very fine halftone screen ruling. The fineness of the screen ruling is related to the size of the reproduction. If the original is reproduced at a greater scale, the image detail is more widely spaced and coarser screen rulings may be used. Extremely coarse screen rulings are used for billboard posters that are normally viewed at great distances.

Screen ruling fineness, however, is constrained by such printing conditions as ink film thickness, paper smoothness, and the registration variability of the press. As a practical matter, the eye cannot perceive improvements in resolution beyond that achieved with about 250-lpi halftone screen rulings. Stochastic screens will also produce high-resolution reproductions that will equal or exceed the finest practical conventional halftone screens.

Sharpness refers to contrast at the edges of tonal values. If adjacent black-and-white tones contain a narrow band of higher-density black and a narrow band of lower-density white at the boundary, then the division between the two

The influence of size and screen rulings on important picture detail: (top) a 65-lpi screen ruling reproduction that is 2.30 times the size of the other two reproductions; (bottom left) a 150-lpi screen ruling reproduction; (bottom right) a 65-lpi screen ruling reproduction.

The large illustration and the bottom left illustration have the same effective resolution.

Photo courtesy ISO

Increase in apparent sharpness (top) due to image enhancement with an electronic color scanner.

tones appears sharper than adjacent black-and-white areas of uniform density gradients in the boundary region. Color scanners use this principle to enhance the sharpness of color separations electronically. The problem with sharpness adjustment is in knowing how far to sharpen a picture. More sharpness is not necessarily better.

Occasionally, one observes unnaturally sharp reproductions in magazines, postcards, or other printed matter. Excessive sharpness enhancement will also emphasize image graininess. Such outcomes are typically caused by incorrect use of scanner sharpness controls, software adjustments, or incorrect scanning aperture selection.

Research has shown (Kubo et al., 1985) that most observers prefer softer-appearance facial tones (indeed, special soft-focus portrait lenses are made for that purpose) than those with sharp definition. On the other hand, the same observers tend to favor sharper detail in non-facial areas within the same scene. Selective use of USM between individual CMYK color separations can approximate this effect for certain originals. As a consequence of these findings, the following guidelines are suggested: photographs of such natural subjects as landscapes or portraits should not have significant sharpness enhancement; photographs of such industrial or consumer products as machinery or jewelry may be improved by increasing the sharpness; and soft-focus mood photographs may even be improved by reducing the sharpness.

Image sharpness has a considerable influence on the perceived contrast of a reproduction. Ralph Evans (1971) suggests that sharper pictures must have their contrast reduced to obtain the same visual contrast as less sharp pictures. This effect can occur within a single picture: an out of focus area in the background will appear lighter and grayer than a colorimetrically identical area in the sharp portion of the picture.

Optimal sharpness settings will also be influenced by the printing conditions. Low D_{max} reproduction systems (e.g., newspapers) generally use higher sharpness settings for the color separations than higher contrast printing systems.

The nature of the interaction between sharpness, saturation, and contrast (tone reproduction) is not known beyond the general relationships stated by Evans. The tradeoffs of one factor against another will presumably vary according to the original and the printing conditions. In any case, it seems that the only satisfactory method of achieving the optimal balance is through an iterative process. Monitor-based approaches may fail to capture the subtleties of sharpness adjustment; therefore, it may be necessary to generate a number of direct digital proofs for really critical jobs.

Graininess generally refers to the nonuniform distribution of silver grains in photographs. The effect of such a phenomenon is to cause unevenness or mottle in what should be a smooth, even tone. Graininess is not a major problem in complex scenes containing fine detail but becomes more obvious in such large even areas as a blue sky. Some stochastic screens can introduce graininess-like effects in smooth tonal areas.

An example of the excessive graininess that can result when an enlargement is made of a color print original.

For optimal reproduction, graininess should be as low as possible. Unfortunately, nothing can be done to reduce graininess in the original, but elliptical dot screening techniques can be used in the reproduction stages to minimize its increase.

Interference patterns are the final image quality factor that should be considered. These patterns may include moiré, gear streaks, wash marks, and spots. From the color reproduction perspective, **moiré** is the most important of these factors. Moiré is caused by the overlap of halftone screens on different angles. All halftone color reproductions have moiré patterns; in some cases these are more objectionable than in others. Objectionable moiré patterns are most likely to show up in browns, grays, greens, or skin tones. This is due to the use of conventional screen angles (yellow 90°, magenta 75°, and cyan 105°) in conjunction with such press problems as doubling. The objective is to reduce moiré patterns to an absolute minimum.

A further aspect of moiré is the subject moiré that occurs when there is an interaction between a texture or pattern in the original subject and the halftone screen. Changing the scale of the reproduction, angling the original prior to screening, or the use of coarser or finer halftone screens may

reduce subject moiré. In some cases, however, stochastic screens must be used to eliminate such patterns.

The near-random-structure stochastic screen eliminates all kinds of moiré pattern and produces high-resolution reproductions. The drawbacks of stochastic screens include loss of fine image elements in proofing and platemaking processes, increased dot gain on press, and, in some cases, increased graininess in smooth tonal areas.

In practice, image structure quality factors are often traded off against each other to suit the reproduction in question. An increase in ink film thickness, for example, will increase image sharpness at the expense of reducing resolution. The nature of these interactions and tradeoffs has been studied (Field, 1990a) and are presented in the tables on the following page. Prepress modifications to image structure can be made on a case-by-case basis, but the press-related image structure relationships should remain fixed for a given ink/paper/press system. The optimal press setup question was addressed in Chapters 8 and 9. The ideal setup is that producing the most reproducible results.

A number of attempts have been made to quantify aspects of image quality. Ralph Jacobson (1995) has evaluated a number of image quality metrics and concluded that most have not undergone sufficiently rigorous testing to merit general application. The accompanying table links certain physical measures to image attributes. It must be kept in mind, however, that halftone images are fundamentally different from the photographic images upon which most measures are based. In either case, it appears unlikely that

Some physical measures of photographic image quality attributes.

Reprinted with permission from Professor R.E. Jacobson, *The Journal of Photographic Science,* vol. 43, no. 1, 1995

Attribute	Physical Measure
Colour	Chromaticity (CIE 1931 xy, CIE 1960 uv, CIE 1976 u'v', CIE 1976 L*u*v*, CIE 1976 L*a*b*)
Tone (contrast)	Tone reproduction curve, characteristic curve, density, density histogram
Resolution	Resolving power
Sharpness (edges)	Acutance, PSF, LSF, MTF
Noise (graininess, electronic)	Granularity, noise-power (Wiener) spectrum, autocorrelation function

Image definition quality factors that may be adjusted at the printing stage of the photomechanical process (Field, 1990a).

	Requirement	How Achieved	Consequences
Image Sharpness	High	Increase ink feed	Lower resolution; tone reproduction influenced
Halftone Graininess	Low	Modify impression pressure; change ink feed	Depends on direction and magnitude of change
Halftone Mottle	Low	Modify impression pressure; decrease ink feed	Depends on direction and magnitude of change
Ink Film Graininess	Low	Increase impression pressure; increase ink feed	Lower resolution; tone reproduction influenced
Ink Film Mottle	Low	Increase impression pressure; increase ink feed	Lower resolution; tone reproduction influenced
Resolution	High	Reduce ink feed	Lower sharpness; tone reproduction influenced

Image definition quality factors that may be adjusted at the color separation stage of the photomechanical process (Field, 1990a).

	Requirement	How Achieved	Consequences
Graininess	Low	Elliptical dot screen	Less resolution
Moire	Low	Same-angle halftones	Critical register
Resolution	High	Fine screen ruling	Increased graininess
Sharpness	Variable	Scanner intensity and aperture control	Increased graininess; critical register

a single image quality metric that includes all attributes will be developed at any time in the near future. This outlook underscores the importance of color-monitor-based iterative approaches to image quality optimization.

Surface Effect Factors

Surface effects such as gloss and texture influence the perceived quality of the reproduction. These factors are largely related to the substrate selection, but can also be influenced by the inks.

The correct gloss or texture depends upon the nature of the original and the end use requirements of the reproduction; for example, an artist's watercolor drawing does not reproduce well on a high-gloss substrate. The paper selected for such a reproduction should probably be uncoated and have a gloss and texture similar to the original paper that served as a substrate for the drawing.

Increases in substrate (and ink) gloss will reduce surface light scatter, which, in turn, will lead to higher saturation and D_{max} of printed colors, and also to higher image sharpness. Higher gloss will, however, cause objectionable glare. Research by Dalal and Swanton (1996) suggests that optimum gloss levels for xerographic pictorial reproductions are in the intermediate range (60–70%), and that very low or very high gloss levels are clearly not preferred. An overprint varnish is sometimes applied to printed matter to achieve the desired gloss level.

The substrate should also be as smooth as possible for optimal reproduction of smooth tonal areas. Smoother papers also make possible finer screen rulings, and thus, higher resolution. A textured substrate can, however, impart certain tactile qualities to the printed product that may outweigh the advantages of smooth substrates in some circumstances.

Concluding Analysis

The color reproduction objective, which is represented by the set point on the color systems engineering diagram, could be either exact color reproduction or optimum color reproduction. Creative color reproduction may also be an objective, but this lies outside the manufacturing programming objectives of a systems engineering approach.

Optimal color reproduction is the most common objective in printed color reproduction. There are three aspects to this objective: preferred color reproduction, which is the deliberate alteration of colors to make the reproduction more pleasing; corrective color reproduction to remove from the reproduction the unwanted distortions present in the original; and compromise color reproduction in which the gamut and density range of the original are selectively compressed to suit the gamut and density range of the reproduction process.

The process of original tone and color compression to suit the reproduction process range has been the subject of much research. The general recommendations that follow from this research are that the tone range should be selectively com-

pressed to favor the interest area of the picture, and that saturation compression should, in most cases, be applied equally to the hue in question.

The non-color factors that influence color reproduction quality are image structure factors and surface characteristics. The relevant recommendations from the research are: resolution should be high enough to suit the image detail requirements (original detail importance, viewing distance, and reproduction scale); sharpness enhancement should be appropriate to the subject matter and must not exaggerate graininess or otherwise disrupt the naturalness of the image; and, graininess, moiré, and other kinds of interference patterns should be minimized as much as possible. In practice, one image quality factor may have to be traded off against another for optimum results.

The optimal surface characteristics will vary according to the nature of the image. A watercolor drawing should, for example, be printed on an uncoated substrate. Most reproductions of photographs will benefit from a glossy finish, but the gloss should be restricted to medium to avoid excessive glare. Textured substrates may impart effects that will enhance the creative quality of the image or the printed piece.

There are two general, and opposing, strategies for achieving color reproduction objectives: the calibration approach that is based upon careful analysis and programming prior to making the scans, and the iterative approach that relies upon a color-monitor display of the image that is manipulated until it looks right. In practice, both strategies should be used in tandem. The process of careful calibration and analysis will produce very good color separations but, to get the best results, color-monitor-based visual refinements are usually required. A process that relies entirely upon a color-monitor-based approach will, however, be wasteful of system operator time. The general principles of good color reproduction are reasonably well established; therefore, it is only sensible to avoid unnecessary trial-and-error monitor-based manipulations by presetting the obvious requirements for color cast removal, tonal compression, and preferred color representation prior to refining the image via iterative processes.

Higher-fidelity color reproduction is possible if extra colors are used during printing. The best extra colors are those that enhance the color gamut in the areas best suited to the kind of color reproduction in question: pinks and pale blues are

used to overcome the light tone-graying effect of proportionality failure; strong reds, greens, and blues are used to boost the saturation of those solid areas that suffer the effects of additivity failure.

The task of the color separator is to adjust the color separation process to both satisfy the color reproduction objectives of the original and to compensate for the ink/paper/process characteristics of the printing process. The task of the color printer in the process of optimum color reproduction is to first establish the optimum setup and running conditions for a given set of manufacturing variables, and to then keep the process operating as consistently as possible.

12 Color Separation

Color Programming

The color separation step is the pivotal control point in a color reproduction system (Chapter 3). This is the only stage where individual halftone values may be independently adjusted to achieve optimal color reproduction objectives within the constraints of a given set of printing conditions.

Quite apart from the optimal color reproduction requirements of a particular original, and the influence of the printing process, the color separator must also assess the characteristics of the color separation system itself when preparing to make a set of color separations. The separation system factors that influence the nature and quality of the color separations include optical-mechanical design of the scanning system, image recording distortions, image processing compromises, and output recording choices. The color separation challenge, therefore, includes the equipment selection process as well as the knowledge and skills of the operator.

The equipment selection factors will be influenced by economic concerns and the quality requirements of the markets being served (see Chapter 15). The knowledge and skill requirements for color separators have undergone considerable change over the years, so that it is now often possible for relative novices to produce reasonable results after taking a few workshops, completing the relevant tutorials, and gaining some practical experience on a modern scanning system with appropriate software. The higher reaches of the quality market, however, still require operators with considerable knowledge of printing systems and optimum color reproduction requirements, together with the experience to use a given color separation system to achieve the desired results.

Scanner Input Technology

Rotary Drum PMT

The first scanner design principle to be examined is known as the rotary drum scanner or PMT scanner. The rotary drum method is the oldest scanning principle, dating back to the 1937 Murray and Morse scanner patent application. In rotary-drum scanning, the scanning head moves parallel to the axis of the drum, or cylinder, while the cylinder rotates. These combined motions cause the scanning head to sense or scan information in a helical path around the drum.

Normally, the scanning pitch is controlled by a servo motor that governs cylinder rotational speed and scanning head axial motion. As the drum rotates, a radial grating/photocell and light source combination, or a similar sensing device, generates electrical signals, which are fed to a control unit that regulates the speed of a servo motor driving a lead screw. Appropriate software may alternatively be used to achieve speed regulation. Once the scanning head engages the lead screw, it traverses the original at speeds influenced by the scanning pitch. The end of the cylinder's shaft are mounted in ball or needle bearings that are secured in the frame of the scanner.

Scanner drum rotational speed may be as high as 1,200 rpm, and the scanning resolution may exceed 10,000 lines per inch. The precision engineering required to achieve this performance explains much of the price differential between rotary drum and flatbed scanners.

The scanning head of a rotary drum scanner contains a lens (microscope optics are generally used), prisms, mirrors, beam splitters, color separation filters, infrared and ultra-violet absorption filters, and a photomultiplier tube (PMT) for each color separation channel (i.e., three) and (sometimes) the unsharp masking channel. The lens is focused onto the emulsion or surface of the original such that the scanning point is only 0.0005 in. or less in diameter. The scanning point is enlarged, split into three beams, and passed through color separation filters prior to striking the PMT sensors.

A photomultiplier is a type of vacuum-tube photoelectric cell that produces a signal multiplication effect within the cell itself. When light strikes the photoemissive material (the photocathode) a stream of electrons is emitted. The electron stream is directed to a secondary electron-emitting electrode (the "target electrode"), which is maintained at a positive potential with respect to the cathode. The secondary electrons emitted by the target electrode are directed towards another target electrode and so on until the accumulated

The helical path point-by-point scanning principle of the rotary-drum PMT scanner.

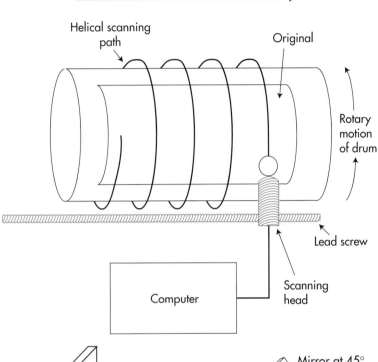

The line-by-line scanning principle of the flatbed CCD scanner.

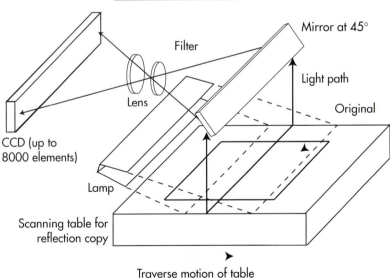

electrons have passed through several stages of amplification. Electrons are finally collected at the photomultiplier's anode. The resulting electrical signal may be amplified still further by appropriate circuits. It is the signal amplification on a point-by-point basis principle that gives PMT-based scanners the ability to handle a high dynamic range (deep shadows in particular).

The final item of interest about the input mechanism of rotary drum scanners is the illuminating light source. Typically, high-intensity quartz halogen or pulsed xenon sources are focused on the original in the area directly under the scanning head. The light source or its optical system should be covered by a UV-absorbing filter in order to avoid the color separation differences that are due to the differing degrees of UV absorption of color transparency films.

Flatbed—CCD

The other scanner design principle is known as the flatbed scanner or CCD scanner. The flatbed principle has been used in conjunction with PMT sensing (the Hardy and Wurzburg experimental design of 1937 and the Hell Colorgraph of the 1950s), and cathode-ray tube scanning (the Crosfield Scanatron of the early 1960s), but this approach did not achieve success until the charge-coupled device (CCD) was used as a sensing device (the 1982 Eikonix scanner was the first to use the flatbed-CCD principle).

Flatbed scanners use a traversing light to sequentially illuminate a band of the transparency or reflection original (the reverse configuration is also used). A system of mirrors directs the reflected or transmitted light through a filter and lens system prior to striking a CCD. In the case of a single-CCD scanner, the original is scanned three times (with a change of filter each time) in order to capture the red, green, and blue color separation signals. Three-CCD systems are also available for capturing the three color separation signals in one pass.

Flatbed and slide (transparency) scanners vary greatly in quality (and price). Some flatbed scanners are able to make x-y direction scanning passes or to make sequential side-to-side passes in order to increase the resolution of the image-capture process. The consumer-market flatbed scanners (some are handheld) usually have lower resolution than those models intended for the professional market.

The charge-coupled device is a semiconductor or solid state device. One layer of a CCD is an array of overlapping metallic electrodes, and another is silicon crystal. The light reflected from or transmitted through the original is recorded by the electrode unit in the following manner: a photon of light strikes an electrode and pairs with an electrode from the silicon, which creates a gap in the crystalline structure of the silicon molecules. The electrons are then conveyed along buried electron-conducting channels within the

device through changing zones of high and low electrical potential. When the electrons reach the end of the channel they enter an output register that moves them in "packets" (one packet per pixel) perpendicularly to their original direction of travel. The technique for moving the electric charge about in this way is called charge coupling. Each element (there may be up to 8,000 in a linear array) in the CCD records a discrete part of the image as an analog signal.

The light source on a flatbed scanner has to illuminate the width of the scanning table or transparency aperture. The quality (color rendering index and evenness) will vary according to the complexity, size, and cost of the scanner.

Scanner Evaluation

The PMT-drum scanner has certain quality advantages over the CCD-flatbed scanner. The PMT scanner will handle longer-density-range originals at a finer resolution than the CCD scanners. The PMT scanner, because of its point-by-point (as opposed to line-by-line), method of analysis produces images that are free from the effects of image flare. The image rays in a PMT scanner are all on-axis of the optical system, unlike those in CCD scanners. Possible lighting unevenness and the influence of lens aberrations on the quality of the image will have a greater effect with CCD-scanned images than those produced on PMT scanners. In practice, however, the influence of optical and lighting effects will not be significant for most originals.

The resolution of the scanning system will become critical when the job requires that small originals (35-mm or smaller transparencies) with very large output requirements (e.g., posters) have to be screened at a fine screen ruling (150 lpi, or finer). Under such circumstances, the job will benefit from the higher-resolution capabilities of the PMT-drum scanner.

Other factors that influence the choice of scanning system are whether rigid originals are supplied, and the size of the original. Flatbed scanners are confined to smaller originals and drum scanners are confined to flexible originals. Digital studio cameras (see Chapter 10) are able to handle both types of original.

A number of books are available with more detail on desktop and prepress equipment and technologies. Two suggested titles are *Understanding Digital Color* by Phil Green (1995) and *Pocket Guide to Digital Prepress* by Frank J. Romano (1996).

Image Capture Distortions

A key requirement of the image capture system (electronic scanner or camera) is to record the image with as few distortions as possible. Distortions, in this sense, refer to visual differences between the original and the reproduction that are due to the influence of the initial recording system. Some image distortions may be corrected at the image processing stage, but this takes time and skill. The primary objective of the image recording stage should be to supply image signals to the next stage of the color separation process that are free of colorimetric and resolution distortions.

The colorimetric distortions that result from the spectral response of the scanner relative to the absorptions of the dyes or pigments in the original are beyond the control of the operator. Similarly, the tonal sampling rate is a characteristic of a particular manufacturer's equipment. Scanning frequency relative to reproduction scale requirements may, to some degree, be controlled by the operator. The degree of control is high for drum scanners and low for hand-held electronic cameras.

It is important to choose electronic scanning and camera systems that are compatible with the image recording quality requirements of the work at hand. Inexpensive systems cannot match the fidelity of high-resolution drum systems when making significant image enlargements.

Colorimetric Distortions

The colorimetric distortion problem concerns the way individual colors in the original are "seen" by the color separation system. In Chapter 4 the problems of metamerism are discussed; that is, where colors appear different to the human eye under different illuminants. The problem of abnormal color vision, where two people perceive the same color differently, is also discussed. The way in which a color separation system sees a color compared to how the human visual system sees the same color can be likened to the phenomena of metamerism and abnormal color vision.

In a color scanner, the response equals the combined effect of the transmission properties of the lenses and condensers, the transmission and reflection properties of the mirrors, the absorption characteristics of the color separation filters, and the spectral response of the photomultipliers or charge-coupled devices.

A further complicating factor in color separation is the fact that the standard viewing conditions are 5000 K, whereas a

color scanner uses a tungsten, xenon, or other non-standard light source.

The key problem in color separation response arises when different types of color transparency films are used, or incompatible dyes or pigments are used for retouching photographs or creating artwork. In these cases it is possible for two colors that appear the same to record differently. The visual relationship between given colors also may be altered by the color separation system; i.e., some colors may shift more than others.

For color transparency films, the major disruptive effect is the cyan dye layer. The red spectral densities may vary considerably in two given films. Because of the poor visual response to near-infrared radiation, the eye may not detect the difference between the two colors, but a color scanner could record the difference and hence distort the color reproduction.

The spectral response of a typical PMT scanner compared to that of the human visual system.

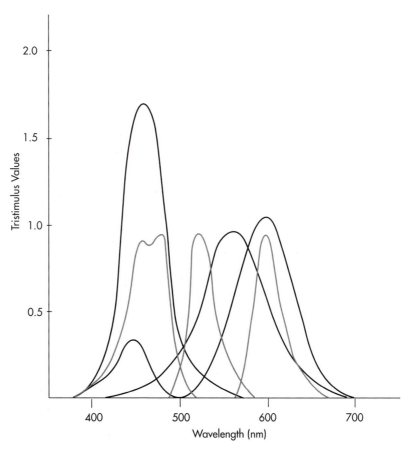

CIE Color Matching Functions for the 1931 2° Standard Observer
Spectral response of a typical PMT-based scanner

The spectral emission curves for (top) 5,000 K light source, (middle) pulsed-xenon lighting, and (bottom) tungsten lighting.

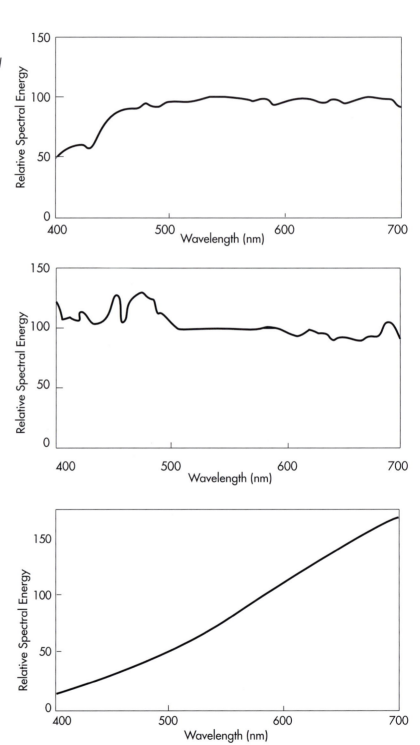

The other effect caused by color transparency films concerns the ultraviolet absorbers in these color films. Given the UV sensitivity of the PMTs or CCDs, a transparency with UV absorbers separates darker than one without. The magnitude of this particular problem may be illustrated by reference to the table where the visual density and the UV density of a series of Kodak films are compared. This problem may be corrected by removing the UV radiation from the illuminant before it reaches the original. For color scanners, the use of a Wratten 2E filter over the light source is recommended. The filter should be periodically replaced.

It is possible to adjust individually for dye set differences on color scanners (e.g., through the IT8.7/1 or IT8.7/2 targets that are used to characterize input sources for use within a color management system). The best way, however, to solve this problem is to use the same brand, type, and speed of color film for the entire job.

It is relatively straightforward to correct for the dye set differences of color transparency (and print) films because all the colors within a transparency are made from the same dye set, which means that colors will separate with the same relationship to each other. Quite different problems arise when separating artist-drawn originals.

An artist may often combine different media on the same piece of artwork. The resultant colors may appear visually correct, but because of the different dyes, pigments, and binders that are used to make up an individual piece of artwork, the separation system may "see" them quite differ-

Comparison of visual and UV highlight densities in processed Kodak transparency films.

	Optical Density	
Process K-12 Films	**Visual**	**UV**
Kodachrome II Film (Daylight) .0.28		0.40
Process K-14 Films		
Kodachrome 25 Film (Daylight)0.24		0.86
Kodachrome 64 Film (Daylight)0.25		0.96
Process K-14 Films		
Ektachrome 64 Professional Film 6117 (Daylight)0.18		1.21
Ektachrome Professional Film 6118 (Tungsten)0.21		0.37
Ektachrome Duplicating Film 61210.28		1.03
Ektachrome 64 Professional Film (Daylight)0.28		1.21
Ektachrome 160 Professional Film 5037 (Tungsten)0.20		0.24
Ektachrome 200 Film (Daylight)0.28		1.16
Ektachrome 160 Film (Tungsten)0.22		0.36

Spectral dye densities of (A) Kodachrome 25 film (daylight) and (B) Kodak Ektachrome 64 professional film (daylight).

A. Normalized dyes to form a visual density of 1.0 for a viewing illuminant of 3200K

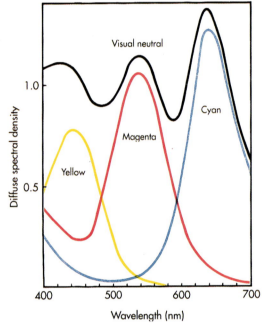

B. Normalized dyes to form a visual density of 1.0 for a viewing illuminant of 5000K

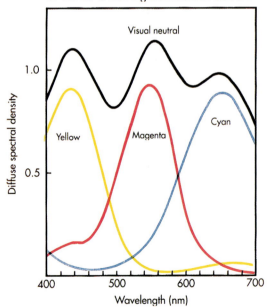

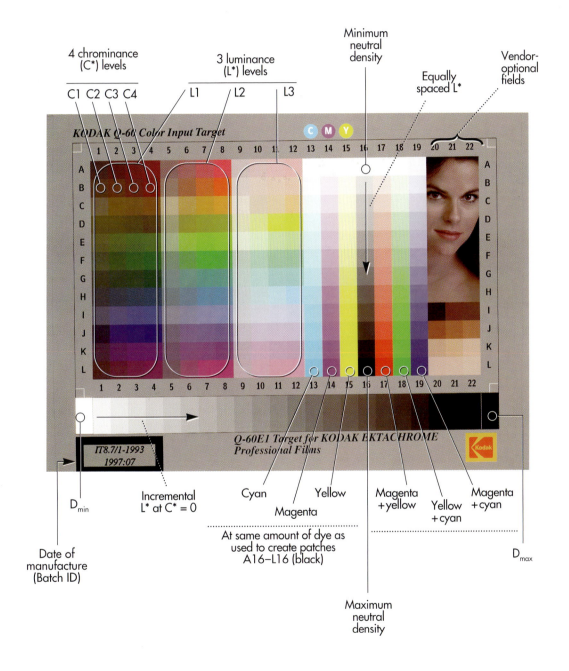

4 chrominance (C*) levels
C1 C2 C3 C4

3 luminance (L*) levels
L1 L2 L3

Minimum neutral density

Equally spaced L*

Vendor-optional fields

KODAK Q-60 Color Input Target

C M Y

Q-60E1 Target for KODAK EKTACHROME Professional Films

IT8.7/1-1993
1997:07

Kodak

Cyan

Magenta

Yellow

Magenta +yellow

Yellow +cyan

Magenta +cyan

At same amount of dye as used to create patches A16–L16 (black)

D_min

Incremental L* at C* = 0

Date of manufacture (Batch ID)

D_max

Maximum neutral density

The general layout of the IT8.7/1 and IT8.7/2 targets that are used to develop source profiles for a given combination of input device (scanner or electronic camera) and photographic material.

Reprinted from The GATF Practical Guide to Color Management *by Richard M. Adams II and Joshua B. Weisberg*

ently. This same effect may be observed when a color transparency or print is retouched with dyes or pigments that are not compatible with the dyes in the photographs.

The problem of color distortion within a piece of artwork or a photograph becomes especially troublesome when materials that fluoresce are used. If the substrate used for artwork preparation, the photographic print, or the transparency material fluoresces, digital alteration of the image files or hand retouching of the separation films are the only ways to correct for this influence. This same solution applies when the retouching dyes or pigments fluoresce.

The influence of fluorescence is often noticed on watercolor or poster color originals where a number of near whites are included. If these near whites have been mixed by using fluorescent pigments, the color in question will record as whiter than white on the color separations. A fluorescent substrate could easily alter the photographic effects of one color relative to another.

One method of detecting fluorescence problems is to view the copy under a black light source. Retouching and other problems become apparent under this illumination if fluorescent compounds have been used. To keep manual correction to a minimum, UV absorbing materials should be placed over the light sources of color separation equipment.

Resolution Distortion

The image resolution or detail recording quality is influenced by the frequency with which image signals are recorded. The segmentation of the image that occurs during electronic scanning or photography is a form of digitization that results, to some degree, in a loss of image detail. Conventional photography, by contrast, forms an image in analog form with no capture-related loss of resolution.

Electronic cameras vary considerably in their image-resolving ability. The coarser-resolution hand-held, area-array systems may record as few as 640 pixels (picture elements) across the long dimension of an image while the finer resolution systems may record over 3,000 pixels across the long dimension of an image. The linear-array studio camera systems may record around 8,000 pixels across the image in some systems.

The image sampling frequency also varies considerably within electronic scanning systems. The PMT-based rotary drum scanners are capable of the highest scanning frequency;

Image detail is lost when the sampling frequency is too low for the reproduction scale: (top) low-frequency scan, (bottom) high-frequency scan.

up to 12,000 lines per inch in the scanning head direction may be achieved by some scanners*. The CCD flatbed or slide scanners are generally limited to about 8,000 scan lines across the image. The scanning frequency for a CCD scanner, therefore, depends upon the size of the original. Small transparency originals may actually record with very high resolution.

**Note: In order to avoid confusion with halftone screen ruling the input scan frequency is often designated in pixels per inch (ppi) rather than lines per inch.*

The term "optical resolution" is used to describe the image capture performance of a scanning system. Interpolation techniques may be used to achieve higher reported resolution specifications, but such "improvements" are not based on actual image detail.

The key issues in scanning frequency are the required degree of enlargement, and the specified screen ruling. Images that undergo significant enlargement must be scanned at a higher frequency than those images that are reproduced at same size or reduced. Fine-screen halftone reproductions require higher input scan resolution than coarse-screen reproductions. A 300-lpi screen reproduction, for example, requires twice the scanning frequency of a 150-lpi screen reproduction.

As a general rule, about 1.5 lines of input scan resolution are required for every row of halftone dots recorded at the output stage, assuming same-size reproduction. Scanning frequency is increased in proportion to the degree of enlargement. If, for example, an original image is enlarged ten times, and the reproduction is printed with a 250-lpi halftone screen, then the required input scan frequency will be 3,750-ppi (10 times enlargement \times 1.5 scan lines per row of dots \times 250-lpi screen ruling = 3,750-ppi input scan frequency).

The size of the original, the size of the reproduction, and the required screen ruling will determine the suitability of the scanning system's resolving power. Modest enlargement, coarse-screen newspaper reproductions, for example, will reproduce satisfactorily on most scanning systems, and also with many electronic camera systems.

Supplied CD-ROM versions of photographic images may be unsuitable for fine screen reproductions that require considerable enlargement. The images should be closely examined before the job is accepted and, if necessary, the original photographic images should be submitted for reproduction.

Image Processing Distortions

The process of converting the color separation signals into digital form, and the subsequent image processing procedures, will influence the color, tonal, and image structure aspects of the color reproduction. The degree of influence is dependent upon the sophistication of the algorithms and the associated power and memory of the computer system. The image processing issue is, essentially, an economic rather than a technical problem. Special-purpose analog computers (with superior precision) proved to be too expensive and diffi-

cult to calibrate than the general-purpose digital computer (with superior accuracy) in common use today.

Digitization

The red, green, and blue image signals captured by either PMT or CCD scanners are in analog form. An analog-to-digital (A/D) converter is used to sample the signals and to express them as a series of discrete tonal steps. An 8-bit (256-step) tonal rendition is common. Finer (e.g., 10-bit or 12-bit) steps may be used for sampling purposes, but the file sizes would be much too large for storage. Unwanted sections of a high-resolution data file are discarded prior to the data-storage and output-recording stages.

A certain amount of tonal information is lost during the digitization process. The resulting tonal resolution is established by the number of steps chosen to represent the image. Eight-bit color, for example, represents 256 tonal steps for each color channel (i.e., red, green, blue). This level of tonal representation is usually quite satisfactory for most applications because the human eye cannot detect more than about 10 million different colors. The 16.7 million ($256{\times}256{\times}256$) colors commonly associated with 8-bit color systems is marketing hyperbole; if the eye cannot detect a color, it does not exist. In fact, for most practical situations, the eye cannot detect more than about 4 million distinct colors (see Chapter 4).

There are, however, occasions when 10- or 12-bit image recording systems may be of value. Most CCD-based scanning systems do not have the same dynamic range as PMT systems; therefore, deep shadow detail may be lost in CCD scans. An 8-bit digital representation of the scanned image will contribute further to loss of tonal distinctions in shadow tones. A 10- or 12-bit record of the tone scale will more faithfully render what tonal detail was captured by the CCD. Important shadow detail may be expanded during the image processing stage if distinct signals exist for the darker tones. PMT-based scanning systems have little need for higher frequency tonal recording systems because their dynamic range is greater than that of any original. There may, however, be some unusual circumstances that would benefit from a high-frequency digital representation that is closer in tonal quality to a particular region of the original analog image.

Image Compression

Digitized scanned images are often compressed for one of three reasons: to reduce storage requirements, to reduce computational time, and to reduce data transmission time.

A review of data compression techniques has been published by Green (1995, pp. 189–194) and the mathematical details have been described by Kang (1997, pp. 177–207).

Data compression may result in an unacceptable loss of definition if excessive amounts are applied. In practice, however, a 5:1 file size reduction ratio may be used in many cases with little perceptual loss of detail. Detail is maintained by selective application of compression within the image file. Areas of busy detail have less compression applied than do large, smooth areas of constant color. A compression routine known as JPEG (Joint Photographic Experts Group) is commonly used to reduce file sizes.

The required degree of compression may be chosen by scanner operators according to the tonal and detail makeup of the original. Some images have properties that will not tolerate any degree of compression.

Image fidelity suffers when excessive data compression rates are used within color image processing systems; (left) high compression image, (right) uncompressed image.

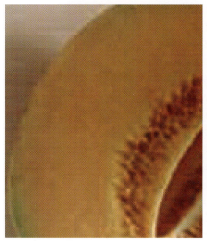
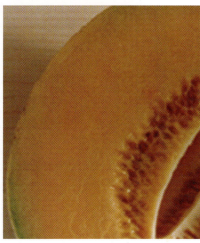

Maximum JPEG compression at 500% enlargement
File size: 130 K

No compression at 500% enlargement
File size: 2.5 MB

Interpolation

Lookup tables (LUTs) are essential elements in digital computer-based image processing systems. There are three aspects of LUT formation and use: packing, extraction, and interpolation.

Packing (or partition) is a process that divides the domain of the source space (e.g., RGB scanner input) and populates it with sample points (e.g., CMYK values) to build the lookup table. The LUT is normally built by an equal-step sampling along each axis of the source space (Kang, 1997, pp. 64–101). In practice, however, many source-to-destination color conversions are nonlinear; therefore, the RGB space is usually scaled according to equal values of L* (the CIELAB lightness dimension) in the destination color space.

Extraction is the process of selecting the points within the LUT that will be required for computing the destination specification of the input point. If the input point coincides with an LUT location, no interpolation is necessary.

Interpolation is the process required to compute the destination values that do not coincide with particular LUT entries. Surrounding values ("lattice points") are chosen (the extraction process) for use in either geometrical (trilinear, prism, pyramid, tetrahedral) or cellular regression interpolation equations.

The quality of the interpolation process is dependent upon the number of entries in the LUT (more is better), the division of color space with the LUT, and the number of terms used within the interpolation equations. The engineers who design such systems seek an appropriate balance between memory size, computation speed (or cost), and the quality (precision) of the color transformation process. In other words, different image processing systems will, because of the interpolation process, produce different output colors.

Color Space Conversion

Conversions of image data between source, destination, monitor, and perceptual color space can cause color distortion. Kang (1997, pp 172–175) reports a color transformation study by R. Rolleston that examined the computational errors due to round-off error, truncation error, and integer and floating point arithmetic. The first part of the study used the Xerox Color Encoding Standard and reportedly produced no change in a conversion from an RGB to a Xerox YES color space and back to RGB. The second part of the study used an 8-bit quantization technique between both the forward and backward transformations. Most of the subsequent color

errors fell between ± 2 ΔE units. The final part of the study used integer lookup tables for the forward and backward transformation. Nearly all of the 16 million test values were mapped back to another location, but over 97% of points still only had a color difference of ± 3 ΔE units. The color errors increased significantly when the RGB values were transformed through CIE XYZ or CIELAB color spaces.

Edge Enhancement

Unsharp masking (USM) is a term derived from photography for a process that was designed to improve the overall apparent sharpness of the final image. The term "unsharp masking" has been adopted to describe the same enhancement technique as applied within electronic scanning and imaging systems.

There are two methods of applying USM within electronic systems: physical and computational. The physical method is exclusive to PMT scanners and is based upon the signal differences that are created by different apertures that cover the separation-signal PMTs and a special USM PMT. The width of the enhanced boundary at an edge, and the magnitude of the enhancement may both be adjusted.

The computational method of edge enhancement is applied to digitized images; i.e., it may be used with either PMT or CCD methods of image capture after the A/D conversion occurs. This method usually involves the analysis of a given picture element and the surrounding tonal value. A weighted average of the surrounding value is computed and applied to the boundary enhancement zone.

The principles of electro-mechanical sharpness control using a drum scanner: signal A (from normal scanning aperture), signal B (from unsharp-masking aperture), and signal C (a composite of signal A plus the voltage differential between signal A and signal B).

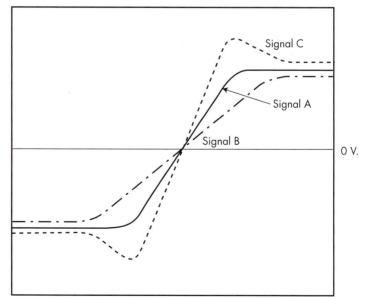

Electronic USM is not true sharpening in the optical sense of that term. It is edge enhancement that, if overdone, may emphasize graininess and also create unnatural image effects.

In general, USM is a positive technique that helps overcome the loss of image sharpness (i.e., density differentials at edges) that is caused by the tonal compression that results from printed D_{max} being lower than the original D_{max}. The optimal sharpness setting may also depend upon the specific shape of the tonal compression curve. This being the case, sharpness adjustments are best applied selectively to the specific tonal region that requires emphasis.

Image Display

Today's color separation systems rely upon color monitor displays for image evaluation prior to generating output film, proofs, or plates. Monitor displays also represent a critical element in the interactive get-the-color-right adjustment process. Such displays are used by operators for making judgments during the image correction and enhancement stages of color image processing and adjustment.

To be effective guides, color monitors must be accurately calibrated and used in a controlled lighting environment. The room lighting conditions for optimum monitor use were discussed in Chapter 5.

Monitor Properties

Monitor properties can vary from manufacturer to manufacturer and, for any given device, can also vary over time. The time-related variation includes the changes that occur during warmup, as well as the long-term drifts that are associated with age. Variability should be monitored by making calibration checks at regular intervals.

Initial brightness and contrast settings should be set to suit the room lighting and associated environmental conditions. Image perception is greatly influenced by these controls; therefore, it is important that ambient room lighting conditions must be constant and that the brightness and contrast settings should not be changed from their initial settings.

In general, most monitors can display a color gamut that mostly exceeds that of the ink/paper/press output system. The most saturated levels of cyan and magenta printed ink films are, however, outside the gamut boundary of most color monitors. The other monitor characteristics that may pose some difficulties when making image evaluations are the white point color temperature (9,300K), the unevenness from

Characterizing Monitors

center-to-corners of the screen, and the system's comparatively low resolution (0.21 mm dot pitch, at best).

A monitor profile must be created if the device is to be used for making color judgments. As part of this process, the monitor is configured to limit the displayed colors to those that may be reproduced by the output device (e.g., ink/paper/press system).

Apart from the brightness and contrast adjustments discussed earlier, the monitor's gamma level and white point color temperature are adjusted via the internal system software. These calibrations are a prerequisite to the profiling activity.

The profiling software initially generates a series of reference color signals that are displayed in turn on the monitor. A spectrophotometer with a feedback connection to the monitor is mounted (via a suction cup) on the screen over the reference color target area. A series of measurements are made from each target color at every 10 nm across the visible spectrum. The resulting measurements are then compared to the reference values that were used to drive the monitor, and the differences are used to establish the profile.

The intermediate color space (CIELAB, for example) is used to translate XYZ tristimulus values of a printed output profiling target into corresponding monitor values. The input original tristimulus values are compressed as needed to lie within the output device's gamut as reproduced by the monitor display.

On-screen spectrophotometers are used as part of the monitor profiling step.

Photo courtesy Light Source Computer Images, Inc.

Output Recording Distortion

The recorded image is that forming the structure of the printed result. The minimum recording spot size does much to establish the quality of the output record (and of the subsequent printed image). The tradeoffs between screen ruling and tonal steps associated with digital image recording techniques are well known (see Blatner and Roth, 1993, for example). The exact structure of the recorded image and its interference with other images (i.e., the other colors) are the other aspects of output recording that involve choices by the system designer or operator.

Resolution Consideration

The nature of the tradeoff between screen ruling and tonal steps may be illustrated by considering a theoretical 5,000-dpi (dots per inch) recording system. If a 10-lpi halftone screen ruling is chosen, the dots will be formed by 500 (i.e., $\frac{1}{10}$ of 5000) recording lines. This means that the halftone dot will be formed by on-and-off laser beam exposures within a 500×500-element grid; i.e., 250,000 separate tone levels are possible. If a 100-lpi halftone screen ruling is considered, then 2500 (50×50-element grid) tonal levels are possible. If a 150-lpi screen ruling is considered, then 1111 (33.3×33.3-element grid) tonal levels are possible. Finally, if a 250-lpi halftone screen ruling is considered, then 400 (20×20) tonal levels are possible. If an image recording system is only capable of recording at 2500 dpi, the theoretical maximum number of tonal steps for each of the screen rulings just considered are:

- 10-lpi screen ruling = 62,500 tone steps
- 100-lpi screen ruling = 625 tone steps
- 150-lpi screen ruling = 278 tone steps
- 250-lpi screen ruling = 100 tone steps

The formation of a 27.8% dot area in a 12×12 digital halftoning system that is restricted to recording 144 distinct tonal steps.

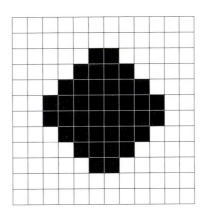

The tone step vs. screen ruling frontiers for recording resolutions of 600, 1,200, 2,400, and 3,600 dots per inch (dpi).

Recording resolution is based upon the desired screen ruling and the required tonal smoothness (144-step maximum usually).

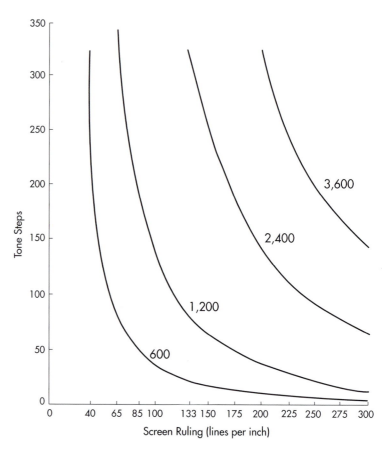

The recording resolution of the output device is a function of the initial specifications rather than a factor that may be increased to any desired level by the operator. The recording resolution performance of an output device must, therefore, be chosen to match the quality level requirements of the color separations.

Image Configuration

The previous section described how a laser beam (or beams) are used to expose or not expose individual elements within a grid structure in order to form a digital halftone image. The halftone screen ruling is adjusted by varying the recording spot size and the number of recording lines (or dots) per inch. The halftone screen is designated as having so many lines per inch (lpi) whereas the recording resolution is usually described in dots per inch (dpi); hence, a halftone image may have a screen ruling of 150 lpi that was formed on an imagesetter having 2,640-dpi recording resolution.

Apart from screen ruling, the other matters of interest concerning the halftone image are screen angle, rosette pat-

pensation for this gain may be incorporated into the color separations.

Black Printer Considerations

A final aspect of output recording choice is the type of black printer that may be selected. Image processing is also influenced by this selection. Black printer choice ranges from the skeleton black to the full scale black.

A skeleton black separation is used to increase the density of dark tonal areas that cannot be satisfactorily reproduced by the chromatic colors alone. Typically, the first printing dot (the 1% dot) of black occurs in the middletone area (equivalent to an original density of about 1.60 in a transparency) of the reproduction. The tone curve of the black is very steep from that point to the deepest shadow region; that is, the black separation tonal values could range from 1% to 100% in the region of the reproduction that extends from middletone to shadow. The maximum black dot value varies according to the density of the deepest shadow; i.e., a low-contrast (foggy day) photograph would require little black, whereas a high-contrast (bright sunshine) photograph would require considerable black in the deeper shadow regions (Clapper, 1964).

A full-scale black separation is one that prints black throughout the entire tone scale in all areas where a combination of yellow, magenta, and cyan would normally be present. The black replaces the "gray component" of the tone. The gray component is a neutral gray that results from removing the smallest of the three chromatic colors together with the corresponding amounts of the other two chromatic colors that are sufficient to form a neutral gray if all three chromatic elements were to be considered. This method of black printer production, today called gray component replacement (GCR), was first described by Yule (1940), but it was not applied to color separation practice until the early 1980s when digital computer-based color computation methods became more common in color scanners.

The process of undercolor removal (UCR), which is a special case of GCR, was applied to industry practices before GCR because practical photographic and analog computer solutions could be formulated for this simpler process. The UCR method of chromatic ink replacement with black is confined to neutral and near-neutral tones, unlike GCR, which occurs in all areas where the three chromatic colors are present.

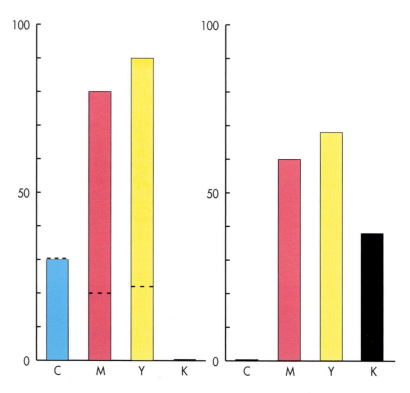

The graphs A and B represent equivalent colors. The dotted lines on graph A correspond to the gray component (30% cyan, 20% magenta, 22% yellow), for the example printing conditions, which is replaced by an equivalent density (0.31) black 38% in graph B.

In practice, the amount of GCR (and UCR) may be varied up to 100%; that is, the point at which one of the three chromatic components is reduced to zero. Theoretically, 100% GCR is the preferred setting.

There are, however, some difficulties associated with using high levels of GCR. When the gray component is replaced in the shadow tone region with the black halftone image, the resulting D_{max} declines to unacceptably low values. The loss of density in shadow tones is overcome by the use of under-color addition (UCA) adjustments when GCR is employed. The UCA technique (Sayanagi, 1987 and Fisch, 1990) adds back yellow, magenta, and cyan dots to those neutral and near-neutral shadow areas that would otherwise be too low in density. In practice, the deepest shadow may be represented by 400% coverage (100% or solid values of each of the four colors) if desired. (See pages 314 and 315 for illustrations of three-color, four-color, and black images produced by normal, GCR, and UCA techniques.)

The key advantages of using GCR, from the quality point of view, are greater stability on press and reduced metamerism effects with variations in viewing conditions. Moiré effects may also be reduced because the tones most susceptible to

patterns are now composed of three rather than four colors. The use of black to replace the equivalent CMY inks will produce a visually equivalent result with the use of less ink. Quite apart from potential cost savings, the reduced ink values may reduce drying problems and improve ink trap.

Black printer selection is usually determined by press requirements or industry specifications. Such specifications as SWOP restrict total ink coverage to 300% (increasing to 325% in small areas), a value that requires the use of GCR/UCR in conjunction with restricted UCA. Gravure printing is not constrained by the wet-on-wet ink transfer problems of lithography (web offset), and has little to gain from imposing the deliberate restrictions on tone reproduction and image sharpness that result from reduced ink coverage. A further consideration in deciding whether to use a skeleton or full-range black is the computational efficiency of the software. Different systems will produce different results from the same original for a given GCR/UCA objective (Field, 1990b, pp. 60–63).

Color Separation Considerations

All of the considerations that have to be addressed when making color separations have now been covered. These considerations, and the general objectives for each are presented below, in no particular order.

Press Feedback Compensation

The tone scale is adjusted to reflect the dot gain for the ink/paper/press combination in question. The tone scales of the yellow, magenta, and cyan color separations are also adjusted to achieve gray balance in a neutral scale. The color correction is adjusted to compensate for the unwanted absorptions of the yellow, magenta, and cyan inks. These component adjustments are discussed in Chapter 9.

If, on the other hand, a color management system (and device profiling) is the method used to characterize the printing system, the output halftone values are automatically adjusted to reflect the subsequent tonal and color characteristics. This integrated approach is discussed in Chapter 3 and Chapter 9.

The screen ruling is chosen to suit the printing conditions. Stochastic dot structure is chosen if two or three extra-high-density inks are being used to print the job. Edge enhancement is selected to counter the sharpness-reducing influence of the ink-substrate combination.

(Left column) Normal color separations with the resulting three-color and four-color combination images and the black separation image.

(Center column) Color separations that have had 100% gray component replacement techniques applied with the resulting three-color and four-color combination images and the black separation image.

(Right column) Color separations that have had 100% undercolor addition applied to compensate for the loss of maximum density when high levels of GCR have been used, with the resulting three-color and four-color combination images and the black separation image.

Normal

Three-color images

Four-color images

Black separations

100% GCR

GCR and 100% UCA

Optimal Color Objectives

The specified interest area of the tone scale is given emphasis during the tone setup process. The saturation compression (the "rendering") is chosen to suit the requirements of the image: colorimetric rendering of gamut boundary colors, or a compression of all saturations (of a particular hue) until the most saturated color lies on the gamut boundary (this latter approach is known as "perceptual rendering"). Adjustment of edge enhancement to meet the image-defined sharpness objectives is selected. Correction of unwanted color distortions and the introduction of preferred color rendering objectives are the other matters also discussed at some length in Chapter 11.

The Original

The color characteristics of the original, as they are modified by the spectral response of the color separation system, may be captured by the source profiling step and incorporated within the color management system. A standard color target on the same type of film as the original is used for calibrating the scanner. This stage is described in Chapter 3 and is also discussed in Chapters 10 and 11.

The reproduction scale requirements (and the compensatory tonal adjustment, if required) are programmed together with the crop or related physical requirements. The scanning resolution is set to suit the reproduction scale and the screen ruling.

The Color Separation System

The color separation and image choice factors are set: screen ruling, recording spot size, dot shape, screen angle, tonal element distribution (i.e., stochastic vs. conventional), GCR/UCR and UCA, black separation requirements, image compression magnitude, and all matters relating to the calibration of the color monitor and the calibration of the output recording system (e.g., imagesetter, plate recording system), direct proofing system, or direct printing system. Most of these issues have been discussed in this chapter and in Chapter 3.

Color Separation Strategies

Two general approaches to color separation have already been described; i.e., the component approach that requires the operator to calibrate individual elements (e.g., tone reproduction) of the reproduction, and the integrative approach that incorporates all the tonal and color properties within an LUT that is optimized by a color management system, and then refined through color monitor adjustments.

Both approaches use calibration techniques; the difference is that the component approach usually requires that the operator conducts individual measurement, analysis, and programming activities, whereas the integrative approach relies greatly on color management software to perform the calibration and characterization tasks. In either case, a color monitor may be used to refine the image and color quality.

There are, despite the best efforts of color and imaging scientists, a number of subjective aspects of the color reproduction process that are beyond the realm of measurement and analysis. The subjective facets of tone and saturation compression, the creative enhancement opportunities that arise, the idiosyncratic differences in color perception between individuals, and the differences in viewing conditions, will all remain mostly resistant to quantification.

If, however, a purely calibration approach to color scanner setup is used, the subjective requirements will have to be marked up on the final proof, thus necessitating a possible color separation remake and a probable reproofing. A similar outcome will result from a purely subjective monitor-guided adjustment approach. The proof will not be sufficiently close to the desired appearance on the monitor, therefore, the separations will have to be remade until the proof reflects the intent of the monitor's image. The key to efficient color separation is to separate the objective requirements from the subjective goals and to apply the calibration and adjustment strategies best suited to each.

Objective Factor Programming

The ink/paper/press feedback characteristics are all objective factors that should be programmed into the color separation system. The gray balance and color correction requirements of a given ink/paper combination, and the dot gain characteristics of a given printing system may be built into the scanner as component based (individual measurement and analysis of each component followed by manual programming or setup) or integrative based (semi-automated measurement and programming with destination profiling software).

The colorimetric distortion that results from the way a scanner records a particular original is an objective factor that may be characterized by a neutral gray scale image on the photographic material in question. The scanner must interpret a visual neutral as a scanned neutral. The source profiling step may be used to develop the corrections that are required to equalize the scanner to the visual response. Care

must be taken, however, not to neutralize or alter the preferred color distortions that have been incorporated into the original via the emulsion selection, exposure, and processing stages. The assumption should be that the original image represents the desired appearance and that the task of the input scan stage is to preserve this appearance and to provide signals to the image processing stage that reflect that objective. There are, however, some occasions where it is desirable to match the original scene; e.g., medical textbooks or clothing catalogs. In these cases, the distorting influence of the photographic material is regarded as negative rather than positive and the input characterization stage is used to correct or neutralize the inherent distortion of the original. In practice, the correction will never be perfect at this stage and will often require the use of localized retouching or adjustment at the monitor image or film stages.

The black printer requirements are calibrated according to industry-wide specifications (e.g., SWOP) or plant practices. The relative percentages of UCR and GCR and their starting points on the tone scale, the maximum percentage ink coverage, and the tonal gradation and other characteristics of the black separation may each be calibrated to established targets. Care must be taken, however, to avoid the unthinking calibration of shadow tones to the same values. In some cases (the misty landscape photograph or the pastel or watercolor sketch) there are no deep shadows and, therefore, there is no need for high levels of black.

The image structure requirements for a particular combination of original and printing conditions are normally objective factors that may be readily programmed. Screen ruling, dot shape, stochastic vs. conventional, and screen angle are all preset on a relatively routine basis.

Such requirements as reproduction scale, image crop, and image rotation are set prior to scanning. A combination of the specified screen ruling and the reproduction scale establishes the input scanning resolution. A tone scale adjustment will be required for significant enlargements or reductions, but there may be subjective aspects to consider when making modifications of this type.

Quite apart from the colorimetric distortions that are related to the scanner's interpretation of the original, there are other aspects of the original that are objective in nature. Undesirable color casts are one such factor. The offending cast may be removed by making adjustments to one or more

of the separation channels; thus achieving a neutral reproduction of tonal areas that should appear neutral. Complementary color correction filters may, alternatively, be placed over the original to neutralize the cast.

The area of just-printable highlight dot is selected to counter the effects of over- or underexposure. In cases of excessive over- or underexposure, some tonal curve corrections will also be required (Maurer, 1972).

The final objective-factor programming requirement is the calibration of the output recording devices (drum plotter, imagesetter, plate recorder, direct proofing system, or printing system) to ensure that a given color separation output value is recorded accurately; i.e., a laser exposure designed to record a 50% tonal value on film should, in fact, produce a 50% tonal value. Calibration tests are run as a routine matter to ensure that drifts in recording devices or photosensitive materials are either corrected or compensated for at the output recording stage.

Jung et al (1992) have described an automated scanner setup procedure that incorporates most of the objective calibration requirements. The scanned image is converted into CIELAB color space and then displayed on a monitor so that the operator may make refinements to the basic setup. This approach frees the operator from routine tasks and allows more time for refining the subjective color factors that cannot be preset by automated analysis.

A number of books are available with more detail on the manual step-by-step scanner setup and color separation production process. Miller and Zaucha's text, *The Color Mac* (1992), is a particularly thorough and well-illustrated guide to many of the objective setup aspects of color separation. Other suggested references that detail the practical aspects of color separation are *Color Separation on the Desktop* by Miles and Donna Southworth (1993), *Understanding Digital Color* by Phil Green (1995), and *Electronic Color Separation* by R.K. Molla (1988). Frank Cost has written (1993) a useful guide for making color separations from PhotoCD input.

Subjective Factor Adjustment The ideal amount of sharpness enhancement depends upon the image content and the printing conditions. There is no satisfactory way to judge the effect of edge enhancement without making a hard copy proof. Image compression is another subjective factor that is dependent upon the nature of the original and is similarly difficult to judge without a proof.

The primary subjective factors of interest, however, are the hue, saturation, and lightness adjustments that are required to establish the desired color. Virtually all aspects of color reproduction involves subjective judgments: the tonal compression that best emphasizes a customer-defined interest area; the saturation compression best suited to the reproduction requirements of particular nongamut original colors; the hue shifts that may be desired following the chosen tone and saturation compressions; the creative alterations that become apparent during the production process; the exact distortion of specific areas to achieve preferred color; the degree of desired color cast or unwanted distortion removal; and the exact adjustment required to compensate for the middletone lightening effects of great enlargements and the middletone darkening effects of great reductions.

A skilled scanner operator is theoretically able to rely upon the color judgments that have been formed by experience to make initial tone curve calibration and color correction adjustments that will achieve many of the desired color outcomes. Tonal compression, saturation compression, preferred color areas, color cast removal, and tonal adjustments due to reproduction scale effects may all be preset to produce results that will be very close to the optimal values. The refinement of color values will be implemented during the iterative proof approval process.

In practice, however, it is usually faster and more accurate to use a color monitor image to evaluate the color reproduction and then provide an aid for making color refinements. Such adjustments make the setup process easier, even for skilled scanner operators. Indeed, there are some adjustments that can only be evaluated by viewing the modified image. It must be borne in mind, however, that monitor images will not capture the surface effect and image structure aspects of the printed sheet and, because of viewing conditions and other constraints, may not fully represent the color appearance of the final result. It is also true, of course, that a photochemical, or even a press proof, may not accurately simulate the ultimate printing conditions. The size of the monitor may also restrict the accurate evaluation of an image. A monitor-sized display will not reflect the tonal perception of an image that will be reproduced at a significantly larger or smaller size. In time, however, scanner and system operators and graphic designers are often able to visualize the final results from the

An enlarged digital image that can be retouched on a pixel-by-pixel basis if desired.

appearance of the color monitor images. The availability of test or sample images together with the associated printed results can help operators to develop an understanding of the production outcomes of monitor images.

There are several ways of adjusting color on a monitor to achieve the desired appearance. Dan Margulis has written (1995, 1996) two books on this subject that should be consulted for full details (and many well-printed illustrations) of his recommended techniques.

Most color adjustments may be implemented by altering the starting and ending points, and the shape of the curves that define the image. Each option has different curves: the RGB approach is composed of the red, green and blue curves that correspond to the separation input signals; the CMYK option is composed of the cyan, magenta, yellow, and black output color separation curves; and the CIELAB color space that has three channels, the L* channel contains the tone scale information, the a* channel the red-green information, and the b* channel the yellow-blue information.

Margulis suggests that most corrections and adjustments for normal originals are best made using CMYK curves, and that L*a*b* color space be used when radical corrections are required to poor quality originals. The L* channel is the best for setting tonal range and also for setting the sharpness objectives.

Curve-based corrections are always preferred over local corrections because they are faster to apply and usually produce more naturally appearing results. There are occasions, however, when local area correction techniques are the only option. Local color corrections are best applied to the electronic files, but in some cases it may be necessary or desirable to make direct modifications to the separation films (Field, 1991).

A color monitor is normally used to help incorporate the subjective requirements of the reproduction into the color separations.

High-Fidelity Color

The best efforts of those making objective and subjective decisions concerning scanner setup are ultimately constrained by the performance of the ink/paper/press system. The output printing step defines the color gamut; it is then the task of the color separator to make the best use of that gamut, relative to the characteristics of the original and the desires of the customer.

Higher-fidelity color may be achieved by adding to the CMYK gamut with extra colors. Typically, extra colors are used to compensate for proportionality failure or additivity failure effects in lithographic printing (see Chapter 9). An investigation of the transformation techniques required for

seven-color printing have been published by Boll (1993), who considered the use of red, green, and blue colors to supplement CMYK inks.

There are, in fact, many approaches to color gamut enhancement other than the use of supplementary red, green, and blue inks. One such method uses orange and green as the supplementary colors, while others use pink and/or pale blue. Theoretical studies by Arthur Ball, that were reported by Leekley et al. (1953), suggested that a yellow, pink, purple, cyan combination would produce a significant color gamut improvement over the standard yellow, magenta, and cyan primaries. He also suggested that a five-color system (yellow, apricot, pink, purple, cyan) provided a near-perfect gamut. A black printer could be applied to either of Ball's four- or five-color systems.

No one set of supplementary inks will always provide the ideal gamut enhancement for any given original. Indeed, there are many cases when the use of extra inks will not produce any useful gamut expansion. Printed color charts that display the gamut of the inks under consideration should be examined to determine what, if any, supplementary colors would benefit the job under consideration. The color gamut gains that are realized when steps are taken to reduce proportionality failure (fine screens) and additivity failure (better ink trap), and to increase density and saturation (overprint varnish or coating), should be fully exploited before using extra colors.

Concluding Analysis

The color separation setup step is the pivotal one in the color reproduction process. It is here where an assessment must be made of all other stages in the process prior to incorporating the effects and influences of those stages into the separation images. The kinds of modifications made during color separation are executed on electronic color scanning and imaging systems. These systems place almost infinitely variable control into the hands of the color separator. The key to getting the most out of this control is to understand and measure the color influences at all stages, and then, to the extent that it is possible, preprogram the compensations or adjustments into the system prior to using the color monitor display to make the final refinements.

One set of information that is required for color separation optimization is the interaction between the image and the color separation system itself. The influence of such

distortions at the image recording, image processing and image recording stages must be measured and neutralized, to the extent that is possible. The influence of the optical-mechanical design of the scanner will also affect the quality of the color separation, but this is a factor to consider when purchasing a scanner rather than a factor that may be modified during the making of the color separations.

Quite apart from dealing with the effects of the scanning and image processing systems on the color separations, the operator must also incorporate the influences of the printing system, the original, the research findings on optimal color reproduction and the specific instructions of the customer into the output files, films, plates, proofs, or printed images. These goals have objective and subjective components that are addressed by a combination of calibration (system programming from measured data), and adjustment (color monitor-guided visual manipulation) strategies.

13 Color Proofing

Purpose of the Proof

The basic purpose of color proofing* is to ensure that the color separation images will produce the desired result when they are printed in color. Even if the separation images satisfy all the tone, color, and image quality requirements that were discussed in Chapters 11 and 12, it will still be difficult to visualize the printed appearance without a proof. This is especially true when there is an assembled juxtaposition of pictures, tint panels, type, and logos that combine to create a new image of unknown appeal. The proof provides the assurance of visual confirmation of the design decisions. Graphs, numbers, and control charts are sadly lacking when it comes to providing the feel, texture, color, size, and overall visual impact of a well-made proof. Proofs are also used as guides within the production process, and as part of the print buying documentation process.

Predicting Printing

In order for the proof to be effective, it must accurately simulate the printed image produced by the subsequent printing conditions. The proof that "looks good" but does not convey how the actual printed job will appear is useless. The proof is actually the prototype for the main production run, and as such, has similar requirements to prototypes for any other manufactured product. This means that the perfect proof actually would be printed on the same press with the same plates, inks, and substrate as those specified for the final job. There may be some rare instances when this happens, but in general it is not practical to go to this extreme to produce satisfactory proofs.

*Proof is a noun of which prove is the verb form; therefore, this activity should be called color proving rather color proofing. The term "proofing" has, however, achieved widespread usage in the printing industry.

Production Target

Another use of proofs is to provide a guide for the production of the job. The OK proof becomes the target for the press operator during the makeready process. Proof and press sheet test images are measured and analyzed prior to making process adjustments during press setup or makeready.

The proof also serves as an internal guide for the color separator. Proofs provide helpful feedback to scanner operators concerning the actual effect of global tone and color adjustments. Another use of the proof in the color separation department is as a guide for local color adjustment. In these cases, the operator is better able to judge the effect of image size, detail, and surround colors on the actual color that is being modified.

Legal Documentation

The third use of a proof is as a legal document or contract. (The term "contract proof" is often used to describe the proof submitted to a customer for final approval.) The customer's OK on a proof is an approval of the appearance of the proof. The related question of whether this OK also constitutes approval of the color separations that made the proof is less clear. The customer, in approving the proof, makes the implicit assumption that he or she will expect the actual printed job to appear the same as the proof. This can happen only if the color separations have been made to suit the printing conditions, or if the printing conditions are selected to suit those that the separations were made to match.

At the center of this circular reasoning stands the proof. If the proof has been made to match the production conditions, then all is well. Problems arise when the production conditions have to be selected or adjusted to match the proof. If the price of the printing has been quoted based upon the use of paper and inks of lower grade to those used for the proof, nothing the printer can do will make the printed job match the proof. The customer, who has a certain responsibility in this tangled web, must either (a) inform the color separator of the printing production conditions for the job and specify that the proofs be a reasonable facsimile of the results obtainable from these conditions; or (b) allow the printer to use the same materials that were used to produce the proof, or, if lower-grade materials are specified, not expect the printer to achieve the same quality as the proof. If the printer knowingly submits a bid for printing that uses lower-grade ink and paper than that used for the proof, then the printer has

the responsibility of informing the customer that the printed product may not match the proof. If the printer sees the proof before submitting a bid that specifies the same ink and paper as the proof, then there is an implicit understanding that the printer can match the production run to the proof. For their own protection, printers should insist that such color bars as the GATF SWOP Proofing Bar or one of the GCA/GATF Proof Comparators be included on the proof.

If the printer is asked to submit a bid before the proofs are made, and if the color separators are not told what materials or conditions they should use to make the proof, then all the printer can do is give a "best-faith" effort. The customer should not be surprised if the printed results are not exactly what was expected. In cases when it is impossible for the proofing conditions to match the printing conditions (a heat-set web offset press, for example), the expectation is that the proof will represent only a reasonable approximation of the printed job.

The Mistaken Purpose

There is one thing a proof is not—it is not a record of what is on the film. The only conditions for which this can be considered a reasonable objective is for position, spots, and other mechanical characteristics of the image. This attitude should not be applied to tone or color appearance. Some separators may have the mistaken belief that the color separation films are an end in their own right and that the proof must capture the tonal values of the separations as precisely as possible. If so, the objective on the part of the printer now becomes that of matching the proof, which the separator says is "not my problem." Some press proofs that are produced by separators are almost handcrafted, a far cry from the mass-production printing technology that must be used to produce the job economically and quickly. The separation films are, of course, merely a means to an end. The color printing industry can prosper only if the final printed product is produced within the time, cost, and quality requirements of the customer. The printed product is the ultimate purchase of the general public; therefore, all of the preceding steps should be executed with the sole intent of maximizing the quality and minimizing the cost of this end product. The proofs-must-match-the-film mentality is misguided. The correct attitude is that the proofs must simulate the final printed result.

Proof Terminology

Press proofs were the sole method for evaluating color separations during the first 50 years of the photomechanical color reproduction era. Prepress photochemical proofs were introduced during the 1950s, and were in turn followed by electronic proofs in the 1970s and direct digital hard copy proofs in the 1980s. The resulting mix of proofing systems has frequently been described within the industry by confusing and sometimes misleading terms. The newer proofing systems have their own descriptive terminology that has, to a large degree, been developed for marketing purposes. The following descriptions of terms are based upon technical distinctions between various systems.

Digital and Analog Proofs

Digital proofs, broadly defined, are those produced from a digital database. In fact, virtually all proofs fit into this category and have done so since the mid 1970s. The laser screening scanning systems of that era used digital computer systems to structure halftone dots as a series of discrete tonal steps. The shift to all-digital images occurred during the early 1980s when the imaging system workstations that permitted the assembly of all image tonal elements started to dominate the industry.

Today, all printed and proof images have a digital structure. Halftone analog images (which are defined as halftone

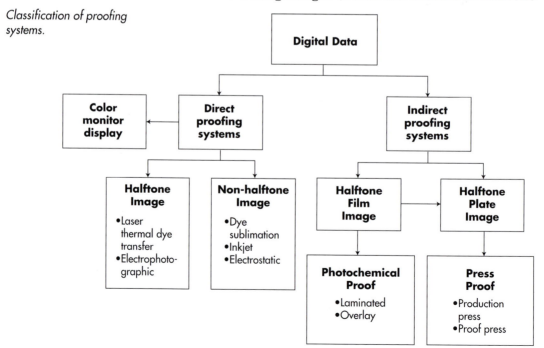

Classification of proofing systems.

images with an infinite number of steps between 0% and 100%) ceased to exist from the late 1970s onward. In fact, the terms "digital color," "digital printing," or "digital proofs" may be simplified by omitting the redundant word "digital." The term "digital" is often used in a marketing context to imply "better." Digital images may indeed be preferred from a production repeatability point of view, but the reality is that analog images have more tonal values than digital images and, therefore, may possess higher quality.

Such images as continuous tone photographs, collotype printing, conventional gravure (infinitely variable cell depth between the limiting values), and television screen images, are all examples of analog images. If we put aside the notion that all halftone images, with their ink or no-ink structures, are per se binary or digital images, then the aforementioned stepless halftone dot structures (pre 1970s) may also be classified as analog images.

Analog images have a continuously variable structure. Continuous-tone images certainly cannot be produced by high-gamma photochemical proofing systems; therefore, analog proofs do not exist except for those that may be produced as continuous-tone silver-halide prints or as continuously variable color monitor images.

Direct and Indirect Proofs

Direct proofs are those produced directly from a digital database without the use of intermediate films or plates. Indirect proofs are those produced indirectly from a digital database via intermediate films, plates, or both. The two broad classes of common proof are, therefore, direct digital and indirect digital. The word "digital" is usually redundant, so the two kinds of color proofs are known as direct or indirect.

Soft and Hard Proofs

A soft proof is the intangible image displayed on a color monitor. A soft proof is derived from digital image data, but has an analog structure on the screen. The electron stream intensity which determines the red, green, and blue image element brightness levels, may be infinitely varied between the limits.

A hard proof is a tangible image consisting of colorants on a substrate. Hard proofs are evaluated by reflected light, and normally have a digital structure (this is not necessarily the case for gravure press proofs). Hard proofs are the only types of proof suitable for contractual purposes.

Halftone Proofs A halftone proof is one that has a halftone dot structure. All indirect proofs have a halftone image structure, but only some direct proofs do. A halftone structure more closely simulates the resolution of the printed image and helps to provide a reliable indication of subject moiré and other kinds of halftone patterns.

Applications Terminology Proof terms based upon applications, rather than technology, are: contract proof, a final proof submitted to a customer for approval; scatter (or random) proof, an assembly of unrelated images on the same proof sheet; position (or register) proof, a large proof of the entire plate layout for checking the position and fit of image elements; design proofs, low-resolution images intended for displaying the approximate visual relationship between the design elements; and, iterative or intermediate proofs, accurate images used for the evaluation of color separation quality during the production process.

Proof Technology Evaluation

Many kinds of imaging technology have been developed for use in direct and indirect color proofing systems. Each technology imposes a characteristic image structure on the proof that influences its usefulness. In practice, however, all systems have found applications, and virtually all organizations that produce color separations use two or more proofing systems. System choice is based upon an evaluation of a number of factors, the importance of which will vary from company to company.

Direct Proofs (Soft) Electronic or soft proofs are generated directly from digital data and displayed in analog form on a color monitor. These proof images are called soft because unlike all other kinds of proofs (i.e., hard proofs), they do not exist as a tangible object. Electronic or soft proofs are also referred to as real time proofs because they can be formed almost at the same instant that the original image is scanned, or that a modification is made to the image data.

Electronic proofing devices are the color monitors that form an indispensable component of image processing systems. The monitor displays a color image that simulates the color properties of the printed sheet. The surface characteristics and image structure of the printed sheet cannot, however, be satisfactorily simulated on a color monitor

Electronic proof considerations. The major advantages and disadvantages of this kind of proof are very distinct. On the advantage side, the ability to interactively generate a color display before separations are exposed is significant. This aid to color correction, tone reproduction, and retouching judgment has revolutionized operator selection and training, output quality, and production time.

Although the electronic proof is unsurpassed as a color separation production aid, it is system-dependent, not permanent, and not portable. A related consideration with this kind of image is that it is formed by a self-luminous source and often displayed under ill-defined room light conditions. It is difficult to adjust the lighting for the satisfactory comparison of self-luminous monitor images and printed images, which are evaluated by reflected light.

Direct Proofs (Hard)

There are several forms of hard direct color proofs (also known as direct digital color proofs, or DDCP). These types of direct proofs use a form of image recording technology that is driven by a computer system and based upon image data files. In many cases, these proofs may be produced on the substrate used for printing the job. The basic systems are:

Thermal dye transfer. A pigmented ribbon or dyed layer of thin plastic foil is transported over a printhead that consists of a row of variably-heated elements. The temperature of each element in the printhead is driven by the image data. The heat releases a proportional amount of dye or pigment from its carrier and causes an image to be deposited onto a substrate. The image is built up line-by-line, one color at a time. The recording resolution of dye sublimation proofs is usually 300 lines per inch and is of sufficient quality that this technology is often used for producing prints from digital camera images.

Ink jet. A liquid or vaporized wax colorant system is used to selectively image a substrate on a line-by-line and color-by-color basis. The print command systems are usually based upon electrostatic deflection systems working in conjunction with a series of fine print nozzles. The image structure of such systems approximates that of a moderate photographic grain. Neither ink jet nor thermal dye transfer systems are capable of recording halftone dot images.

A 10× enlargement showing the image structure of three types of direct proofing systems: (A) dye sublimation, (B) inkjet, (C) laser thermal dye transfer.

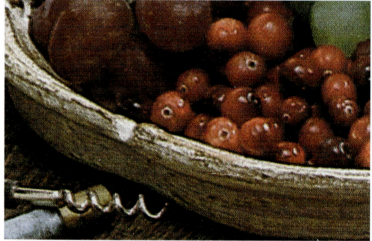

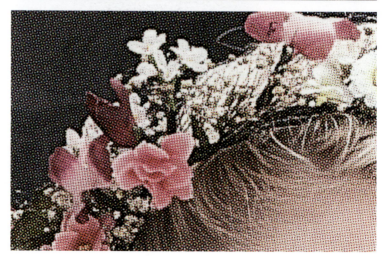

(Left column) Normal color separations with the resulting three-color and four-color combination images and the black separation image.

(Center column) Color separations that have had 100% gray component replacement techniques applied with the resulting three-color and four-color combination images and the black separation image.

(Right column) Color separations that have had 100% undercolor addition applied to compensate for the loss of maximum density when high levels of GCR have been used, with the resulting three-color and four-color combination images and the black separation image.

Normal

Three-color images

Four-color images

Black separations

patterns are now composed of three rather than four colors. The use of black to replace the equivalent CMY inks will produce a visually equivalent result with the use of less ink. Quite apart from potential cost savings, the reduced ink values may reduce drying problems and improve ink trap.

Black printer selection is usually determined by press requirements or industry specifications. Such specifications as SWOP restrict total ink coverage to 300% (increasing to 325% in small areas), a value that requires the use of GCR/UCR in conjunction with restricted UCA. Gravure printing is not constrained by the wet-on-wet ink transfer problems of lithography (web offset), and has little to gain from imposing the deliberate restrictions on tone reproduction and image sharpness that result from reduced ink coverage. A further consideration in deciding whether to use a skeleton or full-range black is the computational efficiency of the software. Different systems will produce different results from the same original for a given GCR/UCA objective (Field, 1990b, pp. 60–63).

Color Separation Considerations

All of the considerations that have to be addressed when making color separations have now been covered. These considerations, and the general objectives for each are presented below, in no particular order.

Press Feedback Compensation

The tone scale is adjusted to reflect the dot gain for the ink/paper/press combination in question. The tone scales of the yellow, magenta, and cyan color separations are also adjusted to achieve gray balance in a neutral scale. The color correction is adjusted to compensate for the unwanted absorptions of the yellow, magenta, and cyan inks. These component adjustments are discussed in Chapter 9.

If, on the other hand, a color management system (and device profiling) is the method used to characterize the printing system, the output halftone values are automatically adjusted to reflect the subsequent tonal and color characteristics. This integrated approach is discussed in Chapter 3 and Chapter 9.

The screen ruling is chosen to suit the printing conditions. Stochastic dot structure is chosen if two or three extra-high-density inks are being used to print the job. Edge enhancement is selected to counter the sharpness-reducing influence of the ink-substrate combination.

Electrophotography. A series of laser beams are used to selectively discharge the nonimage areas on an electrostatically charged photoconductive surface. Toner particles are attracted to the remaining charged areas to form the image. Each colorant layer is exposed and formed sequentially prior to transferring all four colorants to a substrate, which is then heated to fuse the toner particles.

Laser thermal transfer. The heat from a series of laser beams is used to selectively transfer an image from a donor film coated with a colorant onto a carrier sheet. The basic process is repeated until all four process-color images are on the carrier. The assembled images are then transferred by pressure from the carrier to a substrate. The laser thermal transfer and electrophotographic systems may be used to record halftone images.

Silver halide. Conventional silver halide photographic paper could be used to generate halftone or continuous-tone (analog) images. The first direct hard-copy proofing systems (1983) were based upon this technology.

Direct hard proof considerations. Regardless of the direct proof form, most have similar advantages and disadvantages. The major advantage of direct color proofing systems is based upon their independence from the imaging commands used to expose the film or plate image. This independence makes it possible to produce a proof that incorporates the dot gain, trapping, and solid primary color characteristics that will appear on the final printed sheet. In other words, two sets of color separation images are derived from the database: one used for exposing the film or plate

Flowchart of the direct digital proofing process and its relationship to the printing process.

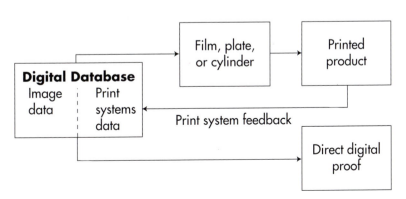

that contains an allowance for press dot gain, and the other, used for generating the proof, simulates the effects of the printing press gain. Quite apart from the tonal transfer curves, the colorimetric qualities of the ink-substrate solid and the ink film overlaps (ink trap) may also be simulated by a direct proofing system.

A key distinction between indirect proofs and direct proofs is the general inability of the latter systems to produce halftone images (some direct systems can produce halftone images). There are two reasons why it may be important for proofs to contain a halftone dot structure: to accurately depict image resolution, and to accurately predict moiré patterns.

Printed halftone images may be produced in screen rulings ranging from below 100 to above 300 lines per inch. Image resolution is further influenced by the fact that each color is screened on a different angle. A single-resolution direct proofing system may, therefore, under- or overdisplay image detail relative to that on the final print.

Moiré patterns are always present in multicolor halftone printing. Most of the moiré is unobjectionable, but sometimes pattern problems that demand corrective action prior to printing will be revealed in a proof. The occurrence of "subject moiré" in particular, can only be predicted by a halftone proof. Subject moiré occurs when there is an interaction between the halftone screen and a fabric pattern or similar periodic structure in the original subject or image.

The suitability of non-halftone structure proofs will depend on both the nature of the subject being reproduced and the screening process that will be used for the job. The non-halftone structure proofs seem to be suitable for stochastic (random) screening systems and subjects or originals that do not contain strongly patterned objects. Leaving aside the resolution and moiré issues, the tonal and color structures of different proofing systems are irrelevant as long as all evaluations and color matches are always made under standard viewing conditions.

Indirect Proofs Indirect proofs (also known as indirect digital color proofs) fall into two main categories: photochemical proofs and press proofs. All indirect proofs are produced from an intermediate image that, in turn, was produced directly from the digital data files. Photochemical proofs are exposed from color separation films that were generated by the digital imaging system. Press proofs are made from plates (or cylinders for

gravure) that are produced directly from the imaging system, or via a film image that was produced directly from the imaging system.

Photochemical proofs. Overlay proofs, or multilayer proofs, are made directly from the color separation films onto individual photosensitive transparent colored films. Each colored film is registered to the others and backed by a sheet of white paper. The resulting proof is viewed by reflected light. The color of the overlay material is preestablished by the manufacturer. The colors closely match most commercially available process inks.

These proofs have several advantages. They do not require any special equipment to make them other than that normally found in a plant's platemaking department. They are also quick to make; 15 minutes or less are all that is required. If necessary, one of the four individual layers could be remade without remaking the others. The major drawback of these proofs is that they do not simulate tone and color as accurately as do other systems. Their primary use is usually confined to register, position, and layout evaluation.

The transfer, or laminated, proof is a development of the overlay proof technology. Like overlay proofs, laminated proofs often consist of photosensitive transparent colored films. Unlike the overlay films, these materials have a release layer between the colored layer and the clear base. The color images are sequentially transferred to a white base material during the processing stage. In one process, a sticky, clear image is transferred to the base. The color is obtained by wiping toners across the sticky image. The advantage of this latter process is that it can be customized to the printing ink color by blending toners and by varying the number of wipe strokes until the correct hue and density have been achieved.

Transfer proof considerations. In some cases, the base support for this kind of proof can be the same substrate that will be used for the pressrun. Another advantage is that the feel and look of this kind of proof is much closer to the printed image than overlay proofs. A reasonable simulation of press dot gain may be achieved by laminating a clear spacer sheet to the substrate before laminating the actual images. A key advantage of all photochemical proofs is their consistency. Exposure is the major variable; therefore, if good

vacuum is obtained and exposure time and light intensity are controlled, consistency is almost assured. The toner application system for some transfer proofs can be applied by machine, thus rendering this process more consistent.

The disadvantages with the transfer proofs include the comparatively lengthy time (about 25 minutes) to make the proof, the cost of laminating and toning machines, and in some cases, the unrealistically high gloss of the proof. Using a matte finish final lamination on the proof overcomes the high-gloss problem. The cost of materials used for both kinds of photo-chemical proofing tends to be high. A final drawback is that these materials cannot simulate four-color press trapping.

In general, transfer or laminated proofs offer a reasonable alternative to press proofs. If they are made with the proper colorants, substrate, dot gain simulation, and surface finish, they are fair guides for the printer and the customer to judge the expected appearance of the future printed sheet. Their relatively low cost and high levels of consistency will continue to convince more and more people that these proofs are sensible alternatives to press proofs. Unusual or extreme printing conditions, however, will continue to require the flexibility afforded by press proofing.

Press proofs. Press proofs are those made with ink and paper using a proof or production press. Presses that are designed specifically for proofing are generally flatbed single-color machines. Rotary presses have also been designed specifically for proofing purposes, some of which are webfed. Four-color production presses are often used for making proofs. These presses are occasionally specially modified to cope with the stop-start nature of proofing, rather than the long runs of production.

Press proof considerations. The major reason for using press proofs has been that they are more likely to be an accurate simulation of the press result than other proofing methods. This point is probably quite true if, say, a litho sheetfed job is proofed on a four-color press that is similar to that used for the production run. For other situations, the argument for press proofs is less compelling.

Virtually all four-color process printing is printed on at least a four-color press. Five- and six-color presses are increasingly being used for color printing. This means that press proofs produced on anything less than a four-color

press will probably not match the ultimate four-color press result because of ink trap differences.

Problems also occur when trying to simulate the performance of a four-color web offset press with a four-color sheetfed press. The inks and papers used for heatset web printing cannot be used on a sheetfed press; therefore, sheetfed inks and papers that have similar appearance properties to the web offset counterparts must be used. Another problem is the difference in gloss between heatset inks and sheetfed inks. The major problems arise, however, when trying to match the printing characteristics of the sheetfed press to the web press. The key problem is to match the dot gain of the proof to that of the production press.

Dot gain may be increased on a sheetfed press by using lower pigment concentration inks, overpacking the press, and employing conventional, as opposed to compressible, offset blankets. The high speeds of web offset printing, the blanket-to-blanket printing configuration, and the particular properties of the web paper and inks may, however, all contribute to a different dot gain function than that which can be produced on a sheetfed press. Indeed, because the printing process—and in particular the lithographic printing process—is so complex, it is sometimes difficult to exactly match two four-color sheetfed results.

Apart from producing a proof with the look and feel of the production job, there are other advantages suggested for the press proof. One valid reason for producing press proofs applies when a large number of proofs are required. A proof for an advertisement that is going to appear in many magazines that are each printed at many sites could probably be produced more cheaply and quickly as a press proof.

The major drawbacks to press proofs are their cost and the time it takes to produce a proof. The cost of a four-color sheetfed press proof can be very high and is in no way offset by the inexpensive paper and ink that are used to produce the proof. In practice, press proofs represent a low proportion of total proofing volume.

Press proofs are, however, produced on a more routine basis in the gravure industry. The gravure cylinder that is used for proofing purposes is also used as the production cylinder. Given that gravure cylinders may be retouched after proofing, and given the relative simplicity of producing gravure proofs, there are compelling reasons for making a press proof. Most gravure pressruns are extremely long;

therefore, the cost of making a press proof can be spread over many copies of the final product. Special proof presses, rather than production presses, are generally used for gravure proofing.

Selecting a Proofing System

There is no universal proofing system that is perfect for every application. In fact, a company may use two or more systems in order to satisfy the many demands expressed in the need for proof images. Proofing, more so than most other stages of color reproduction, requires the blend of technical, financial, production, and human factors into the selection of a given system. Listed below are important selection criteria.

Accuracy. The requirement for accuracy rates very high. A proofing system that is incapable of providing a reasonably close simulation of the printing conditions is not very useful.

Consistency. Consistency is an important feature of a proofing system. The need to be able to make proofs that have the same properties day after day is the reason many people prefer photochemical proofs over press proofs.

Financial factors. The cost of materials, the time taken to make the proof, and the investment in the proofing equipment must all be considered. Press proofs require expensive equipment; however, this may be partially offset if a large number of jobs can be ganged on the same plates.

Production factors. The time required to produce a proof ranges from a matter of seconds for an electronic or soft proof, to as much as several hours for a press proof. The workflow and color judgment requirements must be considered when making tradeoffs between rapid proof production and accuracy of results.

Compatibility. Direct proofing devices must be compatible with the other elements in an electronic prepress production system.

Customer acceptability. Some customers, especially advertising agencies, insist upon press proofs. Other customers refuse to accept proofs that do not have a halftone structure.

Familiarity. Some people prefer a given type of proof because they know how to read the proof; that is, after years of use they are adept at mentally adjusting the proof image to the ultimate printed image.

Matching Proofs and Press Sheets

The results of GATF color surveys were presented in Chapter 7. These and similar studies make it obvious that different printing companies use different inks, substrates and printing techniques. Given that the purpose of a proof is to simulate printing production conditions, we now need to know how to evaluate the available proofing systems so that they may be either selected or adapted to suit the printing conditions of a given plant. In such other cases as where standards exist for a particular type of printed product, we need to know how to match that standard with the proofing system or systems that are available. In yet other cases, it may be necessary to match a press sheet to a proof standard. The key to these challenges is the development of appropriate analytical techniques and control devices or images.

Analytical Techniques for Proof Matching

Several analytical techniques may be chosen to assist the proof-press sheet matching process. Densitometric analysis may be used in those cases where the proof and press colorants are spectrally similar. Spectrocolorimeters should be used in other circumstances.

Densitometric analysis of solids and overprints may be used in conjunction with the GATF Color Hexagon (Cox, 1969). The initial data collection is made by measuring the cyan, magenta, and yellow primaries, and the blue, green, and red overprint solids, each through the red, green, and blue filters of a reflection densitometer.

The GATF Color Hexagon is a form of trilinear graph paper. Each grid direction represents either the red, green, or blue filter data. Starting in the center, the color is plotted by moving sequentially in three directions by amounts corresponding to the respective blue, green, and red densities. The process may be simplified by subtracting the lowest filter density from the other two and to then move in two directions only. The procedure is repeated for the other colors and the six data points are connected by straight lines.

The halftone dot areas of target areas on the proof and press sheet are measured and recorded in tabular form. The print contrast ratios are similarly computed and recorded.

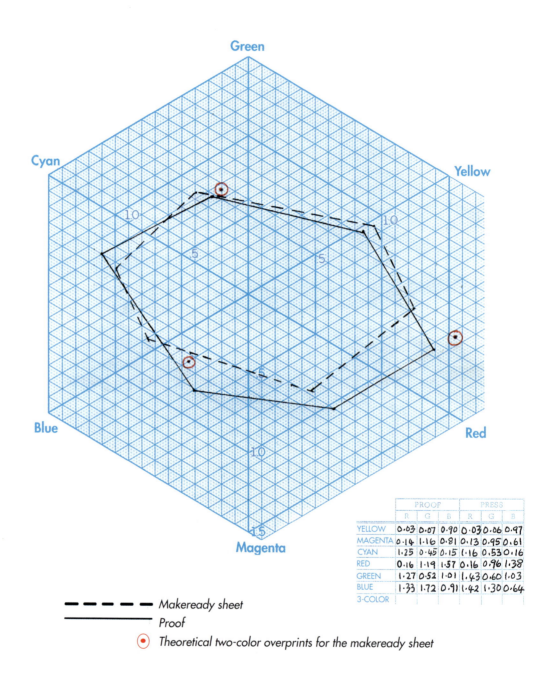

	PROOF			PRESS		
	R	G	B	R	G	B
YELLOW	0.03	0.07	0.90	0.03	0.06	0.97
MAGENTA	0.14	1.16	0.81	0.13	0.95	0.61
CYAN	1.25	0.45	0.15	1.16	0.53	0.16
RED	0.16	1.19	1.57	0.16	0.96	1.38
GREEN	1.27	0.52	1.01	1.43	0.60	1.03
BLUE	1.33	1.72	0.91	1.42	1.30	0.64
3-COLOR						

– – – – – *Makeready sheet*

———— *Proof*

⊙ *Theoretical two-color overprints for the makeready sheet*

The proof and press sheet hexagon plots reveal the following: cyan and magenta densities should be increased and yellow density should be decreased (all for the makeready sheet); two-color overprint trap is poor (especially for the red).

The hexagon display and the halftone dot data are used to guide the adjustment process. The primary adjustment variable is the solid primary density (i.e., the ink film thickness). If the density of one primary is increased, the hexagon plot for that point will move further away from the center, and the plots of the two overprint colors that contain that primary will shift in hue towards that primary (i.e., the red and green overprints are influenced by changes in the yellow primary). An increase in the density of the primary will also increase the dot gain of that color and of the corresponding overprint halftones.

A number of commercial measurement and plotting systems that are based upon scanning densitometers interfaced with plotting devices are available. Such systems allow the operator to make a rapid scan of a test strip, and to generate proof and press sheet displays in a relatively short time.

Spectrocolorimeters may also be used to scan a test strip and to display measures of solids, tints, and overlaps in CIELAB or similar display systems. The primary use of colorimetric measurements, however, is for gray field analysis and control during the pressrun. Densitometric analysis is usually preferred for proof and press sheet matching tasks.

Proof–Press Sheet Matching Strategies

The first step in selecting or adapting a proofing system to match production printing is to select press sheets that represent normal production conditions. The representative press sheet should contain some standardized test images. These images simplify the analysis used to characterize the system. A color bar with solids and overlaps provides solid-area color data, and halftone dot areas (about 40–50% for dot gain, and 75% for print contrast) provide targets for tonal transfer evaluation.

Of course, the key objective in matching proof to press is that the images of the job match each other. A process-color reproduction is almost completely made up of halftone dots; therefore, it is imperative to match the dot gain characteristics of the printed sheet. The other important but strongly related point is that the colors must match as closely as possible. An analysis of most images reveals that the majority of picture colors are the reds, greens, and blues. These important picture color matches are strongly influenced by the color of the overlap colors in process-color printing; consequently, it is probably more important that the red, green, and blue overprints on proof and press sheet match each

other than do the solids of the primary yellow, magenta, and cyan colors.

The proofs that can be made from a digital database (both the electronic and hard copy types) can be excluded from this discussion because they can be individually programmed to match virtually any printing condition. The major area of interest is the matching of press proofs and transfer proofs to the production printed sheet. The matching strategies can be grouped under the headings of overprint solids and dot gain.

Overprint solids. The objective for the solid colors is to create matches of the red, green, and blue solids at the expense, if necessary, of the yellow, magenta, and cyan solids. The color of the proof overprints may be shifted by a variety of techniques. For press proofs or sheets, the densities of the individual primary colors may be varied: the color of an overprint green, for example, may be made yellower by increasing the yellow ink feed. Trapping may also be varied by ink film thickness adjustments, ink tack adjustments, and press speed. The color sequence influences the overprint, with the resulting color showing a shift towards the color of the last-down (second of the two colors that form the overprint) ink. The selection of the process-ink pigments also influences the overprint color.

In the case of photochemical proofs, color sequence and the initial colorant selection are the only methods of influencing the overprint colors. Many manufacturers have a reasonable variety of proof colors available; therefore, a wide range of overprints is possible. The light absorption properties of the primary colorants and their opacities are the key variables in determining the overprint colors.

Dot gain. The proofing dot gain objective is to visually simulate press dot gain. This does not mean that the proof must be physically the same; it should just look the same; i.e., a proof may use a combination of optical and physical gain to match the optical and physical gain of the press sheet. Photochemical proofs, for example, have very little physical dot gain but have considerable optical gain. The reverse tends to be true for press sheets, especially those printed on coated paper.

In the case of press proofs or sheets, a variety of techniques may be used to manipulate dot gain. One of the most effective is to use inks that have low pigment concentrations.

To achieve the required solid density with such inks, it is necessary to print a high ink film thickness, which in turn causes higher levels of dot gain. This technique does have drawbacks; namely, setoff and drying problems, scuffing and marking, possible trapping problems, higher gloss and, for lithography, possible ink/water balance problems. The other major gain alteration technique is the printing pressure. Increasing pressure increases gain. This can be achieved by using extra cylinder packing, moving bearerless cylinders closer together, or, for offset printing, using rubber blankets that tend to distort the dot.

In the case of photochemical proofs, physical dot gain can be influenced by either exposure or spacer sheets. Negative-working proof materials exhibit dot gain when overexposed. Positive-working proof materials exhibit dot loss when over-exposed. These same effects may be observed if a spacer sheet or sheets are placed between the proofing material and the negative or positive when using normal exposure times.

Spacer sheets also may be used to enhance optical dot gain. Some transfer proofs use a clear laminate over the base as a support for the colored images. The subsequent separation between the surface of the base and the colored halftone images produces an optical gain.

The overprint solids and the dot gain characteristics of proofs are sometimes difficult to achieve in the same proof. The adjustments described above should be manipulated until the overall appearance of the proof seems to be the best possible compromise match to the press sheet. Further details about the proof-press matching process have been discussed in some detail by Michael Bruno (1986, pp. 229–270) in his book *Principles of Color Proofing*.

Surface characteristics. The final aspect of proof and print match that can, to some degree, be controlled is the surface appearance, specifically the gloss. Some transfer-type proofs were initially available only with a very high-gloss finish. This type of surface reduced the first-surface light scatter and consequently improved the saturation and density of the colors in the proof. Many of these proofs proved to be unmatchable. The manufacturers responded by marketing matte finish sheets that could be laminated to the top of the finished proof. The finish of transfer proofs must be selected to correspond with the finish of the final print. Press proofs may be varnished, if necessary to match the desired gloss.

The Impossible Proof

On occasion, a printer may receive a press proof that proves impossible to match. There are some legitimate and understandable reasons why it may be difficult to match the proof. Apart from the obvious reasons of using different papers and inks from those used to make the proof, there are other explanations for this difficulty.

The type of plate used for the proof can contribute to the problem of the impossible proof. If, for example, the proof was made from a positive-working plate and the printing is made from a negative-working plate, there can be as much as 5% or 6% difference in the midtone values on the plates.

Another common problem occurs when the films used to make the proof plate are different from those used to make the press plate. This problem often occurs when a color separator has to supply ten or twelve duplicate sets of advertising separations to printers in many locations. The way to handle this aspect of proof matching is to make sure that the same generation of film is used for the proof as for the printed image. That is, the final color separation films should not be used to make the proof plate; rather, duplicates of these films should be used to make the plates. After proof approval, the final films should be used to generate more duplicates that are in turn distributed to the printers. The increasing use of digital file transmission practices for advertising pages in magazines will eventually eliminate the film-difference kind of problem.

A final problem for printers concerns corrections that have been marked on the original proof. Rather than reproof the job, a duplicate of the original proof and the corrected separation films may be submitted. If the printer was not informed that the (uncorrected) proofs are not really supposed to match the final printed image, then a lot of wasted time and energy will be spent in trying to achieve a match.

Whenever possible, a printer should insist that color bars be included on the proof sheet. This provision makes it relatively easy to check the proof for printed ink color, density, dot gain, trapping, and other characteristics.

Apart from the legitimate problems outlined above, which are caused mainly by a lack of communication, the printer may occasionally encounter the dishonest proof. This is a proof that has been "doctored" by persons whose only interest is selling separations and proofs without any concern for the problems the printer may encounter. There are several techniques that can be used to produce suspect proofs. The

best way of detecting this type of proof is through the careful examination of proofs of the individual colors. The use of a high-powered microscope to inspect the image and the insistence upon the use of color bars also can help to detect or deter the dishonest proof. A reflection densitometer is another useful device for the objective characterization of the proof. If there are any doubts about the integrity of the proof, the job should be reproofed.

Specifications for Proofing

In order to reduce the problems of advertising reproduction in publications printing, it is necessary to establish industry-wide specifications for the proofing of advertising pages. A series of specifications has been established to serve this goal. One of the most widely used is SWOP, Specifications for Web Offset Publications. Appendix B lists color-related standards and specifications.

All of these specifications seek the standardization of the inks, paper, and production conditions that are used for proofing advertising work for a particular publication printing method. The rationale is that if the proofs are all produced to the same specifications, then they should all reproduce equally well when printed. In the absence of specifications, some pages may reproduce well while others may be quite unsatisfactory. Apart from common inks and substrates, the other factors that should be specified include screen ruling, proof densities, color sequence, dot gain, UCR, GCR, UCA, color bar, viewing conditions, and such miscellaneous items as register marks and lettering specifications. These specifications are periodically updated by committees that represent the interests of those involved in advertising reproduction. Appendix E includes the names and addresses of the various standards-issuing organizations. They should be contacted directly for the most current copies of their specifications.

Proofing for magazine advertising pages is a special case. The average printed job does not require the printing of separations from as many as fifty or sixty companies. There are, however, other occasions (e.g., catalog or book production) when a printer must have color separations produced by more than one company. To ensure that the films from these companies are compatible, the printer should initially supply them with sample press sheets that contain a normal color bar image. The separators should use (if press proofs are specified) the same ink and paper for proofing their separa-

GATF/SWOP Proofing Bar, designed for evaluating the consistency of advertising page proofs.

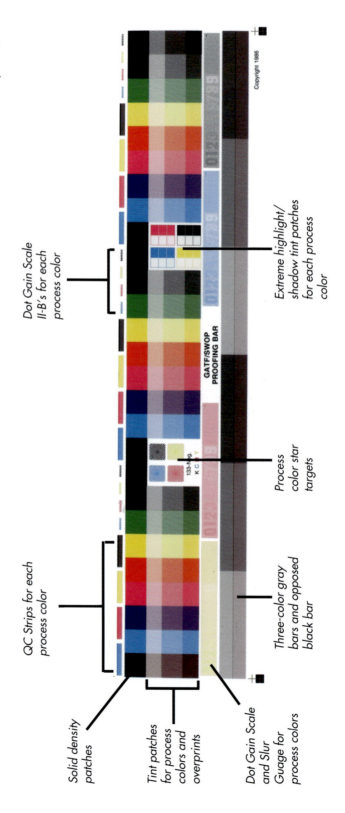

Dot Gain Scale II-B's for each process color

Extreme highlight/ shadow tint patches for each process color

QC Strips for each process color

Process color star targets

Three-color gray bars and opposed black bar

Solid density patches

Tint patches for process colors and overprints

Dot Gain Scale and Slur Guage for process colors

tions. The objective is to match the printer's color bar characteristics.

Any attempt to standardize the proofing conditions across the entire printing industry is certain to fail. The range of printed products is great and requires the use of an unconstrained range of substrates and inks. The creative limitations imposed by standardized conditions are only justifiable to solve such problems as those of advertising reproduction in periodicals.

Concluding Analysis

The color proof represents the major crossroads in color reproduction. It is here that the customer, color separator, and printer are drawn together to make judgments on the desired and expected appearance of the job. The proof is the major communication tool available to help make these judgments and decisions.

In order to be legitimate, the proof must be a reasonable simulation of the appearance of the final printed job. The conditions for "perfect" proofing are almost never realized in practice; therefore, proofs representing the final print with varying degrees of accuracy generally are used in place of an unrealizable ideal. These proofs usually are quite satisfactory for color decision making.

The problem of failure to match the proof is largely one of communication. If the color separator is aware of the nature of the printer's press conditions, it is possible to make proofs that are very close to press results. To facilitate the matching process, test images must be incorporated into the layout of both proof and press sheets. The test images represent a standard from job to job, therefore making it rather easy to spot the proof that is not compatible.

The selection of a proofing system or systems is mainly a technical decision, but the financial and human factors also must be borne in mind. Above all, a proofing system must be capable of producing an accurate simulation of the printed image on a consistent basis.

Today's proof is more likely to be an integral part of the color separation process, rather than a distinct process. Electronic color separation, image assembly, and image recording have expanded the role of proofing from an after-the-fact method of checking color separation quality, to the means of facilitating direct visual interaction with the color separation equipment.

14 Color Communication

The Color Communication Challenge

The nature of color makes it a particularly difficult phenomena to specify, describe, or purchase. Color specification and communication becomes even more complex when a pictorial image contains the color in question. Many factors can cause color communication complexity and difficulties: some may be classified as technical, while others may be classified as behavioral.

The technical and scientific aspects of color and color reproduction form the bulk of this book; however, for the topic of color communication, the focus must be expanded to also include the behavioral aspects. Personality types, social settings, role expectations, economic factors, time constraints, and aesthetic judgment variability will all influence behaviors that are relevant to color communication.

Effective color communication relies upon the use of verbal, administrative, quantitative, and physical-sample based techniques, that are, in turn, influenced by a number of technical, behavioral, physiological, and psychophysical factors. These elements together establish the relative effectiveness of color communication throughout the networks and channels that link people and technologies within the color reproduction system.

There are no prior published accounts of comprehensive color communication strategies for the printing industry; hence, this chapter represents an initial effort to explain the major elements of color communication and to structure them into a useful framework. To some extent, the color communication process will remain somewhat mysterious, but many of the color problems of the printing industry may be solved by the application of the techniques and procedures that are developed in this chapter.

Color Communication Networks

A color reproduction system typically employs two color communications networks. One involves creative process decision making, while the other concerns the manufacturing conditions. The two overlap to some degree when the print buyer makes initial production material and process selections to both suit the cost constraints, and to still allow sufficient creative flexibility and print quality.

The Creative Process Network

In many cases, a given color reproduction ideal is subject to constant modification and refinement throughout the color reproduction process. Each stage of manufacturing has some creative potential and, depending upon the original, may be exploited to enhance the quality of the reproduction. Effective communication is required during each stage of the manufacturing process in order to specify the creative intent in light of the possibilities or constraints afforded by the production dynamics. The creative decision-making opportunities exist at these stages:

Originator of the concept. An art director, for example, may conceive a certain color relationship designed to satisfy the end use requirements. In some cases, this individual will make all color approvals at each stage of the color reproduction communication process. In other cases, another person may make some or all of these decisions.

Artist or photographer. The original concept is translated into the first tangible image by an artist or photographer. The subsequent appearance of the concept is based upon the comments of the art director together with the opinions of the creator of this first color image. The characteristics of the films and art materials used, as well as other factors, strongly influence the appearance.

Color separation. A scanner or system operator makes color programming decisions based upon the original and the type of printing system through which the job will pass.

Color retouching. A color retoucher modifies image files to refine decisions made in color separation, and to make corrections not possible by other methods. A color proof (or proofs) usually is employed at this stage as a guide for subsequent corrections. The art director, or sometimes the color retoucher, makes the decisions regarding these corrections.

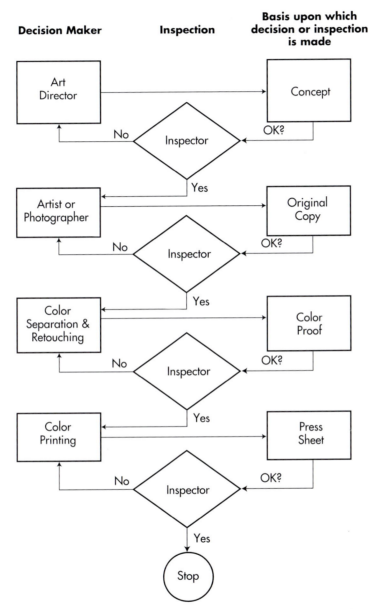

Manufacturing conditions color communication system.

Inspector. This person may be the one making the immediate color decision, or anyone else at a previous step of the process, back to and including the customer originally requesting the job.

Basis for decisions and inspections. A color proof may not be used in some systems, whereas in others, several proofing stages may be required.

Communication example. Referring to the diagram, the original is approved by the inspector, e.g., the art director, and then submitted to the color separation stage. Separation images (digital files, films, or plates) are used to produce a proof to represent the decisions made in color separation and retouching. The proof is then sent to an inspector (e.g., the art director again) for approval. If it is not approved, the proof is returned to the color separation/retouching step for the production of new images and a new proof. The new proof is submitted to the inspector and if it is approved, the job passes to the color printing stage.

Color printing. The objective at this stage of the process is, in many cases, to match the proof; hence, this color decision is theoretically a color-matching decision. There are times, however, when on-press decisions affecting the existing appearance of the job are deliberately made to enhance the results. The final printed sheets are then evaluated by the customer, who may or may not be the same person who originated the concept. The printed product is subsequently evaluated, unconsciously or consciously, by the ultimate consumers—the public.

The steps for creative decision making are diagrammed in the accompanying illustration. The key decision image is the color proof. This image, made from the separation files, should incorporate both the customer requirements concerning the original and the feedback information from the press. The proof is the prototype for the mass-produced printing job; consequently, the prototype will be constantly refined to the point where it represents the optimal appearance within the constraints of the reproduction system.

The Manufacturing Conditions Network

The information that is required from the manufacturing system is more objective and easier to characterize than the requirements for the creative decisions. Basically, information about the kind of original, the customer's objectives, and the printing conditions must all be supplied to the color separation system so that it is possible to produce color separations that will satisfy these requirements.

The proof images are intended for use in making or confirming creative judgments about the color reproduction, therefore, they are technically not part of the manufacturing conditions network. The individual stages of this system are detailed below:

Original copy. This can take the form of an artist's impression or a photograph. The original image takes many forms with respect to color, texture, gloss, graininess, and resolution. It may or may not represent the "ideal" representation of the concept upon which it was based. Information concerning such items as the color film manufacturer and the objectives of the customer ("the highlight detail is the most important aspect of this job") must be conveyed from this stage to the color separation stage.

Manufacturing system.

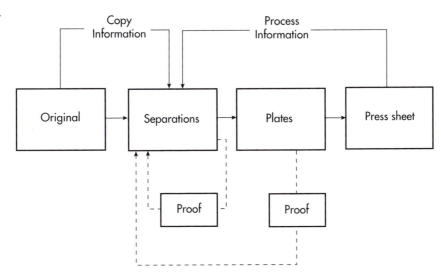

Color separation. This is accomplished through a series of steps that includes scanning, image processing, halftone screening, and image recording. Color separation is the flexible pivot point in the color reproduction process. The color separations incorporate both the creative intent and the production realities.

Platemaking. The images are converted into a printing surface composed of image and nonimage areas. In letterpress and gravure, additional color etching is possible at this stage where the image is mechanically or chemically modified.

Proofing. A prepress proof is normally made from the separation films or files as an intermediate guide to color appearance. Alternatively, the inked image on the plate or cylinder is transferred to a substrate to produce a press proof.

Printing. The inked image is transferred to the appropriate substrate using a particular printing press and process. Information concerning the production printing conditions should be fed back to the color separation stage, ideally by the use of a feedback control chart.

Communication Channels

The creative process network and the manufacturing conditions network must be linked to each other by two communication channels.

Technical factors communication. Technical factors communication concerns the communication of the capabilities and requirements of the manufacturing system to those who will judge and approve the quality of the reproduction. Such communication conveys an appreciation of the techno-economic and production factors that constrain the creative process.

Aesthetic factors communication. Aesthetic factors communication concerns the communication of the aesthetic factors or the creative decisions from such people as art directors or designers to the people in the manufacturing system. The objective is to express the creative objectives in such a way that the persons in manufacturing, particularly color separation and correction, can convert these objectives into tangible form.

The accompanying illustration shows this general two-way model for Technical-Aesthetic communication. The noise in the illustration represents the barriers to communication that are discussed in more detail later in this chapter.

Technical-Aesthetic communication model.

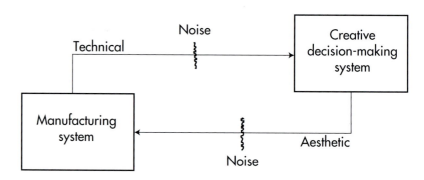

Specification Forms

Color communication can be made less ambiguous by the use of specification forms. These forms can help to convey both the technical and some of the aesthetic information required for successful color reproduction.

One form should be used to convey information concerning the original from the customer to the color separator. This form, one of which should be completed for each original, should contain such information as:

- Required size
- Crop area
- Transparency film manufacturer and type

- Important tonal information area: highlight, middle-tone, shadow (check no more than two)
- Areas of color change (indicate)
- Retouching requirements (indicate)

The specification form that should be used by a printer to convey the printing information to the color separator should contain such information as:
- Printing process
- Ink manufacturer and type
- Substrate manufacturer and type
- Color sequence
- Amount of UCR or GCR (if any)
- Screen ruling
- Dot shape
- Negatives or positives
- Right- or wrong-reading
- Plate type
- Printing densities
- Dot gain at the 50% level
- A sample printed color bar should also be attached to the form

A color separator uses the information from the two forms to help program the color separation system and produce the color proofs. The use of these forms helps to ensure that the proof will be close to the customer's requirements and that the subsequent color separation films will print properly.

Objective Aspects of Communication

There are certain barriers ("noise") to color communication that can be defined as objective factors, that is, they are physical, tangible, or quantifiable. If these factors can be identified as problems in a given situation, then they usually can be solved. The color communication factors that can be classified as objective, are listed below.

Light Source

The matter of light source is discussed in earlier chapters. Serious color matching problems can result if nonstandard light sources are used for color evaluation. Pictorial color matching, in particular, can present special problems if appropriate viewing light intensities and surround conditions are not used. The industry standard light sources should be used for illuminating both the original and the reproduction.

Proofs and Other Color References Sometimes, when multiple proofs of the same image exist, it is possible to mix them up and unknowingly try to match the wrong one. Proofings should be clearly marked as first proof, second proof, etc. In addition, a rubber "OK" stamp with provisions for signatures and dates of approval helps to identify the correct proof or makeready sheet.

If more than one original image or object is submitted for reproduction, each should be clearly marked for correct color reference. This problem sometimes occurs when an original and a merchandise sample are submitted.

Some significant color communication problems could be encountered when using color charts or other similar color guides. A designer may select a color from a printed color chart and then transcribe the corresponding percentage dot values onto the layout. System operators may program the correct screen values, but the printed color may not appear the same as that chosen by the designer because of differences in printing conditions between those used for the color chart and those used for the production pressrun. Printed color charts are not universal color references. They should be used only if they were produced under conditions similar to those that will be used for the printed job. Solid color ink mixing guides can also cause color communication problems if they are old, damaged or faded. Ink mixing guide books and printed halftone color charts should be replaced on a regular basis.

Standard reference systems, such as Munsell, can be used for color specification, but care must be taken to ensure that the color will lie within the available printed color gamut, and that the sample is identified as gloss or matte.

A final concern about communication problems caused by the proof or press sheet, is that the inks and substrate are actually those specified for the job. Drawdown or similar tests should be conducted if there is any suspicion that these materials do not meet specifications.

Abnormal Color Vision As may well be imagined, color communication between people who have markedly different color vision is likely to be difficult. The major problem arises when a person is unaware of having abnormal or defective color vision. Indeed, it is possible for someone to go through life without realizing that his or her color vision is not the same as that of most of the population. It is unlikely that anyone in the printing industry would not know of an existing color vision

defect; however, it is possible that corporate buyers who purchase only a few printing jobs a year may be unaware of any color vision anomalies they may have.

Unfortunately, it is usually not possible to administer a color vision test to a customer, but proof markup behavior can sometimes provide clues. Confusion between green and red hues indicates abnormal color vision.

Color separators and printers should administer color vision tests to their production, sales, and other personnel who are likely to make color judgments or be involved in color communication. Persons found to have abnormal color vision should be restricted in terms of the color decisions they are allowed to make.

Color discrimination ability declines with age. This effect may be countered to some degree by relying upon several opinions in critical color match cases.

Environmental and Surround Effects

The discussion on lighting conditions in Chapter 4 points out the importance of excluding such environmental influences as extraneous light and reflections from the viewing area. Shields should be used to prevent light from both windows and general room lighting from influencing color judgments. Walls and ceilings should be a flat neutral gray, and strongly colored objects should be kept clear of areas where color judgments are being made in order to avoid distorting the color temperature of the standard viewing conditions.

The immediate surround of a given color in a picture influences the perception of that color (the simultaneous color contrast effect discussed in Chapter 4). The practice of using gray cards with holes punched in them to "spot" colors on a color chart for comparison with colors in the original may, therefore, give false correlations if the color in the original is surrounded by a high saturation color. This effect becomes particularly noticeable when the surround color has a large area by comparison with the surrounded color. The white surround on a pictorial original is also important. The size of this surround influences the perceived contrast of the original, particularly if the original is a transparency. When color reproduction judgments are being made, the effect of the picture surrounds should usually be equal on the original and the reproduction.

Subjective Aspects of Communication

The objective aspects of color communication are those that can be explained by logical analysis and corrected fairly readily. The subjective aspects of color communication, by contrast, do not have a strong scientific foundation. They are often more emotional than rational and therefore are more difficult to identify and correct. Subjective factors can contribute significant "noise" to the communication channels.

Personality Factors

The insistence that a particular color be reproduced at a stated level of precision varies from person to person. For some, it is enough that the color reproduction is generally pleasing. For others, nothing less than absolute precision will do. This varying tolerance for inaccuracy exists in other fields of human endeavor. In the use of language, for example, some people insist on searching for the exact word or phrase for a particular circumstance, while others use more familiar words, or even slang expressions, to convey their thoughts on the same matter.

The reasons for these differences between people are not clear. They appear to be influenced by age, sex, education, social class, nationality, and other more or less objective factors. Still other factors have to do with the personality of the individual. The pioneering Swiss psychiatrist Carl Jung classified psychological functions as intuition, sensation, thinking, and feeling. These functions interact with two attitudes, introversion and extroversion, to form eight personality types. Presumably, all possible personality types are involved, somewhere, in the business of buying, selling, or producing color printing. The world view and value system of these types will have a significant influence on the color specification, adjustment and purchasing processes.

Judgment Variability

Some insight into the ways that individual perception differs may be gleaned from the black-and-white tone reproduction research of Jorgensen (Chapter 11). His findings include the following points:
- Individual perception of quality varies, but for high-quality reproductions and low-quality reproductions, there tends to be good agreement among observers.
- If the same person evaluates a given reproduction at different times, the rating or evaluation will be different. This variation will not be large for high- and low-quality reproductions.

- To some degree, the evaluation of the reproduction depends upon the observer's bias for or against the subject matter of the photograph.

It is not known whether these findings also apply to color reproductions, but it is probably reasonable to assume that they do.

Verbal Communication

The verbal communication of color information can entail both the initial specification of color and the desired appearance of a reproduced color. In many cases, however, the words used to specify or describe color may be unfamiliar or unclear because of differences between individuals' vocabularies. A person's vocabulary is shaped by family and education system influences.

For color specification, such terms as sky blue, Mandarin red, eggshell green, electric blue, crimson, buff, and Lincoln green are sometimes used. Many of these names will change over time as the color consultants decide that a new name for an old color will help increase sales for the product in question. Unfortunately, in the absence of a reference color, these terms will not mean the same to everyone.

A more common use of verbal descriptors for color is in the process of proof markup. The markups specify the color changes that are required by the print buyer and may consist of such vague terms as "brighter, glossier, redder reds; cooler; more metallic; more luminosity; too dull; too muddy"; and the more exotic phrases: "Make the reds talk to me," "Flesh needs weight and color," "It's got to be livelier," "I want more drama in this color," and "Make it sing." Again, the use of words to convey information about color is often not particularly satisfactory.

Other Communication Ambiguities

Proof markup does not rely entirely upon words. Sometimes numbers are used to indicate color changes; for example, "+10% yellow" usually means that an extra 10% yellow should be added to the area in question, rather than 10% of the tone value (i.e., a 50% tone should be increased to 60%, not 55%). This terminology is not only ambiguous but also may result in the incorrect color. To accurately specify color by percentage dot value requires either the use of a color chart or many years of color experience.

Sometimes symbols are used on proofs to indicate the desired changes. Attempts have been made in the past to

create a universal set of proofreader's marks for color as a kind of verbal shorthand. Informal symbols such as arrows to identify direction of change (up or down), or circles around the area that needs to be changed, are also used.

Nonverbal communications are sometimes used to express an overall impression about the proof. It is unlikely, however, that this method of communication will convey any particular information about a given color.

Buying Color

Color communication is the key to "buying color" in the printing industry. The customer buys color photographs, artwork, proofs, and printing. The printer buys inks, paper, and sometimes color separations and proofs. The key to each of these transactions is the ability to specify the exact color that is required. The communication technique that should be used depends upon what is being purchased.

Color Specification Techniques

Color information may be communicated between one person and another by numerical specification, a physical sample, or by verbal description. Each method has strengths and weaknesses; therefore, an intelligent mix of techniques must be chosen to suit the circumstances.

Numerical specification. A measuring instrument affords the most objective method of color specification and communication. Spectrophotometers, colorimeters, densitometers, and glossmeters can all be used to quantify color and appearance.

Spectrophotometers find their primary application in the measurement of ink and pigment colors. Ink manufacturers use these instruments to assist with color mixing, color matching, and pigment evaluation. Matching spectrophotometric curves is the ultimate form of color matching.

Spectrocolorimeters are used for the gray field analysis component of press control systems. Colorimeters have also been used to specify ink, original colors, and printed color areas. Indeed, colorimetry is the foundation of the color management systems that are used to convert color separation input signals into output recording values that will, in turn, produce the desired color. Color difference equations, which are used for expressing color tolerances, also form an important element of colorimetry-based methods of color specification.

Densitometers are normally used to measure proofs and printed sheets to ensure that they are within manufacturing tolerances. Proof density values are often communicated

between color separation and printing companies. The responses of the densitometers must be the same for this communication to be successful. To facilitate the proof density standardization process, a central source issues U.S. publication industry density specifications for proofs.

Sample-based specification. Physical samples are an extremely important method of color specification and communication. Indeed, for color selection, nothing can replace a color atlas or similar collection of samples. Special solid ink colors are routinely selected from reference ink mixing books or guides. A code number from this kind of system has an unambiguous meaning to all other holders of the same types of sample books. Color tints of process colors are also selected from printed color charts. Color charts depend upon the particular process inks and the printing conditions used to generate the chart; in other words, these charts are a precise tool for a given color system, but are not a universal reference method. Permanent, standardized color order systems such as Munsell may be used as a universal reference but some reference colors are not matchable by process color printing systems. Some physical reference system design considerations relative to specifying color in the printing industry have been published (Field, 1987).

Color change may also be specified by using any of the color sample systems outlined above. The most common form of color change concerns color adjustments on process color proofs. The process color chart is the most effective communication aid to use for this purpose. The difficulty with many process color charts, however, is that they often do not precisely match the proofing conditions.

A useful device for the specification of color change is the GATF Color Communicator. This device consists of sliding halftone wedges of yellow, magenta, cyan, and black. Each of these colors can be continuously varied from 0% to 100%. The only problem with this system is that the color scales are made from overlay color proofing material and, therefore, will not necessarily match the final printed image. The device is, nevertheless, unsurpassed in its ability to quickly show the effect of increasing or reducing the dot values of a given color.

Verbal color specification. Verbal terminology is the most imprecise of the specification methods but, especially for color proof evaluation, is probably the most common method.

The use of verbal terminology for the initial specification of color is acceptable if one uses a color reference manual to identify the color in question. The ISCC-NBS system of color references and color names (Chapter 6) is a useful system of color naming.

Color proof evaluators often use percentage dot values to specify desired color shifts. This practice is fraught with uncertainty, especially when GCR techniques have been used during the color separation process. Instead of trying to specify how to make a change, evaluators would be better served by describing the appearance of the desired color relative to the proof color. The following color-space based terminology is recommended when specifying color adjustments on proofs:

- **Hue.** When specifying hue shifts, use only four terms— bluer, greener, yellower, redder. The modifiers, more or less, may also be used to indicate direction around the hue circle. For example, an orange that looks too much like a lemon needs its hue shifted towards red: the orange needs to be less yellow or redder (more red).
- **Saturation.** Use two terms for saturation shifts— cleaner or grayer. For example, a gray-green that should be emerald green needs to be cleaner (achieved by removing the ink closest to the complementary of the color in question; in this case, magenta would be removed). The term grayer means making the color more like a neutral (gray, black, or white). Cleaner means making a color less like a neutral.

- **Lightness.** Use two terms for lightness shifts—lighter or darker. For example, a pale blue sky that does not provide sufficient contrast with the clouds needs to be made darker (achieved by increasing all the dot values in the sky).

Color corrections often have to be made where it is necessary to move through at least two color space dimensions. For example, a blue sky may have to be made cleaner and darker (achieved by reducing yellow and increasing the other colors). The magnitude of the desired change may be expressed by using these words: slight, moderate, or substantial. The further application of this terminology to proof markup is discussed in the next section.

The use of symbols as a kind of verbal shorthand for proof corrections has its roots in the proofreader's symbols for the correction of typography and typesetting. One British publisher, the Hamlyn Group, developed a set of proof correction symbols that they claimed helped simplify communication between color separators and printers in Europe. The system is not widely used. When different languages are involved, a set of symbols would seem to be quite useful. The use of international traffic signs is an example of the successful application of this concept.

Proof Markup The most crucial application of color communication techniques is the specification of color changes on a proof. This stage is the "fine tuning" aspect of color specification and represents the last opportunity to achieve the correct color before the printing begins.

Color chart-guided markup. The proof markup process can be divided into markups for color and other markups. As stated earlier, color markup should be keyed to a printed color chart that matches the production conditions of the proof. In cases where a prepress proof—for example, a transfer proof—is used, the following strategy can be employed to help improve color chart-guided markup. Two color charts are made, one on press under the final production conditions, and the other on the transfer proof material. Next, the critical color area in the transfer proof of the job is located on the transfer proof color chart. The corresponding location color patch in the printed color chart represents the final appearance of the critical color in the transfer proof of the job. The

desired color now can be selected from the printed chart, and the corresponding halftone dot values can be used to specify the correction on the proof.

The specification of percentage dots of the process colors should only be done in conjunction with the appropriate printed color chart. If a chart is not available, the print buyer or color evaluator should not act as an "amateur retoucher" and try to guess what dot percentage changes are needed to correct a given color. There is a good chance that such judgments will be wrong in terms of the desired result; also, if the specification is too precise, the retoucher may become overly dogmatic when carrying out corrections. The color retoucher has to execute the final adjustment; therefore, it is advisable to allow this person the flexibility to exercise some judgment.

Color Adjustments are best specified by reference to a representative process color chart.

Verbal-based markup. The color adjustment terminology referred to under "Communication Methods" should be used to indicate the general direction of desired color shifts. These guidelines work well for specifying the direction of a change. Problems arise when trying to specify the degree or magnitude of change. The best way of dealing with this problem is by use of a color chart. In the absence of such a guide, one is reduced to talking about slight, moderate, or substantial color shifts. These words mean different things to different people, but they are probably the best we can do. Color proof markups, therefore, would read something like this: "make sky slightly cleaner and moderately darker," or "change skin

to be slightly redder and moderately cleaner," or "make shadows substantially lighter and slightly dirtier."

It is fruitless to assign ΔE values to verbal indicators of magnitude. If, for example, a 20.0 ΔE value is the lower limit of the "substantial" change classification, then we are faced with a "moderate" change label for the visually identical 19.9 ΔE value. The ΔE values are useful, however, for monitoring the consistent (or otherwise) meaning of verbal magnitude indicators.

Although the magnitude indicators described here are open-ended, the degree of change that can actually be achieved is not. For example, a color that consists of solid yellow, magenta, cyan, and black cannot be made any darker, only lighter. A red consisting only of equal amounts of yellow and magenta cannot be made any cleaner, only dirtier. The hue dimension is circular; therefore, colors can be altered to any degree in this direction. The limits of saturation and lightness are, however, fixed by the ink-paper-press characteristics.

In practice, matters are often more complex than outlined above. Reducing cyan in green, for example, has the main effect of shifting hue toward yellow but also results in a slight increase in saturation and an increase in lightness.

In many cases a color correction may be specified that is impossible to achieve. For example, a red may bear the correction "more saturation" but contain no cyan or black. The solid magenta and yellow overlap on the color bar represents a limiting value; hence, this patch should be initially examined to see if this saturation value is high enough. If not, then the printing/proofing conditions will have to be altered. No change in the halftone dot values can achieve the desired color.

The other aspects of proof markup include those for spots and patterns and those for image definition. Physical spots and patterns can be circled with the indication that the offending mark be removed. Image definition instructions are sometimes confusing. The markup "more detail" conceivably could refer to either greater tonal separation, higher resolution, or more sharpness. Tonal separation can be adjusted, to some degree, in the retouching process, but resolution and sharpness cannot be changed by retouching. If the offending quality was caused by poor color separation work, the original will have to be reseparated. More often, sharpness and resolution disappointments are due to poor originals. Chapter 10 discusses the implications of enlarging unsharp and grainy originals too far or reducing fine detail

too far. These defects cannot be satisfactorily rectified during the color separation or correction stages. New originals must be created if these problems are to be solved.

The Psychology of Color Approval

Proof markup is not merely a problem of how to communicate color in the most precise manner. The same proof can be marked up differently by different people, and differently by the same person at different times. In other words, there is no one objective goal that will produce the "correct" result. Personality and other differences between individuals account for many of these inconsistencies. Some variability, therefore, is the norm. Given this fact, the question now becomes, "Who is right?" The normal answer is, "The customer is right." Given, however, that almost infinite variations are possible within color space, and that any two people probably will not agree on the preferred color for each area within the reproduction, the real question is, "What is reasonable?" The answer to this question is influenced by a number of factors.

Social factors. Some of the social factors that might influence the color proof approval process include the following differences between the print buyer and the sales representative: age, i.e., whether they are both young, both older, or different in age; sex, i.e., whether both are male, both female, or one is male and one female; relative social classes, which include how they speak and dress; individual status or rank within their respective organizations; and years of experience in the areas of buying, selling, or producing color. The exact effects of the above factors are not known, but they probably do influence, to some degree, the sometimes emotional and occasionally irrational process of color approval.

Personality types. The personality types of the buyer and seller may set the stage for a personal conflict where the proof becomes the battlefield. If personality differences cannot be kept separate from color judgments, one or both people may need to be reassigned. The personality type of the buyer influences the kind of proof markups that are made. The Introvert-Sensation type may work in broad terms, whereas the Extrovert-Thinking type may get very particular. Either extreme is not ideal for expressing proof corrections (Introvert-Sensation: "It doesn't do anything for me"; Extrovert-Thinking: "Increase the magenta exactly three percent"). Comments that are too general do not give

enough guidance, while those that are too specific may result in excessive retouching, which only produces the required color at the expense of the natural photographic effect of the picture.

Inspection process setting. Other factors that might play a role in the proof approval process include: the location where the inspection process occurs—in the buyer's company, the seller's company, or some third place; the time of day, in particular, whether the proof is inspected before or after lunch; and the presence or absence of others when the buyer and seller are discussing the proof. The positioning of the proof relative to the original—i.e., to the left or the right— may also influence the inspector's perception of the quality of the proof. The suggestion has sometimes been made that the buyer will make fewer corrections on the proof if the white paper area around the job is kept as small as possible. This tactic will fail, as the buyer will simply write smaller.

Buyer and seller roles. A major factor that influences markup is that of the role of buyer and seller. Art directors or designers, if not the actual buyer, sometimes play the part of decision maker. The role of the buyer is sometimes defined as that of color critic. Buyers with a narrow point of view believe that the role of a critic is to criticize. This approach is sometimes reduced to finding trivial faults or perceived faults that have little or no influence on the quality of the reproduction. Many insecure critics believe that, unless they find a fault, they have not done their job. One can be critical, however, without finding fault. A series of proofs with the OK stamp indicating no corrections does not necessarily mean that the critic or buyer has been easy or lax. Rather, it usually means that the proof is reasonable, and to mark up corrections would only result in delays and increased costs without producing any significantly discernible effect on the reproduction.

Reasonableness is often the result of dialogue between the buyer and seller. The sales representative has a major role to play in this process. A person involved in the activity of selling color proofs or color printing must not only be aware of how much color correction or adjustment is possible within the manufacturing process but also should be able to convey this information to the buyer. The give-and-take between the buyer and seller results in the reasonable balance between

the desire to make another slight change and the possibility or practicality of making this change.

Correction cost responsibilities. The question of color approval is also influenced by who pays the cost of "fine tuning" the reproduction. If the print buyer demands a change that departs from the original instructions, this is an "author's alteration" and is payable by the person requesting the change. For "bargain" separations, the price does not include any corrections; therefore, none should be expected. When the customer agrees to pay the cost of all specified corrections, unlimited fine tuning is possible.

The in-between cases, where a quotation has been submitted for the production of color separations and proofs, are less clear cut. If the color separator submits a reasonable proof to the customer, minor corrections are included in the price of the job; but re-proofs are paid by the customer. If the color separator submits an unreasonable proof, the corrections and the re-proof are paid for by the separator. Of course, individual contractual arrangements may differ from this convention.

Reasonableness. The key question of reasonableness and unreasonableness and how well it is resolved depends largely upon whether the buyer and seller consider it worthwhile to continue doing business with each other. The question of reasonableness must also depend upon the relative price. The higher the price, the higher the expectations. Another concern is the time available for corrections. If insufficient time is allowed to perform the requested adjustments, it is not reasonable to expect both the delivery deadline and the specified changes. If the delivery objective is realized, then the corrections must be accepted as reasonable. Reasonable quality usually means that the proof is so close to the desired appearance that a reproof is not necessary, even if some corrections are marked on the proof. The final aspect of reasonableness concerns the precision of the requested change. Comments such as "increase yellow 2½%" are a waste of time for two reasons. First, it is impossible to measure 2½% with any degree of precision. Second, a change of 2% or 3% will not be very noticeable in the final reproduction; this is especially true for changes in dark colors or changes in the yellow separation.

Color retoucher judgment. Color proofs should be marked up by the use of the terminology discussed under the "Color Communication Techniques" and "Color Proof Markup" sections. This terminology is specific enough to convey the buyer's desires, but not too particular to exclude the judgment of the retoucher. The retoucher is not merely a mechanical extension of the buyer's brain. The skilled retoucher assesses the requested changes in light of the influence on other aspects of the reproduction and then makes adjustments designed to achieve the buyer's wishes while maintaining the integrity of the picture. A buyer who insists on some very particular dot size changes may "win the battle but lose the war," or achieve the color but lose the reproduction.

Color Communication Development

Color reproduction is a complex process that requires the accurate communication of color information between a number of persons and organizations. In practice, considerable time, energy, materials, and money are wasted in the color reproduction process because of unclear or poor communication. Apart from the recommendations discussed so far—that is, standard viewing conditions, the use of color charts and specification forms, testing for abnormal color vision, and the use of objective terms when describing the desired color corrections—there are two further steps that can be taken to produce long-term improvements in the color communication process.

Color Printing Portfolio

It is very difficult to describe the effect of using a particular paper on the appearance of the future color printing. In order to develop customers' visualization of substrate-influenced appearance factors, sales representatives should carry samples of previously printed jobs on more than one paper stock. These samples can be generated easily by running the test stocks through the press at the end of the production run. The reproductions will not be optimal on the test stocks, but they will at least convey the general idea of the appearance shifts that are likely when a given substrate is used.

The sales representatives should carry a portfolio of other printed samples that indicate the effects of varnishing, five- or six-color printing, fine screen rulings, and other production options. Color communication is much more successful when actual samples are used to help describe the expected outcomes. Customers' expectations will be realistic if they

see in advance some samples of work using the ink-paper-press combination of the printer in question. Of course, printed color charts should also be produced and distributed to potential customers.

The appearance difference between prepress proofs and the printed job can be conveyed by including sample proof and corresponding press sheets in the sales representative's portfolio. The customer, upon observing the difference between the proof and printed sheet, can now decide if it is worthwhile to produce a more expensive press proof or to use a prepress proof.

The prompt offering of color-related information to the customer from the sales representative develops the customer's understanding of the color communication process, and enhances the standing of the sales representative in the eyes of the customer. This ongoing informal color education process also develops a firm's reputation for customer service and helps to cement long-term customer relationships.

It is very important that the sales representative volunteers information before the job is printed ("If you use this paper, the color will appear flat"), rather than after the job is printed ("Well, the color looks flat because of the paper you specified"). If the customer is alerted to potential problems before the job is printed, he or she has the option of changing the specifications. An after-the-fact explanation may be correct, but the change option has been foreclosed by then.

Freely-offered timely explanations of color concepts and opportunities will contribute much to long-term customer satisfaction. Such a strategy will also result in fewer color production problems within the plant, and will further enhance the firm's (and the sales representative's) reputation for integrity and service.

Color Education

The process of color reproduction in general and color communication in particular are complex and difficult concepts to fully understand. To help overcome this lack of understanding, some companies conduct special color seminars for their own employees, particularly their sales staff. Other companies even run special seminars for their customers in the belief that an informed customer is a better customer. Some plants use their own personnel to conduct these seminars, while others hire outside consultants for this purpose. Books, video-

tapes, and other aids also can be used to help spread an understanding of color reproduction and communication.

Some buyers of printing already have an excellent color education. A number of graphic design programs at various colleges and universities provide courses in printing and related technologies so that the student will understand the interaction of the design and manufacturing processes. Other institutions shortsightedly ignore printing as "not relevant" to the education of future art directors.

Some printing and color separation companies hire the "born salesman" type who might not know anything about color reproduction but has an impressive sales record. These sales representatives must be trained to understand color concepts, and color reproduction practices and possibilities. Other companies recruit their sales representatives from their own staff who have had either the advantage of a formal color education or extensive color production experience.

Color seminars and similar educational endeavors are useful for production people who might know their own field very well but are unaware of the other stages in the color reproduction process. Exposure to the total system should promote overall awareness, improve communication, reduce costs and improve quality.

Many benefits can, therefore, be derived from a color education program, particularly if high-quality work is the objective. Reasonable-quality work can be produced with a rudimentary understanding of the process, but consistent excellence demands higher levels of knowledge and skill.

Concluding Analysis

The process of color communication is critical to the success of the color reproduction system. The two aspects of this communication are (1) the manufacturing system information that must be supplied to the color separation process and (2) the creative information that represents the buyer's print appearance objectives. Some of the supplied information is primarily technical in nature ("compensate for 15% dot gain on press when the separations are made"), while the other information is largely subjective ("it is important that the fruit looks appealing").

The technical information may be communicated by the use of forms or printed test images. The creative decision usually has to be made by judging a tangible image, such as a proof. The key problem now becomes how to communicate

the results of the creative decision to the person or persons who will put that decision into effect.

The objective barriers to color communication, such as the use of nonstandard viewing conditions, are fairly easy to identify and change. By contrast, the subjective barriers to color communication, such as personality differences between the buyer and seller, are not only difficult to identify but are often almost impossible to correct.

The major communication techniques—instrumental measurements, physical samples, or verbal description— each have their strengths and weaknesses. The verbal technique, in particular, is very convenient to use but suffers from the lack of precision. This lack of precision can be partly overcome by the use of a few specific color terms. If the print buyer specifies the direction of the desired color change, the skilled color retoucher can usually be trusted to produce the appropriate degree of change.

The question of how close is good enough for a given color area on the proof is difficult to answer. It is related to the concept of reasonableness. That is, a color area is reasonable if, within the time, cost, visual, and manufacturing constraints, it meets the customer's expectations. A skilled sales representative has to help educate the customer in the concept of reasonableness.

A complex process of technology and materials, color reproduction contains many unknown nuances. It is a major undertaking to master the knowledge and skills that are required to understand the process and to communicate effectively the color requirements to satisfy creative and manufacturing objectives; therefore, the continuing color education of all those involved in color reproduction is necessary.

15 Color Quality Strategy

Strategic Concepts

Color quality strategy is approached at two levels: macro and micro. The macro level refers to the needs of particular markets and addresses the kinds of technologies and materials required to satisfy that market. The micro level refers to a firm's objectives at the operating level and addresses the procedures and judgments that are required to achieve color excellence.

A macro-level strategy of a newspaper, for example, establishes the best kind of materials, machinery, technologies, and procedures required to meet the quality needs of the newspaper-buying public. A micro-level color quality strategy within a newspaper plant focuses upon tone and color reproduction, image quality, and the elimination of distracting patterns or marks. The micro-level strategic objective is to produce the best possible results within the capabilities of the production system.

What Is Quality?

A key question must, however, be resolved before much headway can be made towards establishing a color quality strategy, namely: what is quality? Many people dodge this question by stating "quality is meeting or exceeding customers' needs," which is, of course, quite true (and very obvious), but is unhelpful or trite if the specific needs are undefined. Others quote currently popular quality authorities, e.g., "quality is conformance to specifications," which again is true, but is far too narrow to fully capture what the word quality means to a customer.

The first research paper to systematically address all facets of quality was that published by Professor David A. Garvin of the Graduate School of Business at Harvard University. His paper, which appeared in a 1984 issue of MIT's *Sloan Management Review*, suggested that eight dimensions

could form a framework for examining product quality. Garvin's work can be used as a useful foundation for building a comprehensive model to evaluate color quality in the printing industry.

Facets of Print Quality

Quality, especially as the term applies to color reproduction, can have many meanings. The importance of a particular meaning or facet of quality depends upon the market needs relative to the product in question. The facets of quality concept must be understood before a strategy can be developed that will enhance a company's operations.

The dimensions (facets) of quality concept was first presented in a systematic manner by Garvin (1984). Since then, a number of other researchers have expanded, modified, or reinterpreted the quality dimensions framework. Most of the published models, however, have not been suitable for printed products, in general, or color reproduction, in particular. An extensive review of the prior studies has led to the following quality-facets framework that is better suited to printed color reproductions.

Conformance to Specifications

This is one of the four quality facets that directly concerns the actual appearance of the printed image. From the color reproduction perspective, the primary meaning of this facet is conformance to some set of printing tolerances; e.g., a density of 1.40 ± 0.05, a dot area of $50\% \pm 4\%$. The ΔE tolerance of a gray field analysis target or the register variation allowance are further examples of this category. This facet of quality refers to the consistency of the product; the successful achievement of which is dependent upon the identification of suitable control points, and the development of realistic tolerances.

A critical aspect of color reproduction cannot, however, be expressed in terms of tolerances. The overall appearance of the proof reproduction is always judged by visual evaluation. It is impossible to specify the exact color of every area in the reproduction in advance, and to also express color tolerances for each of these areas because the relative importance of objects and colors within a scene is usually very subjective. A particular red may, for example, occupy a small part of a background area in one picture, but form a large part of a critical area in another. The tolerance would, in this case, vary according to the context, not according to the color.

Even if it were possible to establish tolerances for the hundreds of color areas within a pictorial subject, it would be extremely inefficient to painstakingly measure these areas for each reproduction. The overall visual evaluation process is far superior, not only because of speed, but also because the eye is uniquely able to evaluate the interaction-of-color effects.

Excellence

This dimension can also be called performance. It refers, in the case of color reproduction, to how closely the reproduction approaches optimum or perfect appearance. Chapter 9 addressed this subject in some detail.

Excellence is materials and process dependent. It is possible, for example, to produce an excellent color reproduction in a newspaper or in an art book. There will, however, be an obvious appearance difference between both images. Judgments of excellence are made within a particular context, so to some degree, the product form establishes the comparative framework.

Judgments of excellence are made at the proof image stage. The corrections specified here represent attempts to modify the image to achieve the best appearance possible within the constraints of the inks, substrate, and printing process. Some further fine or minor judgments and adjustments may be made during the press makeready process.

Some aspects of excellence may be specified in advance (e.g., tone curve shape), but in practice, such target specifications serve to position the reproduction as "generally good." Excellence is defined and redefined after proof images (soft or hard) have been evaluated. Excellent color reproduction is, in other words, often achieved by an iterative process. The ultimate result depends upon who is making the evaluation, the subject and content of the image, the nature of the printed product, and the capabilities of the manufacturing process.

Aesthetics

Aesthetics usually refers to such concepts as beauty, proportion, balance, and form. This dimension is concerned with the creative aspects of the image and usually falls within the realm of art director, graphic designer, artist, and photographer.

Certain classical principles of art and design have been established over the years, but they are somewhat difficult to apply to the evaluation of aesthetics. Designers and artists often deliberately ignore the classical guidelines in order to

produce thoughtful and compelling images. Indeed, the history of art is characterized by a number of artistic movements reflecting the dominant style of a given era. Art fashion trends do influence graphic design, especially in the case of advertising images.

Photographic images may also be evaluated on the basis of composition and the other aspects of classical style; however, the spontaneous nature of much photography often adds elements to image content that outweigh compositional quality. Such deliberate or unavoidable distortions as grain, contrast, optical distortion, and perspective are often effectively used by the photographer as creative tools; therefore, the presence of these influences are not prima facie evidence of a poor image.

The key distinction concerning judgments of image aesthetics is whether the image effectively fulfills the function for which it was created, or whether it is simply a bad photograph or layout. Advertising and clothing fashion photographs are, in many cases, fantasy images that reflect the aesthetic trends or style of a given era. Other kinds of photographs and layouts are usually judged, from the aesthetic point of view, by more traditional and stable criteria. If a distorted or confusing image clearly does not fall into the fantasy category, then it is possibly due to mediocre design or photography.

Permanence

The durability aspect of quality refers to image permanence in the case of color reproduction. Images can fade or deteriorate due to the action of light, chemicals, moisture, or other environmental influences. Permanence of an image is dependent upon the resistance of the inks and substrate to environmental effects. Finishing techniques (e.g., protective varnishes or laminations) may extend image permanence.

The requirements for image permanence will vary considerably from product to product. A billboard poster's life could be as short as a month or so, but during that period it may have to endure severe weather conditions without an appreciable loss of image quality. A fine art print does not have to endure the elements, but it may have an expected life requirement of 100 years or more. Some books ("library editions") are also expected to last many years. Most newspapers, on the other hand, may have a life expectancy of a few hours, or even less. Indeed, much printed matter has a rather ephemeral nature and is quickly discarded or recycled after fulfilling its purpose.

A large group of printed products have mixed life expectancies. Some books and magazines will be kept for many

years by their owners, while such other publications as paperback novels and weekly news magazines may be discarded fairly quickly. Packaging products are discarded soon after the product is removed or used up; however, the image permanence requirement is determined by the time the package will spend on a display shelf, rather than in a consumer's kitchen cabinet. Some packages (e.g., milk cartons or bread wrappers) will have short life because of the perishable nature of the package contents. Other packages (e.g., laundry detergent or children's toy packaging) may have a long shelf life.

Delivery Urgency This and the following facets of color reproduction quality have more to do with the production and economic factors rather than the actual appearance of the image. From a customer perspective, these dimensions can play a critical role in the quality determination process. The quality (excellence facet) of newspaper color reproductions, for example, are irrelevant if the newspaper is produced a day late.

Newspaper and "on demand" short-run printing are the two kinds of printed production with very short lead times and strict delivery time requirements. Most kinds of packaging, by contrast, have long lead times and relatively flexible delivery requirements, because much package printing is produced on a reprint basis that is determined by a fairly consistent consumption rate (grocery items, in particular).

The advances in color separation technology, together with such time-saving developments as direct-to-plate systems, have greatly reduced the origination-to-printing lead times. Various kinds of press automation have also reduced make-ready times to a fraction of what they once were. Customers have been quick to take advantage of these developments: later copy submission deadlines and more frequent and shorter runs allow more current information, and lower inventory storage and holding costs.

Rapid Change The rapid-change facet addresses the need to make timely updates or changes to printed products prior to the pressrun. Newspapers are the obvious example of a product requiring this kind of intervention in the production process, but catalogs, annual reports, news magazines, and much advertising literature routinely requires last minute or unexpected changes to the prepress image files.

The fact that virtually all prepress work, up to the image recording stage, is in electronic format, means that rapid change capability is available for most kinds of printed product. The delays due to image recording, however, can negate the gains from rapid image changes that were made at the digital file stage.

Direct-from-image-files-to-press production processes do not experience any delays between file changes and printing. If, however, image files are first recorded onto film and then the film image is transferred to a plate, the resulting delays may be significant for certain types of work. Direct-recording-on-plate technologies, especially if the imaging is done while the plate material is mounted in position on the press, can reduce the elapsed time to near that for the plateless direct printing systems.

In the case of direct gravure cylinder engraving, however, the time and expense required to produce a cylinder is such that this kind of direct-to-plate technology should not, especially for process-color printing, be viewed as an element within a rapid-change production system.

Creative Interface

The ease of access to the image manipulation stages of the production system can be a critical quality facet for those kinds of work that require significant modification between the stages of image capture and printing. Advertising pages and similar kinds of fantasy images that need extensive modification or precise adjustment, are examples of the kind of work that requires a near-seamless interface between the creative and manufacturing aspects of image processing.

Today's near-complete digital workflow has smoothed the interface between the creative and production stages to such an extent that the rapid and accurate transfer of creative decisions to production fields is available for most printed products. In some cases, however, incompatible files, poor scans, software differences, and other problems can cause delays and frustrations at the interface between production and creative activities. Interface problems are not particularly serious for work with plenty of lead time and few requirements for iterative refinements of the image, but can be quite troublesome for other kinds of work.

Improvements in this facet of quality usually result from improved education. The companies responsible for the production activities must convey the file and related requirements to the creative stages. Creative personnel have to

design within the constraints of the production system in order to produce effective images. Continued software developments, in particular, will help to minimize the differences between creative-supplied files and production file realities. Monitor calibration, standard viewing conditions, and improved color management systems will also help improve the creative-manufacturing interface. In the meantime the "preflight" activity in production situations will help detect problems prior to production, and provide the opportunity for supplying useful feedback to the creative process.

Extras

An imaging extra is an unexpected service or feature that is supplied or is available to the customer. In order to be effective, the "extra" must be valued by the customer and should not be readily available elsewhere. Such extras, if popular with customers, will be adopted by competitors as part of their normal production services; therefore, new extras may have to be developed to preserve a unique position. One extra or feature that is difficult to duplicate is the customer education programs and materials that a company may offer. In fact, this kind of non-job specific extra service is not only valued by the customer, but may, in the long run, lead to improved color communication and a more efficient workflow between the creative and manufacturing processes. Some non-job specific extras, apart from color education programs, include printed color charts, plant tours, and the remote location of direct proof output stations and color viewing booths at the customer's site. The scale of such efforts will, of course, depend upon the customer's importance to the company.

The extras or features facet of quality could become increasingly important in times of cross-media imaging. A company may, for example, offer file output services to suit such processes as gravure, web offset, ink jet, or even an Internet media format.

Certain finishing techniques may be offered as a special feature: in-line varnishing, for example. Certain kinds of proof, such as an ink-jet position proof may also be an extra feature provided as part of the normal production cycle.

Value

The value facet is the relationship between the job's price and the previously discussed facets of quality. A company offers good value if it either charges a lower price than the industry norm for a given mix of qualities, or if it offers a

higher level of qualities than the norm, but does not charge an accordingly higher price.

The relationship between higher quality and higher price is a deeply ingrained (and usually correct) belief. All customers will be attracted to any company that offers more quality for the same price or the same quality for a lower price. To be effective, the edge in price or quality must, however, be significant enough to overcome the inertia against changing suppliers. The difficulty with exploiting this kind of advantage is in convincing the customer that the quality is indeed better for the same price (or the same for a lower price). Many aspects of quality are difficult to measure and, in some cases, are difficult to explain. Sales representatives must be well versed in the concepts and facets of print quality in order to make effective and convincing presentations to potential customers.

The ultimate customer for many kinds of printed products is the purchaser of the newspaper, packaged product, greeting card, book, magazine, or calendar. The product is question is usually purchased for its content rather than its print quality, but lower prices for such products as books (an international commodity) for a given quality level, will increase sales. Book publishers, in particular, often take a global perspective when it comes to locating color printing value. Regional newspapers, in contrast, are somewhat immune from outside competition, but the same pressures to deliver good value will still apply. Advertisers will demand good color and the subscribers will come to expect editorial color. In this case, a newspaper that does not offer color will be perceived as lower value than one that does offer color for the same price (or even, perhaps, for a slightly higher price).

Color Markets

Color printing markets may be classified in a number of ways. The following categories are based upon run length, quality (meaning excellence, in this case), and delivery requirements. For any given market classification, delivery requirements are of lesser importance, hence, early discussion of markets focus upon the first two categories. All of the previously discussed facets of quality are applied to each market classification at the end of this section.

Short-run on-demand. This emerging market serves customers who want a few (500 or so) copies of color images that do not exceed the size of a two-page magazine spread. Deliv-

ery expectations are usually less than 24 hours, and may even be on a "while you wait" basis. The kind of product that fits this classification includes real estate flyers or brochures, preliminary new product information, special sale brochures for narrowly targeted audiences, in-house corporate publications, and any product that requires customized content for a number of different recipients.

Long-run on-demand. The newspaper market represents this category: millions of newspapers must be produced every day in a matter of hours with significant content that usually arrives a matter of hours (often shorter) before printing commences. Some editions of weekly news magazines may fit into this classification in the case of late-breaking news, but the normal production schedule for this product does not expect routine processing of major on-demand segments.

Long-run high-quality. Run lengths measured in millions with color quality approaching or equalling the best available form this classification. Some magazines and catalogs and some kinds of packaging routinely have these requirements. On some occasions, annual reports or advertising brochures may fit this classification.

Long-run routine-quality. Run lengths up to the millions, with quality generally constrained by the price of the substrate and inks, form this classification. Most of the magazine and catalog business and some of the packaging and brochure businesses fit here.

Medium-run routine-quality. The vast bulk of commercial printing fits this classification, as does a significant portion of the magazine, book, and catalog business. Certain segments of the flexible packaging and corrugated industries are also included in this classification.

Medium-run high-quality. Quality approaches the highest levels, and run lengths are modest for products that fit this classification. Some books, magazines, greeting cards, annual reports, luxury product brochures, calendars, posters, art gallery catalogs, and packaging are included here.

Short-run high-quality. This is a small market that requires relatively few copies of high-quality images.

Limited-edition fine art prints or books, and special presentation brochures generally fit this classification. Billboard poster job requirements usually specify a small number of high-quality images.

Quality Facets and Color Markets

The optimal production strategy for a given color market may be determined if there is a sound understanding of the quality facets that apply to that market. The matrix presentation below classifies each quality facet for each market. The evaluation terms are: Y—yes, this is an important quality for this classification; N—no, this is not normally an important quality for this classification; and, S—sometimes this is an important quality for this classification. The evaluations are somewhat subjective and are meant as general guidelines rather than as absolutes. Individual perceptions of color market requirements will differ according to local market expectations; therefore, each quality facet should be reinterpreted relative to local conditions.

Facets of Print Quality

Color Printing Markets	Conformance to Specifications	Excellence	Aesthetics	Permanence	Delivery Urgency	Rapid Change	Creative Interface	Extras	Value
Short-Run On-Demand	S	S	S	N	Y	Y	Y	N	S
Long-Run On-Demand	S	S	S	N	Y	Y	Y	N	S
Long-Run High-Quality	Y	Y	Y	S	N	N	Y	Y	Y
Long-Run Routine-Quality	Y	S	S	S	S	S	S	S	Y
Medium-Run Routine-Quality	Y	S	S	S	S	S	S	S	Y
Medium-Run High-Quality	Y	Y	Y	S	S	S	Y	Y	Y
Short-Run High-Quality	Y	Y	Y	S	N	N	Y	Y	Y

Estimated importance of print quality facets to specific color printing markets. Y = yes, S = sometimes, N = no

Production Systems Analysis

The successful pairing of production technologies with the previously described color markets requires that production systems be evaluated relative to the quality requirements of these markets. Performance, broadly speaking, is the criterion for production systems analysis. Specific performance criteria includes the nine facets of quality and the production economics. Production systems have been grouped, for convenience, under nine headings; two for prepress and seven for printing.

Electronic Prepress

Electronic prepress refers to the nature of the image prior to being converted into a hard (tangible) form. The hard image may be film, image carrier, or final print. The electronic image consists of layouts of image units, complete with text, photographs, tint panels, and other graphic elements.

A complete electronic layout is required for the short-run on-demand color market, and is also often used as a production strategy within the long-run on-demand newspaper color printing market. Most of the long-run high-quality market (the gravure magazine and catalog segment) also requires a complete electronic layout to drive engraving machines.

In fact, all color markets and print production processes may be fed by electronic layout and image data, but there are sometimes good reasons to avoid this option. Film output is often more readily accessible than a data file and provides a reliable backup in cases of computer or storage media failures or damage. Film storage media is also logical for jobs that are likely to be reprinted (packaging and some books). Finally, the highest quality imaging requirements need film output prior to platemaking. Direct-to-plate or direct-to-press recording does not always have the high resolution afforded by direct exposure to film and contacting to plate.

Hybrid Prepress

A hybrid prepress system refers to a part-electronic, part-film image system. Certain workflows consist of image elements that are supplied on a piecemeal basis over a period of time. Previous color separations, new originals, new separations produced by another company, and electronic file transfer from an external agency may all have to come together into the same layout.

In practice, except for the on-demand market, hybrid prepress systems have few serious drawbacks and may, as explained in the "Electronic Prepress" section, even offer

some advantages. Continued cost declines in storage, data processing, and file transmission will, however, make total electronic prepress systems more common in the future.

Gravure

The gravure process is capable of producing high-quality printing on smooth substrates. Print consistency for gravure is also very good. The economics of gravure production, however, restrict its use to long-run work.

Long-run magazines, catalogs, folding cartons, and flexible packaging make up the bulk of the traditional gravure markets. The process is also used to produce wallpaper and other kinds of "product" gravure.

The long-run high-quality and the long-run routine-quality markets are served by the gravure process. The difference between them is generally one of materials: inexpensive substrates and inks are used for the latter market. Gravure is challenged in the long-run routine-quality market by web offset and flexography, but it enjoys some clear advantages over these processes in the long-run high-quality market.

Flexography

The flexographic process can produce good print quality on a variety of substrates, with few print consistency problems. Short to medium run lengths may be handled economically.

A large portion of the flexible packaging industry, all of the corrugated printing industry, and a significant portion of the newspaper printing industry are primary markets served by flexography. The pressure-sensitive label business and, increasingly, some general commercial printing work are also well served by the flexographic process.

The medium-run routine-quality and the long-run on-demand markets are those best suited to flexography. Web offset competes with flexography in the long-run on-demand newspaper business, and also in the medium-run routine-quality market. Gravure competes with flexography for the longer runs of the medium-run routine-quality flexible packaging market.

Web Offset Lithography

The web offset process offers unsurpassed quality (relative to other processes) on rough or textured substrates. Its color quality on smooth substrates is probably second only to gravure, but it potentially surpasses that process for fine detail resolution. Printing consistency has been a problem for lithography, but advances in measurement and control technologies have removed most of these concerns.

Web offset dominates the magazine, catalog, commercial, and much of the book industry. Web offset is also the most significant process for newspaper color production.

This versatile process competes in the following markets: long-run on-demand, long-run high-quality, long-run routine-quality, medium-run routine-quality, and medium-run high-quality. The process is generally restricted to the production of page-format printed signatures, and often has to compete with gravure, flexography, or sheetfed lithography for this market.

Standard Sheetfed Lithography

The print quality and consistency characteristics for sheetfed litho are similar to those previously attributed to web offset. In general, sheetfed litho performs somewhat better than web offset in these categories.

Sheetfed lithography is a dominant force in the commercial printing, folding carton, and label printing businesses. Certain other markets are also served by sheetfed lithography, but are discussed under the "Special Sheetfed" production system heading.

Standard sheetfed litho serves the long-run routine-quality and medium-run routine-quality color printing markets. Sheetfed litho printing also serves the high-quality segment of these markets, but discussion of this application is reserved to the next section. Web offset provides the major alternative to sheetfed lithography, but gravure can challenge in the folding carton business, as can flexography for some kinds of label printing.

Special Sheetfed

Special sheetfed production technology consists primarily of specialized sheetfed lithographic machines. Such presses may print five, six, seven, or even more colors on a single pass through the machine. The extra color capability is designed to overcome the proportionality and additivity failure color-gamut-restricting effects of standard halftone lithographic printing.

A further kind of special lithographic sheetfed printing machine uses digital data to record the plate images directly onto appropriate material that is premounted on the plate cylinder. This rapid file-to-print capability is designed for efficient short-run quality printing.

Special sheetfed (and standard sheetfed), in contrast with the common page format output web offset presses, is capable of producing products in a variety of sizes and shapes.

The special sheetfed process (extra colors) is very strong in the greeting card business, and is also (for the direct-to-plate version) competitive in the on-demand market.

Special processes (extra color) serve the long-run high-quality, medium-run high-quality, and short-run high-quality markets. The direct-to-plate form of special sheetfed process serves the short-run on-demand market and parts of the medium-run routine-quality market. The competing processes, for the direct-to-plate type, are electrophotography and standard sheetfed litho processes. The extra-color special-process technology receives competition from gravure for long-run work and from screen printing for certain kinds (posters) of short-run work. Standard sheetfed lithography and web offset may also offer challenges for some of the medium- and long-run high-quality business.

There are two other special sheetfed color printing processes that are worthy of note: collotype and letterpress. The collotype process works from a continuous-tone relief gelatin image carrier. The process is capable of producing extremely high-quality reproductions, but it is very temperamental and rarely used. Collotype's use is generally restricted to a very small part of the fine art limited print business. Letterpress, once a dominant force in color printing, is capable of producing images of exceptional color saturation and sharpness on smooth substrates. Lithography does have higher resolution, especially on uncoated or textured substrates, than letterpress; however, the main reason for the demise of letterpress in the process color printing market was due to production economics: letterpress was too expensive and too slow relative to litho.

Screen Printing

The screen printing process offers exceptional color saturation and the ability to print on virtually any substrate in any size. The process is slow by comparison with others, and it does have some resolution (screen ruling) restrictions.

The screen printing process is used to produce high-impact, short-run posters, point-of-purchase displays, showcards, labels, and related retail merchandising materials. The process is also used for non-process color applications in the circuit board, clothing, and packaging industries.

The screen printing process primarily competes in the short-run high-quality process-color market. Its major competition comes from sheetfed lithography (standard and

special) and, to some extent, from the inkjet nonimpact process for very-short-run work.

Electrostatic Processes

The electrophotography and ink jet imaging processes are both controlled by electrostatic principles. Their primary advantages are the time-saving elimination of the film and platemaking stages, and the ability to alter the image for every printing "impression" or cycle. The color reproduction quality of these processes is quite good, but some of the higher-speed versions suffer from image resolution limitations and graininess.

Electrostatic production technologies are primarily suited to the short-run on-demand color market. The process may also compete in the short-run high-quality market, but only if the direct proof recording technologies are used to generate the images. The direct-to-plate special sheetfed litho process provides the major competition in the short-run on-demand market.

Production System Choices

The suitability of a given production process to given market segments has been described here in terms of general guidelines. The particular choices for a given company will depend upon the company's manufacturing strategy, the competitive forces, and the requirements and size of the markets they serve or hope to serve.

In general, companies become more efficient and profitable if they focus upon no more than one or two markets. Indeed, such companies as flexible package producers, newspaper, magazine and catalog printers, and on-demand printers usually select a single kind of production system to serve their chosen market. In some cases, a company may employ complementary technologies to serve a single market (e.g., flexography and gravure to serve the medium- and long-run requirements of the flexible packaging industry).

A company will not be profitable if it has an unrelated collection of expensive production technologies with poor capacity utilization rates. To be successful a firm must initially develop a corporate strategy that is based upon serving a particular market need. The facets of print quality that are important to a given market must then be examined to determine the production technologies best suited to that market. The technologies are then assessed against the firm's financial criteria, and evaluated from the health, safety, and environmental points of view before making the

investment. Further details about the financial aspects of technology selection are provided elsewhere (Field, 1996a).

The Dynamics of Color Excellence

Most of the product color quality dimensions are, to some degree, preestablished by the production technology and the color market norms. The materials chosen for a given market set the image permanence limits, and the production technology largely determines the production tolerances that are possible. The aesthetic dimension is one that is beyond (except in cases of in-house design services) the control of the print production processes; therefore, the one dimension that may be influenced by the expertise and processes within production is that of excellence. This is the main facet of product quality that a firm may use to differentiate itself from competitors. Conformance to specifications may be used as a competitive tool but with the widespread use of automated measurements and control technologies, this facet of quality has become less differentiated between firms than it used to be. Further differentiation may also be achieved via the five non-product facets of quality that have been previously described.

The primary focus of this book has been upon identifying and applying those concepts and factors that contribute to color reproduction excellence. Excellence is, however, a somewhat elusive concept that must be examined from a dynamic point of view. The dynamic approach reveals why the conditions for achieving excellence will often vary from case to case. Rather than being a cause for dismay, this variability can be harnessed and applied on a systematic basis to produce consistently excellent printed color reproduction.

Materials Selection

Aspects of materials selection have been covered, to some degree, in Chapter 7. The present focus is upon materials selection with a view to maximizing the excellence of a given color reproduction.

The key substrate decision concerns the texture and smoothness of the surface. The tradeoff is between a glossy finish that will produce high saturation, density, and sharpness, and a textured or matte surface that will produce a softer image with less glare, and that also possesses a tactile element. As a general rule, the glossy finish will usually be preferred for reproductions of scenes containing man-made objects (e.g., buildings, automobiles, aircraft, and electrical appliances), while a textured or matte finish will often be

chosen for reproductions of scenes containing natural objects (e.g., landscapes, animals, people, flowers, and some kinds of clothing). There are, of course, many successful exceptions to these broad guidelines; postcard reproductions of landscapes are, for example, almost always printed on a high-gloss stock.

Substrate selection is a creative choice that is made to suit the subject. Professional photographers are faced with similar choices when producing prints for a given purpose (e.g., wedding photographs vs. oil refinery photographs). Printing company sales representatives can learn much about the substrate selection process by studying the surface characteristic decisions that are made by professional photographers (not those photographs submitted for reproduction: they are always glossy, but those intended for display purposes).

All substrates chosen for printed color excellence should be white and bright with low absorption properties and high opacity. Whenever possible, proofs of a given job should be produced on several substrates in order to better judge the impact of the substrate's surface structure on the total appreciation of the image.

Ink selection is more straightforward than substrate selection. The basic process color set should produce the widest possible gamut consistent with the production realities. The gloss of the printed ink film should approximate that of the substrate.

Supplemental inks should be chosen as needed to enhance required portions of the color gamut that have been degraded by proportionality failure or additivity failure effects. Further compensation may also be needed because of color distortions to the printed ink film that are due to the absorption and gloss properties of the substrate (i.e., the paper surface efficiency effect).

Prepress Decisions

Many of the optimization decisions faced during the prepress process were discussed extensively in Chapters 9 and 11. From a total reproduction process perspective, the greatest changes are possible during the prepress operations. These image changes often trade off one attribute against another. The operator, therefore, chooses the particular mix of settings that are designed to maximize the quality of a particular image within the constraints of the subsequent printing conditions.

The tone and saturation adjustments represent clear cases of trading one part of the image for another. In the case of

tonal adjustment, the tonal separation in the "interest area" is emphasized at the expense of other, less important, tonal areas. Specific saturation compressions could require that all colors be compressed equally until the most saturated (of a particular hue) lies at the gamut boundary; alternatively, colors outside the gamut could be ignored in favor of making a more accurate reproduction of an original color that lies on the gamut boundary. In the former case, saturation distinctions are more or less maintained, while in the latter case, some particular colors are reproduced fairly accurately, but some saturation distinctions are lost. The tradeoff depends upon the relative importance of particular color areas to both the integrity of the image, and to the specific requirements of the customer.

In the case of image structure adjustments, the situation becomes somewhat complex. Certain images (man-made products, for example) may benefit from electronic enhancement ("sharpening") but, at the same time, the enhancement will increase the apparent graininess of the reproduction.

Fine detail resolution may be increased through the use of stochastic screening technology or fine conventional screen rulings; image graininess will, however, probably become more noticeable in both these cases.

Graininess generally becomes most noticeable in smooth, even tones of medium density. This effect becomes greater if a grainy original undergoes significant enlargement. Apparent graininess, in other words, largely depends upon the original subject: subjects with plenty of busy detail do not usually appear to be grainy.

Graininess may be minimized through the use of elliptical dot screens, but only at the expense of resolution. Similarly, the use of stochastic screens to eliminate moiré makes register more critical, and also may increase graininess.

Unlike tone and color adjustments that may be corrected on a local basis, image structure modifications are usually very difficult or time consuming (or impossible) to correct on a localized basis. Image structure modifications must be carefully chosen to ensure that image degradation, for the original in question, does not occur.

Printing Tradeoffs

The image adjustments that may be employed at the printing stage of the reproduction cycle are all global in nature; that is, a change will influence the entire image, not just part. The key question concerning press adjustments

becomes one of whether the enhancement added to one area more than outweighs the problems caused in other areas. Attempted image enhancements via press adjustments should not, of course, be entertained when a fixed makeready target must be followed (e.g., SWOP targets or reprints). Press adjustments, furthermore, should not be made in attempts to "save" a bad set of color separations (well-meaning attempts usually fail; therefore, remake the separations), nor should adjustments be so extreme that press runnability performance is compromised.

The adjustments that are discussed should be viewed more as opportunities to make "fine tuning" refinements rather than major changes. A reliable proof must be supplied to serve as the baseline image before the adjustment process commences.

Ink film thickness (IFT) adjustment is the key image adjustment control on press. When IFT increases, the color strength and image sharpness also increases. What also occurs is that dot gain increases (i.e., resolution is lowered) and trapping problems may occur. When IFT changes are made independently of each other, the combined end results may, or may not, improve the overall impact and appearance of the printed image.

Color sequence and ink trap also represent a tradeoff between one quality and another. The saturation of greens may, for example, improve if the cyan and yellow sequence is reversed; but such a change may now have an adverse effect on reds (assuming that the original sequence was CMY and will now change to YMC) and blues. The acceptability of the change depends upon the relative importance of red, green, and blue areas within the reproduction.

Changing IFT will also influence the following image attributes in the lithographic process: image sharpness, halftone graininess, halftone mottle, ink film graininess, and ink film mottle. A further concern associated with IFT adjustments is the influence upon such non-color reproduction properties as setoff, scumming, or picking. In other words, attempts to enhance the image at the printing stage should be made very carefully and rather infrequently, if at all.

Finishing Options

The key appearance-related finishing option is overprint varnishing. The varnish may be matte, high gloss, or anywhere in between. The ideal gloss level for a varnish is probably similar to that suggested under the "Materials Choice" sec-

tion; that is, gloss should be relatively low for natural object photographs, but may be somewhat higher for photographs of manufactured or constructed objects. Selective image embossing may be used to throw areas into relief; however, such applications are extremely rare. Metallic overprinting is more common and may, in many cases, provide selective enhancement to a product image.

Concluding Analysis

Macro color quality strategy is, essentially, a business decision that reflects a firm's strategic choice relative to a market opportunity. The macro strategy establishes the kind of printing business to be pursued by the company; e.g., short-run on-demand or long-run high-quality. Quality facets, including four that may be observed in the product and another five that cover the service, delivery and economic factors, may be used to describe the color market requirements. The quality requirements of a given market then generally define the production system, e.g., electrophotography or gravure.

In practice, it is often difficult to successfully pursue different macro color quality strategies in the same plant. The technical, personnel, sales, and service requirements, for example, are quite different for both the short-run on-demand, and the medium-run high-quality markets. Organizations may establish two or more companies within a corporate structure to circumvent these difficulties; that is, each company within the structure has its own color quality strategy.

Micro color quality strategy is a business philosophy that is based upon the excellence dimension of color reproduction quality. The successful implementation of this strategy depends upon management's commitment to excellence, the availability of appropriate and well-maintained equipment, the provision of the right materials, and the presence of a skilled and motivated workforce.

A color excellence strategy is based on the concept that it takes no longer, nor costs no more, to do the job right than it costs to do it wrong. Setting a tone curve during the color separation process to enhance the interest area of a particular reproduction, for example, takes no longer than setting a curve that ignores the picture content requirements. There are, of course, some aspects of color excellence that can only be determined through an iterative process. The iterative proofing process is an adjunct to the normal production

process that is designed to help refine the aesthetic and excellence aspects of the job.

This book has analyzed the factors that influence color reproduction excellence. The successful application of these color excellence insights will produce color printing that brings satisfaction, and even pleasure, to the consumer. A color excellence strategy also establishes a sense of purpose and pride in those involved in the challenging art and science of color reproduction.

Appendix A
Symbols and Abbreviations

a	Redness-greeness coordinate in certain color spaces
AGASC	Australian Graphic Arts Specification Council
ANSI	American National Standards Institute
AS	Australian Standard
ASTM	American Society for Testing and Materials
b	Yellowness–blueness coordinate in certain color spaces
B	Blue filter or tristimulus value
BS	British Standard (see BSI)
BSI	British Standards Institution
C	Cyan separation or printer
C*	Chroma or colorfulness in the 1976 CIELAB or CIELUV systems
CC	Color compensating
CCD	Charge-coupled device
CD	Compact disk
CD-ROM	Compact disk—read-only memory
CI	Colour Index
CIE	Commission Internationale de l'Éclairage (International Commission on Illumination)
CIECAM	CIE Colour Appearance Model
CGATS	Committee for Graphic Arts Technology Standards
CMC	Colour Measurement Committee
CMS	Color management system
CMYK	Cyan, magenta, yellow, black
CRT	Cathode-ray tube
CSA	Colour Society of Australia
CTP	Computer-to-plate

D	1. Optical density
	2. CIE D illuminants representing phases of daylight with different correlated color temperatures; e.g., D_{50}, D_{65}
DDAP	Digital Distribution of Advertising for Publications
DDCP	Direct digital color proof
DDES	Digital Data Exchange Standards
DIN	Deutsches Institut for Normung (German Standard Specification)
dpi	Dots per inch
FM	Frequency modulation
FMC	Friele-MacAdam-Chickering
FPO	For position only
FTA	Flexographic Technical Association
G	Green filter or tristimulus value
GAA	Gravure Association of America
GATF	Graphic Arts Technical Foundation
GCA	Graphic Communications Association
GCR	Gray component replacement
GRACoL	General Requirements for Applications in Commercial Offset Lithography
$h°$	Hue angle in the 1976 CIELAB or CIELUV systems
IARIGAI	International Association of Research Institutes for the Graphic Arts Industry
ICC	International Color Consortium
IFT	Ink film thickness
IOP	Institute of Printing
IPA	International Prepress Association
IR	Infrared
ISCC	Inter-Society Color Council
ISO	International Organization for Standardization
IS&T	Society for Imaging Science and Technology
JND	Just noticeable difference
JPEG	Joint Photographic Experts Group
K	1. Black separation or printer
	2. Kelvin, a measure of color temperature
L	Lightness coordinate in certain color spaces
lpi	Lines per inch

LTF	Lithographic Technical Foundation (now GATF)
LUT	Lookup table
lx	Lux—unit of illumination (one lumen per square meter per second)
M	Magenta separation or printer
MAC	Magazine Advertising Canadian Specifications
NAPIM	National Association of Printing Ink Manufacturers
NBS	National Bureau of Standards (see NIST)
NCS	Natural Colour System
NIST	National Institute of Standards and Technology (formerly NBS)
nm	nanometer = 1/1,000,000,000th of a meter
NPES	The Association for Suppliers of Printing and Publishing Technologies
NPIRI	National Printing Ink Research Institute
NSAI	National Standards Authority of Ireland
NZS	New Zealand Standard
OP	Overprint
OSA	Optical Society of America
PCR	Print contrast ratio
PIG	Process Ink Gamut
Pira	Printing Industry Research Association
PMT	Photomultiplier tube
ppi	Pixels per inch
PSE	Paper surface efficiency
R	Red filter or tristimulus value
RAM	Random-access memory
RGB	Red, green, blue
RIT	Rochester Institute of Technology
RPS	Royal Photographic Society of Great Britain
SAA	Standards Australia
SC	Supercalendered
SCC	Standards Council of Canada
SCID	Standard Color Image Data
SCSI	Small computer systems interface
SGIA	Screenprinting and Graphic Imaging Association International
SID	Society for Information Display

SNAP	Specifications for Nonheatset Printing
SPIE	The International Society for Optical Engineering
SWOP	Specifications for Web Offset Publications
TAGA	Technical Association of the Graphic Arts
TAPPI	Technical Association of the Pulp and Paper Industry
TIFF	Tagged image file format
UCA	Undercolor addition
UCR	Undercolor removal
USM	Unsharp masking
UV	Ultraviolet
V	Value (Munsell System)
VDU	Video display unit
X	One of the CIE tristimulus values representing the red primary
x	One of the CIE chromaticity diagram coordinates
XYZ	CIE tristimulus values for the 1931 2° standard observer
$X_{10}Y_{10}Z_{10}$	CIE tristimulus values for the 1964 10° standard observer
Y	1. Yellow separation or printer
	2. One of the CIE tristimulus values representing the green primary and equal to the luminous reflectance or transmittance
y	One of the CIE chromaticity diagram coordinates
YMCK	Yellow, magenta, cyan, black
Z	One of the CIE tristimulus values representing the blue primary

Appendix B
Color-Related Standards and Specifications

The following classification system is based upon that used by David Q. McDowell (1997), a leading authority in U.S. graphic arts-related standards work. The entries presented here were chosen with greater emphasis on the interests of printing companies rather than those of equipment manufacturers.

Measurement and Assessment Procedures

CGATS.4-1993 Graphic Technology—Graphic Arts Reflection Densitometry Measurements—Terminology, Image Elements and Procedures

CGATS.5-1993 Graphic Technology—Spectral Measurement and Colorimetric Computation for Graphic Arts Images

ISO/CD 13656 Graphic Technology—Process Control—Applications of Measurements Made by Reflection Densitometry and Colorimetry to Process Control in the Graphic Arts

AS/NZS 1580.601.3 Colour—Methods of Colour Measurement

AS/NZS 1580.601.4 Colour—Calculation of Colour Differences

AS/NZS 1580.601.5 Colour—Calculation of Small Colour Differences Using the CMC Equation

AS 1580.602.1-1975 Paint and Related Materials—Visual Assessment of Gloss

ASTM Standards on Color and Appearance Measurement, 5th Edition, American Society of Testing and Materials, Conshohocken, Pennsylvania (1996) (contains 92 ASTM standards and 9 ISO and ISO/CIE standards)

CIE 116-1995 Industrial Colour-Difference Evaluation

Characterization Targets and Test Images

IT8.7/1-1993 Graphic Technology—Color Transmission Target for Input Scanner Calibration

IT8.7/2-1993 Graphic Technology—Color Reflection Target for Input Scanner Calibration

IT8.7/3-1993 Graphic Technology—Input Data for Characterization of 4-Color Process Printing

ISO 12640 (under development) Graphic Technology—Prepress Digital Data Exchange—Standard Color Image Data (SCID)

Viewing Conditions

ISO 3664:1975 Photography—Illumination Conditions for Viewing Color Transparencies and Their Reproductions

ANSI PH2.30-1989 Graphic Arts and Photography—Color Prints, Transparencies and Photomechanical Reproductions—Viewing Conditions

AS4004-1992 Lighting Booths for Visual Assessment of Colour and Colour Matching. With Amendment 1:1995

BS 950 Specification for Artificial Daylight for the Assessment of Colour; Part 1 Illuminant for Colour Matching and Colour Appraisal; Part 2 Viewing Conditions for the Graphic Arts Industry

AS/NZS 1580.601-3 Standards for Colour, Visual Comparison and Instrumental Measurement

Printed Output

ISO 2846-1:1997 Graphic Technology—Colour and Transparency of Ink Sets for Four Colour Printing—Part 1: Sheet-Fed and Heatset Web Offset Lithography Printing (Part 2: Coldset Web Offset, Part 3: Gravure, and Part 4: Screen Printing are under development)

CGATS.6-1995 Graphic Technology—Specifications for Graphic Arts Printing—Type 1 (note: this is based on SWOP)

ISO 12647 (under development) Graphic Technology—Process Control for Half-Tone Colour Separations, Proofs and Production Prints

ANSI CGATS TR001-1995 Graphic Technology—Color Characterization Data for Type 1 Printing

ISO 2846-1975 Set of Printing Inks for Offset Printing—Colorimetric Characteristics

BSI 4666-1971 (Amended 1986) Specification for Inks for Offset Three- or Four-Colour Printing

Specifications for Web Offset Publications, Eighth Edition, SWOP Inc. (1997)

Specifications for Nonheatset Advertising Printing, Web Offset Section (Revised June 1994), PIA

The Guide to Publication Production for Heatset Web-Offset Printing, Third Edition, Australian Graphic Arts Specification Council

Australian Print Standards, Australian Government Publishing Service, Canberra, 1995

General Requirements for Applications in Commercial Offset Lithography, Version 2.0, Graphic Communications Association (1998)

Appendix C
Color Difference Equations

Tristimulus Values

Tristimulus values are central to the process of color measurement and color difference calculation. The XYZ tristimulus values are a function of the illuminant, the observer and the sample, and may be represented thus:

$$X = \sum_{\lambda} S(\lambda) R(\lambda) \bar{x}(\lambda)$$

$$Y = \sum_{\lambda} S(\lambda) R(\lambda) \bar{y}(\lambda)$$

$$Z = \sum_{\lambda} S(\lambda) R(\lambda) \bar{z}(\lambda)$$

where:

$S(\lambda) =$	relative spectral energy of the illuminant	
$R(\lambda) =$	reflectance from the sample	
$\bar{x}(\lambda), \bar{y}(\lambda), \bar{z}(\lambda) =$	the 2° or 10° CIE standard observer (the color matching functions)	
$\lambda =$	wavelength	
$\Sigma =$	summation	

The CIE has published standard tables of weighting factors at 1-nm wavelength intervals for the standard illuminants and the two standard observers. Manufacturers of color measurement equipment typically represent these data in abridged form (5-, 10- or 20-nm spacing); therefore, there may be some slight (and inconsequential) differences between instruments that are due to this process.

The values XYZ always refer to the CIE 2° standard observer. The notation $X_{10}Y_{10}Z_{10}$ is used to designate the 10° observer. Technically, these terms are incomplete unless the illuminant is also specified.

Hunter Coordinates and Color Difference

The Hunter system was the first successful attempt to develop a direct-reading color difference instrument that was based on CIE observer and illuminant standards. The transformations are:

$$L = 100 \, (Y/Y_n)^{\frac{1}{2}}$$

$$a = \frac{K_a \, (X/X_n - Y/Y_n)}{(Y/Y_n)^{\frac{1}{2}}}$$

$$b = \frac{K_b \, (Y/Y_n - Z/Z_n)}{(Y/Y_n)^{\frac{1}{2}}}$$

where: $X, Y, Z = $ CIE tristimulus values

$X_n, Y_n, Z_n = $ tristimulus values of the selected standard illuminant, with Y_n always normalized to equal 100.0

$K_a, K_b = $ chromaticity coordinates for the illuminant used

The color difference equations are:

$$\Delta E = \left[(\Delta L)^2 + (\Delta a)^2 + (\Delta b)^2 \right]^{\frac{1}{2}}$$

where:

$$\Delta E = \text{overall color difference}$$
$$\Delta L = L_{sample} - L_{standard}$$
$$\Delta a = a_{sample} - a_{standard}$$
$$\Delta b = b_{sample} - b_{standard}$$

CIELAB Coordinates and Color Difference

The CIELAB transformation of CIE XYZ values took the following form:

For values of X/X_n, Y/Y_n, $Z/Z_n > 0.008856$

$$L^* = 116 \ (Y/Y_n)^{\frac{1}{3}} - 16$$

$$a^* = 500 \left[(X/X_n)^{\frac{1}{3}} - (Y/Y_n)^{\frac{1}{3}}\right]$$

$$b^* = 200 \left[(Y/Y_n)^{\frac{1}{3}} - (Z/Z_n)^{\frac{1}{3}}\right]$$

For values of X/X_n, Y/Y_n, $Z/Z_n \leq 0.008856$

$$L^* = 903.3 \ (Y/Y_n)$$

$$a^* = 500 \left[f \ (X/X_n) - f \ (Y/Y_n)\right]$$

$$b^* = 200 \left[f \ (Y/Y_n) - f \ (Z/Z_n)\right]$$

where:

$$f \ (X/X_n) = 7.787 \ (X/X_n) + 16/116$$

$$f \ (Y/Y_n) = 7.787 \ (Y/Y_n) + 16/116$$

$$f \ (Z/Z_n) = 7.787 \ (Z/Z_n) + 16/116$$

Where X_n, Y_n, Z_n are tristimulus values for any illuminant

the color difference equation is:

$$\Delta E_{ab}^* = \left[(\Delta L^*)^2 + (\Delta a^*)^2 + (\Delta b^*)^2\right]^{\frac{1}{2}}$$

ΔE_{ab}^* is the same quantity as the ΔE Hunter unit except that L^*, a^*, b^* (CIELAB) values are used in the equation. ΔE^* approximates an NBS unit of color difference.

The dimensions a^* and b^* in CIELAB color space are often converted to measures of saturation (C_{ab}^*) and hue angle (h_{ab}^*) for convenience. These values are equal to:

$$C_{ab}^* = (a^{*2} + b^{*2})^{\frac{1}{2}}$$

$$h_{ab}^* = \arctan \ (b^*/a^*)$$

Chroma difference is calculated via:

$$\Delta C_{ab}^* = C^*_{sample} - C^*_{standard}$$

Hue angle difference is calculated via:

$$\Delta h_{ab} = h_{ab_{sample}} - h_{ab_{standard}}$$

For small color differences away from the L* axis

$$\Delta H_{ab}{}^* \cong C_{ab}{}^* \Delta h_{ab} (\pi/180)$$

Hue difference is calculated via:

$$\Delta H_{ab} = \left[(\Delta E_{ab}{}^*)^2 - (\Delta L^*)^2 - (\Delta C_{ab}{}^*)^2 \right]^{\frac{1}{2}}$$

and overall color difference is calculated via:

$$\Delta E_{ab}{}^* = \left[(\Delta L^*)^2 + (\Delta C_{ab}{}^*)^2 + (\Delta H_{ab}{}^*)^2 \right]^{\frac{1}{2}}$$

CMC (l:c) Color Difference Equation

The CMC equation is a refinement of the CIELAB formula, and takes the form:

$$\Delta E = \left[\left(\frac{\Delta L^*}{l\, S_L} \right)^2 + \left(\frac{\Delta C_{ab}{}^*}{c\, S_C} \right)^2 + \left(\frac{\Delta H_{ab}{}^*}{S_H} \right)^2 \right]^{\frac{1}{2}}$$

$$S_L = \frac{0.040975 L^*}{1 + 0.01765 L^*} + 0.638$$

unless $L^* < 16$; then

$$S_L = 0.511$$

$$S_C = \frac{0.0638 C_{ab}{}^*}{1 + 0.0131 C_{ab}{}^*}$$

$$S_H = S_C \,(Tf + 1 - f)$$

$$f = \left[\frac{(C_{ab}{}^*)^4}{(C_{ab}{}^*)^4 + 1900} \right]^{\frac{1}{2}}$$

$$T = 0.36 + |\, 0.4 \cos (h_{ab} + 35) \,|$$

unless h_{ab} values are between 164° and 345°; then

$$T = 0.56 + |\, 0.2 \cos (h_{ab} + 168) \,|$$

L*, $C_{ab}{}^*$, and $h_{ab}{}^*$ are values of the standard; l and c are correction factors that are chosen to suit certain matching conditions.

The CMC (l:c) equation varies the weightings according to positions of the color in CIELAB space to improve the predictive value of the equation.

FMC-2 Color Difference Equations

The Friele-MacAdam-Chickering equation was based on the transformation of MacAdam ellipsoids of just perceptible difference into spheres of the same size. The quite complex formula was refined from what is now known as the FMC-1 version, to the mostly-cited FMC-2 version. The difference between them is the parameter K_1 that was introduced to simulate the change in size of the ellipsoids as a function of Y (the luminance factor), and the factor K_2 that also was introduced for making a lightness conversion.

The FMC-2 color difference equation is:

$$\Delta E = \left[(\Delta C)^2 + (\Delta L)^2 \right]^{1/2}$$

where:

$$\Delta C = K_1 \Delta C_1 \qquad \text{and} \qquad \Delta L = K_2 \Delta L_2$$

$$\Delta C_1 = \left[\left(\frac{\Delta C_{rg}}{a} \right)^2 + \left(\frac{\Delta C_{yb}}{b} \right)^2 \right]^{1/2} \quad \text{and} \quad \Delta L_1 = \frac{(P\Delta P + Q\Delta Q)}{(P^2 + Q^2)^{1/2}}$$

$$\Delta C_{rg} = \frac{(Q\Delta P - P\Delta Q)}{(P^2 + Q^2)^{1/2}} \qquad \text{and} \qquad \Delta C_{yb} = \frac{(S\Delta L_1)}{(P^2 + Q^2)^{1/2}} - \Delta S$$

$$\Delta L_2 = \frac{0.279 \Delta L_1}{a}$$

$$K_1 = 0.55669 + 0.049434Y - 0.82575 \times 10^{-3}Y^2 + 0.79172 \times 10^{-5}Y^3$$
$$- 0.30087 \times 10^{-7}Y^4$$

$$K_2 = 0.17548 + 0.027556Y - 0.57262 \times 10^{-3}Y^2 + 0.63893 \times 10^{-5}Y^3$$
$$- 0.26731 \times 10^{-7}Y^4$$

$$a^2 = \frac{17.3 \times 10^{-6} (P^2 + Q^2)}{[1 + 2.73P^2Q^2/(P^4 + Q^4)]}$$

$$b^2 = 3.098 \times 10^{-4}(S^2 + 0.2015Y^2)$$

$$P = 0.724X + 0.382Y - 0.098Z$$

$$Q = -0.48X + 1.37Y + 0.1276Z$$

$$S = 0.686Z$$

X, Y, Z = tristimulus values of either one of the two colors being compared

ΔP, ΔS, ΔQ = the differences between P, Q, and S values of the two colors being compared

Simplified values for K_1 and K_2 may be used to reduce the computation complexity (although this is hardly an issue given the universal use of computers for solving the color difference equations). They are:

$$K_1 = 0.054 + 0.46Y^{1/2}$$
$$K_2 = 0.465K_1 - 0.062$$

Further discussions of color difference equations may be found in Judd and Wyszecki (1975), Berger-Schunn (1994), McLaren (1986), and Hunt (1991).

Appendix D
Equations for Color Reproduction

The computational approaches to color reproduction are described in Chapter 9. This appendix presents the mathe-matical details.

Demichel Equations

Demichel's equations (1924) are based on the following assumptions:

let:

Fractional dot area of yellow	$= y$
Fractional dot area of magenta	$= m$
Fractional dot area of cyan	$= c$

therefore:

Area not covered by yellow	$= 1-y$
Area not covered by magenta	$= 1-m$
Area not covered by cyan	$= 1-c$

and:

Area not covered by yellow or magenta	$= (1-y)(1-m)$
Area not covered by cyan or yellow	$= (1-c)(1-y)$
Area not covered by magenta or cyan	$= (1-m)(1-c)$
Area not covered by yellow, magenta, or cyan	$= (1-y)(1-m)(1-c) = $ white

similarly:

Area covered by yellow and magenta, but not cyan	$= ym(1-c)$	$=$ red
Area covered by cyan and yellow, but not magenta	$= cy(1-m)$	$=$ green
Area covered by magenta and cyan, but not yellow	$= mc(1-y)$	$=$ blue
Area covered by yellow, magenta, and cyan	$= ymc$	$=$ black

and:

Area that is solely yellow (i.e., not magenta and not cyan)	$= y(1-m)(1-c) = $ yellow
Area that is solely magenta (i.e., not yellow, and not cyan)	$= m(1-y)(1-c) = $ magenta
Area that is solely cyan (i.e., not yellow and not magenta)	$= c(1-y)(1-m) = $ cyan

Therefore, the following expression

$$(1-y)(1-m)(1-c) + y(1-m)(1-c) + m(1-y)(1-c) + c(1-y)(1-m) + ym(1-c) + cy(1-m) + mc(1-y) + ymc$$

is the mathematical representation of the yellow, magenta, and cyan dot areas in a given color.

Neugebauer Equations

The Neugebauer equations (1937) are based on the following conditions:

let:

R_y = red-light reflectance of yellow ink
R_m = red-light reflectance of magenta ink
R_c = red-light reflectance of cyan ink
R_{ym} = red-light reflectance of the overprint of yellow and magenta
R_{cy} = red-light reflectance of the overprint of cyan and yellow
R_{mc} = red-light reflectance of the overprint of magenta and cyan
R_{ymc} = red-light reflectance of the overprint of yellow, magenta, and cyan

This equation works similarly for the green and blue light reflectances.

Assume red-light reflectance from white paper = 1; then, by incorporating the expressions for the reflectance properties of the inks into the Demichel equations representing the halftone dot areas, we have:

$$R = (1-y)(1-m)(1-c) + y(1-m)(1-c)R_y + m(1-y)(1-c)R_m + c(1-y)(1-m)R_c + ym(1-c)R_{ym} + yc(1-m)R_{yc} + mc(1-y)R_{mc} + ymcR_{ymc}$$

$$G = (1-y)(1-m)(1-c) + y(1-m)(1-c)G_y + m(1-y)(1-c)G_m + c(1-y)(1-m)G_c + ym(1-c)G_{ym} + yc(1-m)G_{yc} + mc(1-y)G_{mc} + ymcG_{ymc}$$

$$B = (1-y)(1-m)(1-c) + y(1-m)(1-c)B_y + m(1-y)(1-c)B_m + c(1-y)(1-m)B_c + ym(1-c)B_{ym} + yc(1-m)B_{yc} + mc(1-y)B_{mc} + ymcB_{ymc}$$

where:

R = the total red-light reflectance,
G = the total green-light reflectance, and
B = the total blue-light reflectance.

The equations can be reformulated to determine the dot areas y, m, and c.

Internal Light Scatter Correction of the Neugebauer Equations. Pobboravsky and Pearson (1972) used the Yule-

Nielsen n factor to correct the Neugebauer equations for internal light scatter. Their equation took the form:

$$R^{1/2.05} = f_1 R_1^{1/2.05} + f_2 R_2^{1/2.05} + \ldots + f_8 R_8^{1/2.05}$$
$$G^{1/2.00} = f_1 G_1^{1/2.00} + f_2 G_2^{1/2.00} + \ldots + f_8 G_8^{1/2.00}$$
$$B^{1/1.80} = f_1 B_1^{1/1.80} + f_2 B_2^{1/1.80} + \ldots + f_8 B_8^{1/1.80}$$

where the values f_1 to f_8 represent the fractional dot areas of the eight additive colors, and R_1 to R_8 represent the corresponding red-light reflectances of the values f_1 to f_8, and similarly for G_1 to G_8 and B_1 to B_8. The values 2.10, 2.00, and 1.80 are their values of n for the red, green, and blue reflectances. The n values would change for other screen rulings, inks, and substrates.

Sampled Spectrum Solution of the Neugebauer Equations. Viggiano suggested (1990) that the Pobboravsky and Pearson modification of the Neugebauer equations could be improved by substituting narrow-band measurements for broadband measurements.

let:

$$R\lambda = \text{reflectance of the tint at wavelength } \lambda$$
$$R'\lambda = \text{red light reflectance of the tint at wavelength } \lambda$$
$$a_p, a_c, a_m, a_y, a_r, a_g, a_b, a_3 = \text{relative areas of paper covered by each of the eight elements (paper, cyan, magenta, yellow, red, blue, green, 3-color)}$$

then:

$$R'\lambda = a_p R'\lambda_p, \ a_c R'\lambda_c, \ a_m R'\lambda_m, \ a_y R'\lambda_y, \ a_r R'\lambda_r, \ a_g R'\lambda_g, \ a_b R'\lambda_b, \ a_3 R'\lambda_3$$

and similarly for $G'\lambda$ and $B'\lambda$.

The equations are solved at each wavelength in the sampled spectrum. $R'\lambda$ is raised to the power n (the Yule-Nielsen parameter) to obtain the spectral reflectances. The reflectance spectrum may be integrated to yield tristimulus or density values.

Additivity and Proportionality Failure-Corrected Solution of the Neugebaur Equations. Warner generates correction factors (Warner 1979, Inoue and Warner 1984) that correct Neugebauer equations for additivity failure and proportionality failure.

Warner calls the total correction factor overcolor modification, that is, the apparent modification to the first-down color caused by the second-down color. The general form of this equation is:

$$x.OCM.Az = x.FDA + (x.CDA=x.FDA)\left[\frac{z.A - z.D}{p.A - p.D}\right]^2$$

where:

x.FDA = the film dot area of the first-down color
x.CDA = the printed dot area of the first-down color
x.OCM = the overcolor modification of the printed dot area of the first-down color due to the interimage effects of the second-down color
A = minimum reflectance value of the first-down color
x = first-down color
z = second-down color
D = minimum reflectance value of the second-down color
p = reflectance value of the substrate determined by the minimum reflectance value of the second-down color

The OCM term is used at appropriate points in the Neugebauer equation to correct for the interimage reflectance problems as shown:

R = p.R(1−y.FDA)(1−m.FDA)(1−c.FDA)
 + y.R(y.FDA)(1−m.FDA)(1−c.CDA)
 + m.R(m.FDA)(1−yOCM.Rm)(1−c.CDA)
 + c.R(c.CDA)(1−yOCM.Rc)(1−mOCM.Rc)
 + r.R(yOCM.Rm)(m.FDA)(1−c.CDA)
 + g.R(yOCM.Rc)(c.CDA)(1−mOCM.Rc)
 + b.R(mOCM.Rc)(c.CDA)(1−yOCM.Rb)
 + t.R(yOCM.Rb)(mOCM.Rc)(c.CDA)
G = p.G(1−y.FDA)(1−m.CDA)(1−c.MDA)
 + y.G(y.FDA)(1−m.CDA)(1−c.MDA)
 + m.G(m.CDA)(1−yOCM.Gm)(1−c.MDA)
 + c.G(c.MDA)(1−yOCM.Gc)(1−mOCM.Gc)
 + r.G(yOCM.Gm)(m.MDA)(1−c.FDA)
 + g.G(yOCM.Gc)(c.MDA)(1−mOCM.Gc)
 + b.G(mOCM.Gc)(c.MDA)(1−yOCM.Gb)
 + t.G(yOCM.Gb)(mOCM.Gc)(c.MDA)

$$
\begin{aligned}
B \quad = \quad & p.B(1-y.CDA)(1-m.MDA)(1-c.FDA) \\
& + \; y.B(y.CDA)(1-m.MDA)(1-c.FDA) \\
& + \; m.B(m.MDA)(1-yOCM.Bm)(1-c.FDA) \\
& + \; c.B(c.FDA)(1-yOCM.Bc)(1-mOCM.Bc) \\
& + \; r.B(yOCM.Bm)(m.MDA)(1-c.FDA) \\
& + \; g.B(yOCM.Bc)(c.FDA)(1-mOCM.Bc) \\
& + \; b.B(mOCM.Bc)(c.FDA)(1-yOCM.Bb) \\
& + \; t.B(yOCM.Bb)(mOCM.Bc)(c.FDA)
\end{aligned}
$$

where:

r.R	=	red reflectance value of the overprint color red
b.R	=	red reflectance value of the overprint color blue
g.R	=	red reflectance value of the overprint color green
t.R	=	red reflectance value of the three-color overprint

and:

yOCM.Rb = Overcolor modification of the yellow dot area [equivalent dot area red reflectance component due to the cyan and magenta overprint color (blue)].

The same notation as described above is used in the corrected equations for the green and blue reflectance values.

Four-Color Version of the Neugebauer Equations. The four-color version of the Neugebauer equations (Hardy and Dench 1948) contain the following extra terms:

let:
Fractional dot area of black = k

then:
Area not covered by black = $1-k$

and let:
R_k = red-light reflectance of black ink
G_k = green-light reflectance of black ink
B_k = blue-light reflectance of black ink

assuming:
$R_{yk} = R_{mk} = R_{ck} = R_{ymk} = R_{mck} = R_{ymck} = R_k$

then the equation for red-light reflectance becomes:

$$R = (1-y)(1-m)(1-c)(1-k) + y(1-m)(1-c)(1-k)R_y +$$
$$m(1-y)(1-c)(1-k)R_m + c(1-y)(1-m)(1-k)R_c +$$
$$ym(1-c)(1-k)R_{ym} + yc(1-m)(1-k)R_{yc} + mc(1-y)(1-k)R_{mc} +$$
$$ymc(1-k)R_{ymc} + kR_k$$

(and similarly for green and blue)

Murray-Davies Equation

Murray published (1936) details of how to determine dot area from density measurements of printed halftones.

if:

a = dot area
D_t = density of tint
D_s = density of solid

then:

$$D_t = -\log[1-a(1-10^{-D_s})]$$

or, solving for a:

$$a = \frac{1-10^{-D_t}}{1-10^{-D_s}}$$

Yule-Nielsen Modification of the Murray-Davies Equation.

Yule and Nielsen suggested (1951) an empirical method of correcting the Murray-Davies equation for internal light scatter.

let:

n = correction for internal light scatter

then:

$$a = \frac{1-10^{-D_t/n}}{1-10^{-D_s/n}}$$

Pearson (1980) suggests that a specific value of 1.70 for n is suitable for most practical applications of the Yule-Nielson equation. The equation then takes this form:

$$D_t = -1.7\log[1-a(1-10^{-0.6D_s})]$$

or:

$$a = \frac{1-10^{-0.6D_t}}{1-10^{-0.6D_s}}$$

Clapper Second-Degree Empirical Equations

Clapper (1961) used a 27-element (halftone and solid values) printed test image and regression analysis techniques to empirically derive the dot area required to match a given color.

The model took this form:

$$c = a_{11}D_r + a_{12}D_g + a_{13}D_b + a_{14}D_r^2 + a_{15}D_g^2 + a_{16}D_b^2 + a_{17}D_r D_g$$
$$+ a_{18}D_r D_b + a_{19}D_g D_b$$

(and similarly for m and y)

The values D_r, D_b, and D_g are the colorimetric densities of the printed color patches and c, m, and y are ink amounts needed to match the original color. The a_{11} to a_{19} values are the unknown coefficients that are calculated by the regression analysis.

Appendix E
Sources of Standards and Related Technical Information
(Primarily English-Speaking Countries)

Official Standards Organizations

American National Standards Institute
11 West 42nd Street, 13th Floor
New York, NY 10036, USA
www.ansi.org

British Standards Institution
389 Chiswick High Road
London W4 4AL, England, UK
www.bsi.org.uk

Commision Internationale de l'Eclairage
CIE Central Bureau
Kegelgasse 27
A-1030 Vienna, Austria
www.cie.co.at/cie

International Organization for Standardization
1 Rue de Varembe
1 211 Geneva 20, Switzerland
www.iso.ch

National Standards Authority of Ireland
Glasnevin
Dublin 9, Ireland
www.nsai.ie

Standards Australia
P.O. Box 1055
Strathfield, NSW 2135, Australia
www.standards.com.au

Standards Council of Canada
45 O'Connor Street, Suite 1200
Ottawa, Ontario K1P 6N7, Canada
www.scc.ca

Standards New Zealand
Standards House
155 The Terrace
Wellington 6001, New Zealand
www.standards.co.nz

Specifications Setting Organizations and Other Useful Addresses

American Society for Testing and Materials
100 Bar Harbor Drive
West Conshohocken, PA 19428, USA
www.astm.org

Australian Government Publishing Service
GPO Box 84
Canberra, ACT 2601, Australia
www.agps.gov.au

Flexographic Technical Association
900 Marconi Avenue
Ronkonkoma, NY 11779, USA
www.fta-ffta.org

Graphic Communications Association
(GRACoL Specifications)
100 Daingerfield Road
Alexandria, VA 22314, USA
www.gca.org

Gravure Association of America
1200-A Scottsville Road
Rochester, NY 14624, USA
www.gaa.org

International Prepress Association
(SWOP Color References)
552 West 167th Street
South Holland, IL 60473, USA
www.ipa.org

International Federation of the Periodical Press Ltd.
(Specifications for European Periodical Printing)
Queens House
55/56 Lincoln's Inn Fields
London, WC2A 3LJ, England, UK
www.fipp.com

Magazines Canada
250 Bloor Street East, Suite 502
Toronto, Ontario M4W 1E6, Canada
www.adcan.com

National Association of Printing Ink Manufacturers
Heights Place
777 Terrace Avenue
Hasbrouck Heights, NJ 07604, USA
www.napim.org

National Printing Ink Research Institute
(Ink Testing Standards)
Lehigh University
Bethlehem, PA 18015, USA
www.napim.org/npiri.html

NPES, The Association for Suppliers of Printing and
 Publishing Technologies
(Source for CGATS and IT8 standards)
1899 Preston White Drive
Reston, VA 20191, USA
www.npes.org

Pacific Area Newspaper Publishers' Association Inc.
 (PANPAspecs)
P.O. Box 449
Milsons Point, NSW 2061, Australia
www.panpa.org.au

Printing Industries of America (SNAP recommendations)
100 Daingerfield Road
Alexandria, VA 22314, USA
www.printing.org

Research and Engineering Council of the Graphic Arts
 Industry, Inc.
P.O. Box 639
Chadd's Ford, PA 19317, USA
www.RECouncil.org

Screen Printing and Graphic Imaging Association
 International
10015 Main Street
Fairfax, VA 22031, USA
www.sgia.org

SWOP, Inc.
60 East 42nd Street, Suite 721
New York, NY 10165, USA
www.swop.org

Technical Association of the Pulp and Paper Industry
(Paper Testing Standards)
P.O. Box 105113
Atlanta, GA 30348, USA
www.tappi.org

United States Government Printing Office
Washington, DC 20401, USA

**Professional
Societies**

Colour Society of Australia
c/o Performance Gap
P.O. Box 207
Maylands, W.A. 6931, Australia
www.curtin.edu.au/society/colour

The Colour Group (Great Britain)
c/o Applied Vision Research Center
Department of Optometry and Visual Science
311-321 Goswell Road
London EC1V 7DD, England, UK
www.city.ac.uk/colourgroup

Institute of Printing
8a Lonsdale Gardens
Tunbridge Wells
Kent TN1 1NU, England, UK
www.globalprint.com/uk/iop

The International Society for Optical Engineering
P.O. Box 10
Bellingham, WA 98227, USA
www.spie.org

Inter-Society Color Council
c/o Cynthia Sturke
11491 Sunset Hills Road
Reston, VA 20190, USA
www.iscc.org

Optical Society of America
2010 Massachusetts Avenue, NW
Washington, DC 20036, USA
www.osa.org

Royal Photographic Society
The Octagon
Milsom Street
Bath, BA1 1DN, England, UK
www.rps.org

The Society for Imaging Science and Technology
7003 Kilworth Lane
Springfield, VA 22151, USA
www.imaging.org

Society for Information Display
1526 Brookhollow Drive, Suite 82
Santa Ana, CA 92705, USA
www.sid.org

Technical Association of the Graphic Arts
68 Lomb Memorial Drive
Rochester, NY 14623, USA
www.taga.org

Research Institutes

EMPA/UGRA
Unterstrasse 11
P.O. Box 977
St. Gallen CH-9001, Switzerland
www.empa.ch
www.ugra.ch

FOGRA
Streitfeldstrasse 19
D-81673 Munich, Germany
www.fogra.org

Graphic Arts Technical Foundation
200 Deer Run Road
Sewickley, PA 15143, USA
www.gatf.org

Pira International
Randalls Road
Leatherhead
Surrey KT22 7RU, England, UK
www.pira.co.uk

Rochester Institute of Technology
Munsell Color Science Laboratory
54 Lomb Memorial Drive
Rochester, NY 14623, USA
www.cis.rit.edu/research/mcsl

University of Derby
Colour and Imaging Institute
Kingsway House East
Kingsway
Derby DE22 3HL, England, UK
colour.derby.ac.uk/colour

Museum The Colour Museum
Perkin House
82 Grattan Road
Bradford BD1 2JB, England, UK
www.sdc.org.uk/museum/mus.htm

Glossary

a*,b* diagram
A graphical representation of a* and b* values of the 1976 CIELAB (CIE L*a*b*) color space.

abnormal color vision
One of several kinds of defective color vision (sometimes inaccurately called "color blindness"), which may take the form of protanopia (red and bluish green confusion); protanomalous (deficient in red response for certain color mixtures); deuter-anopia (red and green confusion); deuteranomaly (deficient in green response for certain color mixtures); tritanopia (blue and yellow confusion); and monochromatism (no discrimination of hue and saturation).

absorption
The taking up of light energy by matter and its transformation into heat. Selective absorption of the range of wavelengths compromising white light produces colored light.

achromatic
The term used to refer to white, grays, and black; having no hue.

actinic
Describes the ability of light to produce changes in materials exposed to it such as photographic emulsions.

actinic density
The density of a color, relative to a positive gray scale, when recorded on a given photographic emulsion.

adaptation
The process by which the human visual mechanism adjusts to the ambient radiant energy conditions.

A/D converter
A device that converts a continuous (analog) signal into a series of discrete (digital) signals.

additive color process
A means of producing a color reproduction or image by combinations of blue, green, and red colored lights, such as in color television systems or on computer monitors.

additive primaries
Blue, green, and red lights of high saturation, which when mixed together in varying combinations and intensities can produce any other color.

additivity failure
An ink on paper printing condition where the total density of the overprinted ink films is not equal to the sum of the individual ink densities that form the overprint.

adjacent color effect
See *simultaneous contrast effect.*

afterimage

Sensation that occurs after the stimulus causing it has ceased. The colors of the afterimage are complementary to those registered initially. Also known as the successive contrast effect.

airbrushing

Retouching prints or artwork by dyes or pigments sprayed on with high-pressure air from small hand-held sprays.

algorithm

A sequential procedure for solving a problem or performing a task that often involves repetition of an operation.

analog

Having a continuously variable frequency or intensity. Analog signals are controlled through "more/less" adjustments, typically using knobs or dials.

apochromat

A lens used for color separation work. This lens will bring the red-, green-, and blue-light bands of the spectrum to the same point of focus.

apparent trap

See *trapping*.

array

A group of light-sensitive recording elements arranged in a line (linear array) or in a grid (area array). Used as a scanner or camera image-sensing device.

ATD color space

A transformation of CIE XYZ color space, with A representing achromatic (brightness), T representing tritanopic (red-green), and D representing deuteranopic (yellow-blue) visual mechanisms.

balanced process inks

A set of process inks of which the ratios of the blue and green actinic densities of the cyan and magenta are equal, enabling the use of only one color correction mask for the yellow printer.

beam splitter

An optical device used to split a single beam of light into two or more beams. Commonly used in color scanners in both input and output sections.

bit

Binary digit. The smallest unit of information a computer will recognize. The result of a choice between two alternatives, such as yes/no or on/off, and represented by 1 or 0.

black

The absence of color; an ink that absorbs all wavelengths of light.

black colors

See *wanted colors*.

black light source

A source rich in ultraviolet and low-frequency blue radiation.

black printer

The plate used with the cyan, magenta, and yellow plates for four-color process printing. Its purpose is to increase the overall contrast of the reproduction and, specifically, improve shadow contrast. Sometimes called the key plate. The letter K is often used to designate this color. See *full-scale black* and *skeleton black*.

blanket

A fabric coated with natural or synthetic rubber that is wrapped around the blanket cylinder of an offset press. It transfers the inked image from the plate to the paper.

brightness

1. A paper property, defined as the percentage reflection of 457-nm radiation.
2. The intensity of a light source.

brightness adaptation
The process by which the visual mechanism adjusts in response to the luminance level of the ambient radiant energy.

bronzing
In process-color printing, the effect that appears when the toner in the last color (often black) migrates to the surface of the printed ink film, causing a change in the spectral aspect of surface light reflection.

C print
A term used by some to describe any reflective color print. The term was used to designate a particular Eastman Kodak integral tripack color print material.

candela (cd)
A metric unit of luminous intensity.

carbon black
The pigment commonly used in black inks. Toners are usually combined with this pigment in the ink formulation to make the black ink more neutral.

CC filter
Color compensating filter, a high transmittance filter used to correct the color balance of transparencies. Available in six colors and several strengths.

charge-coupled device (CCD)
An array of light-sensitive semiconductor material used in a scanner or camera to convert an image into a stream of signals utilizing digital shift register techniques.

chroma
The degree of saturation of a surface color in the Munsell System.

chromatic adaptation
The process by which the visual mechanism adjusts in response to the overall color of the ambient radiant energy.

chromaticity diagram
A graphical representation of two of the three dimensions of color. Intended for plotting light sources rather than surface colors. Often called the CIE diagram.

chrome
A term used to describe a color transparency. It is a contraction of such brand names as Kodachrome, Fujichrome, Ektachrome, or Agfachrome.

chrome yellow
An inorganic pigment which is primarily lead chromate, used for making opaque yellow inks.

CIE
Commission Internationale de l'Eclairage (the International Commission on Illumination) an international standards-setting organization for colorimetry and related measurements.

CIE diagram
See *chromaticity diagram.*

CIE standard observer
A hypothetically ideal observer whose color matching performance conforms to either the 1931 CIE color matching functions for a 2° field size, or to the 1964 CIE color matching functions for a 10° field size.

CIE XYZ color space
A color space defined in terms of the tristimulus values X, Y, Z.

CIELAB color space
The 1976 CIE color space transformation with the dimensions L*, a*, and b*, in which equal distances in the space represent approximately equal color differences.

CIELUV color space
The 1976 CIE color space transformation with the dimensions L*,u*,v*, in which equal distance

in the space represent approximately equal color differences.

cleanliness
Synonym for high saturation.

color balance
The balance between yellow, magenta, and cyan tone scales needed to produce a neutral gray. Determined through a gray balance analysis.

color bars
See *color control strip.*

color blindness
An imprecise term that should no longer be used to describe the condition known as abnormal color vision. See *abnormal color vision.*

color cast
A color's tendency, such as yellowish green, pinkish blue, reddish gray, etc.

color chart
A printed chart containing overlapping halftone tint areas in combinations of the process colors. The chart is used as an aid to color communication and the production of color separation films. The charts should be produced by individual printers using their own production conditions. See *Foss Color Order System.*

color circle
A GATF color diagram used for plotting points as determined by the Preucil Ink Evaluation System. The dimensions are hue error (circumferentially) and grayness (radially). See *Preucil Ink Evaluation System, color triangle, hue, grayness.*

color constancy
A perceptual effect that causes natural color objects to retain their relative daylight appearance under significantly different lighting conditions.

color control strip
Small patches of color solids, overprints, tints, 3-color grays and resolution targets for the purpose of monitoring printing press performance. Sometimes called color bars.

color conversion
A color transparency made from a color reflection original. A conversion is made for the purpose of allowing a rigid reflection copy to be color-separated via a drum-type scanner.

color correction
1. A photographic, electronic, or manual process used to compensate for the characteristics of the process inks and of the color separation process.
2. Any color alteration requested by a customer.

color difference equation
A mathematical expression that represents the perceived visual difference between pairs of colors.

color fusion
A process that occurs when the eye interprets a mosaic of color elements as a continuous color. Fusion is dependent upon the size of the mosaic elements, the viewing distance, and the visual acuity of the observer.

color gamut
The range of colors that can be formed by all possible combinations of the colorants used in a color reproduction system.

color hexagon
A trilinear plotting system for printed ink films. Adapted for the printing industry by GATF, the method was originally developed by Eastman Kodak. A color is located by moving sequentially in three directions (at 120° angles) on the diagram by amounts corresponding to the red, green, and blue densities of the printed ink film. The dia-

gram is generally used as a make-ready analysis chart, particularly for detecting changes from standard in the hue and saturation of solids and overprints.

color imaging system
Image processing equipment and software capable of tone and color correction; image creation or deletion, assembly, enhancement; and other manipulations.

colorimeter
An optical measuring instrument designed to respond to color in a manner similar to the human eye for a given light source.

colorimetry
A branch of color science concerned with measuring and evaluating the colors of objects or images.

color management
The use of appropriate mathematical transformations within a computer system to control and adjust color in an imaging system.

color matching functions
A set of curves derived from experiments that require observers to match a sample color by varying three spectral lights. These curves are related to the sensitivity curves of the cone receptors of the eye and have been defined by the CIE for both 2° and 10° observers.

color monitor
A color CRT with a fine pattern of phosphor dots for use at close viewing distances to guide the color adjustment and correction processes. Also called a video display unit (VDU).

color proof
A printed or simulated printed image of the color separation images that is designed to serve as a prototype of the printed job.

color quality index
See *color rendering index*.

color references
A given set of inks printed at specified densities or strengths on a given substrate used for color control.

color rendering index
A measure of the degree to which a light source, especially a fluorescent light, under specified conditions, influences how the perceived colors of objects illuminated by the source conform to those of the same objects illuminated by a standard continuous source. The standard source is usually some aspect of daylight. Also called color quality index.

color reproduction guide
A printed image consisting of solid primary, secondary, three-, and four-color, and tint areas. Its primary purpose is as a guide for color correction of the optical characteristics of the printing inks and the color separation system. The guide should be produced under normal plant printing conditions.

color scanner
See *scanner*.

color separation
The process of making intermediate images from the color original to record the red-, green-, and blue-light reflectances. These images are used to prepare the cyan, magenta, and yellow printing records. A black separation is also made.

color sequence
The color order of printing the yellow, magenta, cyan, and black inks on a printing press. Sometimes called rotation or color rotation.

color slide
A small-format transparency, typically 35 mm.

color temperature
The temperature in the Kelvin scale to which a theoretically per-

fect black body (a Planckian radiator) would have to be heated to produce a certain color radiation. 5000K is the color temperature of the graphic arts viewing standard. The degree symbol or word is not used in the Kelvin scale. The higher the color temperature, the bluer the light. See *Kelvin*.

color transparency
A positive color photographic image on a clear film base. It must be viewed by transmitted light. Available in sizes ranging from 35-mm color slides up to 8×10-in. sheet film transparencies. See *transmission copy*.

color triangle
A GATF color diagram based on the Maxwell Triangle for plotting points as determined by the Preucil Ink Evaluation System. The dimensions are hue error (around the perimeter) and grayness (radially). Color masking, color gamut, and ink trapping may be determined from the diagram by the use of simple geometric techniques. See *Preucil Ink Evaluation System, color circle*.

continuous tone
Variation of density within a photographic or printed image, corresponding to the graduated range of lightness or darkness in the original copy or scene. Sometimes referred to as contone.

contone
See *continuous tone*.

contrast
Differences between light and dark tones, including the visual relationship of the tonal values within the picture in highlight, middletone, and/or shadow tones.

copy
Any material furnished for reproduction. For color printing it may be a color photograph (print or transparency), artist's drawing, or merchandise sample. Sometimes called original copy. See *original*.

cyan
The subtractive transparent primary color that should transmit blue and green and absorb red light. One of the four process-color inks. Sometimes called process blue.

data compression
The use of mathematical techniques to represent the range of image data by a narrower range and smaller quantity of data.

delta E
A measure of overall color difference between two samples. The different is expressed in MacAdam, NBS or other units. Normally written as DE or ΔE.

densitometer
An electronic instrument used to measure optical density. Available in reflection and transmission versions.

density
The ability of a material to absorb light. Expressed as the logarithm (base 10) of the opacity, which is the reciprocal of the transmission or reflection of a tone.

desaturated color
A color that appears faded, printed with too little ink, or as though gray had been mixed with the colorant.

diarylide yellow
A strong organic pigment frequently used in yellow process inks.

dichroic mirror
A mirror that reflects some colors of light and transmits other colors. Used in scanners to split the light beam reflected from or transmitted through the image.

diffuse highlight
The lightest highlight area that carries important detail, such as

white fabric. Normally, these areas are reproduced with the smallest printed tone value.

digital
Using discrete pulses of signals to represent data. The presence or absence of a condition is represented as "on" or "off."

direct digital proof
A proof made directly from a digital database without the use of an intermediate image.

D$_{max}$
Maximum density that can be achieved in a given photographic or photomechanical system.

D$_{min}$
Minimum density that can be achieved in a given photographic or photomechanical system.

doctor blade
A metal blade or knife used in the gravure process to remove ink from the surface of the gravure cylinder, leaving ink only in the recessed cells. Also used in some flexographic presses to remove ink from the surface of the anilox roll.

dot area
The proportion of a given area which is occupied by halftone dots. Usually expressed as a percentage.

dot etching
A manual technique for chemically changing the dot size on halftone films for purposes of color correction or adjustment of individual areas. Can be localized or general.

dot gain
The change in apparent size of a printing dot from the film to the press sheet. Usually expressed as an additive percentage; for example, an increase in dot size from 50% to 70% is called a 20% gain. Dot gain has a physical component —the gain in the dot area—and an optical component—the darkening of the white paper around the dot caused by light scatter within the substrate. See *optical dot gain* and *physical dot gain*.

doubling
A printing defect that appears as a faint second image slightly out of register with the primary image. Can cause moiré patterns in halftone images.

drum scanner
A color scanner on which the original is wrapped around a rotary scanning drum. See *scanner*.

dry back
The change in density of a printed ink film from wet to dry caused by the penetration of ink into the substrate.

dry etching
A technique for creating selective or overall change in dot areas by manipulating contact printing exposures onto photographic material.

ductor roller
On an offset press, the transfer roller that carries the ink from the fountain to the roller train.

dye
A soluble coloring material, normally used as the colorant in color photographs.

dye transfer prints
A method of producing color prints, first involving the making of red-, green-, and blue-filter separation negatives, and then the subsequent transfer of yellow, magenta, and cyan images from dyed positive matrices.

editorial changes
Modifications requested by the customer to change a particular color in the reproduction so it is unlike the original or the initial specification.

electronic color correction
Color corrections made on a color scanner or similar electronic imaging system.

elliptical dot screen
Halftone screen with an elliptical dot structure. Designed to avoid the sudden jump between midtone densities where the corners of square dots join up. Can help to reduce image graininess.

feedback control chart
An image normally produced on a printing press for the purpose of supplying information to the color separation department to guide the production of color separation films. Gray balance charts, color charts, color reproduction guides and the IT8.7 targets are examples of feedback control charts.

file
A set of related data in the form of text, graphics, or other elements stored under a given identity name or code.

filter
A transparent material characterized by its selective absorption of light of certain wavelengths. Used to separate the red, green, and blue components of an original when making color separations.

first-surface reflection
Light scattering from the surface of a printed ink film, substrate or original.

five- and six-color printing
A photomechanical variant of subtractive color reproduction systems that uses such additional chromatic colors as pink, light blue, or red in addition to colors similar to the process primaries. Capable of achieving expanded color gamut.

flare
Nonimage light that veils the image and reduces its contrast. Some light from the image itself can be scattered within the optical system to create image-dependent flare.

flatbed scanner
A color scanner on which the original is mounted on a flat scanning table. See *scanner*.

flat color
An ink specifically formulated to produce a desired hue, printed either solid or as a halftone tint, and not designed to be mixed by superimposing on another ink or inks to produce varieties of hues.

fluorescence
The emission of light by a substance following the absorption of light of a shorter wavelength. Added to the light reflected by the color in the normal way, fluorescence gives an extra brightness. Often occurs through the conversion of ultraviolet radiation into visible radiation. Can occur in printing inks, papers, or original photographs, artwork, or retouching dyes and pigments.

FM screening
See *stochastic screening*.

Foss Color Order System
A printed color chart that features color order, visually equal tone spacing, compact design, and full-range black treatment. Invented by Carl E. Foss.

fountain blade
On an offset press, the strip or segmented blade that forms the bottom of the ink fountain. The fountain roller forms the other side of the ink trough. By moving the blade closer to or farther away from the fountain roller, the thickness of the ink film across the roller can be controlled.

four-color printing
A subtractive color reproduction process that uses yellow, magenta, cyan, and black colorants.

full-scale black
A black printer that will print in all tonal areas of the reproduction from the highlight to the shadow.

gamma
The ratio of the contrast range of all or part of the reproduction to the corresponding contrast range of the original. A gamma of 1.0 means that the reproduction has the same contrast range as the original.

gloss
Physical characteristic of a surface. A high gloss is suggestive of a polished surface that has the effect of reducing first-surface reflections and increasing the density range and saturation of the image.

grain
Silver salts clumped together in differing amounts in different types of emulsions. Generally speaking, the faster emulsions have larger grain sizes.

graininess
Visual impression of the irregularly distributed silver grain clumps in a photographic image, or the ink film in a printed image.

gray balance
The values for the yellow, magenta, and cyan that are needed to produce a neutral gray when printed at a normal density. When gray balance is achieved, the separations are said to have correct color balance. Gray balance is determined through the use of a gray balance chart. See *color balance*.

gray balance chart
A printed image consisting of near neutral grid patterns of yellow, magenta, and cyan dot values. A halftone black gray scale is used as a reference to find the three-color neutral areas. The dot values making up these areas represent the gray balance requirements of the color separations. The gray balance chart should be produced under normal plant printing conditions. See *gray balance*.

gray component replacement
The process of removing the smallest halftone dot in areas where yellow, magenta, and cyan all print, together with quantities of the other two colors sufficient to produce a neutral gray, and replacing that neutral with black ink.

gray-field analysis
The use of a color measurement system and color difference equations to monitor printed variations in the three-color gray field within a color control strip.

grayness
In the Preucil Ink Evaluation System, the lowest of the three (red, green, and blue) densities expressed as a percentage of the highest.

$$\% \text{ Grayness} = \frac{L}{H} \times 100$$

gray scale
A strip containing a series of tones stepped from white to black that is used for monitoring tone reproduction. A gray scale is a photographic image in either transparent or reflective form. Sometimes called a step wedge.

gray wedge
An image that varies continuously from white to black that is used for monitoring tone reproduction. It is a form of gray scale but does not have discrete tone steps. Sometimes used during color scanner setup.

halftone
Image in which the range of tones consists of dots with varying area but of uniform density. Creates the illusion of continuous tone when seen at a distance. The normal imaging technique for reproducing

tones by lithography, letterpress, flexography, and screen printing.

halftone tint
An area covered with a uniform halftone dot size to produce an even tone or color.

halogen lamp
A long-life gas-filled quartz envelope with an enclosed tungsten filament sometimes used as an analyzing source in a scanner (also called quartz-halogen or tungsten-halogen).

hard proof
A tangible, stable proof such as an ink-on-paper proof.

hardware
Computer equipment such as disk drives, central processing units, terminals, keyboards, magnetic tape drives, and all of their components.

helical
Having the form of a spiral.

Hering theory
A theory of color vision proposed during the nineteenth century by the German physiologist and psychologist Ewald Hering. Hering regarded yellow and blue, red and green, and black and white as pairs of opponent colors, where one member of each pair is perceived at a time.

high-fidelity color
The use of supplementary inks to expand the gamut of the yellow, magenta, cyan and black printing system.

high key
A photographic or printed image composed largely of lighter tones in which the main interest area lies in the highlight end of the scale.

highlights
The lightest areas in a reproduction. See *diffuse highlight* and *specular highlight*.

hue
Quality of sensation according to which an observer is aware of differences of wavelength of radiant energy, such as blue, green, yellow, and red.

hue error
In the Preucil Ink Evaluation System, the largest unwanted absorption of a process ink, expressed as a percentage of the wanted absorption, both after subtracting the lowest unwanted absorption. Red-, green-, and blue-filter densitometer readings are made of a given color and used to compute the hue error with the following equation:

$$\% \text{ Hue Error} = \frac{M - L}{H - L} \times 100$$

where H = the highest density reading, M = the middle, L = the lowest. The term is used to indicate departure from the hypothetical ideal hue for a process ink.

Hurvich-Jameson Theory
See opponent-process model.

illuminant metamerism
Differences in color matches of spectrally different samples reported by the same observer under different illumination conditions.

image carrier
A plate, stencil or cylinder containing an image that is preferentially inked.

image processing
The manipulation of pictorial data to change its characteristics for a specific purpose.

indirect digital proof
A proof made indirectly from a digital database via an intermediate film or plate image.

ink film thickness
Thickness of an ink film printed on
a substrate. There is no simple
relationship between this term and
density, although the two are
related.

ink trap
See *trapping*.

integral tripack
Photographic film or paper with
three main emulsion layers coated
on the same base. Each layer is
sensitive to one primary color of
light. During processing, a subtrac-
tive primary color dye image is
formed in each layer.

intensity
A synonym for color saturation.

interest area
The region of the tone scale within
a particular photograph that con-
tains the object of primary interest
or importance to the customer or
observer.

interimage reflection
The passage of light between layers
of ink and the substrate. Can con-
tribute to additivity failure and
other printed image characteristics.

Jones diagram
A graphical method of presenting
steps in objective tone reproduction
from the original to the separation
images and the printed sheet. The
relevant information at each stage
is linked to the next by plotting the
graphs on a quadrant in such a way
that the influence of each succes-
sive step is displayed. Named after
its inventor, Lloyd A. Jones.

just noticeable difference (JND)
A term used to describe the differ-
ence in color perception which is
statistically noticeable in 50% of
tests.

Kelvin (K)
Scale and unit of color temperature
measurement starting from
Absolute zero, which is equivalent
to –273.15 degrees Celsius. The
units of the scale are the same as
those in the Celsius scale. Named
after the Scottish mathematician
and physicist Lord Kelvin. See *color
temperature*.

key
1. In photography, the emphasis on
 lighter or darker tones in a print;
 high key indicates prevalence of
 light tones; low key, prevalence
 of dark tones.
2. See *black*.

laser
An acronym for Light Amplification
by Stimulated Emission of Radia-
tion. A device that produces a
single-wavelength, unidirectional,
intense beam of light.

lead screw
Means of providing axial movement
of the analyzing and recording
heads of a rotary-drum scanner.

lightness
Perception by which white tones
are distinguished from gray or
black, and light from dark color
tones.

lightness/dot gain trade-off
The nature of the decision made by
the press operator when adjusting
printed ink film thickness. Thin ink
films will produce low dot gain
along with light solids. Thick ink
films will produce darker solids
along with increased dot gain.

lithol rubine
A reddish pigment used for making
magenta inks. This pigment has
relatively poor blue-light reflection.

lookup table
A two- or three-dimensional array
of stored color input signals and
corresponding output signals.

low key
A photographic or printed image composed mainly of darker tones in which the main interest area lies in the shadow end of the scale.

lux
Metric unit of illumination equal to 1 lumen per square meter.

MacAdam Unit
A just perceptible difference in color. See *NBS unit* and *just noticeable difference*. Named for David L. MacAdam.

magenta
The subtractive transparent primary color that should transmit blue and red and absorb green light. One of the four process-color inks. Sometimes called process red.

masstone
Color of ink in mass. Will differ for transparent inks from the printed color of the ink.

matte
A dull surface that scatters incident light, thus causing the underlying tone to appear lighter or desaturated. Lacking gloss or luster.

Maxwell Triangle
Equilateral color triangle devised by James Clerk Maxwell in 1851 to show the composition of the ranges of colors produced by additive mixtures of red, green, and blue light.

memory
A device into which data can be entered and held for subsequent retrieval and use in a computer system.

metameric colors
Colors that are spectrally different but visually identical under particular illumination conditions. Also known as metamers.

metamerism
The process where a change in illuminant will cause visual shift in a metameric color for a given observer. See *observer metamerism* and *illuminant metamerism*.

metamers
See *metameric colors*.

midtones or middletones
The tonal range between highlights and shadows.

modeling
The apparent detail in a picture that shows an article has surface texture or relief, such as the surface of an orange.

moiré
An interference pattern caused by the out-of-register overlap of two or more regular halftone dot or line patterns. In process-color printing, screen angles are selected to minimize this pattern. If the angles are not correct, an objectionable effect may be produced. See *rosettes*.

mottle
Uneven color or tone.

Munsell System
A method of classifying surface color in a three-dimensional solid. The vertical dimension is called value, the circumferential dimension is called hue, and the radial dimension is called chroma. The colors in the collection are spaced at subjectively equal visual distances.

Murray-Davies Equation
An equation for the calculation of printed dot area based on densitometer measurements. The resulting calculations are for total dot area, including the optical and physical aspects. See *Yule-Nielsen Equation*.

nanometer
Unit measure of wavelength applying to electromagnetic radiation. Equivalent to 10^{-9} meters. Visible light wavelengths range from about 400–700 nanometers.

NBS unit
The overall color difference between two samples. Sometimes referred to as a Judd Unit or a Judd-Hunter Unit. it is approximately four times as great as the smallest difference that is observable under ideal conditions. See *MacAdam Unit.*

Neugebauer Equations
A set of linear equations used for calculating tristimulus values of halftone color mixture combinations when the dot areas of the contributing colors are known.

neutral
Any color that has no hue, such as white, gray, or black.

noise
Unwanted optical effects or electronic signals that distort an image.

nonreproducible colors
Colors in an original scene or photograph that are impossible to reproduce using a given set of colorants because they are outside the gamut of the system. See *color gamut.*

normal key
A photographic or printed image in which the main interest area is in the middletone range of the tone scale, or is distributed throughout the entire tone range.

observer metamerism
Differences in color matches of spectrally different samples between different observers under constant illumination.

off-press proofing
See *prepress proofing.*

OK sheet
An approved press sheet that is intended for use as a quality guide for the rest of the production run.

opacity
Describes a material's lack of transparency. In photography, it is defined as the reciprocal of the fraction of light transmitted through, or reflected from, a given tone. For printing ink, it is defined as the ink's ability to hide or cover up the image or color over which it is applied.

opponent-process model
A theory of color vision that has been refined by Leo M. Hurvich and Dorothea Jameson. The theory assumes the existence of long, medium, and short wavelength cone receivers linked to cells that process stimuli in an opponent manner. It contains elements of the Young-Helmholtz and Hering theories.

optical density
The light-stopping ability of a photographic or printed image expressed as the logarithm of its opacity, which in turn is the reciprocal of the reflection or transmission.

optical dot gain
The optical effect that occurs around the perimeter of a halftone dot that makes it appear darker than would be predicted from its physical size.

optimum color reproduction
A technically excellent reproduction that incorporates the compromise, corrective and preferred objectives that are imposed by the printing system, requested by the customer, or subconsciously preferred by the observer.

original
A photograph, artist's drawing, or merchandise sample submitted for reproduction by the photomechanical process. Sometimes called original copy. See *copy.*

Ostwald System
A system of arranging colors in a color solid. The colors are described in terms of color content, white content, and black content. The solid appears as two cones, base to

base, with the hues around the base, and with white at one apex and black at the other.

overprint colors

A color made by overprinting any two of the primary yellow, magenta, and cyan process inks to form red, green, or blue secondary colors.

Pantone Matching System

A system of solid ink color mixing based on nine colors plus white and black. Not to be used for the specification of process dot percentage combinations. Mixed colors were referred to as PMS colors. The term PMS is no longer used by Pantone.

pastel colors

A term used to describe soft or light colors usually in the highlight to midtone range.

peaking

Electronic edge enhancement produced by exaggerating the density differences at tonal boundaries to create the visual effect of increased image sharpness.

Photo CD

A color imaging system developed by the Eastman Kodak Company that uses compact disks to store images originally existing as 35-mm color negatives or color transparencies. A professional version can handle transparencies up to 4×5 in.

photomultiplier

Highly sensitive photoelectric element that transforms light variations into electric currents. Used in scanners to convert image information into electrical signals.

phthalocyanine

A pigment available in green shade or blue shades. A combination of the two is often used to create the cyan ink for process-color printing.

physical dot gain

The characteristic physical spread of ink around the perimeter of halftone dots during the process of transferring ink to a substrate.

picking

A disturbance of the paper's surface that occurs during ink transfer when the forces required to split an ink film are greater than those required to break away portions of the paper surface.

pigment

An insoluble coloring material in finely divided form. Usually the colorant in printing inks.

pixel

Picture element. The smallest tonal element in a digital imaging or display system.

potentiometer

A variable resistor. Used for setting the analog computer input values on analog scanners or for varying light intensity.

prepress proof

A photochemical or electrophotographic image designed to simulate printed results that are produced directly from digital image files or indirectly from those files via film images. See *direct digital proof* and *indirect digital proof*.

press proof

A color proof produced on either a regular printing press or a special proof press.

Preucil Ink Evaluation System

A color evaluation system developed by Frank M. Preucil. A reflection densitometer is used to measure a printed ink film through Wratten #25, #58, and #47 filters relative to the substrate. These measurements are converted into hue error and grayness parameters for plotting on color diagrams. See

hue error, grayness, color circle, color triangle.

primary colors
Colors that can be used to generate secondary colors. For the additive system, these colors are red, green, and blue. For the subtractive system, these colors are yellow, magenta, and cyan.

process blue
See *cyan.*

process-color reproduction
A printed color reproduction using the three process inks or the three process inks and black.

process-ink gamut chart
A color chart for comparing the gamut or color limits that can be produced from any given ink set and substrate combination.

process inks
A set of transparent yellow, magenta, and cyan inks used for full-color printing. A black ink is also included in a four-color process ink set.

process red
See *magenta.*

profile
A mathematical relationship between a standard color space and either the input color response of an image capture device, or output color values of a color recording device or of a color monitor.

program
A set of instructions for manipulating data on a computer.

progressive proof
A set of press proofs that includes the individual colors, interspersed with overprints of the two-, three-, and four-color combinations in their order of printing.

proof
A prototype of the printed job that is made from plates (press proof), film, or electronic data (prepress proofs). It is generally used for customer inspection and approval before mass production begins. See *press proof, prepress proof, color proof.*

proportionality failure
A common condition in halftone color printing where the ratio of red- to green- to blue-light reflectance in halftone tints is not the same as that in continuous ink solids of the same color.

purity
A synonym for saturation.

quality
When applied to printed images, it could mean: (1) the aesthetic aspect, influenced largely by the creativity and knowledge of the designer; (2) the technical or excellence aspect, the way the original is processed through the photomechanical system; (3) the consistency aspect; or (4) the permanence aspect.

quartz-halogen
See *halogen lamp.*

random proof
See *scatter proof.*

real-time
Computing at a speed that can produce results without a noticeable delay.

reflection copy
An original that must be viewed by reflected light.

reflex blue
Used as a toner in black inks to neutralize the brownish tinge of carbon black pigments.

resolution
The ability to record or discern discrete image elements. High-resolution images are more lifelike.

Retinex theory
Color vision theory developed by Edwin Land postulating the interaction between cone signals in the retina or the visual cortex as a means of explaining color constancy.

retouching
The art of making selective corrections of images.

rhodamine
A bluish red pigment used for making magenta ink. The Y or yellow shade form of the pigment is normally selected. Has the best blue-light reflectance of the commonly used magenta pigments.

rosettes
The patterns observed in lighter and medium tones when halftone color images are printed in register at the correct angles.

rotation
See *color sequence*.

rubine magenta
See *lithol rubine*.

sampling rate
The frequency used to record an image. Great enlargements require the use of high-frequency scanning and a high sampling rate.

saturation
The dimension of color that refers to a scale of perceptions representing a color's degree of departure from an achromatic color of the same brightness. The less gray a color contains, the more saturated it is.

scanner
A color separation device that converts the optical properties of originals into electronic forms of color separation images that are suitable for subsequent image processing.

scatter proof
A proof containing many unrelated images positioned on the substrate with the intent of fully using the maximum area available from a prepress or press proofing system. Also called a random proof.

screen angle
The angle at which the rulings of a halftone screen are set when making screened images for halftone process-color printing. The halftone dot pattern angle.

screen ruling
The number of lines per inch, in each direction, on a halftone screen.

screen tint
A halftone screen pattern of all the same dot size that creates an even tone.

secondary colors
Colors produced by overprinting pairs of the primary colors. The subtractive secondary colors are red, green, and blue. Same as overprint colors. The secondary additive colors are yellow, magenta, and cyan.

separation images
Three photographic negative or positive images recording the red, green, and blue components of the colors of the original. A fourth image is usually produced through all three filters for the black printer. May exist in the form of electronic data, films, or image carriers.

separation filters
Red, green, and blue filters each transmitting about one-third of the spectrum and used when making color separations.

servo motor
An auxiliary motor that is controlled by an amplified signal from a command device. Used to power the traverse motion on drum scanners.

setoff
The undesirable transfer of wet ink to the following sheet in the delivery pile of a sheetfed press.

shadows
The darkest areas in a reproduction.

sharpness
The subjective impression of the density difference between two tones at their boundary.

signal-to-noise ratio
The strength of the image signal relative to the strength of the unwanted optical or electronic signals.

simultaneous contrast effect
The visual influence of an adjacent color area on another color. This effect is especially strong when the adjacent color is relatively large and has high saturation. Also known as the adjacent color effect.

skeleton black
A black printer that will print only the darker half of the gray scale from the middletones to the shadow areas.

slide scanner
A CCD-based scanner that accommodates color transparencies up to about 2¼×2¼ in. in a flat frame for scanning.

slur
A directional dot distortion effect that can occur in halftone printing. A round dot on the plate would appear elliptical in shape on the printed sheet.

soft proof
An intangible, unstable proof such as the image on a color monitor.

software
The instructions needed to control and operate a computer. Primarily, a computer program.

solid-state
An electronic device or component that is usually composed of a solid semiconducting material and depends on the movement of charge carriers within it for its operation.

spectral response
The manner in which the eye responds to visible radiation. Often used to also describe how the light-sensitive component (PMT or CCD) in a color separation system responds to visible and invisible radiation.

spectrophotometer
An instrument for measuring the relative intensity of radiation throughout the spectrum that is reflected from or transmitted by a sample.

spectrophotometric curve
A graph showing the reflectance or transmittance of a sample as a function of wavelength.

specular highlight
The lightest highlight area that does not carry any detail, such as reflections from glass or polished metal. Normally, these areas are reproduced as unprinted white paper.

spot color
Localized nonprocess ink color. May be printed as a supplemental color within a process color reproduction.

standard inks
A set of process inks made to the standards of a specifications-setting organization. Common in the publications industry for proofing advertising reproductions.

standard viewing conditions
A prescribed set of conditions under which the viewing of originals and reproductions are to take place, defining both the geometry of the illumination and the spectral power distribution of the illuminant. For

printed images, the standard specifies 5,000 K color temperature, 90 color-rendering index, 2,200 lux intensity, and viewing at an angle to reduce glare.

star target
A circular test image containing alternating light and dark wedge shapes that meet at a point in the center of the target. Initially developed for evaluating the resolution of optical and photographic systems. Now a common target that was adapted to printing industry use by George W. Jorgensen for monitoring dot gain, slur, and doubling on press.

step wedge or step tablet
See *gray scale*.

stochastic screening
A computer-driven algorithm that disperses halftone dot information or content in semi-random form throughout the individual halftone grids or cells. Also know as FM (frequency modulation) screening.

substrate
The paper or any other generally flat material upon which an image is printed.

subtractive color process
A means of producing a color reproduction or image by combinations of yellow, magenta, and cyan colorants on a white substrate.

subtractive primaries
Yellow, magenta, and cyan transparent dyes or pigments. When combined in various intensities or areas (dots), they can produce any other color.

successive contrast effect
See *afterimage*.

superadditivity
The opposite of additivity failure. Occurs when the total density of overprinted ink films exceeds the sum of the individual ink densities that form the overprint.

tack
The resistance to splitting of an ink film between two separating surfaces, i.e., stickiness. To improve trapping in wet-on-wet printing, the ink being printed should have a lower tack than the ink film that was printed before it.

texture
1. A property of the surface of the substrate that imparts a tactile quality or sensation.
2. Variation in tonal values to form image detail. See *modeling*.

three-color gray
A neutral or near neutral area, or field, within a color control strip. Composed of about 40% cyan and amounts of magenta and yellow required to achieve an approximate neutral.

tinctorial strength
The concentration of colorant in a printing ink.

tint
1. A halftone area that contains dots of uniform size, that is, no modeling or texture.
2. The mixture of a color with white.

toggle
The act of switching back and forth from one file or display to another for the purposes of comparing two images. The two images usually represent "before" and "after" stages of image processing or manipulation.

tone reproduction
A term that relates the density of every reproduced tone to the corresponding original density. This relationship is best described by the use of graphical techniques.

toner
A supplementary pigment that is added to printing inks for greater tinctorial strength or improved color.

transformation algorithm
A set of instructions or equations used to transform input values (such as yellow, magenta, and cyan colorants) into output values (such as red, green, and blue signals used to create a simulation on a color monitor).

transmission copy
An original that must be viewed by transmitted light. Typically, a color transparency or color slide.

transparent ink
An ink that contains a vehicle and a pigment with the same refractive index. Excluding the selective color absorption, these inks will allow light to be transmitted through them without loss. See *opacity*.

trapping
The ability of an ink to transfer equally to unprinted substrate and a previously printed ink film. Also known as ink trap to distinguish it from image trap. Apparent trap is measured via the equation:

$$\frac{D_{op} - D_1}{D_2} \times 100$$

where D_1 = the density of the first-down color, D_2 = the density of the second-down color, and D_{op} = the density of the overprint, all measured through the filter complementary to the second-down color.

tristimulus colors
Three color stimuli which, when combined in appropriate proportions, will closely match any given reference color. In practice, red, green, and blue lights are used. Their composition may range from monochromatic spectral lines to bands of wavelengths, each of which comprises about one-third of the visible spectrum.

tungsten-halogen
See *halogen lamp*.

ultraviolet (UV)
Invisible electromagnetic radiation of a shorter wavelength (1–400 nm) than blue. Can create fluorescence effects with the appropriate materials.

undercolor addition (UCA)
A technique for adding more cyan, magenta, and yellow to dark, neutral tonal areas of a reproduction.

undercolor removal (UCR)
A technique used to reduce proportionate yellow, magenta, and cyan dot percentages in neutral tones and replacing them with increased amounts of black ink.

undertone
Color of ink printed in a thin film. See *masstone*.

unsharp masking
Typically, an electronic simulation of a photographic effect that relies upon the combined influence of a light unsharp negative photographic mask and the sharp original image from which it was made to enhance the sharpness of subsequent images from the combination.

unwanted colors
Colors that should not be in three of the patches of a color-separated Color Reproduction Guide; for example, no yellow in cyan, blue, and magenta in the yellow separation. Sometimes called white colors.

value
Term used in the Munsell System to describe lightness.

viewing conditions
See *standard viewing conditions*.

wanted colors

Colors that should be in three of the patches of a color-separated Color Reproduction Guide; for example, yellow in red, yellow, and green in the yellow separation. Sometimes called black colors.

wavelength

Quantitative specification of kinds of radiant energy.

white

1. The presence of all colors.
2. The visual perception produced by light of relatively high overall intensity and having the same relative intensity of each wavelength in the visible range that sunlight has.

white colors

See *unwanted colors*.

Wratten filters

Comprehensive range of photographic filters manufactured by Eastman Kodak Company.

xenon lamp

A high-pressure lamp used as the analysis light source in some scanners.

yellow

The subtractive transparent primary color that should transmit red and green, and absorb blue light. One of the four process-color inks.

Young-Helmholtz Theory

The theory of color vision proposed by Thomas Young in the early nineteenth century that our judgments of color are based on the functioning of three kinds of receptors in the eye, each having peak sensitivities in the red, green, and blue parts of the spectrum, respectively. H.L.F. von Helmholtz and James Clerk Maxwell elaborated on this theory.

Yule-Nielsen Equation

A modification of the Murray-Davies Equation to compensate for light scatter within a substrate when measuring printed dot area with a reflection densitometer. This equation calculates the physical dot area.

zone theory

See *opponent-process model*.

References

Adams, R.M. and J.B. Weisberg, *The GATF Practical Guide to Color Management*, Graphic Arts Technical Foundation, Pittsburgh, Pennsylvania (1998).

Albers, J., *Interaction of Color*, Yale University Press, New Haven (1963).

Anacona, E.P., Letter to the editor, *ISCC News* No. 303, pp. 21–22 (September/October 1986).

Bartleson, C.J. and E.J. Brenemen, "Brightness Reproduction in the Photographic Process," *Photographic Science and Engineering*, Vol. 11, No. 4, pp. 254–262 (1967).

Bassimer, R.W. and J.S. Lavelle, "Colorimetric Parameters of Lithographic Prints at Various Film Thicknesses," *TAGA Proceedings*, pp. 327–347 (1993).

Bassimer, R.W. and W.F. Zawacki, "A Method for the Measurement and Specification of Process Ink Transparency," *TAGA Proceedings*, pp. 297–312 (1994).

Berger-Schunn, A., *Practical Color Measurement,* John Wiley & Sons, Inc., New York (1994).

Berlin, B. and P. Kay, *Basic Color Terms*, University of California Press, Berkeley and Los Angeles, California (1969).

Billmeyer, F.W., Jr., "Survey of Color Order Systems," *Color Research and Application*, Vol. 12, No. 4, pp. 173–186 (August 1987).

Blatner, D. and S. Roth, *Real World Scanning and Halftones,* Peachpit Press, Berkeley, California, pp. 15–21 (1993).

Boll, H., "A Color to Colorant Transformation for a Seven Ink Process," *Proceedings of IS&T's Third Technical Symposium on Prepress, Proofing & Printing,* pp. 31–36 (1993).

Bourges, J., *Color Bytes,* Chromatics Press, Forest Hills, New York (1997).

Brill, M.H. and G. West, "Chromatic Adaptation and Color Constancy: A Possible Dichotomy," *Color Research and Application*, Vol. 11, No. 3., pp. 196–264 (Fall 1986).

Brunner, F. "System Brunner PCP Picture Contrast Profile," *TAGA Proceedings,* pp. 256–263 (1987).

Bruno, M.H., *Principles of Color Proofing*, GAMA Communications, Salem, New Hampshire (1986).

Burch, R.M., *Colour Printing and Colour Printers*, Paul Harris Publishing, Edinburgh, reprinted ed. (1983), original edition Sir Isaac Pitman and Sons, Ltd., London (1910).

Bureau, W.H., *What the Printer Should Know about Paper*, second edition, Graphic Arts Technical Foundation, Pittsburgh, Pennsylvania (1995).

Burnham, R.W., R.M. Hanes and C.J. Bartleson, *Color: A Guide to Basic Facts and Concepts*, John Wiley & Sons, Inc., New York (1963).

Chevreul, M.E., *The Principles of Harmony and Contrast of Colors and Their Applications to the Arts* (ed. F. Birren), Schiffer Publishing, West Chester, Pennsylvania (1987).

Clapper, F.R., "An Empirical Determination of Halftone Color-Reproduction Requirements," *TAGA Proceedings*, pp. 31–41 (1961).

Clapper, F.R., "Improved Color Separation of Transparencies by Direct Screening," *Journal of Photographic Science*, pp. 28–33 (1964).

Clapper, F.R., "Computerized Colour Correction," *Printing Technology*, Vol. 13, No. 1, pp. 3–8, and Vol. 13, No. 2, pp. 94–96 (discussion) (1969).

Clapper, F.R., "Modified Use of Subtractive Color Triangle to Obtain Mask Percentages," *TAGA Proceedings*, pp. 503–512 (1971).

Coote, J.H., *The Illustrated History of Colour Photography*, Fountain Press, Surbiton, Surrey (1993).

Cost, F., *Using Photo CD for Desktop Prepress*, RIT Research Corporation (1993).

Cox, F.L., *The GATF Color Diagrams*, GATF Research Progress No. 81, Graphic Arts Technical Foundation, Pittsburgh, Pennsylvania (1969).

Cox, F.L., *GATF Gray Balance Chart*, GATF Research Progress No. 83, Pittsburgh, Pennsylvania (1969).

Dalal, E.N. and P. C. Swanton, "Preferred Gloss Levels for Color Images," *TAGA Proceedings*, pp. 195–205 (1996).

Delabastita, P.A., "Screening Techniques, Moiré in Four Color Printing," *TAGA Proceedings*, pp. 44–65 (1992).

Demichel, E., Report in: *Le Procédé à la Société Française de Photographie* (La Section Procédés Photomécaniques), Vol. 26, No. 3, pp. 17–21, 26–27 (1924).

Eldred, N.R. and T. Scarlett, *What the Printer Should Know about Ink*, Second Edition, Graphic Arts Technical Foundation, Pittsburgh, Pennsylvania (1990).

Elyjiw, Z. and F.M. Preucil, *The New GATF Color Reproduction Guide*, GATF Research Progress No. 67, Pittsburgh, Pennsylvania (1964).

Elyjiw, Z., *GATF Compact Color Test Strip*, GATF Research Progress No. 79, Pittsburgh, Pennsylvania (1968).

Elyjiw, Z. and J. A. C. Yule, *A Color Chart for Representing Process Ink Gamuts*, Report No. 137, Rochester Institute of Technology, Rochester, New York, Revised Edition (1972).

Evans, R.M., *An Introduction to Color*, John Wiley & Sons, Inc., New York (1948).

Evans, R.M., "Accuracy in Color Photography and Color Television," in *ISCC Proceedings* (ed. Milton Pearson), RIT Graphic Arts Research Center, Rochester, pp. 38–59 (1971).

Evans, R.M., *The Perception of Color,* John Wiley & Sons, Inc., New York (1974).

Fairchild, M.D., *Color Appearance Models*, Addison-Wesley, Reading, Massachusetts (1998).

Fenton, H.M. and F.J. Romano, *On-Demand Printing: The Revolution in Digital and Customized Printing* (2nd ed.), Graphic Arts Technical Foundation, Pittsburgh, Pennsylvania (1997).

Field, G.G. *Balanced Inks—A Review of "Standards,"* GATF Research Progress Report No. 87, Pittsburgh, Pennsylvania (1971).

Field, G.G., "The 1970–71 GATF Color Survey," *TAGA Proceedings*, pp. 297–317 (1972).

Field, G.G. (ed.), *Advances in Color Reproduction*, Graphic Arts Technical Foundation, Pittsburgh, Pennsylvania (1973).

Field, G.G., *A Systems Analysis of Color Reproduction*, GATF Annual Research Department Report for 1973, Graphic Arts Technical Foundation, Pittsburgh, Pennsylvania, pp. 57–66 (1974).

Field, G.G., "Color Sequence in Four Color Printing," *TAGA Proceedings*, pp. 510–521 (1983).

Field, G.G., "The Systems Approach to Color Reproduction—A Critique," *TAGA Proceedings*, pp. 1–17 (1984).

Field, G.G., "Ink Trap Measurement," *TAGA Proceedings*, pp. 382–396 (1985).

Field, G.G., "Color Specification Methods," *TAGA Proceedings*, pp. 8–25 (1987).

Field, G.G., "Influence of Ink Sequence on Color Gamut," *TAGA Proceedings*, pp. 673–677 (1987).

Field, G.G., "Color Correction Objectives and Strategies," *TAGA Proceedings*, pp. 330–349 (1989).

Field, G.G. "Image Structure Aspects of Printed Image Quality," *Journal of Photographic Science*, Vol. 38, pp. 197–200 (1990a).

Field, G.G., *Color Scanning and Imaging Systems*, Graphic Arts Technical Foundation, Pittsburgh, Pennsylvania (1990b).

Field, G.G., *Tone and Color Correction*, Graphic Arts Technical Foundation, Pittsburgh, Pennsylvania (1991).

Field, G.G., *Printing Production Management,* Graphic Arts Publishing Company, Livonia, New York (1996a).

Field, G.G., "Printed Image Quality Thresholds," *TAGA Proceedings*, pp. 14–25 (1996b).

Field, G.G., "Color Approval in the Graphic Arts," *Proceedings of the Fifth IS&T / SID Color Imaging Conference*, pp. 56–61 (1997).

Fisch, R.S., "Studies on the Levels of Undercolor Addition and Black Printer Levels in GCR/UCA Four-Color Lithographic Printing," *TAGA Proceedings,* pp. 11–29 (1990).

FFTA, *Flexography: Principles and Practices*, 4th edition, (ed. Frank Siconolfi), Foundation of the Flexographic Technical Association, Inc., Ronkonkoma, New York (1991).

Foss, C.E. and G.G. Field, *The Foss Color Order System*, GATF Research Progress Report No. 96, Graphic Arts Technical Foundation, Pittsburgh, Pennsylvania (1973).

Ganz, E. "Whiteness Formulas: A Selection," *Applied Optics*, v. 18, no. 7, pp. 1073–1078 (1979).

Garvin, D.A., "What Does 'Product Quality' Really Mean?" *Sloan Management Review,* pp. 25–43 (Fall 1984).

GATF, *The Lithographers Manual*, 9th edition, (ed. Thomas M. Destree), Graphic Arts Technical Foundation, Pittsburgh, Pennsylvania (1994).

GEF and GAA, *Gravure Process and Technology*, (ed. Brett Rutherford), Gravure Association of America, Rochester, New York (1991).

Genshaw, M.A., B.F. Phillips and K.A. Ruggiero, "Computer Formulation of Colors for Letterpress," *Journal of Coatings Technology*, pp. 75–79 (August 1984).

Giorgianni, E.J. and T.E. Madden, *Digital Color Management: Encoding Solutions*, Addison-Wesley, Reading, Massachusetts (1998).

Girod, R., "Changes in Contrast in Great Enlargements and Reductions," *Hell Topics*, No. 1, p. 3 (1984).

Granville, W.C., "Colors Do Look Different after a Lens Implant!" *Color Research and Application*, Vol. 15, No. 1, pp. 59–62 (February 1990).

Green, P., *Understanding Digital Color*, Graphic Arts Technical Foundation, Pittsburgh, Pennsylvania (1995).

Grum, F., "Colorimetry of Fluorescent Materials," in *Optical Radiation Measurements*, *Vol. 2: Color Measurement* (eds. Franc Grum and C. James Bartleson), Academic Press, New York, pp. 235–288 (1980).

Grum, F. and C.J. Bartleson, eds. *Optical Radiation Measurements*, *Vol. 2: Color Measurement,* Academic Press, New York (1980).

Gustavson, S., "Color Gamut of Halftone Reproduction," *Journal of Imaging Science and Technology,* Vol. 41, No. 3, pp. 283–290 (1997).

Hardy, A.C. and E.C. Dench, "An Electronic Method for Solving Simultaneous Equations," *Journal of the Optical Society of America*, Vol. 38, No. 4, pp. 308–312 (April 1948).

Hardy, A.C. and F.L. Wurzburg, Jr., "An Electronic Method of Colour Correction," *The Penrose Annual*, Lund Humphries & Co. Ltd., London (1949).

Heuberger, K.J., Zhou Mo Jing and S. Persiev, "Color Transformations and Color Lookup Tables," *TAGA Proceedings*, Vol. 2, pp. 863–881 (1992).

Hull, H.H., *Controlling Ink Distribution in Lithography and Letterpress*, GATF Research Project Report No. 95, Pittsburgh, Pennsylvania (1973).

Hunt, R.W.G., "Objectives in Colour Reproduction," *Journal of Photographic Science*, Vol. 18, pp. 205–215 (1970).

Hunt, R.W.G., *Measuring Colour*, Second Edition, Ellis Horwood Ltd., London (1991).

Hunt, R.W.G., *The Reproduction of Colour*, Fifth Edition, The Fountain Press, Tolworth, England (1995).

Hunter, R.S. and R.W. Harold, *The Measurement of Appearance*, second edition, John Wiley & Sons, New York, pp. 75–89 (1987).

Hurvich, L.M., *Color Vision*, Sinuaer Associates, Sunderland, Massachusetts (1981).

Inoue, M. and R.D. Warner, *A Revised Interimage Reflectance Model and Its Application to Prepress Proofs*, GATF Annual Research Department Report 1983–84, Pittsburgh, Pennsylvania, pp. (3)1–15 (1984).

Jackson, R., L. MacDonald and K. Freeman, *Computer Generated Colour*, John Wiley & Sons, Chichester, England, pp. 158–159 (1994).

Jacobson, R.E., "An Evaluation of Image Quality Metrics," *Journal of Photographic Science*, Vol. 43, pp. 7–16 (1995).

Johnson, A.J. and J.W. Birkenshaw, "The Influence of Viewing Conditions on Colour Reproduction Objectives," *14th IARIGAI Conference Proceedings* (ed. W. H. Banks), Pentech Press Ltd., Plymouth, Devon, pp. 48–72 (1977).

Johnson, T., *Colour Management in Graphic Arts and Publishing*, Pira International, Leatherhead, Surrey (1996).

Johnson, T. and M. Scott–Taggart, *Guidelines for Choosing the Correct Viewing Conditions for Colour Publishing*, Pira International, Leatherhead, Surrey (1993).

Jones, L.A., "On the Theory of Tone Reproduction with a Graphic Method for the Solution of Problems," *Journal of the Society of Motion Picture Engineers*, Vol. 16, pp. 568–599 (1931).

Jorgensen, G.W., *Sharpness of Halftone Images on Paper*, LTF Research Progress No. 47, Chicago, Illinois (1960).

Jorgensen, G.W., *Lithographic Image Definition*, LTF Research Progress No. 62, Chicago, Illinois (1963).

Jorgensen, G.W., *The Rendition of Fine Detail in Lithography*, GATF Research Progress No. 73, Pittsburgh, Pennsylvania (1967).

Jorgensen, G.W., "Preferred Tone Reproduction for Black and White Halftones," in *14th IARIGAI Conference Proceedings* (ed. W. H. Banks), Pentech Press, Plymouth, Devon, pp. 109–142 (1977).

Jorgensen, G.W., *Control of Color Register*, GATF Research Project Report No. 114, Pittsburgh, Pennsylvania (1982).

Jung, E.J., H. Winkelmann and G. Bestmann, "Use of Image Analysis and Colorimetric Calibration for Automatic Setting of Scanner- and Reproduction-Parameters," *TAGA Proceedings*, pp. 161–178 (1992).

Kaiser, P.K., "Phototherapy Using Chromatic, White, and Ultraviolet Light," *Color Research and Application*, Vol. 9, No. 4, pp. 195–205 (Winter 1984).

Kang, H.R., *Color Technology for Electronic Imaging Devices*, SPIE Optical Engineering Press, The Society of Photo-Optical Instrumentation Engineers, Bellingham, Washington (1997).

Kelly, K.L. and D.B. Judd, *The ISCC-NBS Method of Designating Colors and a Dictionary of Color Names*, National Bureau of Standards Circular 553, U.S. Department of Commerce, Washington, DC (1955).

Keuhni, R.G., *Color: An Introduction to Practice and Principles*, John Wiley & Sons, Inc., New York (1997).

Kipphan, H. "Color Measurement Methods and Systems in Printing Technology and Graphic Arts," *Proceedings No. 1912 SPIE*, pp. 278–298 (1993).

Korman, N.I., *Self-Adaptive System for the Reproduction of Color*, U.S. Patent 3,612,753 (October 12, 1971).

Korman, N.I. and J.A.C. Yule, "Digital Computation of Dot Areas in a Colour Scanner," *11th IARIGAI Conference Proceedings* (ed. W. H. Banks), pp. 93–106 (1973).

Kubo, S., M. Inui and Y. Miyake, "Preferred Sharpness of Photographic Color Images," *Journal of Imaging Science*, Vol. 29, No. 6, pp. 213–215 (Nov/Dec 1985).

Land, E.H. and J.J. McCann, "Lightness and Retinex Theory," *Journal of the Optical Society of America*, Vol. 61, No. 1, pp. 1–11 (January 1971).

Land, E.H., "The Retinex Theory of Color Vision," *Scientific American*, pp. 108–128 (December 1977).

Leekley, R.M., F.L. Cox and J.G. Jordan, "The Ball Four- and Five–Color System," *TAGA Proceedings*, pp. 78–88 (1953).

Lind, J.T., "How to Establish Color Tolerances," *GATFWorld*, v. 2, no. 1, pp. 29–38 (1990).

MacAdam, D.L., *Sources of Color Science*. MIT Press, Cambridge, Mass. (1970).

MacPhee, J., "A Definitive Strategy for the Closed Loop Control of Process Color Printing—Round One," *TAGA Proceedings*, pp. 180–203 (1988).

MacPhee, J. and J.T. Lind, "The Primary Paper Property That Affects Density Range," *TAGA Proceedings*, pp. 414–432 (1994).

Margulis, D., *Professional Photoshop*, John Wiley & Sons, Inc., New York (1995).

Margulis, D., *Makeready—A Prepress Resource*, MIS Press, New York, pp. 2–16 (1996).

Maurer, R.E., "The Reproduction of Over and Under Exposed Transparencies," *TAGA Proceedings*, pp. 38–64 (1972).

McDowell, D.Q., "Graphic Arts Color Standards Update—1997," *SPIE Proceedings*, Vol. 3018, pp. 148–155 (1997).

McLaren, K., *The Colour Science of Dyes and Pigments*, Adam Hilger Ltd., Bristol, second edition (1986).

Miller, M.D. and R. Zaucha, *The Color Mac*, Hayden, Carmel, Indiana (1992).

Molla, R.K., *Electronic Color Separation*, RK Printing and Publishing, Montgomery, West Virginia (1988).

Mollon, J., "Seeing Colour," in *Colour Art & Science* (eds. Trevor Lamb and Janine Bourriau), Cambridge University Press, Cambridge, pp. 127–150 (1995).

Murray, A., "Monochrome Reproduction in Photoengraving," *Journal of the Franklin Institute*, Vol. 221, No. 6, pp. 721–744 (1936).

Neugebauer, H.E.J., "Die Theoretischen Grundlagen des Mehrfarbendruches," *Zeitschrift Weissenschaften Photography*, v. 36, pp. 73–89 (1937).

OSA, *The Science of Color*. Committee on Colorimetry of the Optical Society of America, Washington, DC (1953).

Paul, A.," Brighter Colours, Higher Costs: 7-Colour Printing Opens Up New Possibilities in Specific Sections of the Market," *Professional Printer*, Vol. 40, No. 6, pp. 12–14 (1996).

Pearson, M. (ed.), *ISCC Proceedings 1971* (Optimum Reproduction of Color), RIT Graphic Arts Research Center, Rochester, New York (1971).

Pearson, M. "n Value for General Conditions," *TAGA Proceedings*, pp. 415–425 (1980).

Pobboravsky, I., "Transformation from a Colorimetric to a Three- or Four-Colorant System for Photomechanical Reproducton," *Photographic Science and Engineering*, pp. 141–148 (May/June 1964).

Pobboravsky, I. and M. Pearson, "Computation of Dot Areas Required to Match a Colorimetrically Specified Color Using Modified Neugebauer Equations," *TAGA Proceedings*, pp. 65–77 (1972).

Pointer, M.R., "Measuring Colour Reproduction," *Journal of Photographic Science*, Vol. 34, No. 3, pp. 81–90 (1986).

Preucil, F., "Color and Tone Errors of Multicolor Presses," *TAGA Proceedings*, pp. 75–100 (1958).

Preucil, F.M., *How to Test the Effect of Paper Color on Process Color Reproductions*, LTF Research Progress No. 51, Chicago (1961).

Preucil, F.M., *A New Method of Rating the Efficiency of Paper for Color Reproductions*, LTF Research Progress No. 60, Chicago (1962).

Preucil, F.M., "How Strong to Run the Colour?" *The Penrose Annual,* Lund Humphries, London, pp. 273–278 (1965).

Pugsley, P. C., *Image Recording Methods and Apparatus,* British Patent 1,369,702 (9 October 1974) and U.S. Patent 3,893,166 (July 1, 1975).

Rhodes, W.L., "Review of the Aims of Color Reproduction in Printing," in *ISCC Proceedings* (ed. Milton Pearson), RIT Graphic Arts Research Center, Rochester, New York pp. 126–138 (1971).

Rhodes, W., "Fifty Years of the Neugebauer Equations," Neugebauer Memorial Seminar on Color Reproduction, (ed. Kazuo Sayanagi), *SPIE Proceedings*, Vol. 1184, pp. 7–18 (1990).

Rich, D.C., "The Effect of Measuring Geometry on Computer Color Matching," *Color Research and Application*, Vol. 13, No. 2, pp. 113–118 (April 1988).

Rolleston, R. and R. Balasubramamian, "Accuracy of Various Types of Neugebauer Model," *Proceedings of the First IS&T/SID Color Imaging Conference*, pp. 32–37 (1993).

Romano, F.J., *Pocket Guide to Digital Prepress*, Delmar Publishers, Albany, New York (1996).

Rudomen, B., "Digital Imaging Brings 'True Color' to Separations," *Computer Graphics World*, pp. 40–42, 46 (September 1985).

Sayanagi, K., "Black Printer, UCR and UCA—Gray Component Replacement," *TAGA Proceedings,* pp. 711–724 (1987).

Schirmer, K.-H. and D. Tollenaar, "Optical Densities of Halftone Prints," *11th IARIGAI Conference Proceedings* (ed. W. H. Banks), pp. 109–121 (1973).

Schläpfer, K. and J. Keretho, "Undertrapping in Wet-on-Wet Printing and Undercolor Removal (UCR)," *14th IARIGAI Conference Proceedings* (ed. W.H. Banks), pp. 195–213 (1979).

Sherman, P.D., *Colour Vision in the 19th Century*, Adam Hilger, Bristol (1981).

Sipley, L.W., *A Half Century of Color*, Macmillan Company, New York (1951).

Stanton, A.P., "Measured Photography," *GATFWorld*, Vol. 6, No. 1, pp. 19–26 (1994).

Southworth, M. and D. Southworth, *Color Separations on the Desktop*, Graphic Arts Publsihing, Livonia, New York (1993).

Tritton, K., *Colour Control for Lithography,* Pira International, Leatherhead, Surrey (1993).

Tritton, K., *Stochastic Screening*, Pira International, Leatherhead, Surrey (1996).

Viggiano, J.A.S, "Modelling the Color of Multi-Colored Halftones," *TAGA Proceedings*, 1990, pp. 44–62.)

Warner, R.D., *"A Three-Color Interimage Reflectance Model,* GATF Annual Research Department Report, 1979, Pittsburgh, Pennsylvania, pp. 133–146 (1980).

Warner, R.D., T.A. Whiteman and T. Phillips, *The Electronic Color Scanner: Color Correction and Gray Balance*, GATF Technical Services Report No. 7729, Pittsburgh, Pennsylvania (1982).

Yule, J.A.C., "The Theory of Subtractive Color Photography III. Four-Color Processes and the Black Printer," *Journal of the Optical Society of America,* Vol. 30, pp. 322–331 (1940).

Yule, J.A.C., *Principles of Color Reproduction*, John Wiley & Sons, New York (1967).

Yule, J.A.C., and W.J. Nielsen, "The Penetration of Light into Paper and Its Effect on Halftone Reproductions," *TAGA Proceedings*, pp. 65–76 (1951).

Index
Author and Name

Index
Subject

About the Author

Gary G. Field is an Imaging Scientist and Professor of Graphic Communication at the California Polytechnic State University, San Luis Obispo, California. He is a leading authority on color reproduction and printing quality, and has lectured on these subjects at universities and conferences in the United States, Britain, Australia and Canada.

Gary Field, who was born in Melbourne, Australia, entered the printing industry in 1960, and worked as a color separator and printing technologist at a number of companies in Australia and England prior to being appointed Supervisor of the Color and Photography Research Division at the Graphic Arts Technical Foundation. His research work at GATF, and later as a university faculty member, covered the application of systems engineering concepts to color reproduction, and also explored aspects of color printing, image quality, color separation, and quality measurement.

Author of the GATF books *Color Scanning and Imaging Systems* and *Tone and Color Correction*, Professor Field has also written over 60 technical and scientific papers for such publications as the *TAGA Proceedings, Professional Printer,* the *Journal of Photographic Science,* and the *McGraw-Hill Encyclopedia of Science and Technology*. Professional recognition of his research work has included the Gold Medal of the Institute of Printing, the TAGA Honors Award, and Accredited Senior Imaging Scientist certification from the Royal Photographic Society.

Mr. Field's formal printing education commenced at the Royal Melbourne Institute of Technology, and was followed by advanced studies in printing science and technology at the Nottingham Trent University. An expansion of his color-correction strategy research work at Nottingham led to the Insignia Award in Technology from the City and Guilds of

London Institute. He also holds an MBA degree from the University of Pittsburgh.

An active participant in the work of professional societies, Professor Field is a Fellow of the Institute of Printing, a member of the Technical Association of the Graphic Arts, and a Fellow of the Royal Photographic Society. He is also a member of the Society for Imaging Science and Technology, The Colour Group (Great Britain), and the Colour Society of Australia, and is a TAGA delegate to the Inter Society Color Council.

About GATF

The Graphic Arts Technical Foundation is a nonprofit, scientific, technical, and educational organization dedicated to the advancement of the graphic communications industries worldwide. Its mission is to serve the field as the leading resource for technical information and services through research and education.

For 75 years the Foundation has developed leading edge technologies and practices for printing. GATF's staff of researchers, educators, and technical specialists partner with nearly 2,000 corporate members in over 65 countries to help them maintain their competitive edge by increasing productivity, print quality, process control, and environmental compliance, and by implementing new techniques and technologies. Through conferences, satellite symposia, workshops, consulting, technical support, laboratory services, and publications, GATF strives to advance a global graphic communications community.

The Foundation publishes books on nearly every aspect of the field; learning modules (step-by-step instruction booklets); audiovisuals (CD-ROMs, videocassettes, slides, and audiocassettes); and research and technology reports. It also publishes *GATFWorld,* a bimonthly magazine of technical articles, industry news, and reviews of specific products.

For detailed information about GATF products and services, please visit our website at **www.gatf.org** or write to us at 200 Deer Run Road, Sewickley, PA 15143-2600. Phone: 412/741-6860.

GATF*Press*: Selected Titles

- ***Careers in Graphic Communications: A Resource Book***
 by Sally Ann Flecker & Pamela J. Groff

- ***Color Scanning and Imaging Systems***
 by Gary G. Field

- ***Computer-to-Plate: Automating the Printing Industry***
 by Richard M. Adams II & Frank J. Romano

- ***Digital Photography: New Turf for Printers***
 by David L. Milburn with John L. Carroll

- ***Flexography Primer***
 by J. Page Crouch

- ***The GATF Encyclopedia of Graphic Communications***
 by Frank Romano and Richard Romano

- ***The GATF Practical Guide to Color Management***
 by Rich Adams and Joshua Weisberg

- ***Glossary of Graphic Communications***
 compiled by Pamela Groff

- ***Gravure Primer***
 by Cheryl Kasunich

- ***Guide to Desktop Publishing***
 by James Cavuoto and Steven Beale

- ***Handbook of Printing Processes***
 by Deborah Stevenson

- ***Implementing Quality Management in the Graphic Arts***
 by Herschel L. Apfelberg & Michael J. Apfelberg

- ***The Lithographers Manual***
 edited by Thomas M. Destree

- ***Lithography Primer***
 by Dan Wilson

- ***On-Demand Printing:***
 The Revolution in Digital and Customized Printing
 by Howard Fenton and Frank Romano

- ***The PDF Bible: The Complete Guide to Adobe Acrobat 3.0***
 by Mark Witkowski

- ***Printing Plant Layout and Facility Design***
 By A. John Geis

- ***Screen Printing Primer***
 by Samuel T. Ingram

- ***Sheetfed Offset Press Operating***
 by Lloyd P. DeJidas & Thomas M. Destree

- ***A Short History of Printing***
 by Frank Romano & Peter Oresick

- ***Solving Sheetfed Offset Press Problems***
 by GATF Staff

- ***Solving Web Offset Press Problems***
 by GATF Staff

- ***Tone and Color Correction***
 by Gary G. Field

- ***Total Production Maintenance:***
 A Guide for the Printing Industry
 by Kenneth E. Rizzo

- ***Understanding Digital Color***
 by Phil Green

- ***Web Offset Press Operating***
 by GATF Staff

- ***What the Printer Should Know about Ink***
 by Nelson R. Eldred & Terry Scarlett

- ***What the Printer Should Know about Paper***
 by Lawrence A. Wilson

An Introduction to CHEMISTRY

MARK BISHOP

Monterey Peninsula College

Benjamin Cummings

Capetown Hong Kong London Madrid Mexico City
Montreal Munich Paris Singapore Sydney Tokyo Toronto
San Francisco Boston New York

Editorial Director: Frank Ruggirello
Executive Editor: Ben Roberts
Assistant Editor: Lisa Leung
Design Manager: Blakeley Kim
Managing Editor: Joan Marsh
Senior Development Editor: Margot Otway
Development Editor: Moira Lerner Nelson
Media Producer: Claire Masson
Market Development Manager: Chalon Bridges
Marketing Manager: Christy Lawrence
Text Designer: Thompson Steele, Inc.
Cover Design: Blakeley Kim, Emiko-Rose Koike
Art Studio: Thompson Steele, Inc.
Photo Researcher: Thompson Steele, Inc.
Manufacturing Coordinator: Vivian McDougal
Project Coordination and Electronic Page Makeup: Thompson Steele, Inc.

Library of Congress Cataloging-in-Publication Data
Bishop, Mark A.
 An introduction to chemistry / Mark Bishop.-- 1st ed.
 p. cm.
 Includes index.
 ISBN 0-8053-2177-2 (student ed. : alk. paper)
 1. Chemistry. I. Title.
QD33.2 .B57 2002
540--dc21
 2001047343

1 2 3 4 5 6 7 8 9 10—QWV—04 03 02 01

www.aw.com/bc

Brief Contents

Contents

Preface
To the Instructor

AN INTRODUCTION TO CHEMISTRY is intended for use in beginning chemistry courses that have no chemistry prerequisite. It was written for students who want to prepare themselves for general college chemistry, for students seeking to satisfy a science requirement, and for students in health-related or other programs that require a one-semester introduction to general chemistry. No matter what your students' goals, this book will help them to learn the basics of chemistry.

I have taught introductory chemistry for over 25 years, and for much of that time I have considered writing my own text. One reason was that the existing textbooks struck me as disjointed. They read more like a list of skills to master than like a coherent story of the nature of chemistry. I thought it should be possible to organize the fundamentals of chemistry so that each would flow smoothly into the next, but it wasn't until I made some changes in my course that I began to take the prospect of writing a new textbook seriously.

The first change I tried was to move the description of unit conversions from the beginning of the course to the middle. I decided that one reason why the course felt disjointed was that I kept jumping back and forth between the description of the basic concepts of chemistry and the explanation of unit conversions. Postponing the mathematics enabled me to focus on chemistry in the first part of the course. Moreover, as a result of this change, my students develop far stronger computational skills than I was able to give them before. (The reasons for this are described below.) While I recommend this change, I know it is not an option in all courses. Therefore, I designed this text so that unit conversions can be either introduced at the start of the course or postponed (as I prefer) until later.

The second change I made was to put more emphasis on developing my students' ability to visualize the particle nature of matter. Students too often view chemistry as a set of rules for manipulating numbers, symbols, and abbreviations, never really connecting these rules to a physical reality. They can balance equations and do chemical calculations, but they cannot answer questions about what is happening on the particle level when an acid reacts with a base. Thus, whenever appropriate, I enhance the standard topics covered in introductory chemistry with corresponding descriptions of events from the particles' "point of view."

The final factor that led to the creation of this text and its supplements is that I learned to create computer-based tools myself, and it occurred to me that a package whose text and computer-based ancillaries were all produced by the same person would offer real benefits. The Web-based tools that accompany this text include animations, glossary quizzes for each chapter, tutorials to consolidate and enhance important skills, and Web pages that provide extra information. Because I have created both the tools and the text, I think you will find that they fit together seamlessly.

Read on for a more detailed discussion of how these changes have been incorporated into *An Introduction to Chemistry* and its supplements. Each innovation has been developed with the ultimate goal of making it easier for you to give your students a coherent understanding of chemistry, a positive attitude toward chemistry (and toward you and your course), and a solid foundation on which to build, should they decide to continue their chemistry studies.

Flexible Order of Math–Related Topics

Do you spend a lot of time in the first week or two of your course teaching unit conversions and significant figures? If so, do many students lose interest or even drop the course because they find the math-related topics boring and perhaps intimidating?

The single most beneficial change I have made in my prep-chem course has been to shift the coverage of unit conversions from the beginning to the middle of the semester. As detailed below, this book can be used to support either that approach or a more traditional one. Delaying the coverage of unit conversions enables me to describe elements, compounds, and chemical reactions earlier than usual and, I believe, to give my students a much better understanding of what chemistry really is. Students emerge from the first lectures with a better attitude toward the course and with more confidence in their abilities—which, in my experience, has translated into significantly lower drop rates. One of the most important by-products of this change, in my assessment, is that my students end up *better equipped* with math-related skills than would otherwise be the case (see "More Emphasis on Math–Related Topics," below). Immediately after I teach them the technique of dimensional analysis, they begin using it in mole calculations. Thus, instead of learning the technique at the start of the course, and then largely forgetting it, and then trying to relearn it in haste, the students learn it well and then immediately consolidate their knowledge.

Because not everyone will choose to restructure their course in this way, I organized this book to allow several approaches to teaching unit conversions. The optional Inter-Chapters 1A, located between Chapters 1 and 2, gives a brief introduction to dimensional analysis and metric–metric conversions. Chapter 8, which covers dimensional analysis comprehensively, can be used either in its current position or early in the course.

■ An instructor who wishes to introduce unit conversions briefly at an early point in the course (perhaps to prepare the students for labs), while postponing a comprehensive treatment of the topic, can use the text in its current order.

■ An instructor who wishes to teach unit conversions in detail early in the course can skip Inter-Chapter 1A and instead cover Chapter 8 immediately after Chapter 1. Chapter 8 is written so that students can read it without confusion before reading Chapters 2 through 7.

■ An instructor who, like myself, wishes to delay the discussion of unit conversions until the middle of the course can skip Inter-Chapter 1A and cover the remaining chapters in their current order. Chapter 8 is located

so that it teaches unit analysis immediately before the students need the technique for mole calculations.

Early Introduction to Chemical Reactions

Are you ever frustrated that it takes so long to get to describing interesting chemical changes?

Most prep-chem texts don't describe chemical reactions until midway through the text or even later, thereby reinforcing students' expectations that chemistry will be boring and irrelevant. In this text, chemical reactions are described in Chapters 4 through 6.

More Emphasis on Math-Related Topics

Do you ever wish that you could cover unit conversions in more detail but resist doing so because it would further postpone the introduction of the description of elements, compounds, and chemical changes?

Although I postpone the math-related topics in my prep-chem courses, I think they are extremely important. Therefore, I have devoted three full chapters to them. Chapter 8 teaches unit conversions using dimensional analysis, Chapter 9 describes chemical calculations and chemical formulas, and Chapter 10 covers chemical calculations and chemical equations.

More Logical Sequence of Topics

In many texts, Chapter 1 or 2 asks the reader to classify substances as elements, compounds, or mixtures and to classify changes as chemical or physical. Do you find it difficult to describe compounds before your students have a clear understanding of atoms and elements? Do you find it hard to describe chemical changes before your students know about chemical bonds and chemical compounds?

In the first week of class, I used to ask my students to classify substances as elements, compounds, or mixtures. That required me to introduce the concept of an element long before any significant discussion of atoms and to describe compounds without first presenting a clear depiction of elements. I was equally uncomfortable asking students to classify changes as chemical or physical before they had any clear definition of chemical bonds. Now I move smoothly from the kinetic molecular theory to a description of atoms and elements (Chapter 2). This flows into a description of chemical bonds and chemical compounds (Chapter 3), which in turn forms the basis for an understanding of the nature of solutions and the processes of chemical changes (Chapters 4, 5, and 6). The introductory discussions that felt so disjointed to me in the past now seem to follow a logical progression—a story, really—that flows from simple to more complex.

Emphasis on the Development of Visualization Skills

Do you ever worry that your students can write balanced chemical equations but do not have a clear mental image of the events that occur during a chemical reaction?

I think it is extremely important for students to develop the ability to visualize the models that chemists use for describing the structure and behavior of matter. I want them to be able to connect a chemical equation with a visual image of what is happening in the reaction. Throughout the text, I emphasize the development of a mental image of the structure of matter and the changes it undergoes. I start with a more comprehensive description of the kinetic molecular theory than is found in most books, and I build on that description in the sections on elements, compounds, and chemical changes. To help the student visualize structures and processes, I provide the colorful and detailed illustrations that are a prominent feature of the book. Moreover, the book's Web site provides animations based on key illustrations.

Identification of Skills to Review

When your students have trouble with a task, is it ever because they have not completely mastered some of the lessons presented in earlier chapters?

The Review Skills section at the start of each chapter lists skills from earlier chapters that will be needed in the present chapter. The students can test their mastery of each skill by working the problems in the Review Questions section at the end of each chapter.

Instructors who wish to teach chapters in a different order than the one in the book can use these sections to identify topics that may require supplementation. The Instructor's Manual contains a list of various possible chapter orders, with suggested detours to ensure that the students always have the skills they need.

Sample Study Sheets

Are the best-organized students in your class often the most successful? Do you ever wish that the text you were using helped students get more organized?

In an introductory chemistry course, it really pays to be organized. This text helps students get organized by providing Sample Study Sheets for many of the tasks they will be expected to do on exams. Each study sheet describes how to recognize a specific kind of task ("Tip-off") and then breaks the task down into general steps. Each study sheet is accompanied by at least one worked example.

Extensive Lists of Learning Objectives

Do your students ever complain that they do not know what they are supposed to be able to do after studying a chapter in the text?

The learning objectives listed at the end of each chapter are more comprehensive than the objectives in other texts. They list all the key skills taught in the chapter, thus helping students to focus on the most critical material. Objective references in the margins of the chapter denote the paragraphs that pertain to each objective, so that a student who has trouble with a particular objective can easily find the relevant text discussion. Many of the end-of-chapter problems are similarly referenced, so that students can see how each objective might be covered on an exam.

Chapter Glossaries and Glossary Quizzes

Do you wish your text did more to help students learn the language of chemistry?

Learning the language of science is an important goal of the courses for which this text is designed. Most books have a glossary at the back, but I suspect that students rarely refer to it. In addition to a glossary at the back of the book, this text also has a list of new terms at the end of each chapter, where it can serve as a chapter review. Glossary quizzes for each chapter can be found on the book's Web site.

More Real–World Examples

Do your students feel that what they read in their textbook is far removed from the real world?

This text is full of real-world examples, both in the chapter narrative and in the problems. For instance, after introducing the idea of limiting reactants, Section 10.2 explains why chemists design procedures for chemical reactions in such a way that some substances are limiting and others are in excess. Chapter 9 problems mention vitamins, cold medicines, throat lozenges, antacids, gemstones, asphalt roofing, fireworks, stain and rust removers, dental polishing agents, metal extraction from natural ores, explosives, mouthwashes, Alar on apples, nicotine, pesticides, heart drugs, Agent Orange, thalidomide, and more. The chemical reactions used in problems often represent actual industrial processes. Several of the Special Topics scattered throughout the book describe the achievements of "green chemistry."

Key Ideas Questions

Have you ever wondered whether the chapter reviews in many textbooks are useful to students?

After the Review Questions section at the end of each chapter is a section titled Key Ideas. Students are given a list of numbers, words, and phrases that they use to fill in the blanks in a series of statements that follows the list. The statements summarize the most important ideas from the chapter—that is, they add up to a chapter review. Because this review is a game of sorts, the students get more actively involved and are more interested in recalling key ideas than they do when reading a chapter summary.

Acknowledgments

Writing a textbook is a much bigger project than I ever imagined it would be, and to bring such a project this far requires many people, all of whom deserve my heartfelt thanks. The biggest thank you goes to my family. My loving and beautiful wife, Elizabeth, has not only done much more than her share of the tasks necessary to keep our home running smoothly, she has also kept our home a happy one. Her patience and generosity have allowed me to "disappear" to work on the project with a minimum of guilt. My kids (Meagan, Benjamin, and Claire) have had to do without their dad all too often, but they have always been understanding. I want to

give a special thanks to my adult daughter, Meagan, to my brother, Bruce, and to my mother, C. Joan Ninneman. They each provided a sympathetic ear when the project got me down, and they were constant sources of good advice. I'm a truly lucky man to have been blessed with such a family.

Next on my list of those to thank are my saintly developmental editors, Sue Ewing and Moira Lerner Nelson. Sue was there at the beginning, not only helping to convert the original book that existed only in my head into a realistic text, but also giving me support and advice at every step of the way. Moira took over at the midpoint of the process, and her suggestions have led to extensive improvements in the organization and language of the text. Moira, like Sue before her, has been a caring friend as well as a constant source of good ideas. It has been a great pleasure to see the book get better and better in response to the advice of these two professionals.

I want to thank the people of Benjamin Cummings who have been essential in guiding the project to completion. First, I want to thank Anne Scanlon Rohrer, the acquisitions editor at Benjamin Cummings who had the courage to sign an unknown author to a book contract. Although she moved on to other things soon after the signing, I still appreciate her confidence in me and her belief in the value of the project. I also want to acknowledge the contributions of others at Benjamin Cummings: Linda Davis, president; Ben Roberts, executive editor; Maureen Kennedy, former acquisitions editor; Joan Marsh, managing editor; Margot Otway, senior advisor; Chalon Bridges, market development manager; Christy Lawrence, marketing manager; Frank Ruggirello, vice president and editorial director; Stacy Treco, director of marketing; Lisa Leung, assistant editor; Claire Masson, Tony Asaro, George Ellis, Nancy Gee, Claudia Herman, Blakeley Kim, and Emiko-Rose Koike.

I am grateful to the people at Thompson Steele Production Services who found the photos, improved my images, copyedited and proofread the text, and did the composition and page layout. I really enjoyed working with Andrea Fincke, my project editor. She has the toughness required to keep things moving, combined with a charming personality and a quick wit. I also want to thank Sally Thompson Steele, designer and consultant; Cia Boynton, art editor; Abby Reip, photo researcher; Connie Day, copy editor; Jeff Coolidge, photographer; Jim Atherton, illustrator; and Suzanne Kelly, page layout artist. I would also like to thank the principal and the science department at the Bromfield School for their assistance.

Another person who contributed significantly, though indirectly, to the writing of this text was Rodney Oka, my colleague and friend at Monterey Peninsula College. Rod shouldered many of the chemistry department tasks that I was just too busy to do, and he allowed me to continue to teach the same introductory courses long after he would have preferred to switch with me. (I'm sure he would rather get cash, but I thought a strong thank you in print would be more lasting.)

Next, I want to thank Ron Rinehart, another of my colleagues, and Adam Carroll for checking the solutions for all of the problems in the text. Their attention to detail was much appreciated. Last, but certainly not least, I want to thank the many people who have reviewed the text at every stage in the process. They have been my main contact with the community of chemistry instructors and, in that capacity, have given me both invaluable

advice on many aspects of the work and encouragement to see the project through to the end. I want to give special thanks to Phil Reedy of Delta College and Walter Dean of Lawrence Technological University. They have been reviewing the manuscript from the beginning, and I hope they will see something of themselves between these covers. I also want to thank Donald Wink of the University of Illinois at Chicago, who, until he decided to write a competing text of his own, did his best to keep me honest. I want all of the following reviewers to know that I greatly appreciate their contributions:

Elaine Alfonsetti, Broome Community College; Nicholas Alteri, Community College of Rhode Island; Joe Asire, Cuesta College; Caroline Ayers, East Carolina University; M.R. Barranger-Mathys, Mercyhurst College; Cheryl Baxa, Pine Manor College; Bill Bornhorst, Grossmont College; Tom Carey, Berkshire Community College; Marcus Cicerone, Brigham Young University; Juan Pablo Claude, University of Alabama at Birmingham; Denisha Dawson, Diablo Valley College; Walter Dean, Lawrence Technological University; Patrick Desrochers, University of Central Arkansas; Howard Dewald, Ohio University; Jim Diamond, Linfield College; David Dollimore, University of Toledo; Tim Donnelly, University of California, Davis;Jimmie G. Edwards, University of Toledo; Amina El-Ashmawy, Collin County Community College; Naomi Eliezer, Oakland University; Roger Frampton, Tidewater Community College; Donna Friedman, St. Louis Community College; Galen George, Santa Rosa Junior College; Kevin Gratton, Johnson Community College; Ann Gull, St. Joseph's College; Greg Guzewich; Midge Hall, Clark State Community College; James Hardcastle, Texas Women's University; Blaine Harrison, West Valley College; David Henderson, Trinity College; Jeffrey Hurlbut, Metropolitan State College; Jo Ann Jansing, Indiana University Southeast; Craig Johnson, Carlow College; James Johnson, Sinclair Community College; Sharon Kapica, County College of Morris; Roy Kennedy, Massachusetts Bay Community College; Gary Kinsel, University of Texas, Arlington; Leslie Kinsland, University of Southern Louisiana; Deborah Koeck, Southwest Texas State University; Kurtis Koll, Cameron University; Christopher Landry, University of Vermont; Joseph Lechner, Mount Vernon Nazarene College; Robley Light, Florida State University; John Long, Henderson State University; Jerome Maas, Oakton Community College; Art Maret, University of Central Florida; Jeffrey Mathys; Ken Miller, Milwaukee Area Technical College; Barbara Mowery, Thomas Nelson Community College; Kathy Nabona, Austin Community College; Ann Nalley, Cameron University; Andrea Nolan; Miami University Middletown; Rod Oka, Monterey Peninsula College (class tester); Joyce Overly, Gaston College; Maria Pacheco, Buffalo State College; Brenda Peirson; Amy Phelps, University of Northern Iowa; Morgan Ponder, Samford University; Matiur Rahman, Austin Community College; Pat Rogers, University of California, Irvine; Phil Reedy, Delta College; Ruth Russo, Whitman College; Lowell Shank, Western Kentucky University; Ike Shibley, Pennsylvania State Berks; Trudie Jo Slapar Wagner, Vincennes University; Dennis Stevens, University of Nevada–Las Vegas; Jim Swartz, Thomas More College; Sue Thornton, Montgomery College; Philip Verhalen, Panola College; Gabriela Weaver, University of Colorado, Denver; William Wilk, California State University; Dominguez Hills; Linda Wilson, Middle Tennessee State University; Donald Wink, University of Chicago;James Wood, University of Nebraska at Omaha; Jesse Yeh, South Plains College; Linda Zarzana, American River College; David Zellmer, California State University, Fresno.

If you have any questions about the text that you would like to ask me, I'd be happy to have the opportunity to answer them. Your Benjamin Cummings sales representative can provide you with my email address. I hope that your teaching experience using this book (or any other text) will be a satisfying and pleasurable experience.

Mark Bishop
Monterey, California

Features of This Book

Many of the chapters begin with a short introduction that describes how the topics in the chapter relate to the reader's daily life.

The Review Skills section instructs the reader to review specific skills from earlier chapters that are necessary for success in the present chapter.

CHAPTER 4

An Introduction to Chemical Reactions

N OW THAT YOU UNDERSTAND THE BASIC STRUCTURAL DIFFERENCES between different kinds of substances, you are ready to begin learning about the chemical changes that take place as one substance is converted into another. Chemical changes are chemists' primary concern. They want to know what, if anything, happens when one substance encounters another. Do the substances change? How and why? Can the conditions be altered so as to speed the changes up, slow them down, or perhaps reverse them? Once chemists understand the nature of one chemical change, they begin to explore the possibilities that arise from

an old house as is, with the water turned off. It will go, and all you get is a slow drip, drip, to ruin ... ty that ... ning, you ... ur trou-... change ... ventually ... s, you ... ve that ... tooth-... that can ... help right cavities.

Chemical changes, like the ones mentioned above, are described ... chapter begins with a discussion of how to interpret and write chemica...

Review Skills

The presentation of information in this chapter assumes that you can a... listed below. You can test your readiness to proceed by answering the F... the chapter. This might also be a good time to read the Chapter Object... Questions.

- Write the formulas for the diatomic elements. (Section 2.5)
- Predict whether a bond between 2 atoms of different elements would be covalent or ionic. (Section 3.2)

- Des...
- Com...
 binary covalent compounds, and ionic compounds. (Sections 3.3–3.5)

A chemical reaction causes solids to form in hot water pipes.

174 Chapter 4 ▌ An Introduction to Chemical Reactions

▌ Review Questions

1. Write the formulas for all of the diatomic elements.
2. Predict whether atoms of each of the following pairs of elements would be expected to form ionic or covalent bonds.
 - a. Mg and F
 - b. O and H
 - c. Fe and O
 - d. N and Cl
3. Describe the structure of liquid water, including a description of water molecules and the attractions between them.
4. Write formulas that correspond to the following names.
 - a. ammonia
 - b. methane
 - c. propane
 - d. water
5. Write formulas that correspond to the following names.
 - a. nitrogen dioxide
 - b. carbon tetrabromide
 - c. dibromine monoxide
 - d. nitrogen monoxide
6. Write formulas that correspond to the following names.
 - a. lithium fluoride
 - b. lead(II) hydroxide
 - c. potassium oxide
 - d. sodium carbonate
 - e. chromium(III) chloride
 - f. sodium hydrogen phosphate

▌ Key Ideas

Complete the following statements by writing one of these words or phrases in each blank.

above	minor
charge	negative
chemical bonds	none
coefficients	organized, repeating
complete formula	partial charges
continuous	positive
converted into	precipitate
created	precipitates
delta, Δ	precipitation
destroyed	same proportions
equal to	separate ions
gas	shorthand description
homogeneous mixture	solute
left out	solvent
liquid	subscripts
major	very low

7. A chemical change or chemical reaction is a process in which one or more pure substances are _____ one or more different pure

Photographs give the reader visual reminders that chemistry is important in their world.

Students can test themselves on the problems in the Review Questions section found at the end of each chapter.

The Key Ideas section gives the reader an opportunity to review the most important ideas from the chapter.

Salt towers rise from the water in Mono Lake, California.

This is a sample page showing the features of the textbook.

The comprehensive list of Chapter Objectives at the end of each chapter identifies the key skills taught within the chapter (in the same logical order as in the chapter) so that students can concentrate on learning the most important material. The number of each objective appears in the margin next to the text where that objective is described. Many of the end-of-chapter problems are also accompanied by references to the corresponding objectives.

A Chapter Glossary of new terms at the end of each chapter makes it easy for the reader to learn these terms and provides a brief review of the chapter information.

In-chapter Examples provide the reader with models for how to complete important problems.

This text is full of real-world examples, both in the chapter narrative and in the problems. The **Chapter Problems** not only test readers on specific skills, but they also teach them how chemicals are made, how substances are used, and some of the issues that relate to chemicals.

The Examples are followed by similar **Exercises** that provide the reader with an opportunity to test their skills. The Exercises are in the back of the book, and the complete solutions are in the Student Study Guide.

Page 222

Chapter 5 ❙ Acids, Bases, and Acid-Base Reactions

Chapter Objectives

The goal of this chapter is to teach you to do the following.

Section 5.1 Acids

1. Define all of the terms in the Chapter Glossary.
2. Identify...
3. Describe... to water...
4. Identify...

...duce fever H₃O⁺ ions in water than strong
...umbers of acid molecules are added to equal

ong monoprotic acids: HCl and HNO₃,
protic strong acid.
sulfuric acid is added to water.
any acid, identify it as a strong or a weak acid.

and formulas for binary acids and oxyacids.

Nomenclature

ormula, tell whether it represents a binary ionic
nd with polyatomic ion(s), a binary covalent
an oxyacid.
ds with polyatomic ion(s), binary covalent

OBJECTIVE 31

EXAMPLE 5.8 Bronsted–Lowry Acids and Bases

Identify the Bronsted–Lowry acid and base for the forward reaction in each of the following equations.

a. $HClO_2(aq) + NaIO(aq) \rightarrow HIO(aq) + NaClO_2(aq)$
b. $HS^-(aq) + HF(aq) \rightarrow H_2S(aq) + F^-(aq)$
c. $HS^-(aq) + OH^-(aq) \rightarrow S^{2-}(aq) + H_2O(l)$
d. $H_3AsO_4(aq) + 3NaOH(aq) \rightarrow Na_3AsO_4(aq) + 3H_2O(l)$

Solution

a. The $HClO_2$ loses an H^+ ion, so it is the Bronsted–Lowry acid. The IO^- in the NaIO gains the H^+ ion, so the NaIO is the Bronsted–Lowry base.
b. The HF loses an H^+ ion, so it is the Bronsted–Lowry acid. The HS^- gains the H^+ ion, so it is the Bronsted–Lowry base.
c. The HS^- loses an H^+ ion, so it is the Bronsted–Lowry acid. The OH^- gains the H^+ ion, so it is the Bronsted–Lowry base.
d. The H_3AsO_4 loses three H^+ ions, so it is the Bronsted–Lowry acid. Each OH^- in NaOH gains an H^+ ion, so the NaOH is the Bronsted–Lowry base.

EXERCISE 5.10 Bronsted–Lowry Acids and Bases

Identify the Bronsted–Lowry acid and base in each of the following equations.

a. $HNO_2(aq) + NaBrO(aq) \rightarrow HBrO(aq) + NaNO_2(aq)$
b. $H_2AsO_4^-(aq) + HNO_2(aq) \rightleftharpoons H_3AsO_4(aq) + NO_2^-(aq)$
c. $H_2AsO_4^-(aq) + 2OH^-(aq) \rightarrow AsO_4^{3-}(aq) + 2H_2O(l)$

Chapter Glossary

Hydronium ion H_3O^+.

Arrhenius acid According to the Arrhenius theory, any substance that generates hydronium ions, H_3O^+, when added to water.

Acidic solution A solution with a significant concentration of hydronium ions, H_3O^+

Chapter 14 ❙ Liquids, Condensation, Evaporation, and Dynamic Equilibrium

Chapter Problems

OBJECTIVE 2

Section 14.1 Change from Gas to Liquid and from Liquid to Gas—An Introduction to Dynamic Equilibrium

39. A batch of corn whiskey is being made in a backwoods still. The ingredients are mixed and heated, and because the ethyl alcohol, C_2H_5OH, evaporates more rapidly than the other... the liquid it forms has a... mixture is enriched in C_2H_5... C_2H_5OH is converted into a... from a high-temperature ga...

40. Why is dew more likely to...

41. Acetone, CH_3COCH_3, is a l... nail polish remover.
 a. Describe the submicros... liquid acetone when it c...
 b. Do all of the acetone m... liquid escape? If not, wh... molecule to escape fro... phase?
 c. If you spill some nail po... feel cold?
 d. If you spill some aceton... rapidly than the same a...
 e. If you spill acetone on... more quickly than the same amount of acetone spilled on the cooler lab bench. Why?

42. Consider two test tubes, each containing the same amount of liquid acetone. A student leaves one of the test tubes open overnight and covers the other one with a balloon so that gas cannot escape. When the student returns to the lab the next day, all of the acetone is gone from the open test tube, but most of it remains in the covered tube.
 a. Explain why the acetone is gone from one test tube and not from the other.
 b. Was the initial rate at which liquid changed to gas (the rate of evaporation) greater in one test tube than in the other? Explain your answer.
 c. Consider the system after 30 minutes, with liquid remaining in both test tubes. Is condensation (vapor to liquid) taking place in both test tubes? Is the rate of condensation the same in both test tubes? Explain your answer.
 d. Describe the submicroscopic changes in the covered test tube that lead to a constant amount of liquid and vapor.
 e. The balloon expands slightly after it is placed over the test tube, suggesting an initial increase in pressure in the space above the liquid. Why? After this initial expansion, the balloon stays inflated by the same amount. Why doesn't the pressure inside the balloon change after the...

OBJECTIVE 3
OBJECTIVE 4
OBJECTIVE 5
OBJECTIVE 7
OBJECTIVE 9
OBJECTIVE 10
OBJECTIVE 12

By taking advantage of the properties of gases at high temperatures and pressures, scientists have invented a new, environmentally friendly spray-painting process.

SPECIAL TOPIC 13.1 A Greener Way to Spray Paint

United States industries use an estimated 1.5 billion liters of paints and other coatings per year, and much of this is applied by spraying. Each liter sprayed from a canister releases an average of 550 grams of volatile organic compounds (VOCs), including hydrocarbons, alcohols, esters, and ketones. Some of these VOCs are hazardous air pollutants.

The mixture that comes out of the spray can has two kinds of components: (1) the solids being deposited on the surface as a coating and (2) a solvent blend that allows the solids to be sprayed and to spread evenly. The solvent blend must dissolve the coatings into a mixture that is thin enough in consistency to be easily sprayed. But a mixture that is thin enough to be easily deposited on a surface. Therefore, the solvent blend contains additional components so volatile that they will evaporate from the spray droplets between the time the spray leaves the spray nozzle and the time the spray hits the surface. Still other, slower-evaporating components do not evaporate until after the spray hits the surface. They remain in the coating mixture long enough to cause it to spread out evenly. Because the more volatile solvents have escaped, the mixture that hits the surface is thick enough not to run or sag.

The Clean Air Act has set strict limitations on the emission of certain VOCs, so safer solvents are needed to replace them. One new spray system has been developed that yields a high-quality coating while emitting as much as 80% fewer VOCs of all types and none of the VOCs that are considered hazardous air pollutants. This system is called the *supercritical fluid spray process*. The solvent mixture for this process still contains some of the slowly evaporating solvents that allow the coating to spread evenly, but it replaces the rapidly-evaporating solvents with high-pressure CO_2.

Some gases can be converted into liquids at room temperature by being compressed into a smaller volume, but for each gas, there is a temperature above which

The critical temperature of CO_2 is 31 °C. Above this temperature, carbon dioxide can be compressed into a very high-pressure and relatively high-density critical fluid. Like a liquid, the supercritical ca... ide will mix with or dissolve the blend of coat... low-volatility solvent to form a product that is ... enough to be sprayed easily, in very small dro... supercritical CO_2 has a very high volatility, so ... rates from the droplets almost immediately af... are emitted from the spray nozzle, leaving a m... that is thick enough not to run or sag when it ... surface. The mixture is sprayed at temperature... 50 °C and a pressure of 100 atm (about 100 tim... room pressure).

Because carbon dioxide is much less toxic t... VOCs it replaces and because it is nonflamma... It is also far less expensive. Moreover, the CO_2... obtained from the production of other chemic... new process does not lead to an increase in ca... ide in the atmosphere. In fact, because the VO...

Figure 5.14
Hydronium and Hydroxide Ions

This proton, H^+, is transferred to a hydroxide ion.

$$H_3O^+(aq) + OH^-(aq) \rightarrow 2H_2O(l)$$

Figure 5.15
After Reaction of Nitric Acid and Sodium Hydroxide
OBJECTIVE 23a

Nitrate ion, NO_3^-

After the reaction between nitric acid and sodium hydroxide, hydroxide ions, OH^-, and hydronium ions, H_3O^+, have combined to form water, H_2O.

The sodium ions, Na^+, and the nitrate ions, NO_3^-, remain in solution in the same form they were in before the reaction.

Sodium ion, Na^+

...d not actively participate in the reaction. In other ...ns, so they are left out of the net ionic chemical ...tion for the reaction is therefore

$$\rightarrow 2H_2O(l)$$

...bit of describing reactions such as this in terms ...en though hydrogen ions do not exist in a water ...e that sodium ions do. When an acid loses a ...proton immediately forms a covalent bond to ...it forms a covalent bond to a water molecule to ...n. Although H_3O^+ is a better description of

Figure 13.4
Relationship Between Temperature and Pressure
Increased temperature leads to increased pressure if the moles of gas and the volume are constant.
OBJECTIVE 10b

Piston locked in position
A constant amount of gas . . .
Constant volume
Increased temperature
Increased pressure
Heat added

Increased temperature
Increased average velocity of the gas particles
Increased number of collisions with the walls → Increased force per collision
Increased total force of collisions
$\dfrac{\text{Increased force due to collisions}}{\text{area of wall}}$
Increased gas pressure

Increased temperature → Increased volume OBJECTIVE 10c

Decreased temperature → Decreased volume OBJECTIVE 10c

OBJECTIVE 10c

The Relationship Between Volume and Temperature

Consider the system shown in Figure 13.5 on the next page. To demonstrate the relationship between temperature and volume of gas, we must keep the moles of gas and the gas pressure constant. If our valve is closed and our system has no leaks, the moles of gas are constant. We keep the gas pressure constant by allowing the piston to move freely throughout our experiment, because then it will adjust to keep the pressure pushing on it from the inside equal to the atmospheric pressure pushing on it from the outside. The atmospheric pressure is the pressure in the air outside the container, which acts on the top of the piston because of the force of collisions between particles in the air and the surface of the piston. We can assume that it is constant throughout our experiment.

If we increase the temperature, the piston in our apparatus moves up, increasing the volume occupied by the gas. A decrease in temperature leads to a decrease in volume.

Increased temperature → Increased volume

Decreased temperature → Decreased volume

The increase in temperature of the gas leads to an increase in the average velocity of the gas particles, which leads in turn to more collisions with the walls of the container and a greater force per collision. This greater force acting on the walls of the container leads to an *initial* increase in the gas pressure. Thus, the increased temperature of our gas creates an internal pressure, acting on the bottom of the piston, that is greater than the external pressure acting on the top of the piston. The greater internal pressure causes the piston to move up, increasing the volume of the chamber. The increased volume leads to a decrease in gas pressure in the container, until

Special Topics in each chapter describe important issues relating to chemistry, including environmental issues and health-related applications. Several of these Special Topics describe the achievements of "green chemistry" (or environmentally benign chemistry), which has as its goal the development of new ways to produce, process, and use chemicals so as to reduce the risks to humans and to the environment.

Many features of the book help students develop the ability to visualize the models that chemists use for describing the structure and behavior of matter. The reader is continually encouraged, with the aid of colorful and detailed illustrations, to visualize particle movements and particle interactions that accompany chemical changes.

Figures throughout the text illustrate important ideas and act as constant reminders of the particle nature of matter. Key concepts are often summarized with logic sequences that show how one component of an explanation leads logically to the next.

Figure 7.5
Relationship Between Stability and Potential Energy

OBJECTIVE 6

- More stable
- Lower potential energy

- Less stable
- Higher potential energy

Figure 7.6
Endergonic Change

OBJECTIVE 7

greater force of attraction		lesser force of attraction
atoms in bond		separate atoms
lower PE		higher PE
more stable		less stable

$$O_2(g) + radiant\ energy \rightarrow O(g) + O(g)$$

the more stable atoms in the bond. For example, the first step in the formation of ozone in the earth's atmosphere is the breaking of the oxygen-oxygen covalent bonds in more stable oxygen molecules, O_2, to form less stable separate oxygen atoms. This change could not occur without an input of considerable energy—in this case, radiant energy from the sun. We call changes that absorb energy **endergonic** (or endogonic) changes (Figure 7.6).

The attraction between the separated atoms makes it possible that they will change from their less stable separated state to the more stable bonded state. As they move together, they may bump into and move something (such as another atom), so the separated atoms have a greater capacity to

The bonds between oxygen atoms in O_2 molecules are stronger and more stable than the bonds between atoms in the ozone molecules, so...

like the situation depicted in Figure 16.6, where a rolling ball rolls back down the same side of a hill it started up.

If a rolling ball does not have enough energy to get to the top of a hill, it stops and rolls back down.

Figure 16.6
Not Enough Kinetic Energy to Get Over the Hill

OBJECTIVE 6

The activation energy for the oxygen-ozone reaction is 17 kJ/mole O_3. If the collision between reactants yields a net kinetic energy equal to or greater than the activation energy, the reaction can proceed to products (Figure 16.7). This is like a ball rolling up a hill with enough kinetic energy to reach the top of the hill, from which it can roll down the other side (Figure 16.8).

If a ball reaches the top of a hill before its energy is depleted, it will continue down the other side.

Particles that collide with a net kinetic energy greater than the activation energy can react.

Particles that collide with a net kinetic energy less than the activation energy cannot react.

Figure 16.7
Collision Energy and Activation Energy

OBJECTIVE 6

Figure 16.8
Ball with Enough Kinetic Energy to Get Over the Hill

OBJECTIVE 6

represent the combustion reactions for methane, the primary component of natural gas, and hexane, which is found in gasoline.

$$CH_4(g) + 2O_2(g) \rightarrow CO_2(g) + 2H_2O(l)$$
$$2C_6H_{14}(l) + 19O_2(g) \rightarrow 12CO_2(g) + 14H_2O(l)$$

The complete combustion of a substance, such as ethanol, C_2H_5OH, that contains carbon, hydrogen, and oxygen also yields carbon dioxide and water.

$$C_2H_5OH(l) + 3O_2(g) \rightarrow 2CO_2(g) + 3H_2O(l)$$

When any substance that contains sulfur burns completely, the sulfur forms sulfur dioxide. For example, when methanethiol, CH_3SH, burns completely, it forms carbon dioxide, water, and sulfur dioxide. Small amounts of this strong-smelling substance are added to natural gas to give the otherwise odorless gas a smell that can be detected if a leak occurs (Figure 6.3).

$$CH_3SH(g) + 3O_2(g) \rightarrow CO_2(g) + 2H_2O(l) + SO_2(g)$$

Figure 6.3
Odor to Natural Gas
The methanethiol added to natural gas warns us when there is a leak.

OBJECTIVE 8

Combustion reactions include oxygen as a reactant and are accompanied by heat and usually light.

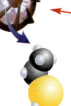

SAMPLE STUDY SHEET 6.2
Writing Equations for Combustion Reactions

OBJECTIVE 8

The following sample study sheet lists the steps for writing equations for combustion reactions.

TIP-OFF You are asked to write an equation for the complete combustion of a substance composed of one or more of the elements carbon, hydrogen, oxygen, and sulfur.

GENERAL STEPS
Step 1 Write the formula for the substance combusted.
Step 2 Write $O_2(g)$ for the second reactant.

A variety of art, combining photos and illustrations, highlight the key concepts.

SAMPLE STUDY SHEET 9.1

Converting Between Mass of Element and Mass of Compound Containing the Element

OBJECTIVE 15

Tip-off When you analyze the type of unit you have and the type of unit you want, you recognize that you are converting between a unit associated with an element and a unit associated with a compound containing that element.

General Steps The following general procedure is summarized in Figure 9.3.

- **Convert the given unit into moles of the first substance.**

 This step often requires converting the given unit into grams, after which the grams can be converted into moles using the molar mass of the substance.

- **Convert moles of the first substance into moles of the second substance using the molar ratio derived from the formula for the compound.**

 You convert either from moles of element into moles of compound or from moles of compound into moles of element.

- **Convert moles of the second substance into the desired units of the second substance.**

 This step requires converting moles of the second substance into grams of the second substance using the molar mass of the second substance, after which the grams can be converted into the specific units that you want.

Example See Example 9.6.

Figure 9.3
General Steps for Converting Between the Mass of an Element and the Mass of a Compound Containing the Element
The calculation can be set up to convert from the mass of an element to the mass of a compound (top to bottom) or from the mass of a compound to the mass of an element (bottom to top).

OBJECTIVE 15

Any unit of an element
↕ Using conversion factors from Chapter 8
Grams of element
↕ Using molar mass derived from atomic mass (1 mol element / atomic mass g element)
Moles of element
↕ Using the mole ratio from the compound's formula (number of atoms in formula / 1 mol element)
Moles of compound containing the element
↕ Using molar mass derived from formula mass (formula mass g compound / 1 mol compound)
Grams of compound
↕ Using conversion factors from Chapter 8
Any unit of a compound

INTER-CHAPTER
1A

A Brief Introduction to Unit Conversions

CHAPTER
8

Unit Conversions

[M]athematics . . . is the easiest of sciences, a fact which is obvious in that no one's brain rejects it . . .
ROGER BACON (c. 1214–c. 1294)
ENGLISH PHILOSOPHER AND SCIENTIST

Stand firm in your refusal to remain conscious during algebra.
In real life, I assure you, there is no such thing as algebra.
FRAN LEBOWITZ (b. 1951)
AMERICAN JOURNALIST

You may agree with Roger Bacon that mathematics is the easiest of sciences, but many beginning chemistry students would not. Because they have found mathematics challenging, they wish it were not so important for learning chemistry—or for answering so many of the questions that arise in everyday life. If you are one of the latter group, it will please you to know that even though there is some algebra in chemistry, this chapter teaches a technique for doing chemical calculations (and many other calculations) without it. The technique is called dimensional analysis. You will be using it throughout the rest of this book, in future chemistry and science courses, and any time you want to calculate the number of nails you need to build a fence or the number of rolls of paper necessary to cover the kitchen shelves.

Review Skills

The presentation of information in this chapter assumes that you can already perform the tasks listed below. You can test your readiness to proceed by answering the Review Questions at the end of the chapter. This might also be a good time to read the Chapter Objectives, which precede the Review Questions.

- List the metric base units and the corresponding abbreviations for length, mass, volume, energy, and gas pressure. (Section 1.4)
- State the numbers or fractions represented by the following metric prefixes, and write their abbreviations: giga, mega, kilo, centi, milli, micro, nano, and pico. (Section 1.4)
- Given a metric unit, write its abbreviation; given an abbreviation, write the full name of the unit. (Section 1.4)
- Describe the relationships between the metric units that do not have prefixes (such as meter, gram, and liter) and units derived from them by the addition of prefixes—for example, $1\ km = 10^3\ m$. (Section 1.4)

- Define temperature and describe the Celsius, Fahrenheit, and Kelvin scales used to report its values. (Section 1.4)
- Given a value derived from a measurement, identify the range of possible values it represents, on the basis of the assumption that its uncertainty is ±1 in the last position reported. (For example, 8.0 mL says the value could be from 7.9 mL to 8.1 mL.) (Section 1.5)

Dimensional analysis, the technique for doing unit conversions that is described in this chapter, can be used for a lot more than chemical calculations.

Supplements to This Book

Instructor's Supplements

Instructor's Manual and Complete Solutions (0-8053-3215-4)

The Instructor's Manual has complete solutions to all of the in-chapter exercises and all of the end-of-chapter problems. It also contains suggestions for using the book most efficiently, possible variations in the order of coverage, lists of topics that can be skipped without causing problems for the coverage of later topics, and lists of the available computer tools for each chapter.

Printed Test Bank (0-8053-3213-8)

This printed test bank includes over 1500 questions that correspond to the major topics in the text.

Computerized Test Bank (0-8053-3214-6)

This dual-platform CD-ROM includes over 1500 questions that correspond to the major topics in the text.

Benjamin Cummings Science Digital Library (0-8053-3209-X)

The CD-ROM provides instructors a wealth of illustrations for incorporation into lecture presentations, student materials, and tests.

Transparency Acetates (0-8053-3212-X)

Includes 125 full-color acetate transparencies.

Instructor's Manual for Lab Manual (0-8053-3217-0)

The Chemistry Place, Special Edition for Bishop, allows students to learn chemistry in an interactive environment, helping to consolidate and enhance important skills.

Student's Supplements

Study Guide and Selected Solutions (0-8053-3211-1)

Each chapter in the Study Guide contains introductions to every section in the corresponding text chapter, a checklist to help students study efficiently, lists of important skills to master, a concept map to help students visualize the connections among the chapter topics, solutions to the in-chapter exercises, and solutions to selected end-of-chapter problems.

Laboratory Manual (0-8053-3217-0)

This introductory chemistry Laboratory Manual, written to accompany the Bishop text, contains 25 labs. It is designed to help students develop data acquisition, organization, and analysis skills while teaching basic techniques. Students learn to construct their own data tables, answer conceptual questions, and make predictions before performing experiments. They also have the opportunity to visualize and describe molecular level activity and explain the results.

Special Edition of The Chemistry Place
www.chemplace.com/college

This special edition of The Chemistry Place engages students in interactive exploration of chemistry concepts and provides a wealth of tutorial support. Tailored to the Bishop textbook, the site includes detailed objectives for each chapter of the text, interactive activities featuring simulations, animations, and 3D visualization tools, multiple-choice and glossary quizzes, and an extensive set of Web links. For instructors, a Syllabus Manager makes it easy to create an online syllabus complete with weekly assignments, projects, and test dates that students may access on the ChemPlace site.

A world of chemistry awaits you.

I would watch the buds swell in spring, the mica glint in the granite, my own hands, and I would say to myself: "I will understand this, too. I will understand everything."

PRIMO LEVI (1919–1987)
ITALIAN CHEMIST AND AUTHOR, *THE PERIODIC TABLE*

T IS HUMAN NATURE TO WONDER—about the origins of the universe and of life, about their workings, and even about their meanings. We look for answers in physics, biology, and the other sciences, as well as in philosophy, poetry, and religion. Primo Levi could have searched for understanding in many ways, but his wondering led him to study chemistry . . . and so has yours, although you may not yet know why.

1.1 What Is Chemistry, and What Can Chemistry Do for You?

One thing is certain: Once you start studying chemistry, all kinds of new questions begin to occur to you. Let's consider a typical day.

Your alarm rings early, and you are groggy from sleep but eager to begin working on a chemistry assignment that's coming due. Chemistry has taught you that there are interesting answers to questions you might once have considered silly and childish. Preparing tea, for example, now makes you wonder why the boiling water bubbles and produces steam, whereas the teakettle retains its original shape. How do the tea leaves change the color of the water while the teabag remains as full and plump as ever? Why does sugar make your tea sweet, and why is the tea itself bitter?

You settle down with tea and newspaper, and the wondering continues. An article about methyl bromide, a widely used pesticide, says some scientists think it damages the ozone layer. What *are* methyl bromide and ozone? How does one destroy the other, and why should we care? How can we know whether the ozone really is being depleted?

An understanding of chemistry opens up a window to the world around you.

Later, as you drive to the library to get some books you need to complete that chemistry assignment, you wonder why gasoline burns and propels your car down the road. How does gasoline pollute the air we breathe, and what does the catalytic converter do to minimize this pollution? At the library, you wonder why some books that are hundreds of years old are still in good shape, whereas the pages of other books only 50 years old are brown, brittle, and crumbling. Can the books with damaged pages be saved?

Chemists can answer all these questions and others like them. They are scientists who study the structure of material substances—collectively called matter—and the changes that they undergo. Matter can be solid like sugar, liquid like water, or gaseous like the exhaust from your car's tail pipe. **Chemistry** is often defined as the study of the structure and behavior of matter.

Chemists do a lot more than just answer questions. Industrial chemists are producing new materials to be used to build lighter and stronger airplanes, more environmentally friendly disposable cups, and more efficient antipollution devices for your car. Pharmaceutical chemists are developing new drugs to fight cancer, control allergies, and even grow hair on bald heads.

In the past, the chemists' creations have received mixed reviews. The chlorofluorocarbons (CFCs) used as propellants in aerosol cans are now known to threaten the earth's protective ozone layer. The durable plastics that chemists created have proved *too* durable; so when they are discarded, they remain in the environment for a long, long time. One of the messages you will find in this book is that, despite occasional mistakes and failures, most chemists have a strong social conscience. Not only are they actively developing new chemicals to make our lives easier, safer, and more productive, but they are also working to clean up our environment and minimize the release of chemicals that might be harmful to our surroundings (see Special Topic 1.1: *Green Chemistry*).

As you read on in this book, you will find, perhaps to your disappointment, that only limited portions of each chapter provide direct answers to real-life questions. An introductory chemistry text, like this one, must focus instead on teaching basic principles and skills. Some of the things you need to learn in order to understand chemistry may seem less than fascinating, and it will not always be easy to see why they are useful. Try to remember that the fundamental concepts and skills will soon lead you to a deeper understanding of the physical world.

Before you could run, you needed to learn how to walk. Before you could read a book or write a paper, you needed to learn the alphabet, build your vocabulary, and understand the basic rules of grammar. Chemistry has its own "alphabet" and vocabulary, as well as many standards and conventions, that enable chemists to communicate and to do efficient, safe, and meaningful work. Learning the symbols for the common chemical elements, the rules for describing measurements, or the conventions for describing chemical changes might not be as interesting as finding out how certain chemicals in our brains affect our mood, but they are necessary steps in learning chemistry.

This chapter presents some suggestions for making your learning process easier and introduces some of the methods of scientific measurement and reporting. You will then be ready for Chapter 2, which gives you a first look at some of chemistry's basic underlying concepts.